# SPACE

FROM MAXXI'S
COLLECTIONS OF ART
AND ARCHITECTURE

D1450478

**Libri MAXXI**
Series supervised by Pio Baldi

# SPACE

FROM MAXXI'S
COLLECTIONS OF ART
AND ARCHITECTURE

Curators
Stefano Chiodi
Domitilla Dardi

**Electa**

MUSEO NAZIONALE
DELLE ARTI
DEL XXI SECOLO

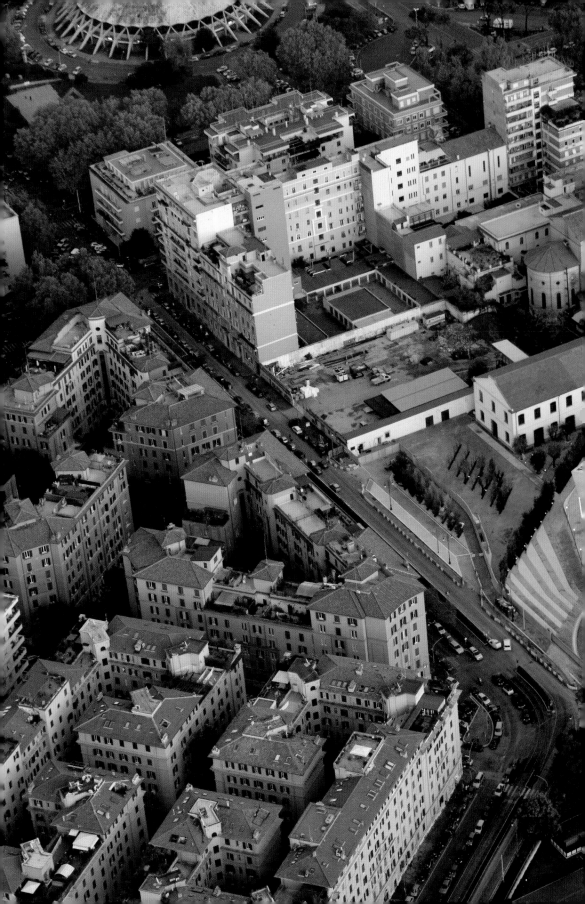

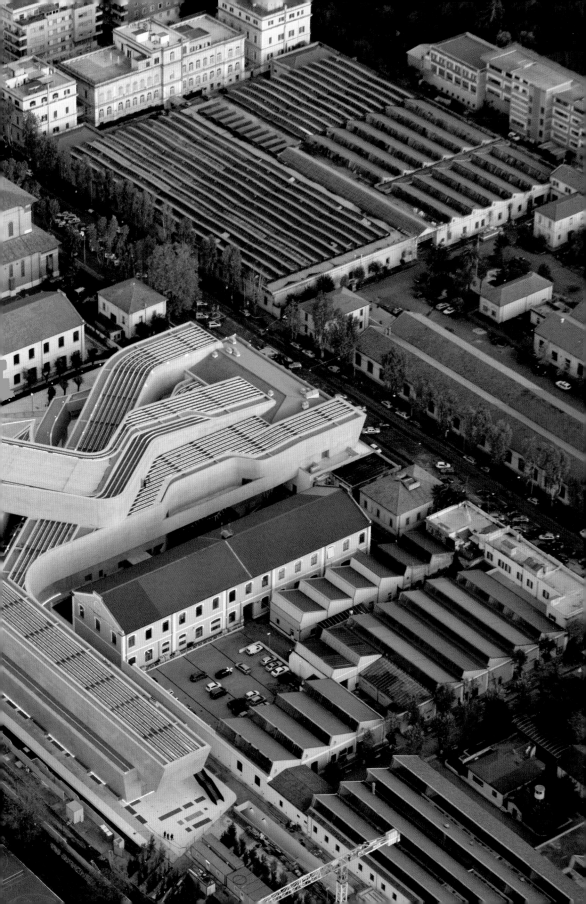

# SPACE

## FROM MAXXI'S COLLECTIONS OF ART AND ARCHITECTURE

MAXXI – Museo nazionale delle arti del XXI secolo
Rome, May 30, 2010 – January 23, 2011

**Director, MAXXI Architettura**
Margherita Guccione

**Director, MAXXI Arte**
Anna Mattirolo

**Curators**
Pippo Ciorra
Alessandro D'Onofrio
Bartolomeo Pietromarchi
Gabi Scardi

**General coordination**
Laura Felci
Monia Trombetta

**Organization**
Irene de Vico Fallani
Alexandra Kaspar
Luigia Lonardelli
Anne Palopoli
Giulia Pedace
with Ilenia D'Ascoli

**Mounting plan**
Laura Felci
Claudia Reale

**Executive mounting plan**
Studio DAZ
with Dolores Lettieri

**Registrar**
Francesca Fabiani
Silvana Freddo
Monica Pignatti Morano

**Conservation**
Alessandra Barbuto
Simona Brunetti

**Restorers**
Fabiana Cangià
Andrea Carini
(Superintendence BSAE of Milan)
Francesca Preziosi

**Educational Department**
Stefania Vannini
Sofia Bilotta
Simona Antonacci
Marta Morelli
Antonella Muzi

**Press Office**
Beatrice Fabbretti
Annalisa Inzana
Paolo Le Grazie

**Graphics**
Graphics plan
MA design (Ps)
**coordination**
Daniela Pesce
Elisabetta Virdia

**Mounting implementation**
Ares
Cavir S.r.l.
Maida Bros S.r.l.
Media Arte Eventi

**Lighting tech suppliers**
Zumtobel
coordination
Paola Mastracci

with
LUCE e DESIGN S.r.l. – Domenico
Capezzuto

**Audio-visual systems mounting**
Natali Multimedia

**Artwork movers**
Bastàrt

**Transportation**
Arteria, Gondrand, Montenovi

**Insurance**
Axa, Progress Fine Art

For Massimo Grimaldi's work
Giordano Pastorini for S.D.R. snc,
Anguillara Sabazia, Rome

For Maurizio Mochetti's work
Alenia
Chief Executive Officer:
Giovanni Bertolone
Eng. Vincenzo D'Ambrosio (CTO)

Finmeccanica
President:
Pierfrancesco Guarguaglini
Scientific advisor: Andrea Aparo

Caltec
Technical Director:
Eng. Michelangelo Giuliano
Technical Office: Eng. Paolo
Caccavale

With the collaboration of:
MDAA
Architetti Associati
Arch. Marco Bevilacqua

Fabio Pennacchia
Gaia Scaramella
Eng. Maurizio Sperandini

**Lenders**
Associazione per l'arte Fabio Mauri,
Rome
Castello di Rivoli Museo d'Arte
Contemporanea, Rivoli - Turin
Fondazione Sandretto Re
Rebaudengo, Turin
Galleria nazionale d'arte moderna,
Rome
GaMEC – Galleria d'Arte Moderna e
Contemporanea, Bergamo
MAMbo – Museo d'Arte Moderna,
Bologna
Museo civico di Palazzo della Penna,
Perugia
Palazzo Reale Caserta
SMS Contemporanea, Siena
Studio Giulio Paolini, Turin

Unicredit Group, Milan
**The Fondazione MAXXI thanks**

Superintendent Maria Vittoria
Marini Clarelli and the entire staff of
the Galleria nazionale d'arte moderna,
in particular: Angelandreina Rorro,
Paolo Di Marzio, Stefano Marson,
Chiara Mutti, Barbara Tomassi,
Luciana Tozzi, Paola Carnazza,
Barbara Cisternino, Lucia Lamanna,
Claudia Palma, Silvio Scafoletti,
The MAXXI Library for its valued
contribution

Embassy of Finland
Embassy of the Netherlands
The Royal Norwegian Embassy
Archivio Domus
Archivio progetti IUAV
Archivio Ferrovie dello Stato
ACER – Associazione Costruttori Edili
di Roma e Provincia
Associazione per l'Arte Fabio Mauri
La Biennale di Venezia – Archivio
Storico delle Arti Contemporanee
Centro Sperimentale di
Cinematografia Production
CISA Palladio
Fondazione Olivetti
Fondazione La Triennale di Milano
Museo di Castelvecchio
RAI Teche
3D Produzioni, Ultrafragola
Dora Aceto, Riccardo Bagnetti,
Claudio Belleri, Andrea Bellini,
Marina Bertinetto, Marina Bon
Valsassina, Raffaella Borrelli,
Roberta Carlocchia, Andrea Cernicchi,
Cho Haeng Ya, Eduardo Cicelyn,
Ferdinando Creta, Paola Raffaella
David, Loredana De Luca,
Luca di Lorenzo, Giacinto Di
Pietrantonio, Maddalena Disch,
Michela Dowe, Sara Fumagalli,
Antonella Fusco, Claudio Gamba,
Gabriele Gaspari, Simona Inesi,
Riccardo Lami, Carla Mantovani,
Francesca Marabini, Gianfranco
Maraniello, Benedetta e Giovanni
Marcarelli, Achille Mauri, Neve
Mazzoleni, Beatrice Merz, Stefania
Napolitano, Camille Nesbitt,
Giovanni Oberti, Chiara Olivieri
Bertola, Deborah Palmieri, Marco
Pierini, Vincenzo Pizzuto, Maria Grazia
Prencipe, Cesare Querci, Mattia
Rebichini, Antonella Renzitti, Pier
Maria Riccardi, Mark Robbins, Bruna
Roccasalva, Alessandro Romanelli,
Sabrina Samorì, Patrizia Sandretto Re
Rebaudengo, Mario Scacchi, Guido
Schinclert, Filippo Seganti, Fabio
Speranza, Eder Staffolani,
Luigi S. Tiberi.

with the support of

technical partner for lighting

for Recetas Urbanas

for Rintala Eggertsson Architects

for West 8

for Cino Zucchi Architetti

# SPACE

## FROM MAXXI'S COLLECTIONS
## OF ART AND ARCHITECTURE

**Catalogue editors**
Stefano Chiodi
Domitilla Dardi

**Editorial coordination**
Carolina Italiano

**Editorial staff**
Emilia Giorgi
Carlotta Sylos Calò

**Iconography research**
Giulia Pedace

**Text by**
Marco Belpoliti
Giuliana Bruno
Maristella Casciato
Pippo Ciorra (p.c.)
Stefano Chiodi (s.c.)
Gilles Clément
Domitilla Dardi (d.d.)
Alessandro D'Onofrio (a.do.)
Emilia Giorgi (e.g.)
Margherita Guccione
David Joselit
Anna Mattirolo
Bartolomeo Pietromarchi (b.p.)
Telmo Pievani
Franco Purini
Elena Giulia Rossi
Gabi Scardi (g.s.)
Maurizio Vitta
Eyal Weizman

The editors wish to thank all those
who have contributed to the realization
of this catalogue, in particular:
Alessandro D'Onofrio, Emilia Giorgi,
Carolina Italiano, Alexandra Kaspar,
Manuel Orazi, Giulia Pedace,
Prisca Cupellini, Claudia Reale,
Carlotta Sylos Calò.

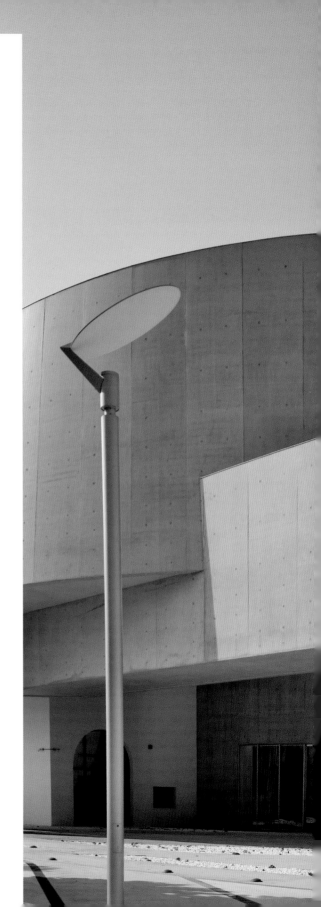

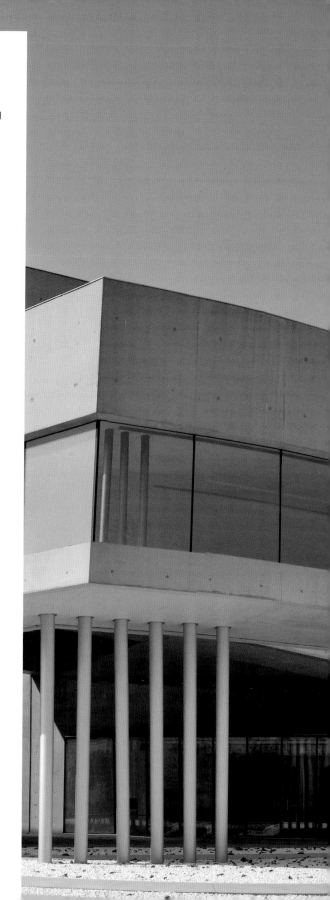

## Natural-Artificial

## From the Body to the City

**Maps of Reality**

**The Scene and the Imaginary**

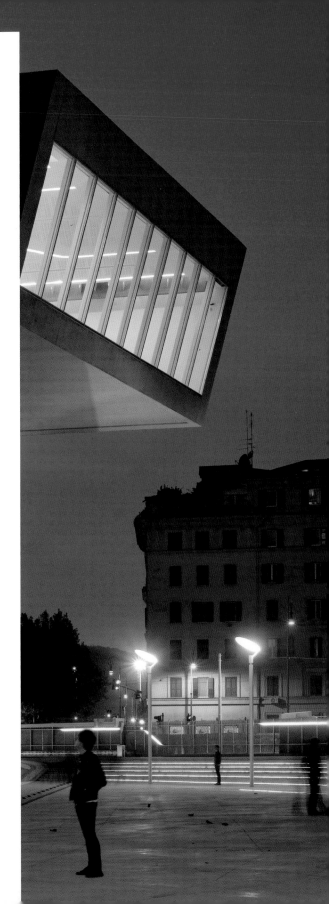

# Introduction

Pio Baldi

Although MAXXI is an acronym for the national Museum for the Arts of the twenty-first century, calling it a 'museum' may seem too restrictive, at least in the most common sense of the term. What has been taking shape in recent days, after years of intense effort, is a grand laboratory of present-day culture, dynamic, evolving, sensitive to the continual and abrupt variations of today's society. It has two cores – MAXXI Arte and MAXXI Architettura – but is open to all aspects of Italian and international creativity. Because in our era, as pages and pages of literature demonstrate, it no longer makes sense to speak of boundaries: art, architecture, design, fashion, dance, theater etc. coexist in an exchange of ideals and forms, and the task of a contemporary museum is to stimulate and record this rewarding dialogue.

The MAXXI has embraced this objective since the launch of the competition that resulted in the choice of Zaha Hadid's design for the structure intended to host an intense future activity. In fact, the MAXXI is the first example of this type of museum in Italy, and aims to keep pace with the most important corresponding institutions, such as Paris' Centre Pompidou and New York's MoMA.

The exhibition *Space* is the important first step along this new path, with works from the contemporary art collection openly dialoguing with installations created specifically for the occasion by ten experimentally minded international architecture studios. These specially commissioned installations will contribute to the formation of a contemporary/current architecture collection.

The exposition develops along the lines of four thematic areas that together offer a bird's-eye view of possible interpretations of contemporary

space: *Natural-Artificial, From the Body to the City, Maps of Reality* and *The Scene and the Imaginary.* Visitors can explore each area – populated by works of art and architecture in juxtaposition – in an absolutely free and spontaneous manner, in keeping with the openness suggested by Hadid's building in its original interpretation of Rome's urban fabric.

The result offers the most varied of publics the opportunity to navigate through a field of intersecting data and information, vicissitudes and visions, and develop a personal reflection on the social and environmental transformations of our present day.

On the basis of guidelines suggested by artists and architects – who are often keen to exchange their roles, achieving new expressive forms – the visitor will be a guest in a new 'space' of living, determined by an extraordinary complicity among all the arts.

# Space for Architecture

Margherita Guccione

In 2007 I asked Achille Bonito Oliva what function he thought a museum could have in our current era. "The museum still makes sense", he answered, "if it manages to make space for complexity and contradict the spectacularized, purely glittery simplification that surrounds us and that has produced what I call a filmic sensibility in society. The museum can restore complexity, highlighting interweavings, links, connections, short-circuits. That's the only way it can rejuvenate itself".

Three years later, the MAXXI is opening its doors to the public with a series of exhibitions dedicated to art and architecture. One in particular places them in direct relation with one another, undertaking the difficult endeavour of making the multiple languages of contemporary culture dialogue in the sinuous space created by Zaha Hadid.

The challenge is great, and it seems to me that the exhibition *Space* is an efficacious response to the questions Oliva raised. Here, contemporary art collections invade the exhibition space: paintings, photographs, installations, videos and web art capture the attention of museum visitors. Among these works, we have the dynamic presence of the site-specific installations by ten architectural studios from around the world, the fruit of commissions that will augment the museum's contemporary architecture section. Open to experimentation with new forms and planning strategies for today's metropolis, the studios invited to participate represent different currents of thought and language. From California's Estudio Teddy Cruz and Spain's Recetas Urbanas – both actively engaged in creating alternative ways of maximizing the urban territory – to Lebanon's Bernard Khoury, creator of architectures capable of judiciously re-elaborating the most contradictory aspects of a society scarred by war; from Italy's

Cino Zucchi, who presents a walk-through installation at the MAXXI in which the city becomes a living, pulsating body, to the Scandinavian firm Rintala Eggertsson, with their ecological dwelling prototype. And more: the New York-based Diller Scofidio + Renfro, who reflect on the random transformation of space by automatic action; France's Lacaton & Vassal, who deal with the broad theme of exhibiting contemporary art; R&Sie(n), with a mysterious object that investigates the material nature of the environment; and finally, the imaginary forest by the Dutch firm West 8 and the vibratile installation by Helena Paver Njirić.

The common denominator among all the installations – aside from the desire to express a personal vision of architectural space in our current circumstances – is open dialogue with the museum configuration created by Zaha Hadid.

The theme of space alludes not only to the operational space, but also to the *cultural space* that the Museum of Architecture intends to occupy with its present and future activity. In fact, the selection of invited architects and themes developed offers us an initial thematic indication of the museum's future activity and the 'ways' in which its collection will grow. Toward this end, each architecture studio was asked to donate all or part of the original project development materials: sketches, drawings and models that will add to the important legacy conserved in the museum. With *Space*, the MAXXI asserts itself as a great laboratory for the production of ideas, in which art and architecture take on ever-changing forms for a much broader public than that of "insiders".

The acquisition policy – crucial for any cultural institution – has until now taken documentation and research as the starting point for critical reflections on the present and recent past of architectural culture, considering the works, important figures and stories that designed the panorama of the twentieth century and will design it in the future. The collection of archives of architects and engineers such as Carlo Scarpa, Aldo Rossi, Pierluigi Nervi, to cite just a few, pertains to the twentieth century. In addition to such personal archives, the architecture collections also include thematic archives that group together projects linked to a particular theme or context, like Giancarlo De Carlo's polychromatic drawings, Paolo Soleri's long scrolls, Toyo Ito's multimedia installations and Alessandro Anselmi's perspective sketches. The collections will grow through traditional forms of acquisition as well as commissions and co-productions coordinated with the museum's research and exposition activities. In this way, the twentieth century archives will be joined by the most experimental creations of new Italian and international generations, who will be called upon to present their ideas within the museum.

Along these lines, to mark the occasion of the museum's opening exhibitions, the *Italian Geographies. A Journey through Contemporary Architecture* project took shape, promoted by the MAXXI and realized by Studio Azzurro as a permanent installation/laboratory. *Italian Geographies* is a dynamic archive in progress; a locus of reporting/analysis of Italian architectural matters, represented through a specific narrative style and a targeted selection of iconographic and visual materials. The installation is made up of a sequence of "worlds" containing scenarios of Italian architecture from the end of the Second World War to the present day: *cities, engineering, landscape, competitions, heritage, design, landmark, museum, protagonists, media* and *next*. The interactive work allows the visitor direct and personal access to the materials representing each world.

The qualities and intuition that made Zaha Hadid's project stand out are today reflected in the incredible capacity of the building's architectural form to anticipate developments in urban planning and design, the flexibility and fluidity of zones in constant change. This energy-charged, changeable and attractive museum space left the curators with no museographic or museological precedents; its sinuous lines represent the broad system of spatial and temporal relations and connections that the museum is intended to explore. More a workshop than a mere container/display, the museum seeks to create the conditions for the growth and development of the culture of the future, rather than limiting itself to interpreting what already exists. All of this, thanks to Zaha Hadid's vision, within a dynamic architectural organism that has flexibility of utilization and versatility as its strong suit, offering the public ever-diverse experiences beyond rigid, easily codifiable spaces. A museum that is an exemplar of architecture and at the same time a setting in which to efficaciously talk about it.

# A New Space

Anna Mattirolo

In 1998, when we set off on the adventure that has led us to today's inauguration of the MAXXI, perhaps we had not yet realized the project's magnitude and complexity. As we oversaw the progress of the architectural project, it became clear that organizing this exhibition would require meeting the challenges presented by a space that was unique in terms of its particular structure and relationship with the public.

The building's structural complexity was just the beginning. A great deal of effort was put into developing new ideas for the museum's cultural offering, which had to meet the public's ever changing needs and deal with the demands of works of art in such varied and dynamic materials and techniques. Through perseverance we addressed each of these questions and now find ourselves in a context that is an *unicum*, beyond the scope of any museological or museographical reading. The collection was the starting point for the architectural project, and the artwork remained the standard and unifying principle as it developed. The collection and the worksite grew together, and the building's forms developed in constant harmony with the works of art. In the future we will continue to link the acquisition of new works with the exhibition program. Exhibitions serve as the testing grounds for works, and only after such a vetting process will they become part of our collection.

The museum will be a place for experimentation, a continuous workshop that will allow us to choose which works merit inclusion in our permanent collection. In fact, the process of preparing an exhibition is fundamental in deciding which works to acquire. It gives us the possibility to directly relate with the works and develop relationships with artists. It allows us to understand the key aspects of an artist's biography and artistic development in order to place the work in a

broader historical and critical context.

The museum's policy is based on two principles. The first is the care and study that goes into developing and maintaining the museum's collection. This is a daily and continuous effort which is interconnected with the second principle, exhibition. Thus the museum's activity is based on the continuous passage from collection to exhibition and vice versa, a reciprocal exchange between the two areas. We are working on putting together future exhibitions which, through careful and in-depth analysis, will explore the work of single artists in relationship to the museum and its activities.

One of our objectives is the creation of collaborative relationships with Italian and foreign museums to make joint acquisitions with the goal of sharing responsibilities and knowledge. Starting from this premise, we have confronted the challenging mission of collecting the present. While we understand that there are many unknown difficulties inherent in writing the history of the present, we believe that the museum makes sense only if it is able to become a critical tool.

With work still in progress, we developed a series of cultural projects for the exhibitions hosted in the building which now houses our service area. During this trial period, we established connections with the local community and our public, interactions that have become fundamental in creating our program. This first exhibition is a response to the needs identified during that period. It attempts to read the collection through the theme of space and starts with an exploration of the worksite itself, a source of inspiration over the past years. The exhibition is therefore a reflection on the ways in which works of art react to the dimensional and formal demands of the building. The theme developed naturally out of the museum itself, but also responds to the public's desire to

experience the MAXXI as an 'open space' of interaction. The choice of the theme for the fist hanging of the collection is therefore clearly related to the museum itself. At the same time, it moves beyond a certain kind of critical perspective in that it focuses on the physical presence of works of art in the spaces which they inhabit. Since the 1990s, artistic exploration has been marked by de-territorialization, and consequently, the museum institution has taken on an elastic and open form. Today, we feel the need to re-establish firm principles, and the MAXXI seeks to place itself at the intersection of these two visions of the museum. It becomes a platform of ideas, welcoming and remolding the dialectic between open and closed.

It is not surprising that many of the most interesting artists working in recent years have explored various elements of space.

Marjetica Potrč's treatment of the concept of home comes to mind, or the role of the urban environment in the work of Atelier Van Lieshout, or Jana Sterback's geographical imagery. We also wanted to pay homage to currents in the Italian tradition that reflect on this theme, starting with the work of Lucio Fontana. Step by step, Italian artists have progressed from frontal-view works to works that reveal themselves in their relationship to the third dimension. It is a tradition which continues in Nunzio's work in wood, Stefano Arienti's newspaper ropes, and Micol Assaël's vortex of air. *Space* has also been an opportunity to rethink the way in which some historic works have been exhibited in the past. Pino Pascali's river, liberated in the MAXXI's galleries, is finally able to breathe freely. Alongside these works, others offer the opportunity to measure the museum in different ways, like Luigi Ontani's *Le ore*, which makes a temporal scan of the space.

All of the exhibited works come from our collection, public collections, and foundations, with the exception of those by Fabio Mauri – a necessary tribute to an indispensable and key figure – which clarify the progression from the experimentalism of the 1960s to more recent work. Also exhibited are works from a generous donation by the consummate gallery owner and collector Claudia Gian Ferrari. The works on loan were chosen after careful research of public collections in Italy. We felt it was our duty to promote our own contemporary artistic patrimony, and in the coming years we will work towards responding to the rich heritage present in Italian museums in order to create a platform of common interests and professionalism.

The MAXXI's next step is to create exhibitions that explore a wider geo-cultural reality, redefining the role that certain areas in Europe and the Mediterranean basin have played in the formation of contemporary visual culture. Such areas have not been adequately studied, and clarification of their influences and traditions is warranted.

If the museum is to become a place of meeting and mediation, it must respond to local and global realities. It must foster continuous dialogue and transform itself from a theatre of representation into a laboratory of sociocultural processes.

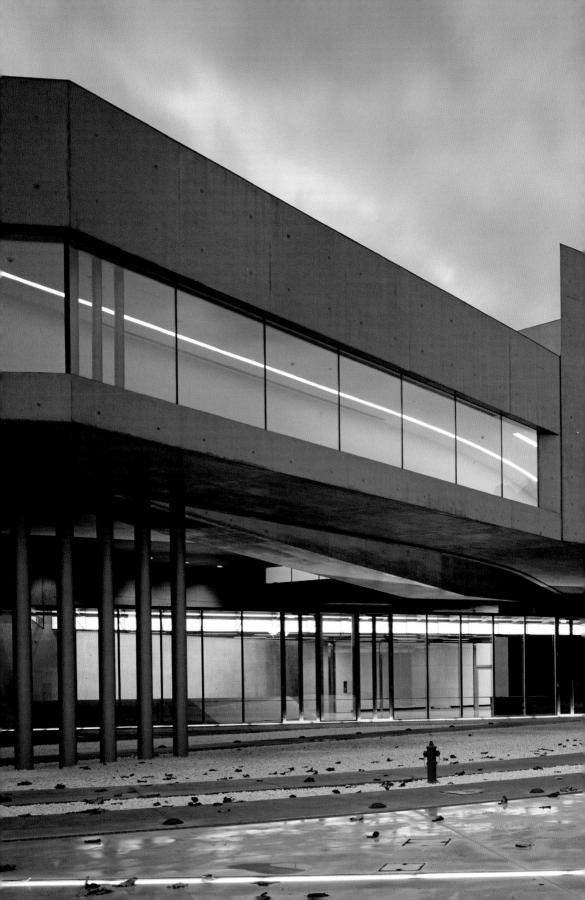

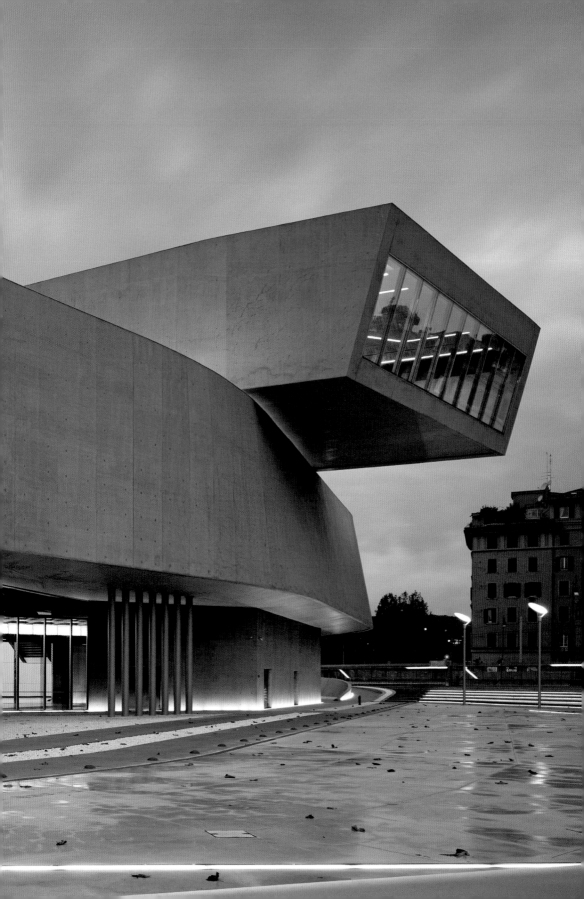

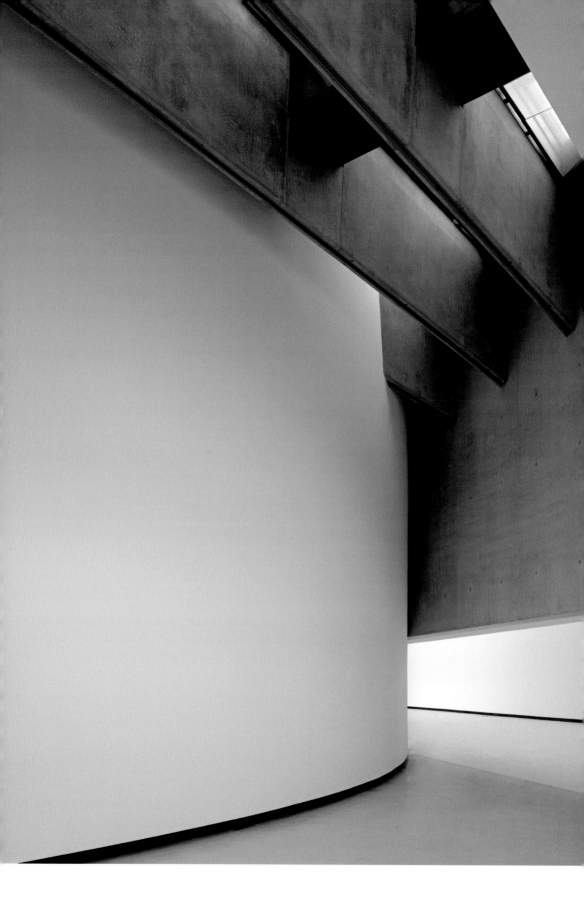

# Species of Space

Stefano Chiodi

The man walks towards an imposing colonnade, the entrance to a museum; shortly thereafter we see him hesitate at the threshold of a large room. He enters. He passes slowly through the space, glancing quickly at the paintings hung on the walls. Then he stops. A woman is sitting perfectly still, staring at the portrait of an unknown lady. Next to her is a small bouquet of roses, just like the one in the painting. Even her chignon, a spiral of light blonde hair, seems identical to the painted one. The man, standing behind her, scrutinizes every detail in silence. Then he leaves, approaches a custodian, and asks: "Who's the woman in the painting?". "That's Carlotta. You'll find it in the catalogue", he answers, offering him a booklet. The man leaves. In just a few frames, this famous scene from Alfred Hitchcock's *Vertigo* condenses the complex and silent negotiation of gazes, questions, expectation, hypotheses, identification and confirmation that occurs between spectators, works of art and the privileged space that contains them. Images that 'speak' through texts, labels, catalogues; anonymous effigies that acquire a date and an epoch, if not a name and a biography; assorted objects transformed into mute witnesses of a past now safe from the inevitable destructive force of time; and finally, artists, rescued from anonymity and oblivion, and brought back into the bright fold of an Art History in which we as spectators are invited to recognize what would have been called – with a now rather outmoded word – a *civilization*.

But what exactly constitutes the privilege of the museum, and the art museum in particular, in comparison to other 'socialization' spaces available to the inhabitants of the civilized world? The story has been told many times: at the height of the Enlightenment, the museum was born as a secular temple dedicated to the aesthetic education of citizens. "Through Beauty – wrote Friedrich Schiller in his *Letters on the Aesthetic Education of Man* (1795) – the sensuous person is led to form and to thought; through Beauty, the spiritual person is brought back to matter and restored to the sensory world". Later, in the Victorian age, in the midst of the industrial revolution, national pride and aesthetic idealism joined forces to define the museum as a space of decantation of conflicts, impervious – at least apparently – to social Darwinism and devoted to promoting civil cohesion (and the dominant hierarchies) through the cult of art and its 'eternal' values. And it is precisely for this role as strict guardian of History and of the social order, as well as dispenser of enduring formal teachings, that the museum became the target of attacks by

the avant-garde at the beginning of the twentieth century ("We want to destroy museums, libraries and every type of academy..." proclaimed the 1909 *Manifesto of Futurism*), a Bastille to be expunged in the name of abolishing the distance between art and life with an indictment of the *art institution* "as something separate from the praxis of life", as Peter Bürger wrote in his *Theory of the Avant-Garde*. Striking out at the museum, the avant-garde proposed to expose the emptiness of aesthetic existence and create "a *new* living practice", a criticism of the fatal contradiction between art's promise of spiritual emancipation and the impossibility of its actual realization.

In a certain sense, it is paradoxical that the museum would later become the scenario of the canonization of the very same avant-garde that had sought to destroy it, transformed from antagonist into essential reference point, into its *muse*, as suggested by the title of an exhibition a few years back at the Museum of Modern Art in New York, the paradigmatic locus of this upheaval since its foundation in 1929. The modernist *white cube*, the rarefied, whitewashed space so typical of museum architecture from the 1930s to the 1960s, appeared to sacrifice the authoritarian character of its nineteenth century predecessors, but was in effect based on a no less selective and dogmatic re-reading of the "tradition of the new". The systematic application of principles of exclusion, of genealogies (of styles, of genres etc.), of hierarchies, at the center of which there remains – as Douglas Crimp demonstrated from a postmodern perspective in his 1980 essay *On the Museum's Ruins* – a 'disciplinary' idea of the museum's function based on strict separation between high and low culture, between avant-garde and kitsch, against the background of the reaffirmation of the bourgeois religion of art. At the end of the 1960s, this sort of space became the target of actions by artists like Michael Asher, Marcel Broodthaers, Daniel Buren and Hans Haacke, who developed a radical re-reading of the relationship between artist, artwork, spectator and exhibition space, endeavoring to make visible (and then contest) the rules that converge to establish the physiognomy of the museum-institution and fuel its particular production of 'value'. Asher's site-specific installations, for example, were conceived as instruments to bring the exposition space out of its apparent neutrality – as in the 1969 installation at the San Francisco Art Institute, in which an enigmatic white 'wall' divided the exhibition space into two unequal parts – or to underline its

'immaterial' aspects, as was the case of the installation in which air currents created invisible barriers (Whitney Museum, 1969). On a different note, Marcel Broodthaers's dark irony tackled the historicist idealism of the museum with the creation of the mythical Musée d'Art Moderne, Département des Aigles, a parody the Belgian artist used to question – with ineffable humor – the typical discursive formations of museums (taxonomies, classifications, chronological orders etc.), parameters of attribution of aesthetic value and their 'vested' interests (in 1970 he drew the comedy to a close by announcing the bankruptcy of the embryonic institution). In all of these cases the museum appears as a *frame*, or as Daniel Buren wrote in the 1970 text *Function of the Museum*, "the effective support upon which work is inscribed/composed. It is at once the centre in which the action takes place and the single (topographical and cultural) viewpoint for the work". A frame that presents itself as a natural fact, but is in reality an eminently historical product that "permeates and marks" the works displayed within it, and is effectively the indispensable element of their very existence. In fact, in a double-action move, this frame – the museum, and more in general the system, the "art world" – not only encloses, but enters within the artwork, which in turn ends up framing *it*, lending it visibility: in short, to paraphrase Derrida's motto, we might well say that for art, "il n'y a pas de hors-musée".

In the last thirty years – paralleling transformations of the cultural and social scenario in the postmodern period – art museum space has undergone a further metamorphosis. Rather than promoting a principle of selectiveness, the museum-institution today tends to explicitly favour a mixture, a hybridization among genres, narrations, traditions and origins, avoiding – at least at first glance – imposing its own authoritarian point of view on artistic matters, and at the same time asserting itself as art's crucial hub, its symbolic center of gravity, simultaneously contested and coveted by artists. And this occurs simultaneously with the exponential increase in the number of the museum's visitors and its new visibility in the urban space, as well as with the macroscopic reordering of the artistic field in which, as David Joselit reminds us elsewhere in this catalogue, artists focus not on invention but on the *reconfiguration* of forms and images, and on affirmation of an interpretive model that privileges inclusion over opposition. This is in keeping with an ambivalent principle of tolerance that can be read as both openness to different visions and sensibilities and their neutralization in the context of a market that

has now become the single 'common place' of postindustrial societies. The prototype of this new space is without doubt the Centre Pompidou in Paris inaugurated in 1977, a museum Jean Baudrillard harshly judged a model "entertainment machine", a "hypermarket of culture" in which any different element risked being sapped of its uniqueness and the sensationalized, entertainment function ended up becoming the prevailing parameter. With its theatrical architecture and its transformation into a brand capable of imposing and exploiting its image in the mass-media landscape, the "Beaubourg machine" announced an irreversible change in the relationship between museum and cultural production, an opening up to the fluid and undifferentiated 'everything' of the present day which is indeed the effect of a substantial increase in access to evolved cultural forms, but also of a process of fetishization that extracts substance from reality and replaces it with an erratic variety of consumable forms, all different and all equivalent. In the end, as Baudrillard noted with pessimism, the aim of the contemporary museum – or rather, of the museum-function it embodies – will be to conquer the world, dystopically (and perversely, as Slavoj Žižek's analyses indicate) fulfilling the avant-garde's promise to aestheticize every aspect of social life, objects and behaviours, as well as the surrealist and situationist utopia of the *loisir*, a time removed from the iron-clad logic of production, simultaneously liquidating the demand for truth and the compulsion of forms of life to transform themselves.

With its ambivalent nature – supermarket or monument, *Wunderkammer* or archive – the museum space today presents a physiognomy that is difficult to decipher. The flamboyant visibility of architectures that have become the epicenters of bona fide urban redevelopment projects (as in the well-known cases of the Guggenheim Museum in Bilbao and the Tate Modern in London), with their extensive impact in terms of 'image' and consequent capacity to attract ever-increasing masses of visitors, has contributed significantly in the last two decades to establishing the museum as the symbol-edifice of the age of globalization. But it has been far less successful in terms of rejuvenating the museum's capacity to propose alternative viewpoints with persistence and penetration, or to cultivate attention to the duration, stratification and poly-significance of art. The inevitable contrast between an accommodating adaptability to the needs of the culture industry and its heterotopian nature – that of a space in which, as in Michel Foucault's famous

definition, an alternative conception of time and reality is manifested – has been grasped by certain artists (like Andrea Fraser, Mike Kelley, Renée Green and Cesare Pietroiusti) who have dealt, *inside* the museum space, with the semantic and political devices that broadly define its physiognomy. These artists have thus contributed to demystifying a space modeled on an immediate adhesion to a supposed 'principle of reality' and at the same time have underlined the struggle for survival faced by radical critical elements within an institution that has in the meantime become more 'tolerant', at least outwardly.

The tension between contrasting polarities – between selectiveness and receptivity, between desire for integration with the 'system' and the ambition to distinguish oneself, between the dictatorship of numbers and the pursuit of autonomy – now defines the character of a space that, as much as any other cultural institution, is subject to the profound ambiguity generated by a social model in which an oversupply seems to level out or erase differences and distinctions, but without providing any key for a more enduring comprehension of them. Thus, just as the role that art claims for itself today must necessarily be based on recognition of the long-term consequences of the 'success' of the avant-gardes (that is, not the destruction of the institution-art, but its diffusion beyond the traditional boundaries of media and of traditionally artistic objects and aesthetic criteria themselves), the contemporary museum cannot avoid coming to terms with a heterogeneity of experiences in which it is impossible to maintain the imaginary distance between material 'interests' and cultural value, between the supposedly neutral viewpoint of history and involvement in the material dynamics of the present. And it is precisely in this already 'mediated' dimension that the museum (and especially a newly built museum like the MAXXI) continues to be an irreplaceable space of sharing, an open space in which to hypothesize potentially fruitful relations between spectators and artworks – relations that are not predictable or 'authorized', that remain outside (albeit temporarily) the economic logic that dominates public space, and that are also very different from the immaterial, atomized dimension of digital platforms. Art, it has been said, is an experience that changes those who come in contact with it: it is political, as Jacques Rancière recently argued, due to the specific way in which it creates perceptive and emotional experiences that convey something of the social world, at the same time providing

glimpses of other developments and other possibilities not taken into account by the dominant lines of thinking. Rather than confining it to the ultra-individual isolation of the monitor/screen and keyboard, the museum invites the spectator to have this experience in a real space, inside which the relationship with the work of art is always simultaneously a relationship with others, with the collective dimension – an encounter marked by tension stemming from the unknown, from what has not yet been assimilated, from the enigma of the woman in the portrait and the mysterious visitor in *Vertigo*: in other words, from that negative, that "something that remains" of which, as Adorno said, the work of art becomes the vehicle and the factor of revelation. And this relational dimension in which, for the spectator, 'looking' equates to identifying himself as a subject immersed in a collective sensorial space, today constitutes one of the main arguments in favor of the museum, of a 'common place' that offers the possibility to rethink social relations and individual identity, to re-establish a circulation of meaning in a space that is both architectural and discursive, characterized by complexity and difference. And ultimately, the possibility of opening up our present to redefinition.

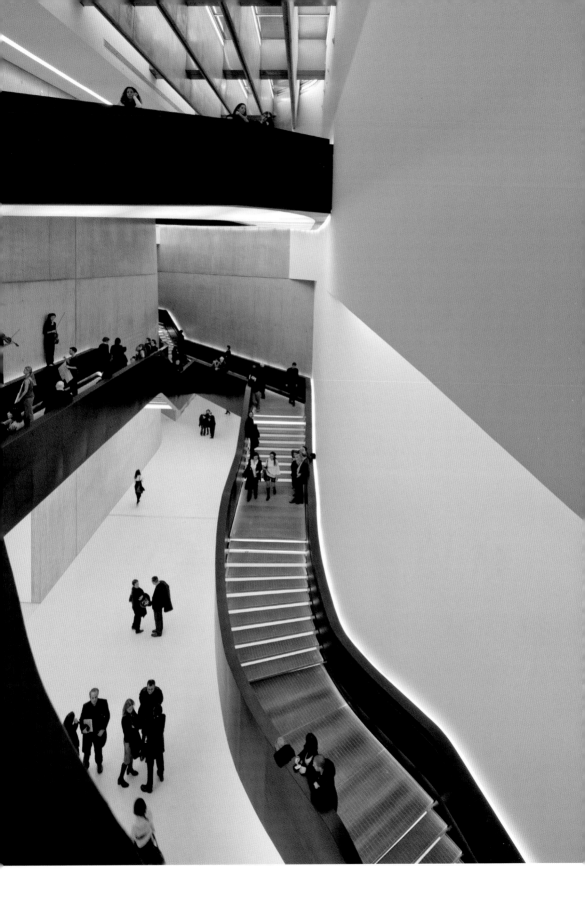

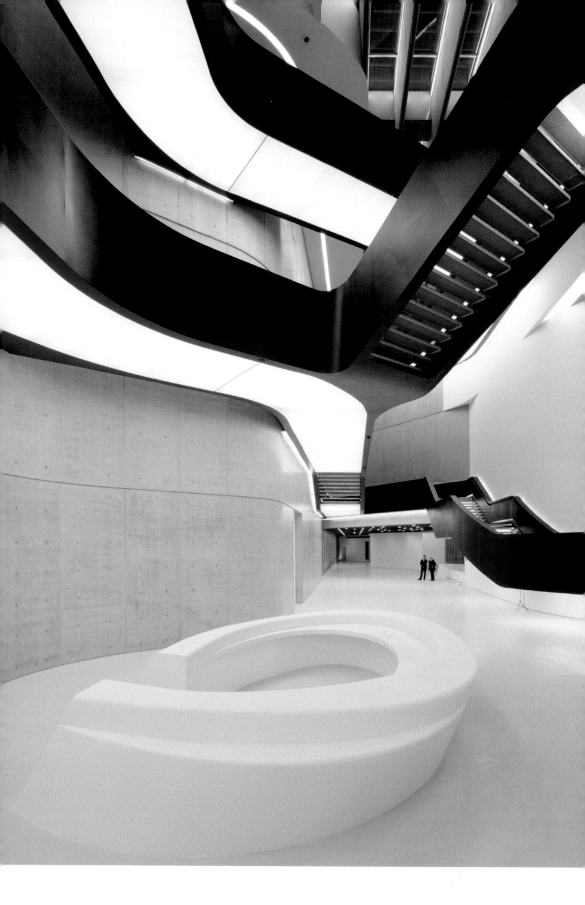

# Vanishing Points

Bartolomeo Pietromarchi

Perhaps the Museum has understood, after hosting
the works of so many artists, that it has the power
to imitate them. It can, and it does so successfully.
*Fabio Mauri*

When the MAXXI opened to the public a few months ago, reactions
were mostly very positive. In his piece for the *New York Times*,
architecture critic Nicolai Ouroussof expressed his appreciation for
the quality of the structure. He also questioned how curators would
be able to manage the large and fluid gallery spaces and suggested
that "it would take several years of exhibitions to understand how the
galleries could be used". Indeed, the first attempt at hanging the
collection entailed facing the challenges presented by the structure's
radically new forms: curved surfaces, multiple vanishing points, and
visual accelerations. The conceptual framework of Zaha Hadid's
project was the appropriate starting point to deal with these
difficulties. Understanding the project's ideological premises and
theoretical influences was fundamental to comprehending the nature
of the 'space'. Fabio Mauri has recently argued that the purpose of
new museums is "the preparation of terrain for a revolution of
principles, through a radical overturning of criteria with whatever
benefits or damage may come". If this is true, deep reflection and
revision are necessary with regards to the presentation and
exhibition of art.

In a recent essay Boris Groys, writing about the ways in which
contemporary art museums function, distinguished between
"traditional" and "installation-based" types of exhibitions. In the first
type, the visitor passively contemplates the work of art from the
outside. In the second he is invited to physically enter into the space
of the work, inside the installation, thus becoming a part of it. Groys,
citing McLuhan, associates the artistic space of installations with
"cold" forms of media, those which render the entire space of
communication perceivable and induce an effect of collective
perception. When artistic space is understood in this way "the
individual works of art are transformed into holistically complete
elements designed in space".

The MAXXI, designed by Zaha Hadid, is one such space. Based
on the installation format, it envelops the visitor and invites the public
to participate in a collective and integrated experience. The space is

completely open yet extremely mobile, liquid, and non-contemplative. The first thematic presentation of the collection lays out a path, or rather various paths that wind through the architectural space. Dialogue with the space is achieved through the works of artists and architects who confront the concept of 'space' and give it a wide array of possible functions and meanings. The path is not chronological, just as the space lacks a linear progression. Instead, it is rhizomatic, made up of individual events and an archipelago of signs. In order to more easily read the works of art, we have divided them into four thematic areas reflecting different experiences of space.

### The Inhabitable Body

As they move through the museum, visitors get lost and begin to doubt their own perceptions. They are fooled by overlapping planes and sloping surfaces that distort distances and proportions. It is a disorienting and disoriented space with numerous points of entry, none of which predominate. The visitor becomes lost in an experience that challenges conventional spatial categories. He is immersed in a fluid dimension which prevents him from pausing and relentlessly moves him along a path with no predefined direction. We have moved from a Euclidean conception of architecture in which space is ordered through hierarchical and linear mental abstraction, to an architecture based on experience. It is the category of architecture Peter Eisenman explored in the early 1990s: "dislocation". For the American architect, dislocation involved abandoning traditional architectural types when thinking about space. It meant perceiving space through all of the senses and being perceived by space itself. Space looks back towards the subject. Michel Foucault had already suggested the concept of dislocation in his definition of heterotopia, a radical transformation of the idea of space in which "the world is perceived as a network which connects points and weaves its own skein" connected with all other spaces "to suspend, neutralize, or invent the set of relations that they designate, mirror, or reflect".

This corporeal and sensory experience of space finds, in the layout of the MAXXI, direct correspondence in the works of artists who explore the body, its physical and ethical limits, and its

psychological, social, political and gender-related implications. Moving through the exhibition, the visitor encounters a fragile domestic body in Kiki Smith's sculptures. As he turns the corner he is blasted by a rush air coming from a hole in the wall illuminated by an electric spark (Micol Assaël). It is a body that is aware of itself and its value and potential. It has the ability to become politically expressive or domestically intimate. Through self-awareness and consciousness of the extent of his own presence, the artist explores the space surrounding him, the minimal unit of habitation, the primary form. The result is Mario Merz's igloo which is both "the world and small home", a space that is personal yet cosmological, physical and mental. It is Alfredo Jaar's interpretation of Gramsci's cell, the quintessential heterotopic environment, which opens and liberates a closed space through the use of mirrors and infinite reflections. Or perhaps it is Lara Favaretto's 'rope' of hair caught in its obsessive circular movement. It is the 'inhabitable body' of art which introduces a radically new way of experiencing space.

### Natural-Artificial

"Let us exalt nature in all of its essence. Matter in movement manifests its total and eternal existence, developing in time and space, adopting different stages of existence as it mutates". Lucio Fontana opened his *Manifesto Blanco* with these words in 1946. And, like the "matter in movement" that appears in his *Nature* series – rough material that becomes a sign of life, the symbol of transformation in which art imitates nature and becomes energy and flux – the works of art extend beneath the MAXXI's finned ceiling, which regulates light according to the time of day. The museum's architectural space imitates nature's volatile irregularity but achieves composure in its general visual harmony. The space becomes a landscape, an inhabited location in which the works of art find their place as events. Art and architecture imitate nature through artifice, transforming matter and its meanings, transforming spaces into places and things: rivers, forests, tree bark, earthquakes, volcanoes and dawns. Industrial and technological materials become fluid and temporary. It is a new kind of 'naturalness', in that artificiality recreates an expressiveness and functionality which only the natural world can give us.

In Pino Pascali's *Fiume con foce tripla*, a dialogue is established between form and content. The river flows according to the physical forces and slope of the space as it would in nature. Yet, it is an industrial and technological nature, functional and abstract. Like nature, it can seem accidental and unexpected, but it follows a different set of rules, no longer rational but 'emotional'. It is the artificial nature Armin Linke captures in his photographs: a ski slope constructed in a gigantic building in the middle of a city. It is the domesticated nature of Gilbert & George's *General Jungle*. However, art also warns of nature's destructive power. Andy Warhol immobilizes the uncontrollable energy of an earthquake through everyday voices in *Fate presto*. The fleeting quality of human existence, caught between catastrophe and chance, reminds us, as Joseph Beuys explained, of the irrationality of life.

### Geographies of Distance

The MAXXI is located in a neighbourhood that was built according to a strict, regular and rational urban plan. In the original urban plan, space was linked to functions which determined its form. Zaha Hadid's structure breaks out of this framework and inverts the original logic of the urban design. The building is almost camouflaged, and it manages to reconnect once-divided urban elements. It creates new public spaces and is structured as a fluid 'in-between' place where individuals can connect with each other or simply pass through. From this perspective the museum space is neither inside nor outside.
It allows the internal spaces of the museum and the external environment to interact. In this way, the MAXXI takes on qualities, of different scales and various and simultaneous functions, which are normally associated with urban planning. The structure is a territorial building, a building-map.
In her book *L'oeil cartographique de l'art*, Christine Buci-Glucksmann reflects on and traces the history of the use of maps in contemporary art, which can be allegorical, tautological, entropic or virtual. For the author, the map can be defined as a veritable *plateau*, as Deleuze and Guattari understood the term; a complex surface made up of layers (memories and power), concepts (territory and deterritorialization) and complexities (real and virtual

worlds). The map is defined as an "abstract machine" which is both immanent and particular. It is a series of attempts to bring about interactions between ordered perspective and the nomadic eye, between Euclidian space constructed upon stable parameters and non-Euclidian space which develops through accumulation, empathy, and direct experience.

In the building-map, on an urban scale, works respond by creating paths and trajectories which project externally towards distant points. The reduction of physical and spatial data to signs and abstract codes (classification and language) becomes an experience mediated by the place and territory: archipelagos, globes, trajectories, paths, diasporas and atlases. Alighiero Boetti's *Mappa* transports us into a mental experience capable of "bringing the world into the world". It reveals an individual experience which becomes defined as a collective act. Giovanni Anselmo, on the other hand, tries to orient subject and space between cardinal points in a process of deterritorialization and reterritorialization. It is a 'geographic representation of expression', like that of Lawrence Wiener, which provides a linguistic translation of space on the curved and sloping surfaces of the museum. Or, it is the disarticulation and recomposition of Italy into a sensory landscape in Luca Vitone's *Sonorizzare il luogo.*

### The *mise-en-scène*

In Haim Steinbach's work, the concepts of exhibition and presentation underscore a reflection on the fetish, the object as merchandise, and its nature as something both desired and desiring. In an essay for an exhibition at the Castello di Rivoli, Mario Perniola used the term 'performance' in reference to Steinbach's work. The philosopher intended to contrast "the feeling of being inside" an intimate experience with "the feeling of being outside", in which the subject becomes a "foreign body" and is perceived by the objects around him. The opposition between performance-exhibition and intimacy can also be applied to the museum's spaces. As we have already seen, the visitor is immersed in an open space in which an intimate experience of space is juxtaposed with a collective experience of space. A work of art becomes an "additional space", a theatrical scene. This can be seen in the work of Luigi Ontani, who

Bibliography

— B. Groys, *Il museo nell'epoca della cultura di massa*, in S. Chiodi ed., *Le funzioni del museo. Arte, museo, pubblico nella contemporaneità*, Le Lettere, Florence 2009.
— P. Eisenmann, *Oltre lo sguardo. L'architettura nell'epoca dei media elettronici*, in "Domus", n. 734, Editoriale Domus, Milan, January 1992.
— L. Prestinenza Puglisi, *This is Tomorrow. Avanguardie e architettura contemporanea*, Testo e Immagine, Turin 1999.
— C. Buci-Glucksmann, *L'oeil cartographique de l'art*, Edition Galilée, Paris 1996.
— B. Zevi, *Il linguaggio moderno dell'architettura. Guida al codice anticlassico*, Einaudi, Turin 1973, p. 37.

reinvents himself through cultures, times and places, or in Francesco Vezzoli's use of icons and masks.

The building-museum becomes the *mise-en-scène* of the architectural space. It becomes an icon, a symbol, an image. It is a kind of architectural performance that becomes part of the collective urban imagination. It is an object of desire, a machine of communication. Yet, unlike other iconic buildings (such as the Guggenheim Museums in Bilbao and New York), Zaha Hadid's structure cannot be characterized by an image of its façade, because it lacks a clear front or back. The only image, the only means of communicating its nature, is the floor plan, the abstract representation of its overlapping floors. The visitor's journey through the museum ends (or begins?) with Ilya and Emilia Kabakov's installation in which artistic space is configured in three different dimensions, from gigantic to microscopic. The visitor is projected outside of the work through the use of an imaginary vanishing point.

The museum space presents a succession of superimposed vanishing points which subvert all forms of perspective. It represents the way in which our idea of space has been transformed over fifty years of artistic and architectural experimentation, starting with Bruno Zevi. At the beginning of the 1970s, Zevi proposed seven "invariants" to demolish the cornerstones of modern architectural language. "If the box is taken apart, the planes will no longer make up finite volumes, containers of finite space. Instead, they will make the spaces fluid and force them into continuous discourse. The static nature of classicism will be replaced by a vision which is dynamic, temporal, and, perhaps, four dimensional". The museum becomes a form without form, interchangeable, permeable, susceptible and malleable. It has the power to promote a new way of understanding art and contemporary cultural production while at the same time shedding new light on important works of art from the past.

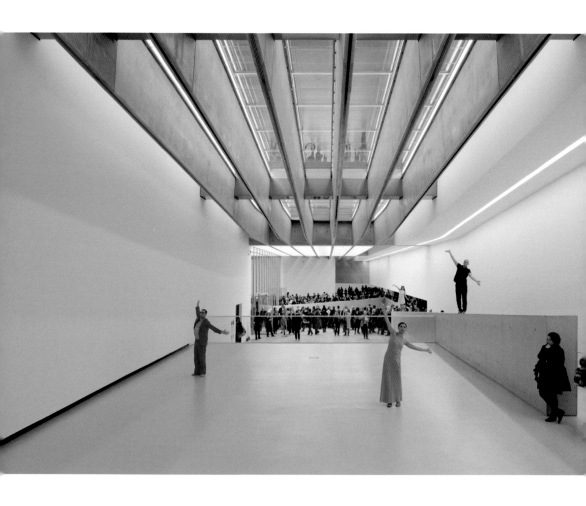

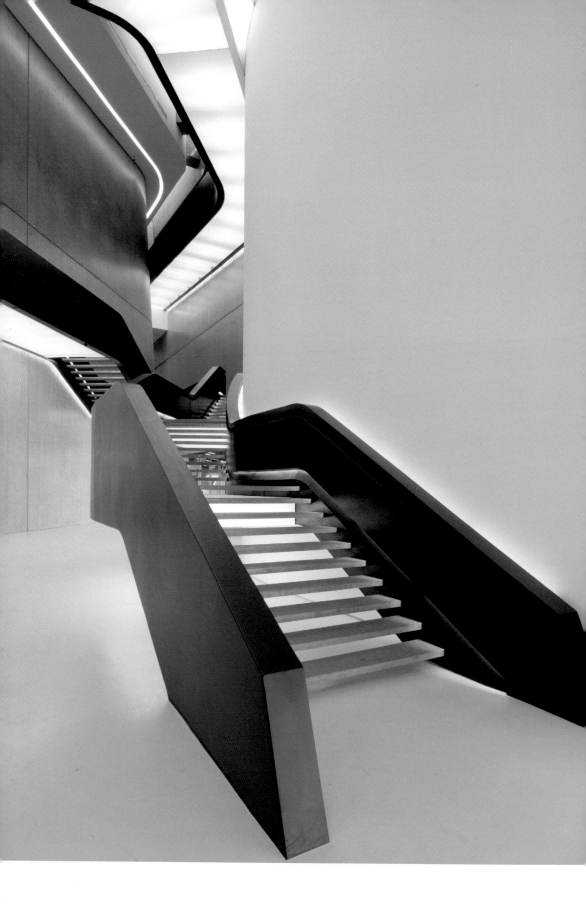

# Other Spaces

Gabi Scardi

A fluid and dynamic structure, a vast spatiality, an uncommon potency of impact – the MAXXI has been endowed from its birth with an exceptional site. For years, before its public opening, this hypertrophic and inescapable architectural subject constituted a stimulus-guideline for a reflection on the meaning and role of spaces for art. Both limitation and opportunity with regard to the artistic discourse, the museum should be viewed in terms of its essential elements: physical space, institutional space, space for conservation and exposition of the collection. With this multi-faceted and variable identity, it inevitably works on several different levels: as a place for the construction and transmission – necessarily oriented in one direction or another – of cultural memory (transmission does not exist without interpretation); as a reference point within a territorial context for which it serves as both activator and result of dynamics of cultural and social change; as a physical space that necessarily exercises a strong influence on the artwork, its exposition possibilities and its perception by the visitor; as a fulcrum and legitimizing element of a highly regulated art system; but also as a viable platform for creation, an enhancer of visibility and a driver of the artwork's meaning.

The space, intended in terms of its various definitions and in the logics and practices it generates, thus spontaneously offered itself as a common thread for the first, pivotal event presenting the MAXXI to the public: a curatorial itinerary among works from the collection. With the uninterrupted intersection of its spaces, the building obviously inspired the decision to create a single exposition pathway involving the two sectors that make it up, Art and Architecture. Two neighbouring sectors destined for close collaboration: we need only consider the degree to which space has for decades constituted an element of strong contiguity between the experimentation carried out by the two spheres. We have simply received this stimulus, orienting ourselves towards a single, unifying exhibition in which the works of artists and architects can co-exist, dialogue with one another and resonate reciprocally.

Space in art: an extremely broad theme, charged with a history that reached a crucial juncture in the 1960s, the decade that also marks the starting point for the MAXXI's collection. In fact, it was then that the concept of artwork and environment were profoundly revamped. From that moment, the artwork became in many cases a three-dimensional assemblage, installation, or even a performance, happening or intervention, thus being transformed from an object of

contemplation into an agent of active and ever-unique relation with the context, with other works sharing the space and with the figure of the visitor, now considered an active interlocutor. From that moment on, the artwork tended to regenerate itself in reference to the exhibition space, or was actually conceived on the basis of the available space and its characteristics; and with regard to the physical and institutional context in which it is placed, it now establishes a correspondence, entering into synchronicity or into tension with it, adapting to or clashing with it, dialoguing or creating an immersive situation.

The question of space thus became, from that moment on, one of the cruxes of artistic practice, critical argumentation and curatorial and museum discourse. It still is today. But it has developed in a direction of greater permeability of spaces for art, and an increase in artists' sensitivity with regard to the non-artistic context. Increasingly, in recent decades artists have made art a mechanism of 360° openness, with an inclination towards contamination, towards the impurity of languages, and with a tendency to comprise everything – reality, current events, the most crucial issues of our contemporary world. In sum, art as an expression of man in his totality: nothing can be left out. The space that interests the artist, then, is increasingly anthropized, variegated, fragmented, interwoven with relationships, traversed by History and stories, by currents of sensibilities and memories.

Indeed, the theme of space lends itself to infinite interpretations; space is, as has already been noted, the space of the museum, understood as both physical and institutional, and, more in general, the context in which we live. It is the space of the critical journey and of the 'in-between'. Space is defined in individual, social, geographic, historical-temporal and cultural terms. Space is the primary place, the mother's body; space is the room of one's own and the house to dwell in, capable of accommodating our needs and personal desires and most essential relationships; space is social, shared, characterized by inter-subjectivity, consisting of a network of relationships and conventions. Space is the space of architecture and urban design, of the planned city, but is also the informal and less controllable space that appears between the plan's folds. It is the complex and interconnected space of geopolitics; but it is also the immense space of sidereal depths. It is the transcendent, yearned-for, incommensurable space of the interior universe – a

labyrinth of rooms and corridors capable of opening itself up to ineffable visions. It is the other space, that of the theatre, of literature, of virtual reality; that of art, which seeks to embrace and incorporate all of this. There are some artists particularly sensitive to the context that take the path of the real, while others wander through the meanderings of the mind and of individual or collective memory. None of these descriptions or meanings of space can do without the others. Each lives on an organic complementarity that alone give it meaning.

These and many other dimensions will be organically linked in the exhibition. In fact, different meanings of space are exemplified by different works that make up the collection. Works which, on the basis of an assonance of meaning or a formal association, have been grouped into thematic areas.

Organized according to spontaneously-arising islands of meaning, the exhibition revolves around a definition of the theme of space in relation to the concept of distance. The parameter of reference is the individual, the unit of measure of human experience of the world, possessed by an inalienable yearning to seek and explore: one only need think of Lucio Fontana, the first artist we encounter entering the exhibition, with his tireless pursuit of a fourth dimension, a poetic, ideal beyond that also speaks to interest in and consonance with coeval scientific discoveries.

So it is the artists who show us how to see the extremely close, the intimate and the everyday – the space we live in – with new eyes, and who then guide us through the urban landscape which, in its complexity, reflects the life it contains: an accumulation of existences and functions, of processes in which contemporary experience is concentrated and develops most rapidly, in which questions are formulated and become crucial, in which answers become more urgently sought. The city as an ordered system on the one hand and a contradictory place of conflict on the other, full of folds and fissures – it is in these little air spaces that the homeless live, like the *Sleepers* depicted by Francis Alÿs; it is in these interstices that provisional crisis housing is developed by those forced to make do with local jurisdictions and salvaged materials, illegal architecture that does without planning and design, but for this very reason must enhance the value of available resources and seize every opportunity that presents itself. Artists like Marjetica Potr č see this sort of informal construction as a laboratory of dwelling

strategies for the future; others, like Alterazioni Video, interpret them as iconic expressions of the present in which we live. And not only: recuperating cast off objects and attributing expressive and metaphorical value to what seemed to be relegated to the bottom of the economic and life cycle is a consummate poetic act, consubstantial with artistic activity itself.

From constructed space to the landscape and the complex relationship between natural and artificial. The realm of the born and the realm of the made: two dimensions linked by an increasingly complex relationship, if the very notion of nature is part of the cultural apparatus we contribute to constructing. We need only consider Gilbert & George's dense and immersive landscape, with its lights and shadows, with its suggestions and echoes; a landscape that is a place of passage and of recreation, that lives in relation to our presence, that is imbued with culture.

And here the question of the contended landscape arises, of the inexorable transformation that strikes every territory, of the ecosystem at risk and the need for sustainable development. Here we must inevitably invoke the name of Joseph Beuys and his groundbreaking work, all by the need to achieve an integration of the natural, cultural, scientific and spiritual dimensions – an integration that would offer the only path to complete humanity.

Around the same time Beuys was developing his research on an ecology of the mind and heart, in Italy, *Arte Povera* was salvaging elementary materials, as well as the original structures of language and social behavior, and in the United States, Andy Warhol was giving a new impetus to Western art, borrowing the language of the mass media and distilling the quintessence of consumer society in his work.

The concrete space of living and dwelling, then, and that of global geopolitics with its circulation of ideas, finances, its traffic of merchandise, tourists on journeys and transhumances of refugees and laborers; but also the extremely expansive space of sidereal space, and that of the infinite possibilities offered to us by its imagery. The cosmos, in which the trajectories of astral bodies become emotional without losing their heavy baggage of history. Consider the skies in works by William Kentridge and Anselm Kiefer – the former South African, the latter German, both participating witnesses of tragic national histories and keen on recounting their ruinous ends in universal terms; both capable of a grandiosity that

makes them true heirs of the historical genre. Alfredo Jaar also narrates History condensing it into a space: a copy of the Roman jail cell in which Antonio Gramsci was imprisoned. For Gramsci, that cell was a place of suffering, but also an accelerator of thinking. The cell created by Jaar, identical to Gramsci's in size but endowed with mirrored walls, envelops the visitor in the infinite multiplication of the space; it thus becomes a metaphor of the separation between culture and society and the lack of freedom, the web of conformism and conventions we continually deal with, but also of how intellectual passion and freedom of thought can radiate beyond any barrier.

The organizational scheme we used to conceive the exhibition arrangement is by necessity simplistic; and what counts most with regard to the thematic areas individuated is their intersection. There is no interruption between interior and exterior maps, between spaces of individual and collective living, between the meanders of the mind, the intricate shadows of a wood and the streets of a city, between the landscapes that spring from archetypal memory and historical memory. The existing and the imaginable – for the artist, everything becomes the space of the critical journey and of possibility. Everything is knitted together in the complex dynamic of transformation of the world we live in.

It is precisely this dynamic that the artist is able to express, and sometimes, moving like a seismograph of the present, to anticipate. And if the slightest beat of a butterfly's wing can provoke a hurricane on the other side of the world, artists, working in the world and bringing dreams and fears, passions and desires to the surface, introducing a sense of infinite possibility, inscribe infinite variables onto it. Endowed with an expressive value, their works take a place in history, they orient it; in this sense they already pertain to the future. The museum lives on their works and their actions.

The artwork, in turn, has the vocation of encountering an interlocutor, and acquires meaning and value from the innumerable interpretations to which it is subject. There can be no gaze without interpretation, without a shift from the literal meaning of what we are seeing to what we can comprehend intellectually, add from our personal experience and expectations and integrate with emotions and imagination. With every individual viewing breathing new life into the artwork, the path of interpretation renders it multifaceted, intrinsically plural.

This constitutive multiplicity is what allows artworks to reveal to

each viewer something of his or her own individual identity – to each of us, something of our human quality and the world we live in.

For a museum, the attention to interpretative space that works of art offer the individual necessarily translates into an attention to the audience, the visitors. An exhibition space that encourages an empathetic, intimate interpretive approach will be able to generate ideas and profundity, but also openness and interaction; it will become an active, lived place.

Our hope is that the MAXXI will become a vital, participatory space of encounter between artworks and their interlocutors.

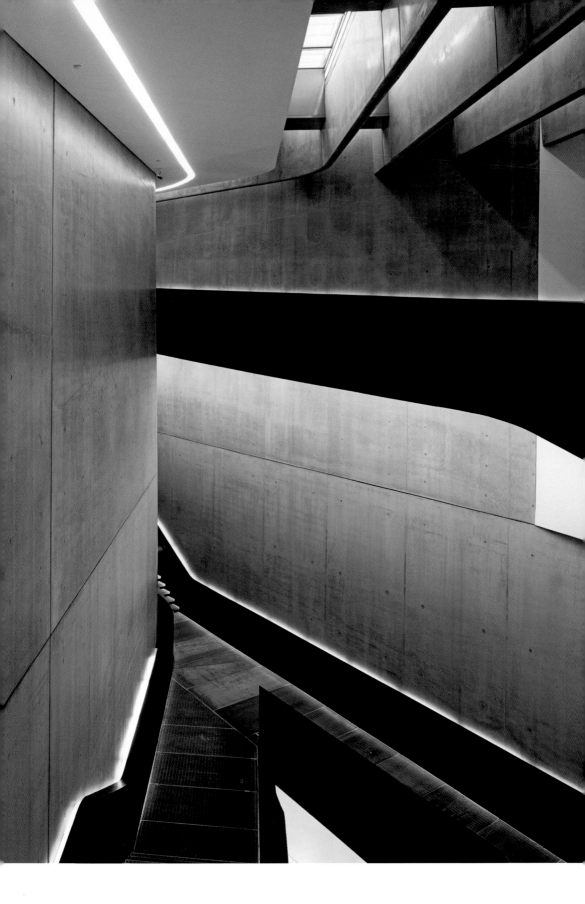

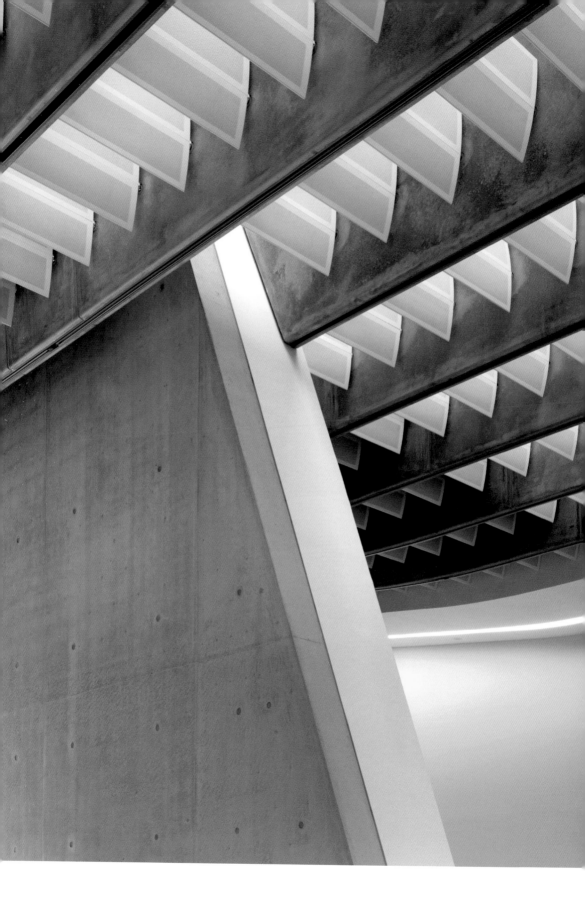

# Three Steps in Space

Pippo Ciorra

### The First Step: Contemporary Space

Architects and academics have been pondering the nature of modern space for a century. When using the term "modern space", they intended to highlight the way in which 'relationships' between the individual, buildings, neighbourhoods, the workplace, cities, society and the environment have been transformed since the nineteenth century. Giedion, pioneer and hero of modernism, introduced us to a notion of [architectural] space that was wholly a product of the second Industrial Revolution, and entirely based on technology, productive relationships and their territorial impact. Zevi spent his entire life trying to codify modernity in terms of a pure spatiality made up of dynamic sequences, asymmetry and mechanisms of relation between body and environment.

De Carlo worked tirelessly to rediscover a sort of originating spirit of modernity, and to restore architecture to a definitive position equidistant between *Space* and *Society*.

In short, modern architecture has long oscillated between its technical/tectonic/functional nature and the possibility of a symbolic spatial invention capable of overturning nineteenth century hierarchies of representation and summing up the spirit of the times, thus pursuing the same ambitious objective as the artist avant-gardes, although the latter, with a few exceptions, had the advantage of being able to limit themselves to exploring the two-dimensional representation of a revolutionized space.

In any case, there was a highly ideological conception of space, as was directly reflected in politics, drawn from the dominant twentieth century concepts of History and Utopia, forced to continually deal with the disappointment of a partial, contradictory and almost always imperfect reification (it is no coincidence that the twentieth century is also the century of "critical space"). Once past the half-century mark, after wars and revolutions, many were forced to accept the fragile and contradictory nature of "modern space", which, while looking towards the future, remained a prisoner of history. For some – like Ernesto Rogers and the CIAM – this realization represented the beginning of a crisis that has yet to be resolved. Others – like Venturi and Scott Brown above all – understood that the contradictory and post-ideological nature of "modern space" gave the final phase of the 1900s its vitality and opened new pathways to expression and dialogue with society.

Society, in turn, began to manifest the desire to enjoy the comforts and pleasures of modernity while avoiding ideological confrontation.

It is easy to see the conception of space during the final decades of the twentieth century as a synthesis of two points of view. On the one hand we have the dramatic representation of hypermodern crises: Anthony Vidler's "warped" or "uncanny" spaces, the representation of flow and continuous movement (another modernist and then baumanian obsession), the anti-Euclidean rhetoric of Eisenman and his followers, and Tschumi's event-cities. On the other hand, we see the triumph of irony and the ability to wear contradiction with elegance: Venturi's city "without space", Rossi and Gehry's atectonic construction, the digital and the immaterial, and Koolhaas, who unrepentantly identifies the *cadavre exquis* of modern space, first in New York's skyscrapers, then in the crises of the metropolitan landscape, and finally in the apparent capitulation to instability.

In any case, the contortions and jubilance of the final decades of the twentieth century challenged the utopian concept of the completeness (the capacity to plan/predict the future) of the modern idea of space. The media, computers, new modes of collective and individual communication, new forms of community, and the acceleration of urban, environmental, and geopolitical phenomena have brought about variability and unedited "types of space". As complexity grows and new forms of relationships become possible, greater strength and intelligence become necessary to control space.

All of this, for the purposes of this essay, has two clear consequences. First, we can affirm that the concept of space has been destabilized and modified in recent decades to the extent that it has become an appropriate theme for an inaugural exhibition of a museum dedicated to the twenty-first century. We can also affirm that the expression "contemporary space" (however conventional and temporary, and awaiting clearer definition) has become an acceptable term. Secondly, it authorizes us to investigate, within the framework of this exhibition, how such phenomena have affected architectural vocabulary and instruments, and which architects best interpret and answer the questions that have been raised.

## The Second Step: The *Beat* City

While it is universally recognized that Giedion, Zevi, the Smithsons, and De Carlo are among the central figures in the study of modern space, it is difficult to single out the authors of the most significant manifestos of contemporary space from among the many followers of postmodernism. We can, at least as a premise for this exhibition, identify some essential reference points and use them to define the boundaries in which to explore the most interesting architectural ideas. By choosing a few names and drawing connections between them, we can better understand the structure of this exhibition and its relation to reality. Although it may seem strange, Venturi and Scott Brown's work on Las Vegas and in *Complexity and Contradiction*, and Koolhaas's subsequent elaboration, remain appropriate starting points. They continue to teach us (although skeptics continue to exist) that the city is no longer identified by spatial forms and figures but by a system of signs, media incursions, and the visual jargon of pop and youth culture. From Venturi's pop/beat concept we can move on to Mitchell's "city of bits" and the entirely media-based city of de Kerckhove and followers. Both are completely indifferent to the form of space and see meaning as coming almost entirely from the interactions between man and computers or the spatial conception of digital applications. We can consider the multitude of philosophers – *primus inter pares* Virilio – who have helped us to understand how postmodern space has substituted the structure of text with the fragmentation of criticism. We can think of Rifkin and the centrality of the economy and the *natural-artificial* environment, understood as the dominant paradigm in planning theory and landscape architecture. Finally, we can look to scholars such as Weizman – appropriately, one of the authors of this catalogue – who understand that the political use of architecture is one of the few methods capable of giving it new meaning. They are not thinking about political appropriation in the traditional sense of the construction of symbols and languages of power, but rather the conception of architecture as a useful tool in mapping out, analyzing and unmasking political action.

Names like Mitchell and Virilio, de Kerckhove and Rifkin might create a certain sense of uneasiness. They are in fact vigorous proponents of worlds without space, thinkers who, unlike the pioneers of the modern such as Zevi and Vidler (but also Heidegger

or Rudolf Steiner in the end), have no desire to associate a concept of space with a concept of form. They are representatives of what Tafuri would have called a concept without *logos*. In short, we all know that the collapse of the World Trade Center preceded an even greater crash of the stock market. For this and other reasons, the delirious economic optimism and *hyper-architecture* that characterized the end of the twentieth century has rightly been followed by a 'world without architecture', or at least a world in which architects focus on principled strategies and procedures rather than forms and spaces.

### The Third Step: The Space of Architecture

The outlook might seem exceedingly gloomy, like the prelude to an inevitable period of lean times characterized by renunciation and moderation, particularly worrying in a country like ours where times of plenty never seem to arrive for architecture. Yet the MAXXI, as one can clearly see from this exhibition, is a museum of art dedicated to fostering the richest possible dialogue between various forms of expression. In the first years of this century dialogue with art, media, politics and communications has taught the most attentive architects how to build meaning and how to intervene in situations where figurative culture seems antiquated and inadequate.

This exhibition, *Space*, is nothing less than an attempt to give a surprisingly optimistic answer to the questions posed in the previous paragraph. Is there a place for architecture in a society dominated by non-spatial relationships, by meaning detached from place, by a community in constant motion, by pixilated images on computer screens which play with the concepts of solidity and permanence? Yes, there is, as long as architecture is willing to pursue innovative strategies and tactics, does not limit itself to figurative spectacle, and learns to recognize new conflicts and reestablish a productive dialogue with politics.

In selecting these architects, we have tried to identify those who move freely and confidently inside the boundaries established by the above-cited authors and who have been able to find a role and form for architecture within this framework. The themes of the four sections of the exhibition, despite or perhaps owing to their strategic breadth, have functioned well in directing our attention towards the

Bibliography

— S. Giedion, *Space, Time and Architecture. The Growth of a New Tradition*, Harvard University Press, Cambridge (MA) 1941.
— R. Koolhaas, *Delirious New York. Retroactive Manifesto for Manhattan*, Thames & Hudson, London 1978.
— W.J. Mitchell, *City of Bits. Space, Place, and the Infobahn*, The MIT Press, Cambridge-London 1996.
— J. Rifkin, *The European Dream: How Europe's Vision of the Future Is Quietly Eclipsing the American Dream*, Jeremy P. Tarcher, New York, 2004.
— R. Venturi, D. Scott Brown, S. Izenour, *Learning from Las Vegas. The Forgotten Symbolism of Architectural Form*, The MIT Press, Cambridge-London 1972.
— R. Venturi, *Complexity and Contradiction in Architecture*, The Museum of Modern Art Press, New York 1966.
— A. Vidler, *The Architectural Uncanny. Essays in the Modern Unhomely*, The MIT Press, Cambridge-London 1992.
— A. Vidler, *Warped Space. Art, Architecture, and Anxiety in Modern Culture*, The MIT Press, Cambridge-London 2000.
— P. Virilio, *L'espace critique*, C. Bourgeois, Paris 1984.
— B. Zevi, *Saper vedere l'architettura. Saggio sull'interpretazione spaziale dell'architettura*, Einaudi, Turin 1948; trans. *Architecture as Space. How to look at Architecture*, Horizon Press, New York 1957.

most vigorous and original energies, the best starting points to stimulate research and experimentation: Khoury, Cirugeda and Cruz for their ability to construct tools for spatial survival appropriate for the political atmosphere of our time; Zucchi and Lacaton & Vassal for the way in which they filter and exalt what remains of urban space; R&Sie(n), DS+R and Helena Njirić for their investigation of the realm between the material and immaterial which seems to constitute the primary ingredient of our era; Rintala & Eggertsson and West 8 for how they identify possible paths to render the memory of a paradise lost habitable and perhaps enduring. Together, these architects constitute a solid platform, made up of 'new space' and 'new time', from which to begin the search for other architects, projects, and tenable hypotheses for the future of architecture and the planet.

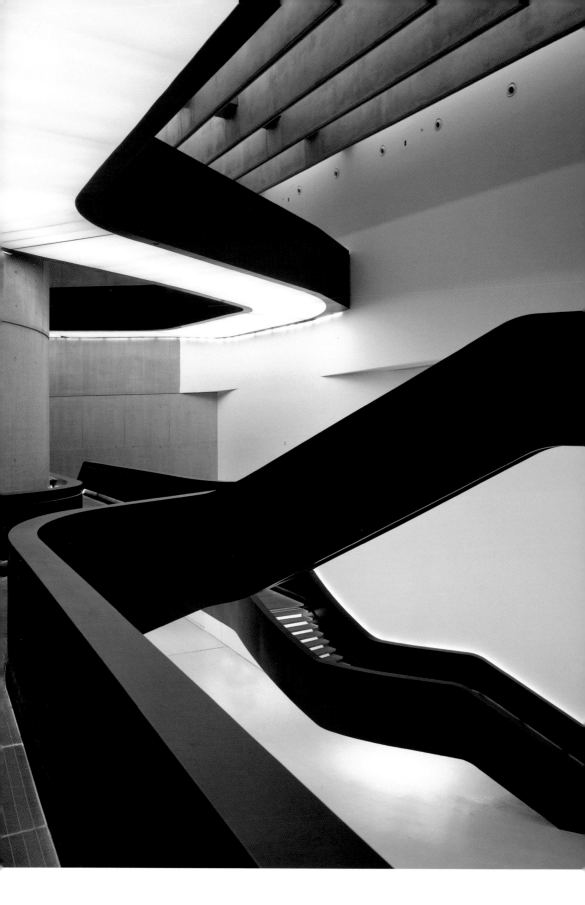

# Space *versus* Object

Domitilla Dardi

"Il a eu de la chance, Palladio. They did not do this to him". It was 1934 and Le Corbusier had just returned from visiting the Villa in Garches, which he had designed seven years earlier for Mr and Mrs Stein. The German historian Julius Posener reported the architect's reaction adding that the master "had never allowed the interior of the villa to be photographed because the Steins had decorated it with such horrid furniture that the spaces had become completely corrupted". Moreover, Le Corbusier had waited for the Steins to move out before going to see firsthand what must have seemed like the destruction of his work. Nevertheless, it would be neither the first nor the last time. For example, it seems that Madame Savoye dabbled in interior design and did not spare her Villa Poissy, despite the fact that the architect had endowed the celebrated villa with every conceivable kind of "furnishing": fixed furniture, *casier standard*, tables, chairs and armchairs, all perfectly functioning machines which avoided disrupting the *promenade architecturale*.

There are numerous anecdotes about 'imprudent' residents decorating their homes which traditional architectural history neglects to report. Indeed, there seems to be a clear dichotomy between history's description of architectural spaces and what is reported in more popular sources. Essays and magazines show us spaces either uncorrupted by objects or with their carefully studied placement. However, we know that order is a Western myth utilized to counter the undeniable crudeness of man, his body and his sometimes-brutish physicality.

Historians employing a spatial reading of architecture, like Schmarsow, Zevi and others have described space as a physical entity that receives life from the equilibrium and balance between fullness and emptiness, but never as emptiness in itself or to be filled. Nonetheless, as Dorfles has noted, *horror vacui* has represented a dominant aspect of our culture in the same way that *horror pleni* dominates our contemporary state. The tendency to hoard is a part of the human spirit that the architect, in his spatial vision, tends to correct through planning. In reality, an object in space is "an impediment which interrupts and obstructs the path, blocking and arresting movement" (Bodei). Therefore, in the processional nature of a space, the impediment-obstacle needs to be studied, positioned, or even erased in some cases. Le Corbusier, for example, sought to fuse furniture with the architectonic structure itself or to design it in such a way that it achieved maximum visual

transparency so as not to impede movement and the space's readability.

An alternative to this approach is designing objects to be visible corollaries to the spatial theorem. Since the middle of the nineteenth century *Gesamkunstwerk*, the goal of creating a total work of art, has played an undeniable role in the relationship between space and object. Spatial scales have been altered by this dominant concept, and objects have become dimensional variants of the same spirit of space. "When individuals like Breuer, Aalto, or Albini design an object", explained Argan in 1954, "they do not 'apply' architecture to the object. They create architecture just as when they design a house, a group of houses, or a neighbourhood". It is the triumph of Ernesto Rogers's "from the spoon to the city" concept. The idea of the object as micro-architecture reaches its logical conclusion with the leaps in scale of the Radicals, who imagine domestic space as a "domestic landscape" composed of volumes. The most recent example would be the *Tea & Coffee Plaza* project in which Mendini, designing for Alessi, envisions the coffee set as "a story of micro-architecture for the table, of micro-urban planning for the apartment".

Even today the trend that sees 'starchitects' designing objects does not seem so far removed from the nineteenth century ideal of *Gesamkunstwerk*. However, Adolf Loos has already warned us against hypertrophy and excess in design. For Loos, the integrity of "austere beauty" is the architect's greatest aspiration, but, by depriving him of vital desire, it condemns him to unhappiness. So it seems that the only form of rebellion left to him is to contaminate space with the virus of design, with equally insidious dangers, as Hal Foster rightly highlighted in his *Design & Crime*.

The designer, unlike the architect, does not need to know the specific space in which his objects will be located. On the contrary, design objects by definition find their purpose in their adaptability to various contexts. The space for which they are designed is an emptiness to be filled, an entity with limits, at most a spatial 'type'. However, it is not the fruit of an authorial vision or *genius loci*. The object becomes, in a manner of speaking, the means by which the user reminds architecture that it is also a container, an emptiness to be filled. It is a 'weapon' used to reclaim one's status as an individual.

Perec understood this and saw his characters Jérome and Sylvie as dreamers of an identity, which is communicated through *les*

*choses*. Possessions are the means by which they assert their membership in a particular social class. Space becomes an almost unimportant variable. But in reality, the object is all-too-often dulled by standardization, the prepackaging of forms that seeks to divide the great population of human individuals into "psychological types", final target groups. A scene from the film *Fight Club* is emblematic of this idea: Edward Norton, afflicted with the "Ikea nesting" syndrome, walks through an absolutely neutral space filled with catalogue furniture and asks himself: "What kind of dining set defines me as a person?". Ready with an answer, his alter ego Tyler Durden (Brad Pitt) warns him that "the things you own end up owning you", leading to devastating consequences.

Is there any alternative for objects? Must they be designed as components of a work of total art or risk becoming parasitic contaminants of a space? Some have proposed counteracting the sort of compulsive and ill-informed purchasing encouraged by a consumer culture that has fetishized the design object, with more informed choices. An example is Bruce Sterling's *Spimes*: things, objects, or people whose movement in time and space can be continuously tracked using electronic chips. Such data provides a complete story (including any exploitations and corruptions) rather than just the part the producer wants to reveal.

Another option is the nihilistic renunciation of all kinds of objects, which is the ideological root of the "no logo" movement, and the extreme trend towards completely empty spaces containing solely anonymous functional elements. Up to this point, we have only dealt with the 'internal' or private dimension. But what happens in the grey area of a shared common space when the line between private and public is crossed? From this viewpoint, acts of vandalism in urban spaces, so common in cities, become acts of rebellion on a larger scale in that the perpetrators, feeling unrepresented, wish to mark the territory with a sign of their identity. It is an extreme act of shouting out one's existence, a kind of graffiti counteraction to the Freudian *unheimlich*, the disquieting consequence of unwelcoming architecture. Others take refuge in the immaterial nature of things and space. The cosmopolitan nomad, the rootless citizen of the world and the jaded adolescent travel indifferently through space, finding a sense of belonging and home in their computers, iPods and mobile phones, instruments of a shared space that project into a virtual but 'customizable' dimension (which in many ways replicates

Bibliography

— J. Baudrillard, *Les système des objets*, Gallimard, Paris 1968.
— J. Posener, *E i mobili? Me lo chiede?* in "I clienti di Le Corbusier", Rassegna n. 3, year II, Editrice Compositori, Bologna July 1980, pp. 15 ff.
— A. Vidler, *The Architectural Uncanny. Essays in the Modern Unhomely*, The MIT Press, Cambridge-London1992.
— D.A. Norman, *The Invisibile Computer*, The MIT Press, Cambridge-London 1998.
— D. de Kerckhove, *L'architettura dell'intelligenza*, Testo e Immagine, Turin 2001.
— H. Foster, *Design & Crime*, Verso, London 2002.
— A. Mendini, ed.,*Tea and coffee towers*, Electa, Milan 2003.
— G.C. Argan, *Progetto e oggetto*, Medusa, Milan 2003.
— B. Sterling, *Shaping Things*, The MIT Press, Cambridge-London MA 2005.
— R. Bodei, *La vita delle cose*, Laterza, Rome-Bari 2009.
— G. Dorfles, *Horror Pleni*, Castelvecchi, Rome 2009.

the physical dimension, as our brain replicates mental space). The success of social networks is based on connectedness but also on the ability to communicate one's identity through choices using a very personal playlist of images, sounds, and ideas. This is easier than decorating one's room with posters of favorite musical groups as teenagers might do. With the Internet 'I' can be invaded by the world or 'I' can invade it: the computer is both the receiver and the transmitter. Space is a "network of life" in this sense, but also a two-dimensional plane on which to project one's individuality. From this perspective perhaps today's greatest designers are those who design connectedness, those who see human skin as an excellent electrical conductor, those who have replaced sight with touch in order to bring the subject back to center stage, towards a new humanism of cyberspace, towards the triumph of "the sex appeal of the inorganic." Technology exists, but it is unseen. Indeed, as technology functions better, "the computer becomes invisible".

One possibility might be to share objects in the same way that the Internet has allowed us to share information. Sharing services could be a solution to combat the parasitism of the object. Nowadays, "we don't need refrigerators, we need cold beers" (Amory Lovins). That which belongs to us in a symbolic sense, those objects that identify us as unique human beings, would remain in our homes and public spaces. This uniqueness is not expressed by single objects, which are vehicles for their creators' visions, but by the playlist, something the individual can create in his own image and likeness, made up of an array of hybridized and connected objects that we link together at will, because "our freedom to choose causes us to participate in a cultural system whether we are willing or not" (Baudrillard).

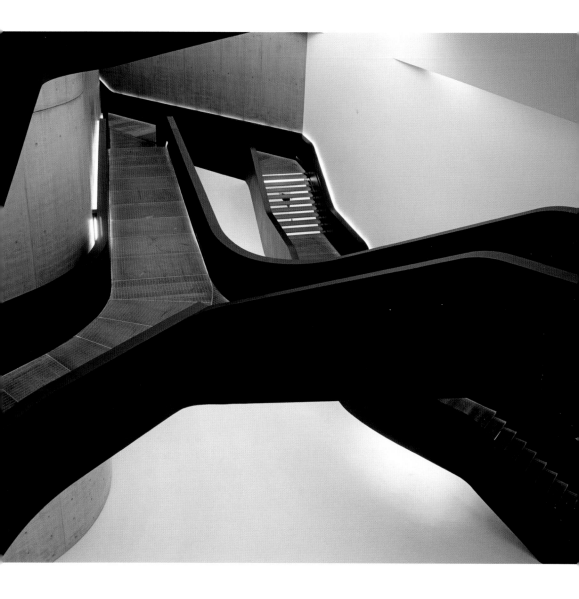

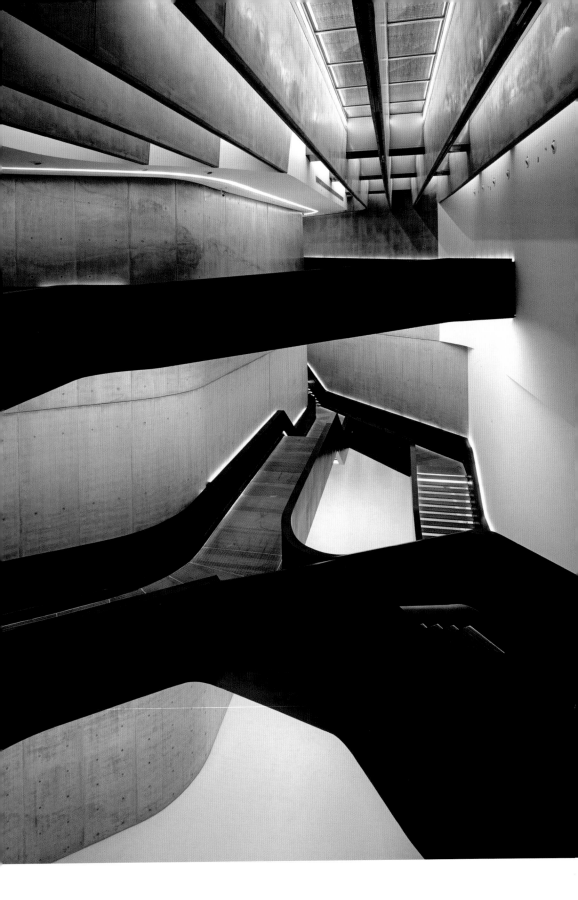

# The Ineffable Grey Box of Contemporaneity

Alessandro D'Onofrio

There can be no doubt that displaying works of art in such spatially complex surroundings as those of the MAXXI museum entails certain difficulties. But this is only the case if we think of artistic products as objects to be contemplated, completely unrelated to the spatial context that hosts them. If we instead begin to look at art as something more multifaceted, contaminated by new expressive forms and means (Net Art, public art, relational art etc.), we can come to realize that the museum's strong personality in fact provides a unique setting for art works, and that Zaha Hadid's flowing space is the natural materialization of absolutely contemporary lines of thought, shared by the artists and architects whose work it will host.

The MAXXI is the cement solidification of a three-dimensional digital model from the world of boolean thought, incubated and developed through the computer, contaminated by memories of the place (take a look at some photographs of the old demolished hangars, long, narrow spaces capped by skylight fissures) strong enough to create a short-circuit with reality.

If we carefully observe the distribution of the museum, we realize that each zone – it is in fact difficult to define it in terms of parts or "rooms" – has at least three different points of entry. This hampers the classic sequence of exhibition rooms arranged all in a row, making it practically impossible to orchestrate the visitors' path in any sort of hierarchical way. It may seem disconcerting, this layout, which some will see as 'anarchical' and others as 'equalizing'. The museum forces us to conceive of an exhibition without pre-set diachronic paths of comprehension, in a 'uniform' and synchronous space capable of offering visitors the chance to create their own pathway of edification or contemplation, similarly to the ways in which they might use an Internet portal.

Building on these simple reflections, for the inaugural exhibition *Space*, the architecture section has proposed ten site-specific installations by ten architects, intended not only to highlight the dialogue between content and container, but also to individuate and illustrate different interpretations of contemporary architectural experimentation. Each participating architect, with his/her work, area of exploration and expressive capacities, represents questions, reactions, proposals, interpretations and perhaps even possible paths towards solutions to problems that have emerged in the space of global society. The installations presented are a sort of index of themes that the museum proposes to deal with programmatically in

the exploration phase of the next few years. Analyzing the changes that revolve around the vast concept of Space means attempting to understand which systems control and organize our lives, and which powers and philosophies are struggling for ascendancy behind them; ultimately, it means becoming aware of and taking a position on the macro-history that we all passively live through.

It might be said that space does not exist if it cannot be communicated, told of, represented; try to imagine the infinite universe, or try to convince any Web 2.0 user that his space is physically inexistent.

Naturally, its codes of interpretation have, historically, almost always been regulated by the dominant powers: religion, ideologies, politics, the economy.

In this sense, our contemporary era is no exception. However, it differs from earlier epochs in terms of the co-existence of multiple systems; it is characterized by the continued presence of aggregative and organizational forms from the last century, which have undergone a total twisting of their original meaning. In fact, nation-states still exist, even though economic tides, giant, detached commercial corporations and trans-national political organisms have usurped much of their statutory role. Traditional geopolitical boundaries have been supplemented by the geo-economic ones of the globalized world, which necessitate passports for Egyptians going to work in Sharm el Sheik, or for Chinese people entering Shanghai. National laws have been joined by autonomous regulations – sometimes in conflict with the former – as occurs in some gated communities, or in refugee or 'reception' camps for immigrants, where certain inalienable rights are, in practice, suspended. And these are just a few examples.

At the same time, the global environmental question has become the one transversal system of thought, perhaps the only 'ideology' openly accepted by all and lazily pursued by governments and individuals.

The architect, on the other hand, as an organizer of spaces and through his projects, carries out a critical process of analysis of what already exists, and in this is quite similar to the artist; but the architect is also proactive with regard to what must continue to exist. He wants to, and must, and cannot do otherwise than to attempt to generate other, different physical models. Thanks to his training, he is resistant to the monolithic nature of systems, and so, by modifying

even a few of the elements that make up his product, he can more or less consciously generate visions of new possible forms of social, political and economic relations. He can spur us to find a new use for a space originally conceived for a different purpose, just as Zaha Hadid has done with the MAXXI.

In our specific case, the ten studios invited to the MAXXI were selected from an initial list of about sixty. They employ architects who, although well-known in the architecture world, are definitely outside the mass-media circuit of 'starchitects'. All are characterized by a strong theoretical component, also discernable in their realized works. For seven of them, the average age of the associates is around forty. To give an extremely concise summary, we can trace a decidedly limited outline of their favored lines of experimentation.

Estudio Teddy Cruz (San Diego, California) and Recetas Urbanas (Seville, Spain) are emblematic of an approach to architecture as pure art in the service of social issues.

Cruz's group experiments on the dynamics of urban conflicts generated by intense waves of migration in boundary zones. Their means of operation are rooted in spontaneous architecture and an attentive reading of how a territory is used by its most vulnerable – from an economic and legal point of view – populations. Recetas Urbanas, through real acts of civil disobedience on the borderline between legality and illegality, seeks to lend free access to temporary and parasitic constructions for people excluded from the mechanisms of control of capital and the dominant culture. In both cases, architecture as a shared, participatory process starting from the bottom of the social pyramid takes on the thaumaturgic quality of metropolitan tensions.

Epitomizing the concept of the architectural profession as a constant field of authentication and improvement of proposed spatial models, we have the HPNJ+ (Zagreb, Croatia), Lacaton & Vassal (Paris, France) and Cino Zucchi Architetti (Milan, Italy) studios.

In their works, Helena Paver Njirić and Cino Zucchi reinterpret historical typologies, such as habitations, and new categories, like the spaces of urban hyper-consumerism, creating new processes of identification and use. Lacaton & Vassal transport the grand tradition of French functionalism, which has always been linked to the industrialization of constructive elements, into the contemporary era. Interventions geared towards the strictly essential and the decision to use pre-fabricated materials do not hinder them from always

maintaining a degree of reversibility and flexibility when new needs arise.

In all three cases, a certain 'optimism' with regard to the potential of the architect's profession shines through, a positive disciplinary autonomy that manages to skillfully blend poetry, artisanal techniques and environmental technology with the complexity of functional plans.

We can also place Bernard Khoury's (Beirut, Lebanon) work among that of these first two groups. The difficult and unstable context in which he operates offers him the opportunity to work directly on the body of the city. He does so through two means: on the one hand, professional competence, and on the other, the irony or even cynicism that transpires from many of his works. His architecture not only impeccably respects the desires of his demanding private clients, but always manages to transmit a cue for reflection on the economic and political system of which it is a part as well.

Two studios pertaining to the part of the architectural world that contaminates the discipline with methods from other doctrines, albeit with very different results, are Diller Scofidio + Renfro (New York, USA) and R&Sie(n) (Paris, France).

The American studio is known for a performatory approach intimately linked to conceptual and visual arts. Exploiting our mental habituation to the paradigms of everyday life, they use every possible means to induce perceptive disorientation, with the goal of creating a paradoxical collective-intimate space.

François Roche and his associates, on the other hand, exploit the vast possibilities offered by the digital world. Architecture, intended as a sampling of pure and recognizable forms or shapes, is deformed and contaminated by fractal mathematics formulas capable of generating complexities similar to those found in nature.

Both studios aim to give shape to new collective imagery, and to indistinctness.

We can place the works and installations by the studios West 8 (Rotterdam, Netherlands) and Rintala Eggertsson Architects (Oslo, Norway) within the dialectic of the separate poles of nature and artifice.

The Dutch studio, a true prototype of a multidisciplinary operation, deals mainly with landscape and urban design; its approach is that of 'naturalizing' urban artificialness, often with

surrealistic and ironic contaminations. The studio's production is geared towards developing environments of perfect synthesis – in formal terms as well – between categories that were once diametrically opposed. The Norwegian studio is at the other extreme, attempting to reintroduce elements pertaining to archetypes of the relationship between man and nature into or on the edges of urban zones. The limitation to essential forms, natural materials and clean, eco-compatible technologies goes along with a disenchanted awareness of contemporary man's condition and needs, as their prototypes of micro-habitations demonstrate.

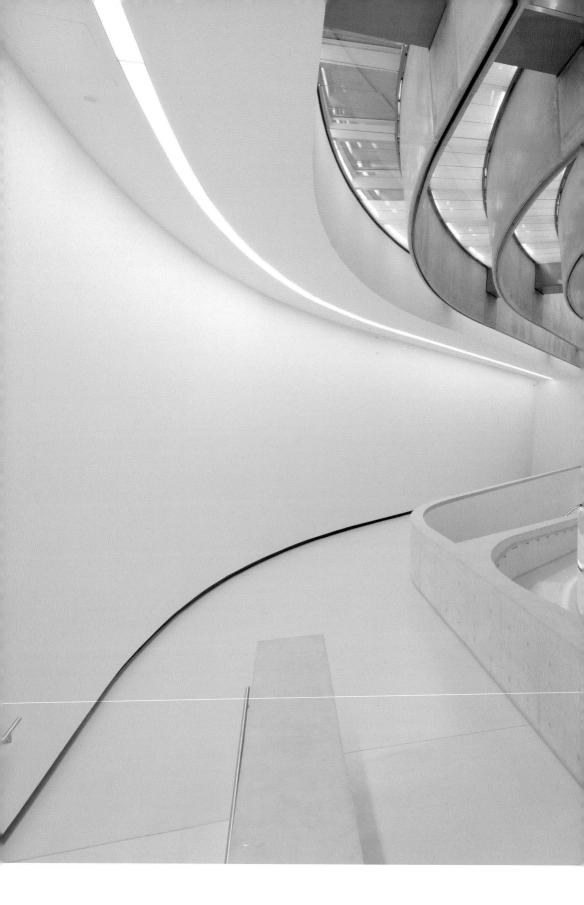

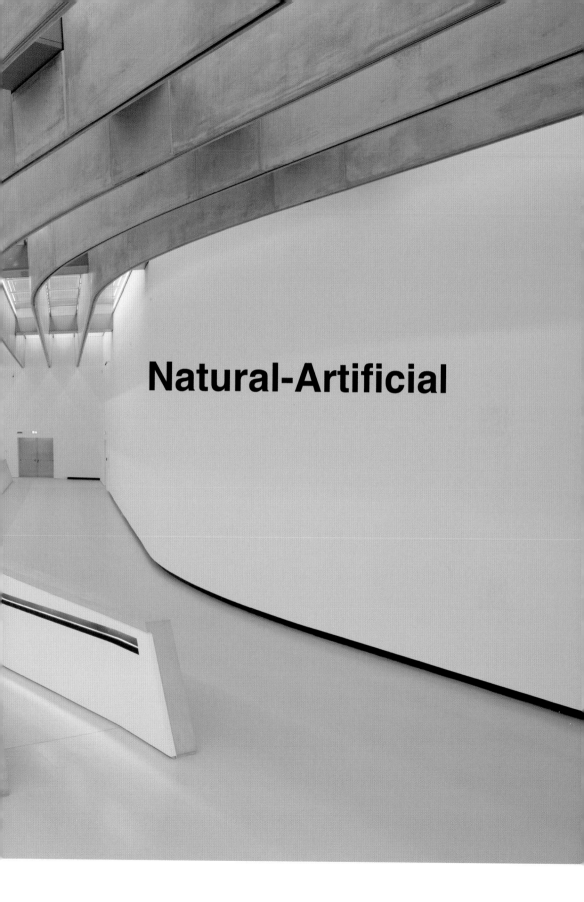

Natural-Artificial

# Symbiotic Man

Gilles Clément

Six drawings which, together with earlier drawings, deal with the notion of Symbiotic Man.

Each drawing, numbered 1 to 6, corresponds to a stage that illustrates the transformation of a monolithic system (a single line of thought, capitalism as the sole economic theory, centralization of power, centralization of circuits of production and distribution etc.) into a multitude of autonomous systems that work according to a model of material and intangible exchanges on various scales.

It all corresponds to the vision of a system destined to fail, while another is being born.

The ensemble of autonomous systems, grouped into a "milky way"

1 – The dominant power, undermined from within, attempts to reestablish an unsteady equilibrium, threatened by its own tendency to drift. A multitude of opposing powers applies pressure from the outside, adding to the fragility of this monolithic edifice based on faith in a single economic and social system.

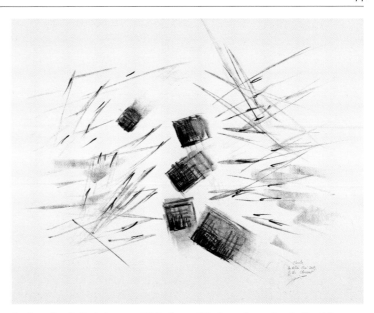

2 – In spite of efforts to consolidate the architecture of a system built solely on the mechanics of material exchanges and consumption, said architecture collapses.

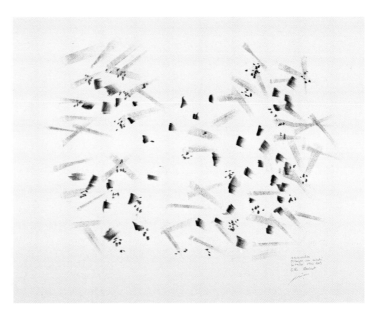

3 – Breaking down, the system joins forces with the autonomous structures that contributed to its downfall. It merges with them, it's transformed when it comes into contact with them, unable to impose its own rule and model. This dispersed whole corresponds to an atomized society that must invent new models of exchange, sharing and distribution of material and intangible goods.

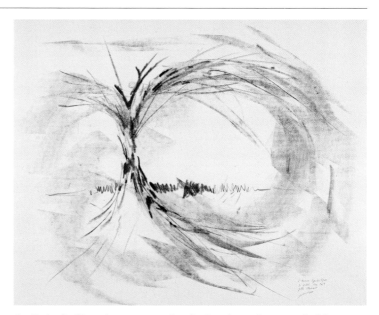

4 – During its life cycle, every tree gives back to the environment all of the energy it draws from it. The Symbiotic Man is the man who adopts this functional model to respond to the question posed by the Planetary Garden: "How can we make use of diversity without destroying it?".

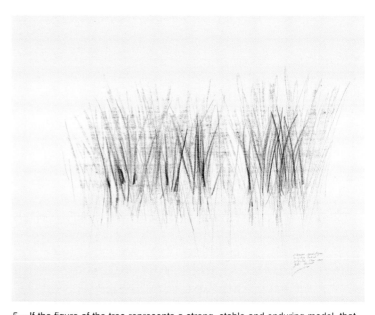

5 – If the figure of the tree represents a strong, stable and enduring model, that of grass might be seen as representing a fragile, unstable and short-lived model. In reality, the two figures function according to the same relationship with the environment: a constant recycling of energies, with no further accumulation of waste except for organic, decomposable material. (Plants, autotrophic beings, produce their food from solar energy and minerals derived from the breakdown of organic materials, rocks etc.).

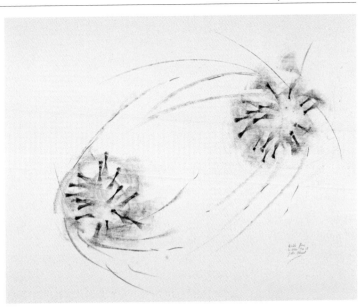

6 – As heterotrophic (predatory) beings, human animals, incapable of synthesizing their own food, must draw it from the environment. The possibility of transforming and returning energy drawn from the environment presupposes the formation of an economy diametrically opposed to the one that now reigns over our planet. The new model is oriented towards a non-accumulation of material goods and waste that takes up space in an unwieldy way and pollutes the substrata to the detriment of life.

(fig. 3), ensures its own autonomy while guaranteeing for every entity:
- a short cycle of production and distribution of indispensable goods;
- one or more localized energy-producing plants that allow the system to function without being dependent for vital needs on any distant, main system;
- a systematic, direct or indirect, recycling of products resulting from the usual functioning of human society.

This series of localized exchanges appears in short, dark sections in figure 6.

On the other hand, every system exchanges with adjacent, nearby or distant systems intangible (or essential) goods that are impossible or difficult to find locally and are necessary for the cultural enrichment of such an atomized society. These long-distance exchanges, which involve intangible goods and, more rarely, material goods impossible to procure locally, appear in gray in the drawing, linking distant systems (fig. 6).

The two modes of exchange – in proximity and long-distance – correspond to a new economy that functions according to the tree-and-grass model, in which everything drawn from nature goes back to nature without qualitative deterioration, whatever the form of restitution or level of transformation may be. This new economy characterizes the Symbiotic Man.

A dead leaf on the ground is not rubbish, it is nourishment.

*La Vallée, June 1, 2009*

# The Space of Possibility: Becoming Human in the Natural-Artificial Era

Telmo Pievani

The scientific world is founded on the contents of research – ideas, hypotheses, and discoveries – but also on methodology, the comparison of hypotheses, and the provisional nature of findings. In defending "the reasons for lightness" from the temptation to "escape into dreams or the irrational" Italo Calvino, in the *Lezioni americane*, appeals to science: "The infinite universe of literature is constantly opening new avenues to be explored, both very recent and very ancient, styles and forms that can change the image of our world. But if literature is not enough to assure me that I am not just chasing dreams, I look to science to nourish my visions in which all heaviness disappears. Today every branch of science seems intent on demonstrating that the world is supported by the most minute entities, such as messages of DNA, the impulses of neurons,

quarks and neutrinos wandering through space since the beginning of time…" [p. 9].

## Metaphors That Make the Difference

Hovering somewhere between science and imagination, writers, utilizing diverse narrative tools, have interpreted the destinies of these minute entities. The biographies of "beautiful minds" at work, accounts of complicated personal lives, politics, academic rivalries, misunderstandings, disputes, and other entertaining anecdotes, have become a successful literary genre. The paradoxes of quantum mechanics, from Schrödinger's cat to parallel universes, continue to generate stories and shocking-albeit-impertinent retellings. Anecdotes that attempt to glean illumination from marginal events are ever more common in scientific accounts. Scientific history is populated by not-so-bad-after-all individuals – those who were right for the wrong reasons, and those who were wrong for excellent reasons.

Today science writing is characterized by varying degrees of intensity. The high language of science and the low language of pop culture and the media have merged, mingling with and changing each other. In other words, while literature and cinema utilize scientific models and theories, science also lifts themes from popular culture in order "to narrate itself". The world of science and media has become a zone where both science and fiction are free

to experiment with one another (Carmagnola, Pievani, 2003). Today, the myth of the universality of the scientific method is being called into question (Dupré, 1993), and the unproductive barrier between laboratory research and the communication of scientific advances is being challenged.

When science begins to speak about us, would-be *sapiens*, prejudices abound. The important American "science writer" Stephen J. Gould understood the powerful role of great narrative iconographies in the history of biological thought. We are indebted to him for his acute analyses examining the role of the "iconography of hope" which describes human evolution as a linear progression (Gould, 1989). Gould, a paleontologist and New Yorker, collected numerous versions of this popular but inaccurate iconographic representation. The image should be familiar: a hairy and hunchbacked ape dragging himself about stupidly at the far left of the sequence, followed by the less hairy and more human depiction of *Homo* walking more upright, then our supposed direct ancestor (Neanderthal?), almost but not quite human with his sloping forehead and perhaps a rudimentary weapon, until we reach, at the far right end of the sequence, a tall, young, white, male specimen of *Homo sapiens*, fully upright and striding confidently.

The Internet and the advertising world continue to utilize this image, although sometimes more ironically than 'literally'. The representation of *Homo sapiens* at the apex of the evolution might be an obese man, bent over his keyboard, drunk, or hypnotized by the television. To consider such liberal use of the metaphor as merely superficial and to ignore its profound heuristic role would be a mistake. Today we know that this triumphal march of progress has no scientific basis; the metaphor has tripped over itself and fallen to pieces. There are no 'missing links' because there is no linear succession which sequentially and predictably leads to our species. Yet such teleological metaphors are so cognitively and psychologically powerful that every paleoanthropological discovery inevitably leads to newspaper headlines heralding the discovery of the 'missing link'.

Science, according to Gould, a "lover of detail" like his illustrious predecessor Charles Darwin, is always a matter of biographical fragments and idiosyncratic habits, revealing eccentricities and unexpected intellectual genealogies. He avoids the pitfalls of

anecdotal details by always falling back upon the unifying 'recurrent themes' of historical contingency, the continuity of life, unity in diversity, natural equality, the plurality of rhythms and levels of change, and evolutionary opportunism (Gould, 2002[a]). Gould believed that the history of nature could teach us about the nature of history. It is an ancient idea, constantly under threat, of a "natural philosophy", where science is culture, scientists are intellectuals, and scientific thought is an integral part of the "forever living" Republic of Letters (Gould, 2002[b]). For Gould the symbiotic relationships between science and other fields were not motivated by mere interdisciplinary syncretism but by the belief in the "unified nature of human creativity".

### Darwin's Coral and Space in Evolution

Next we shall see how two metaphors that helped shape the concept of evolution were developed and then set aside. The young Darwin's *Notebooks on Transmutation* are an extraordinary example of personal scientific writing, a detailed first-hand account of the birth of a scientific revolution. In a rapid succession of hypotheses, interpretive models, sudden discoveries and connections, the English geologist and naturalist erected a spectacular theoretical framework, culminating in the summer of 1837 with the first drawing of the "tree of life". It was an attractive and successful metaphor, however imperfect (Bredekamp, 2005). Just a few pages after his first attempt at describing evolutionary branching Darwin noted that "the tree of life should perhaps be called the coral of life".

Darwin found the traditional image of a genealogical tree unsatisfying because its linear nature implied an intrinsically hierarchical organization of living creatures. He wrote in his *Notebooks* that if the tree metaphor was to be used, it had to be a tree with very "irregular branches". The tree, additionally, did not allow Darwin to demonstrate the role of extinction in evolution, the flowering of diversity which follows the death of species. Therefore he contrasted the idea of a "tree" with the more irregular and "bushy" image of coral, with its numerous branches preserving history in calcified tangles and randomly fanning out in every conceivable direction. For Darwin, the coral represented the true

symbol of the drama of death and survival, the synthesis of the relentless diversification of nature, the most accurate evolutionary model to represent the absolute unpredictability of extinction and speciation. Above all, however, it was an antidote against any temptation to associate evolution with a process leading to perfection.

Darwin would later return to the more popular image of the tree of life in 1857, perhaps because it was more effective in describing the gradual effects of natural selection and the gladiatorial fight for survival. It is clear that the metaphors Darwin chose were neither aesthetic embellishments to the content of his theory nor tactics designed to convince or communicate with his colleagues. Rather, they were real catalysts of ideas, tools to organize concepts, frameworks for writing about theory that were decisive for the creative moment of discovery. Proof of the theory was naturally empirical, but imagining evolution as a tree rather than coral leads us down a different path and to different questions, and therefore to potentially different discoveries. We need hardly point out that phylogenetic 'trees' constructed by molecular biologists are clearly more similar to the irregularity of a coral formation than to the harmonious symmetry of an oak tree (Pievani, 2010).

The motivation for Darwin's initial choice of coral and irregular budding is even more interesting. The crucial concept is the space of evolution. Darwin initially understood species as discrete entities corresponding to a population of similar organisms distributed in a geographical space. If ecological conditions were not stable and groups of organisms moved, populations became physically separated from one another (migrating, for example, to a nearby territory, colonizing an archipelago, remaining isolated by a river or mountain range). In this way, if a sufficient (but not excessively long) period of time passed, mutagenic divergence and 'drift' and the effects of different methods of adaptation could bring about reproductive isolation. The members of a species were no longer able to reproduce with each other. Nowadays, we say that a barrier forms which blocks the genetic flow from one population to the other.

Such branching demonstrates the need to understand evolution in terms of two axes: the axis of time, or the genealogies and family relationships which fossils and genetic markers allow us to understand with great precision, and also the axis of space, the

bio-geographical rooting of populations in ecological contexts, their movements, cohabitations, and their ranges of distribution (Eldredge, 2006). The misleading "iconographies of hope" which Gould criticized have their basis in the unilateral overemphasis of the axis of time based on descent, transformation and intermediary forms. Recognizing the importance of physical space and its organization is necessary to reveal the irregularity, diversity, and unpredictability of the history of nature.

### Space as a Natural-Artificial Extension of the Species and the Individual

If we view the human species through this lens we discover that its uniqueness has not derived solely from 'specialized' adaptations that occurred over time, if it is true that our brain, like other organs, is the fruit of ingenious reorganization and functional cooptation which gave it its plasticity. We must also consider the particular dynamics of the human species' 'occupation' of space. Much of what makes us human derives from our mobility and from each founder group's progressive expansion of its territory in order to survive (Cavalli Sforza, 1996). After appearing in Africa not more than two hundred thousand years ago, we migrated out of the continent at different exit points. It took tens of thousands of years for the 'Old World' to be fully colonized. We then penetrated Australia and the Americas, bringing about the extinction of native populations of large mammals, until we finally reached the remotest areas of the planet. During this migration we used our culture and technological skills as formidable and malleable tools of adaptation. We became, ecological speaking, an 'invasive cosmopolitan' species rapidly branching out into various cultural and linguistic groups. In the meantime, unlike other Homo groups, we began to construct lunar calendars, decorate our bodies with ornaments, develop burial rituals, engrave and paint dark and almost inaccessible caves, filling the walls with realistic scenes of hunting, fantastic creatures, stylized figures and other nonexistent forms. "Minute entities" made their entrance into the evolutionary process. Spaces that remained free from man's intervention, exotic reserves for exploration and hunting, became progressively scarcer until they finally ceded to the transformative power of the

agricultural revolution. We were capable of making nature produce more than what was necessary, using artificial selection to domesticate plants and animals that, in return, partly domesticated us through natural selection (Diamond, 1997). The concept of uncontaminated nature should therefore be considered as either vain nostalgia or an ideological cover. The coral branch spread like oil in water and grafted cultural evolution onto itself. This is no miraculous "ontological leap", but the beginning of a new and unedited mode of expression, and therefore of thinking and behaving. It is another of Darwin's "infinitely beautiful forms", the fruit of reciprocal compromises amid the pressures of selection, genetic drift, and structural limitations (Carroll, 2005).

Thus, space becomes a great natural-artificial extension, deceptively just outside of us and at our disposal. In reality, it is evolving in step with us. It is an "extended phenotype" which enters into the relationship of reciprocal adaptation between the human species and the various environments of the planet. The evolutionary process of "niche construction", which is now considered to be widespread, is becoming crucial. Our metabolic, social, and perturbative activities allow us to construct our symbolic and cultural niche, which in turn structures the pressures of selection and environmental conditions that influence our evolution (Odling-Smee, Laland, Feldman, 2003). Retroaction accelerates these processes. Therefore, it is, above all, a space that is extended and animated by symbolic and abstract minute entities at the species level. Physical promiscuity, which will increase despite claims of identity, is being transformed into a thick web of permeating symbolic contacts.

Yet, it is an extended natural-artificial space that concerns individual bodies and minds more and more. We already use all kinds of prostheses to improve our capabilities. We see through the lenses of glasses, we are surrounded by technologies that make up the environment in which we live. We play virtual tennis in front of a computer screen, twisting through the air as if possessed. Robots are evolving rapidly to the point that some have argued for a 'robo-ethical' code to regulate their hopefully friendly interactions with human beings in the future. Molecular nanotechnologies will function inside the microstructures of the human organism. Sooner or later, someone will implant a silicon chip in our brains to allow us to feel other people's emotions, as so

many writers and film directors have imagined.

We run the four hundred meter race with limbs made of composite carbon, which allow us to spring with a leopard's stride. Although it seems like science fiction, are we far off from witnessing a runner with two synthetic legs, a biotechnological biped, winning the Olympic four hundred meter race? Since Samuel Butler, many have dreaded the possibility that technology could eclipse natural evolution and that man, having lost control of his prostheses, would be overthrown by evolved and conscious machines. Yet these scenarios continue to depend greatly on the distinction between 'natural' and 'artificial'. The human species has existed in artificial contexts since at least the dawn of agriculture. We have been inventing cultural strategies of physical survival for millennia: clothes, fire and tools. Earth's ecosystems attempt to resist human overpopulation, the exploitation of resources, habitat fragmentation and the invasion of non-native organisms. The human species is a unique evolutionary experiment. We will soon be able to construct the first 'synthetic' organism, which will likely be a 'basic' bacterium with genes selected by us to fulfill specific, determined functions. While this also seemed like the realm of science fiction not so long ago, the success of projects such as genome mapping will certainly lead to continued research and new innovations.

From this perspective, technology is the extreme attempt by evolution to renew itself. In the end, it will be a human being, even if bionic, who, with his weaknesses, emotions and intelligence makes decisions about what is right and wrong. The post-human is fundamentally much more human, and therefore ambiguous. Peaceful and therapeutic uses of technology – cancer treatments, reproductive technologies, agricultural improvements that diminish the use of pesticides, and regenerative and personalized medicine, for example – always carry the risk of being abused. This fact leads to nightmare fantasies of eugenic robots, ranks of clones and biotechnological monsters, which, in turn, lead to the adoption of excessively rigid precautions blocking all uses of technology. Alarmists and skeptics, polarized by this natural-artificial space, forget that the space in which discoveries are made (the value of the scientific knowledge gained from stem cell research should be separated from any debate over its practical applications) has always been a space of 'manipulation', a term which today has

strongly negative connotations. However, if we are fearful and stand at a distance, we cannot hope to understand. Learning comes through firsthand experience, experimentation and exploration of the unknown. The costs and benefits need to be evaluated with more research, not less, in order to better understand what risks we can live with. We must accept ambiguity and unpredictability and be humble and open in our approach.

The gulf between the limited intent of human technological interventions and the array of unimagined consequences these interventions could trigger in our natural-artificial space is widening. Nevertheless, it represents the very heart of scientific knowledge. The human species modifies its and other species' biological identity. Stoking fears of Dr Frankenstein is as unproductive as denying all risks. We need to distance ourselves from both the suffocation of anti-scientific rhetoric as well as uncritical progressivism. The challenge is to conceive human space as a reservoir of evolutionary possibility. Perhaps humanity will be able to reinvent itself again, discovering unexplored cognitive capabilities. Perhaps, we should not define ourselves simply as "human beings" but, as the paleoanthropologist Ian Tattersall has suggested, as "human becomings" (Tattersall, 1998).

## The Space of Possibility

In 2007, when the American Edge Foundation asked the great Stanford University astrophysicist Leonard Susskind what made him optimistic about the future, he replied: "I am optimistic about the adaptability of the human brain to answer questions that evolution could not have designed it for. A brain that can rewire itself to visualize 4 dimensions, or the Heisenberg uncertainty principle, is clearly going way beyond the things that natural selection could have wired it for. It makes me optimistic that we may be able to go beyond our Darwinian roots in other ways" (www.edge.org).

In Yvon Marciano's short film *Emilie Muller* (1993) a girl, played by the enchantingly feminine Veronica Vargas, goes to a casting call where she creates a universe inspired by common objects found in a handbag which we later discover is not hers. It is the perfect metaphor for a process biological evolutionists call

Bibliography

— H. Bredekamp, (2005), *I coralli di Darwin*, Bollati Boringhieri, Turin 2006.
— I. Calvino, (1980), *Una pietra sopra. Discorsi di letteratura e società*, Einaudi, Turin 1980.
— I. Calvino, (1985), *Lezioni americane. Sei proposte per il prossimo millennio*, Garzanti, Milan 1988.
— F. Carmagnola, T. Pievani (2003), *Pulp Times. Immagini del tempo nel cinema di oggi*, Meltemi, Rome 2003.
— S.B. Carroll, (2005), *Infinite forme bellissime. La nuova scienza dell'Evo-Devo*, Codice Edizioni, Turin 2006.
— L.L. Cavalli Sforza, (1996), *Geni, popoli e lingue*, Adelphi, Milan 1996.
— J. Cortázar, (1994), *I racconti*, Einaudi-Gallimard, Turin 1994.
— C. Darwin, (1836-1844), *Taccuini 1836-1844. Taccuino Rosso, Taccuino B, Taccuino E*, Laterza, Rome-Bari 2008.
— C. Darwin, (1842-1858), *L'origine delle specie. Abbozzo del 1842. Lettere 1844-1858. Comunicazione del 1858*, Einaudi, Turin 2009, ed. T. Pievani.
— J. Diamond, (1997), *Armi, acciaio e malattie*, Einaudi, Turin 1998.
— J. Dupré, (1993), *The Disorder of Things*, Harvard University Press, Cambridge (MA) 1993.
— N. Eldredge, (2006), *Darwin. Alla scoperta dell'albero della vita*, Codice Edizioni, Turin 2006.

"exaptation", the cooptation of a structure or behavior for a completely new function and context (Gould, Vrba, 1982-1986, ed. 2008). Gould defined this phenomenon as "evolutionary bricolage", a kind of creative opportunism in which organisms, rather than developing a new structure in response to every selective pressure, pragmatically and creatively reutilize or readapt a preexisting structure. It is still an adaptation process of natural selection, but it involves internal functional reorganization as a strategy of compromise to react to environmental demands. It is an unpredictable 'game' played between structures and functions made possible by the biological redundancy whose mechanism Charles Darwin suggested in *On the Origin of Species*. Indeed, Darwin saw this as the margin of possibility between organs and adaptation without which change would be impossible. In its evolutionary explanation, "exaptation" introduces a strong component of historical contingency because it is based on the idea that every structure or behavior has a wide range of secondary 'possibilities' that can only be explored if the right conditions exist. Emilie is asked to pick up her handbag, and because she has not brought one, takes the first one she sees from the coat rack. The bag contains objects from the life of another woman, a stranger, but in her hands the bag and its contents take on unexpected contours and meanings, becoming unexpected cues to explore new universes of possibility. The distinction between the real and the virtual plays no part in Emilie's story. It is not important that she is lying, that she is sometimes uncertain about her narrative, or that she immediately regrets some of her stories and quickly backtracks. What is important is that her universe, originating from the microcosm of a bag containing another woman's life, is plausible, coherent, logically possible and held together by its minute entities.

Emilie's creative opportunism produces an evolutionary and narrative "bricolage" that is as genuine as its "empiric foundation" is fake. We believe her when she talks about her friends, lovers, childhood, parents and girlish dreams even if her stories spring from randomly chosen objects – a book, a postcard, a diary, an apple, an organ donor card, a plane ticket, a harmonica – taken from a bag and a life which are not hers. The director sees a possible and 'exaptational' world in front of him whose truth is unattainable. It is a world that is open to the unpredictable

demands each object makes as it is taken from the handbag. At the same time, it closes itself inside a structure of reason, which selects each stimulus and integrates it into a coherent narrative plot. Emilie's story is imperfect, sketchy, contradictory and seductive in its incompleteness. It navigates the condition of creative uncertainty, which Julio Cortázar ironically defined as the sense of "not completely being here", an expression that deftly defines (and for exaptational reasons) our evolutionary condition as "becoming human" in a space which glows with possibilities.

— V. Girotto, T. Pievani, G. Vallortigara (2008), *Nati per credere*, Codice Edizioni, Turin 2008.
— S.J. Gould, (1989), *La vita meravigliosa*, Feltrinelli, Milan 1990.
— S.J. Gould, (2002[a]), *La struttura della teoria dell'evoluzione*, Codice Edizioni, Turin 2003.
— S.J. Gould, (2002[b]), *I Have Landed. Le storie, la Storia*, Codice Edizioni, Turin 2009.
— S.J. Gould, E.S. Vrba (1982-1986), *Exaptation. Il bricolage dell'evoluzione*, Bollati Boringhieri, Turin 2008, ed. T. Pievani.
— S. Kauffman, (2000), *Esplorazioni evolutive*, Einaudi, Turin 2005.
— J. Odling-Smee, K.N. Laland, M.W. Feldman (2003), *Niche Construction. The Neglected Process in Evolution*, Princeton University Press, Princeton NJ 2003.
— T. Pievani, (2002), *Homo sapiens e altre catastrofi*, Meltemi, Rome 2006.
— T. Pievani, (2010), *La teoria dell'evoluzione. Attualità di una rivoluzione scientifica*, Il Mulino, Bologna 2010.
— I. Tattersall, (1998), *Il cammino dell'uomo. Perché siamo diversi dagli altri animali*, Garzanti, Milan 1998.

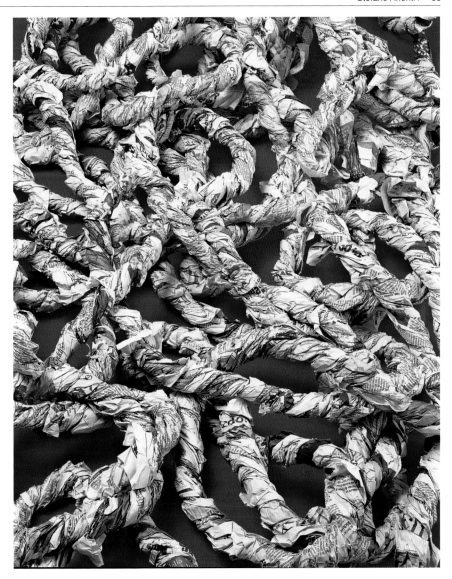

**Stefano Arienti**
— *Corda di giornali*, 1986-2004, rolled newspaper, varying dimensions, MAXXI – Museo nazionale delle arti del XXI secolo.

As it twists and gathers, unravels and tears, this work constantly and organically adapts to the space. Stefano Arienti's rope, made of rolled newspaper sheets, was created over time and appropriates text and images, absorbing their content. Randomly spread out across the floor, it creates an infinite variety of forms. The common theme of Arienti's work is his interest in the metamorphic potential of objects and materials, including those which seem to have outlived their value or reached their limits.

The artist looks to the everyday world and searches for banal or already used images and common materials like paper, cardboard, fabric and putty. He experiments with them, manipulating, folding and transforming them in every conceivable way. *Corda di giornali* is an example of how a material taken out of its context can assume new forms, meaning, and identity. There are no limits to the possibilities of reuse and interpretation. Everything can be considered a precious inheritance with the power to live again in the present. (g.s.)

Born in Asola (Mantua, Italy) in 1961, lives and works in Milan.

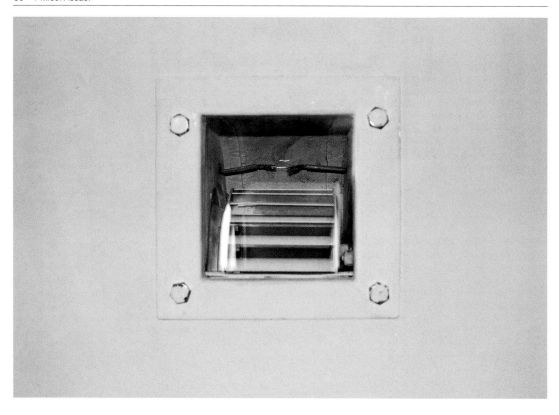

**Micol Assaël**
— *Dielettrico*, 2002, electric motor, spark, room-size,
MAXXI – Museo nazionale delle arti del XXI secolo.

Micol Assaël puts the viewer into a direct relationship with
the work, creating a situation of instability that tests his or
her individual physical and emotional limits, springing from
the idea that – as the artist asserts – "situations of risk are
the ones that most easily trigger a reaction". To carry out
her work, Assaël uses mainly materials and processes
inspired by the principles of physics; for example, she may
drastically drastically lower the temperature of an exhibition
space, or saturate it with static electricity or steam. This
artist's experimentation focuses on the body and its
limitations, and on the relationships it may establish with
external factors such as air currents, magnetic fields and
fluids. *Dielettrico* produces a strong, almost invisible gust of
air on the spectator, investigating the architectural and
spatial dimension and revealing its energy as well as its real
and symbolic critical points. (b.p.)

Born in Rome in 1979, where she lives and works.

**Marina Ballo Charmet**
— *Con la coda dell'occhio n.1*, 1993-1994, photographic print on paper, 150 × 100 cm, MAXXI – Museo nazionale delle arti del XXI secolo.

Since the mid-1980s, Marina Ballo Charmet has worked on long-term photographic and video projects. Her subject is ordinary life – the world around us – as well as the "minute" details of our relationships with others. Her images bring to the foreground what she calls "the background noise of our minds": "the always-seen", the commonplace objects that make up our everyday horizons and which we normally perceive as marginal. Ballo Charmet adopts a gaze characterized by perceptive mobility and a perspective that is out of focus, lateral, 'peripheral', or lowered, and thus typical of childhood. *Con la coda dell'occhio* is one of her earliest photographic series. Created between 1993 and 1994, it consists of black and white images of urban elements, segments of sidewalks, flowerbeds, and traffic islands with cracks and joints filled with weeds, random bits of paper and cigarette butts. Although the subject is ordinary, the large scale of the photographs gives them a monumental quality. Ballo Charmet interprets urban space through the traces of human activity left behind in the urban landscape. (g.s.)

Born in Milan in 1952, where she lives and works.

**Marina Ballo Charmet**
— *Con la coda dell'occhio n.18*, 1993-1994, photographic
print on paper, 150 × 100 cm, MAXXI – Museo nazionale
delle arti del XXI secolo.

**Marina Ballo Charmet**
— *Con la coda dell'occhio n.25*, 1993-1994, photographic
print on paper, 150 × 100 cm, MAXXI – Museo nazionale
delle arti del XXI secolo.

**Joseph Beuys**

— *Lavagna,* 1980.
— *Lavagna,* 1980.
Blackboards mounted on stands, 119.8 × 183.7 × 2 cm
each, dimension including stands 198 × 215 × 135 cm,
Museo civico di Palazzo della Penna, Perugia.

Joseph Beuys, one of the major artists of the second half of
the twentieth century, understood art as a means of acting
on man's behalf. He wanted to develop and disseminate an
idea which was capable of reconciling nature with culture
and science with myth. Central to his vision is the desire to
expand the concept of sculpture to include the entire world.
He considered the world as an entity to be transformed, a
'social sculpture'. His art was inseparable from his life, his
prophesy and his teachings. Beuys worked with words and
action. He combined performance and didactic practices in
a project that mobilized psychic and physical energies. The
goal was to discover a remedy for modern man's alienation
and to make him aware of his social context. Beuys was
also an important precursor of ecological awareness, but
not in the sense of environmentalism. His was an ecological
concept of the mind and heart, a reunification of ethics,
politics and aesthetics. The three blackboards shown in this
exhibition demonstrate Beuys's comprehensive philosophy
which formed the basis of the lesson which the artist taught
in Perugia on April 3, 1980. (g.s.)

Born in Krefeld (Germany) in 1921, died in Düsseldorf in
1986.

J. Beuys writing on his blackboards, 1980.

**Joseph Beuys**
— *Lavagna,* 1980, blackboard mounted on stand,119.8 ×
183.7 × 2 cm, dimension including stand 198 × 215 × 135
cm, Museo civico di Palazzo della Penna, Perugia.

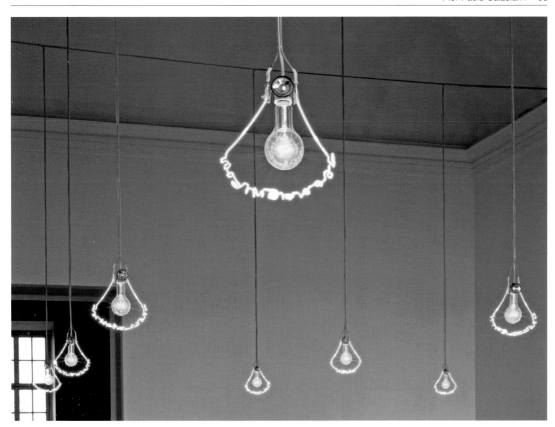

## Pier Paolo Calzolari

— *Untitled (mortificatio, imperfectio, putrefatio, combustio, incineratio, satisfactio, confirmatio, compositio, inventio, dispositio, actio, mneme)*, 1970-1971, 12 neon tubes, 12 light bulbs, trasformers, 12 loudspeakers, CD, room-size, Castello di Rivoli Museo d'Arte Contemporanea, Rivoli-Turin.

Since the end of the 1960s, when he began his career with the *Arte Povera* group, natural, animal or plant materials, physical processes (fusion, freezing, crystallization), allegorical fragments (literary or musical), electronic devices and video and sound recordings have made up the multi-form panorama of Pier Paolo Calzolari's work. The analogy between alterations of physical 'states' and psychic processes and the relationship between "place, person and time", as the title of one of his 1977 works states, are the key components of a process in which elementary physical mechanisms (the "philosophical states of matter", as Antonin Artaud called them) are equated with emotional processes, crucial points in an interweaving of instinctive relationships that embraces body, mind and environment, and against the background of which a hypothesis of sensorial and poetic reconciliation between the subject and his everyday experience is drawn. In this work, the alchemical terms inscribed in the little neon signs – ancient metaphors of psychic processes and unconscious transformations, as Jung's theory suggests – are combined in a luminous installation that recalls Medieval cosmologies in which the star-studded vaulted ceiling becomes a map of a very human process of creation, learning and rebirth. And it is precisely this collision "of times, spaces, ideas and images", as Catherine David wrote, that feeds Calzolari's experimentation with a general form capable of linking worlds, stories and states of matter and of individual experience. (s.c.)

Born in Bologna in 1943, lives and works in Fossombrone (Pesaro, Italy).

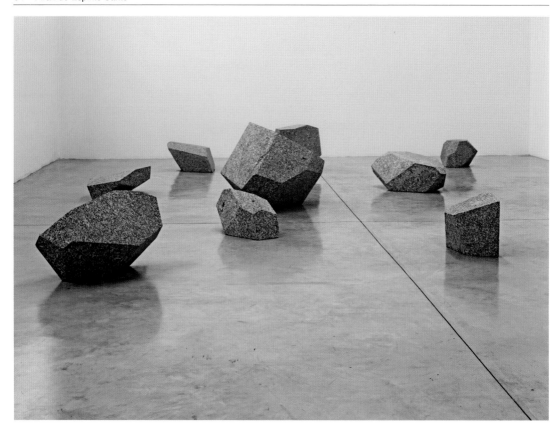

**Iran do Espírito Santo**
— *Correções C*, 2001, granite, 9 pieces, room-size,
MAXXI – Museo nazionale delle arti del XXI secolo.

Iran do Espírito Santo's work explores the duality of reality
and abstraction, nature and representation. It aims to
subvert the severity of minimalist and conceptual art. The
artist focuses on the tactile qualities of materials and the
lines of simple abstract forms fixed in space. He sometimes
decides to play with depth perception or to use illusions
capable of evoking the materials' sensuality. His work
strongly echoes a classical tradition which is always
expressed in relation to the present. *Correções C* consists
of nine granite blocks carved geometrically in a way that
corresponds to their original form. The artist attempts to
harmoniously marry the natural lines of stone with the
activity of sculpture. The result is a series of forms that
reveal rather than represent. The title of the work is a
tongue-in-cheek reference to the artist's paradoxical desire
to "correct nature's imperfections". (g.s.)

Born in 1963 in Mococa (São Paulo), where he lives and
works.

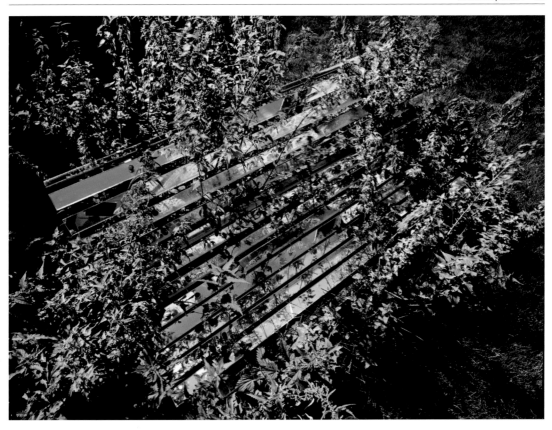

**Bruna Esposito**
— *Aquarell – Bitte nicht Betreten (Acquarello, si prega di non calpestare)*, 1988, mirror, iron, nettle plants, 100 × 220 × 160 cm, Castello di Rivoli Museo d'Arte Contemporanea, Rivoli-Turin.

Bruna Esposito's art is emotional, evanescent and resistant to description. The dramatic pathos of transience and the painful nature of utopia emanate from her work. She creates unstable balances, and the power of her work derives from its explicit vulnerability. The simplicity of the means she uses does not prevent her work from having multiple meanings and possible interpretations. *Aquarell* is characteristic of her work: a nettle plant grows around and within the structure of a park bench with a seat made of mirrors. The bench reflects the environment and the sky and changing weather conditions. It is perceptually elusive. The nettle camouflages the bench, and the mirror, a cold and sharp material, makes the object fragile and delicate, attractive yet uninviting. The growing nettles suggest organic change and passing time, but they make relating to the object more difficult. If a bench suggests the need to regain control of time, to take pleasure in slowness and our need to rest, *Aquarell* transmits a subtly contradictory message. (g.s.)

Born in 1960 in Rome, where she lives and works.

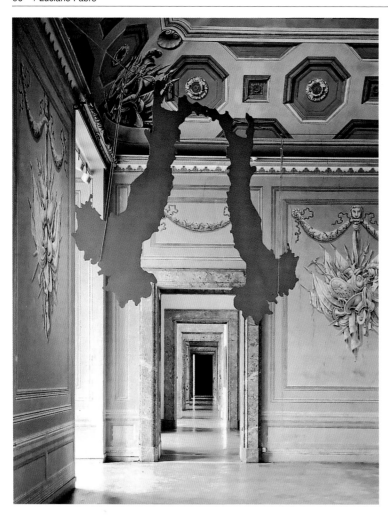

**Luciano Fabro**
— *Italia porta*, 1986, painted shaped sheet metal,
220 × 342 cm, Palazzo Reale, Caserta.

*Italia porta* was originally conceived by the artist for the
*Terrae Motus* project, promoted by gallery owner Lucio
Amelio following the 1980 Irpinia earthquake. Two
silhouettes of Italy, turned upside down, are intertwined to
form an arch beneath which the visitor passes. Fabro
created dozens of works with the silhouette of Italy in
dozens of different materials and sizes. Gold, bronze, lead,
fur and glass Italies; the shape changed depending on the
material used, elongating, turning over, going limp,
becoming transparent or heavy. But the artist was not
interested in creating works that spoke of Italy in its social
and historical contextualization, because, as he wrote, "for
me, form remains a transmigration of the material. The form
is like a pause within the transformation. To be more
precise, I have always accompanied them [the *Italies*] in this
negation of ideology and symbolism with titles that are more
merry than they are cerebral". Italy thus becomes an
archetypal shape through which to experiment with new
semantic and linguistic meanings to deal with the space and
context for which they were originally conceived. (b.p.)

Born in Turin in 1936, died in Milan in 2007.

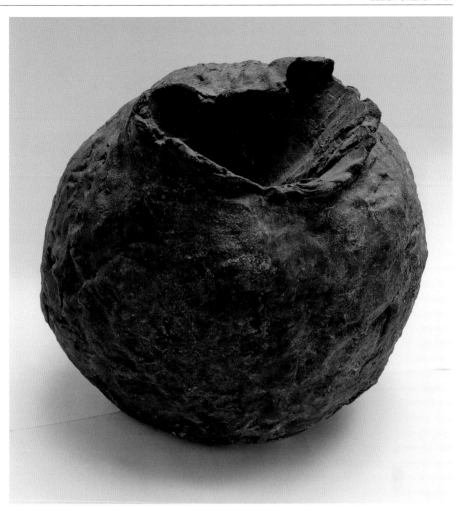

**Lucio Fontana**
— *Concetto spaziale – natura*, 1959-1960, terracotta, 70 × 85 cm, Galleria nazionale d'arte moderna e contemporanea, Rome.

The "spatial concept of art" is the central idea of the mature phase of Lucio Fontana's career, initiated just after the end of the Second World War. Reconnecting with the Futurist legacy, the artist conceived his work as a receptor of energy, an abstract field of contrasting forces that extended beyond the space of traditional representation, involving real space, the invisible currents that flow through it and the time and light that inhabit it, as well as electricity and new materials invented by modern society. The *Nature* series was created around 1959-1960, when Fontana turned again to the terracotta he had worked with in the 1930s. The material – great irregular spherical masses of soft clay – was attacked by the artist with a gesture analogous to the cuts with which he tore through canvases in that same period: a stick was used to etch and dig deep into the clay, producing extraordinarily expressive marks – sometimes a deep hole, in other cases a rip or a furrow – that make some of the blocks appear as erratic masses, and others as asteroids, pieces of solidified lava or gigantic moon rocks. But what is perhaps even more noteworthy in these works is the evocation of the generative force of Nature, celebrated in the mythical and primitive shapes of cosmic vulvas and uteruses with an explicitly sexual symbolism that highlights the life-giving significance that creative endeavor has for the artist. (s.c.)

Born in Rosario (Argentina) in 1899, died in Comabbio (Varese, Italy) in 1968.

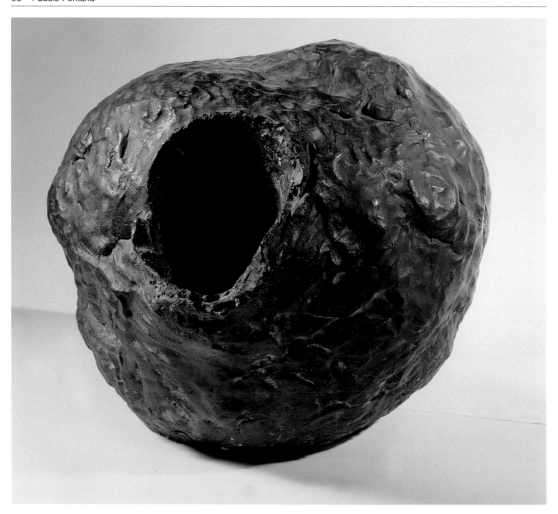

**Lucio Fontana**
— *Concetto spaziale – natura*, 1959-1960, bronze,
cm 70 × 80, Galleria nazionale d'arte moderna e
contemporanea, Rome.

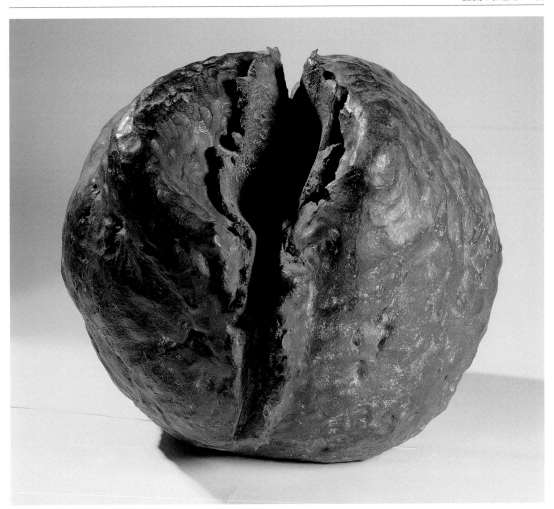

**Lucio Fontana**
— *Concetto spaziale – natura*, 1959-1960, bronze,
cm 57 × 80, Galleria nazionale d'arte moderna e
contemporanea, Rome.

**Hamish Fulton**
— *Twenty eight sticks for twenty eight one day walks from and to Kyoto travelling by way of Mount Hiei walking round the hill on a circuit of ancient paths (Japan 1998)*, 1998, installation, letters and forms in vinyl, approx. 300 × 845 cm, MAXXI – Museo nazionale delle arti del XXI secolo.

"No walk, no work". The British artist Hamish Fulton summarized his work with these words years ago. His work originates in his walks and in a concrete and individual experience of nature. Since the beginning of the 1970s, Fulton has 'walked' thousands of kilometers on five continents. Unlike land artists, he leaves no trace of his passage in the environment. He suppresses any temptation to dominate the landscape. The objects, photographs and texts generated by these experiences have been exhibited in major museums throughout the world, in spite of their apparent simplicity. They are always directly linked to a specific trip. The colors, materials, text and photographs the artist presents are carefully chosen and edited. Fulton remarks: "In this era of communication, we are used to thinking that everything can be transmitted. It isn't so. There are experiences which cannot be communicated". He manages to avoid the pitfalls inherent in representing what is meant to be an intimate and ephemeral experience by combining the tradition of Land Art with a minimalist and conceptual treatment: Fulton distills his experiences. The exhibited work refers to twenty-eight walks completed between 1991 and 1998 around Mount Hiei, Japan. The artist followed a route which Buddhist monks run to test their endurance and self-control in their quest for illumination. The figure that appears in this work is the divinity Fudo, to whom these monks address their mantra. (g.s.)

Born in London in 1946, lives and works in Canterbury.

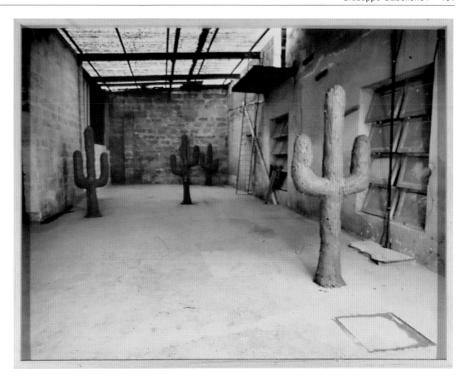

**Giuseppe Gabellone**
— *Untitled*, 1996, color photograph, 71 × 88 × 4 cm,
MAMbo, Museo d'arte moderna di Bologna.

Isolating, camouflaging, displacing. For Giuseppe
Gabellone, making sculpture equates to creating a network
of intellectual and material strategies of which the artwork is
only a final indicator, a fixed element within a flow that
continues to run around it. The fundamental process is
always a form of shifting, of removal from the original
context, of reinforcement of ambiguity, in which the referent
(the preexisting datum, drawn from everyday life or from art
history) undergoes a sort of encrypting or intentional
obfuscation: from "photographed sculptures" to bas-reliefs
that pick up two-dimensional figurative elements, to the
more recent and enigmatic "figures" hoisted onto metal

bases, what interests the artist is shedding light on the
network of conceptual and spatial references within which
the sculpture acquires its meaning (monument, architecture,
modeling, story, abstraction, project etc.), activating a
strategy that simultaneously questions the discipline's past
and its relevance in contemporary space. This series of
photographs can thus be read simultaneously from two
points of view: the conceptual one, with the transposition of
a sculptural element (three clay cactuses) from three
dimensions to two and thus the passage from object to
image, from single "original" to serial multiple, and the more
properly figurative one, in which the iconic plants become
elements of an enigmatic imaginary landscape. (s.c.)

Born in Brindisi in 1973, lives and works in Paris and Milan.

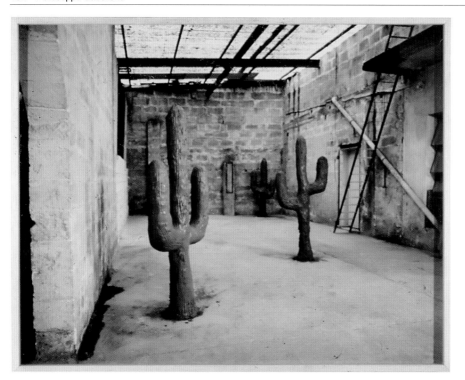

**Giuseppe Gabellone**
— *Untitled*, 1996, color photograph, 71 × 88 × 4 cm,
MAMbo, Museo d'arte moderna di Bologna.

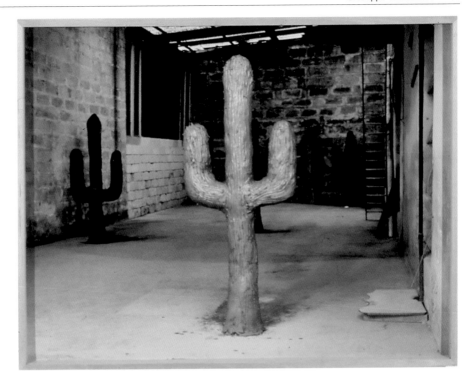

**Giuseppe Gabellone**
— *Untitled*, 1996, color photograph, 71 × 88 × 4 cm,
MAMbo, Museo d'arte moderna di Bologna.

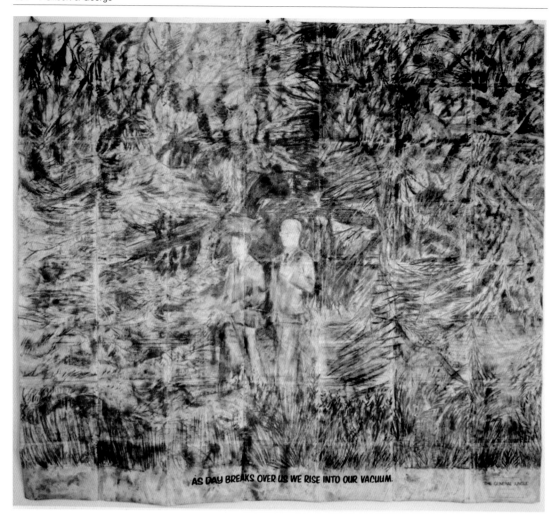

**Gilbert & George**
— *As day breaks over us we rise into our vacuum*, 1971,
charcoal on canvas-backed paper, 280 × 315 cm.
— *Nothing breath-taking will occur here, but...*, 1971,
charcoal on canvas-backed paper, 280 × 225 cm.
MAXXI – Museo nazionale delle arti del XXI secolo.

Charcoal-sketched, almost life-sized, two figures
impeccably dressed in suits and ties stand out against a
background of trees and greenery; a caption at the bottom
reads: "As day breaks over us we rise into our vacuum". In
another panel, the two figures walk along imperturbably,

"with specialised embarrassment", for the sole purpose of
"taking the sunshine". In another charcoal sketch, the two
stand in a frontal pose, with a sense of "looseness", against
the background of a public park where, predictably, as the
caption of another drawing underscores, "nothing
breathtaking will occur here". The four large monochromes
are part of a cycle of twenty-three charcoal sketches
realized by the British duo Gilbert & George in 1971, taking
cues from one of their series of slides, *Nature Photo-Pieces*
(1971), based on the typical romantic motif of "figures in the
landscape"; image after image, we follow the two artists as
they walk though a London park (the extremely genteel

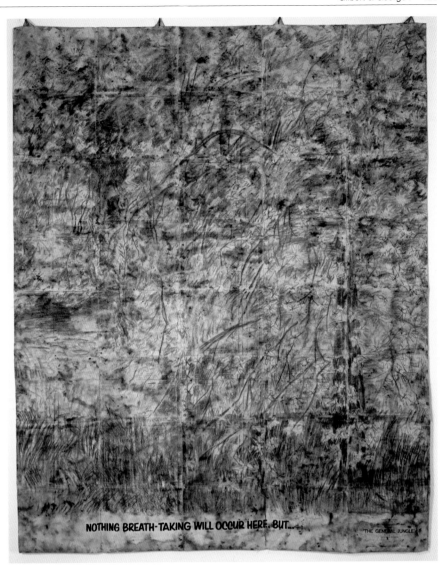

NOTHING BREATH-TAKING WILL OCCUR HERE. BUT...

THE GENERAL JUNGLE

"jungle" mentioned in the title of the series) as they impassively pose ironic questions about art, the artist's craft and his social function. But why "carrying on sculpting", as the title of the cycle states? Because Gilbert & George transform themselves into "living sculptures", as they did in a famous performance of theirs from that same period (*The Singing Sculpture*, 1970), wearing the guise of a normality necessary to "ritualize the horror and the pleasures of ordinary life, somehow making them fruitful", as they would later say in an interview. Treating the utopian ambition of the neo-avant-gardes with their usual and inimitable humor and propensity to broaden the field of artistic experience by overcoming traditional barriers between art and life, Gilbert & George delineate a specific plan of operations in these works: to root their creative process in the vital and contradictory substance of the human condition, forgoing any sort of objectual mediation and transforming themselves into perfect and paradoxical incarnations our era's everyman. (s.c.)

Gilbert Proesch was born in San Martino in Badia (Bolzano, Italy) in 1943; George Passmore was born in Plymouth in 1942. They live and work in London.

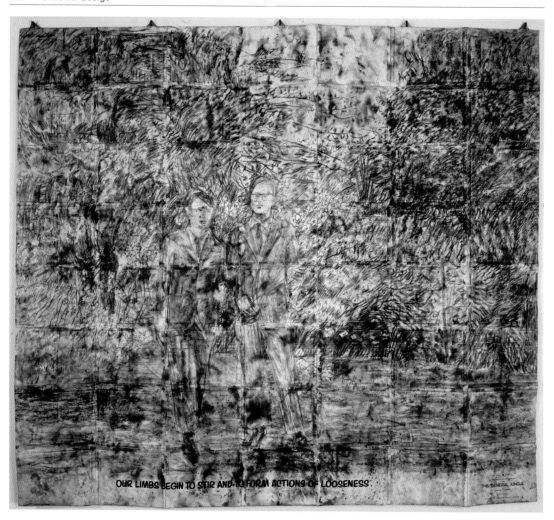

**Gilbert & George**
— *Our limbs begin to stir and to form actions of looseness,*
1971, charcoal on canvas-backed paper, 280 × 315 cm,
MAXXI – Museo nazionale delle arti del XXI secolo.

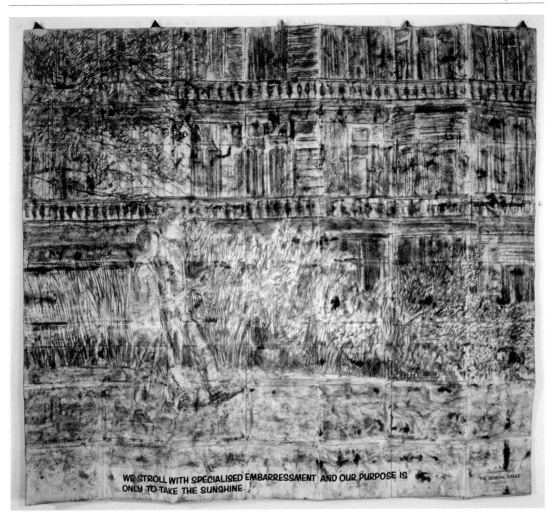

**Gilbert & George**
— *We stroll with specialised embarrassment and our purpose is only to take the sunshine*, 1971, charcoal on canvas-backed paper, 280 × 315 cm. From the series *The General Jungle or Carrying on Sculpting*, MAXXI – Museo nazionale delle arti del XXI secolo.

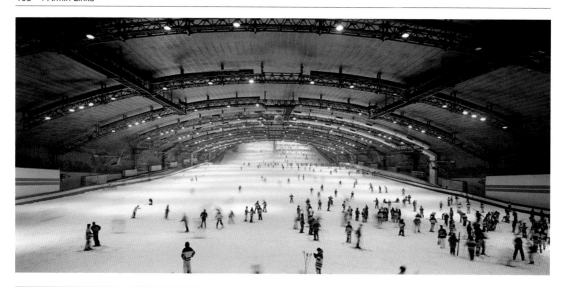

**Armin Linke**
— *Tokyo, veduta dell'interno dello Ski Dome*, 1998,color
photographic print mounted on plexiglas, 150 × 300 cm.
— *Tokyo, veduta dell'esterno dello Ski Dome*, 1998, color
photographic print mounted on plexiglas, 150 × 300 cm.
MAXXI – Museo nazionale delle arti del XXI secolo.

Armin Linke's photographs concentrate on depicting
transformations of contemporary spaces and landscapes in
a global perspective. An indefatigable traveler, over the
years Linke has captured situations that represent great
social, anthropological and territorial changes throughout
the world, often focusing on certain critical moments, from
mass migrations to the phenomenon of climate change,
from megalopolises to new architectural mega-structures to

recent ambitious projects on the Alps and on uninhabited
islands. The result is a body of work that sheds light on the
transformation of the notion of 'place' in our current era, in
which the terms dislocation, de-territorialization and extra-
territoriality suggest a reflection on the individual and the
social dynamics that shape it.
In this dual, interior and exterior view of the Tokyo Ski
Dome, Linke depicts – in his usual panoramic format – the
artificial ski slope built at the city's edge as a mass
entertainment complex. The Ski Dome is a testimony to the
transformation of urban space and the very idea of the
boundary between natural and artificial space, between
reality and its surrogate, in a new experience of place. (b.p.)

Born in 1966 in Milan, where he lives and works.

**Claudia Losi**
— *Arthur's Seat Project*, 1999-2001, embroidery on canvas, woolen felt, 12 pieces,  75 × 190 cm, MAXXI – Museo nazionale delle arti del XXI secolo.

The relationship with the territory is the primary source and object of Claudia Losi's research. Her works include a number of collective, participatory interventions. Most often her projects are based on objects that catalyze energies, relations and memories. Sewing and embroidery are among the artist's favorite techniques, considered as practices strongly tied to time, a sense of transformation and cognitive processes. They are metaphors of the intertwining of ties, stories and cultural sensibilities, and of the possibility "to heal" the traumas and wounds of history.

*Arthur's Seat* is one of her first participatory projects. Produced after the Balkan War, the work consists of a stylized picture of the extinct volcano that stands in the midst of Edinburgh, Scotland. The drawing was traced on a piece of fabric and divided into twelve different pieces. The pieces were assigned to six embroiderers living in Serbia and six living in Kosovo and Albania. Claudia Losi then asked the women to return the newly-embroidered fragments to her, and put them together. The women's names are: Ajshe Bajrami, Zivka Jaksic, Mili Miloti, Luljeta Maloku, Milena Bojanic, Savica Stevanovic, Vasilija Kuljanin, Fatmira Shehu, Sena Markovic, Valbona Koca, Snezana Bozovic, Leze Krasniqi. (g.s.)

Born in Piacenza in 1971, lives and works in Milan.

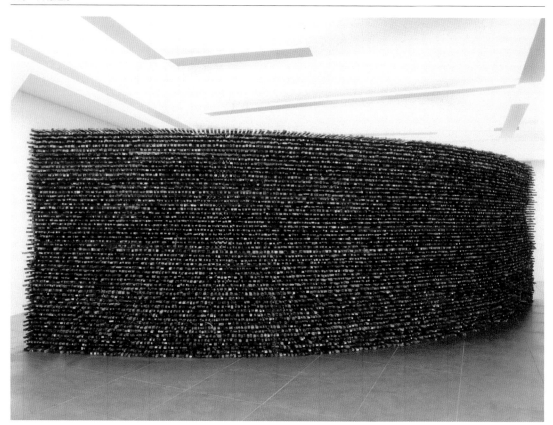

**Nunzio**
— *Avaton*, 2007, burnt and painted wood, 200 × 700 × 160 cm, MAXXI – Museo nazionale delle arti del XXI secolo.

A large, curving wall – coal-black and concave on one side, colored and convex on the other – made of thin wood planks wedged atop one another so as to form a tightly-woven lattice that allows light to pass through it. In this piece, Nunzio returns to the components that have characterized his work since the start of his career: the conception of sculpture as a process of material and psychic distillation, the use of energy-packed materials and forms, the involvement of the surrounding space, and a tension between painterly values and plastic/sculptural development. Combining a formal memory that brings together all the lessons of post-minimalist experimentation and *Arte Povera* with a simultaneous attraction to grand modernist abstraction and archaic and primitive sculpture, over the years Nunzio has honed an instinctive sensitivity for the tactile and evocative qualities of materials, and channeled it towards an increasingly marked involvement of real space, seeking a dynamic synthesis between metaphorical components and plastic tensions. More than a wall or a boundary, *Avaton* is a partition that 'breathes' and sets the space in motion, like the taut surfaces of Baroque architecture, a filter through which a process of passage is crystallized, a slow osmosis between body and mind, between space and energy. (s.c.)

Born in Cagnano Amiterno (L'Aquila, Italy) in 1954, lives and works in Rome and Turin.

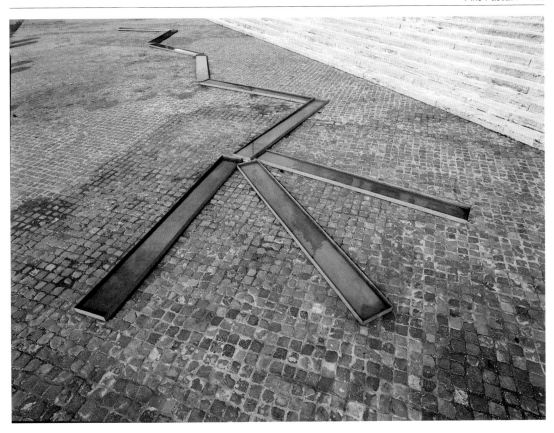

**Pino Pascali**
— *Fiume con foce tripla*, 1968, iron and water, 9 rectangular basins, 6.5 × 337 × 37 cm each, Galleria nazionale d'arte moderna e contemporanea, Rome.

This piece is part of a group of works the artist created towards the end of the 1960s in which primary structures, taking cues from contemporary American Minimal Art, are 'reinterpreted' with elements and references from nature and from pop culture. Hence we have 32 m² of "sea" in large square basins filled with colored liquid, agricultural tools in unfinished wood and rope, dinosaur skeletons in canvas and wood, "silk worms" with heads made of cleaning brushes. The artist, who came from a graphic arts and advertising background, reinterpreted references to the natural and animal world on a monumental scale and with industrial materials, moving into a new dimension of the language of sculpture and installation in late 1960s Italy, in search of new semantic and formal meanings. With a playful, liberated attitude, Pascali's works "reinvent the world", freely and inventively exploring primordial elements of man and nature. *Fiume con foce tripla* is an installation made up of long, narrow rectangular basins that can be virtually arranged in different combinations; the work is a reflection on new boundaries between natural and artificial space, between myth and memory, between originality and standardization. (b.p.)

Born in Bari in 1935, died in Rome in 1968.

**Pino Pascali**
— *Fotografie*,1965, black & white photographic prints on paper, Galleria nazionale d'arte moderna e contemporanea, Rome.

This series of thirty-three photographs resulted from a collaboration between Pino Pascali and Sandro Lodolo (Udine 1929 – Rome 2009), an advertising graphic artist and creator of logos, films and television ads for the RAI national TV and radio broadcaster, which donated them to the National Gallery of Modern Art in 2002. Pascali took the photos in Rome and Naples as studies and visual notes for a 'cavalcade' commissioned by the Lodolo production house, with which the artist collaborated regularly from 1958 to 1967. They show architectural structures and motifs, 'grids' composed of various materials (bricks, wood, stone blocks and slabs etc.) as well as landscapes, seascapes, glimpses of cities (workshops, signs, tools etc.) and, in at least one case, a portrait of the artist himself (presumably taken by Lodolo) dressed as Punchinello. The images are an interesting testimonial of Pascali's research at a crucial moment in his passage from an initial phase influenced by the poetics of pop art to a more mature stage dominated by 'fake sculptures' in archaic shapes and motifs linked to archetypal nature scenarios. (s.c.)

Born in Bari in 1935, died in Rome in 1968.

— *Volo di gabbiani*, 24.2 30 cm.

— *Il mare*, 24.2 30 cm.

— *Passerella sull'acqua*, 24.2 30 cm.

— *Pontile*, 24.2 30 cm.

— *Pontile*, 23.9 30.1 cm.

— *Pozzanghera*, 29.2 29.9 cm.

— *Catasta di mattoni forati*, 17.9   24.2 cm.
— *Passerella di legno*, 23.8   30.4 cm.
— *Catasta di cassette del pesce*, 23.9   30.3 cm.
— *Fontana di piazza del Popolo a Roma*, 23.9   30.4 cm.
— *Sampietrini romani*, 24.2   30 cm.
— *Antica pavimentazione di basolato*, 23.3   30.1 cm.

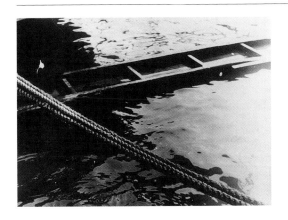

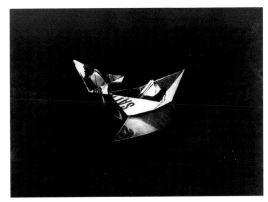

— *Passerella sull'acqua*, 23.8   30.4 cm.

— *Edifici moderni*, 23.9   30.2 cm.

— *Edifici moderni*, 23.85   30.1 cm.

— *Barchette di carta*, 24.2   30 cm.

— Sandro Lodolo e Pino Pascali, *Pino come Pulcinella*,
23.9   30.2 cm.

— *Fiaschetteria romana*, 17.9   24.3 cm.

— *Pane casereccio*, 23.9  30.2 cm.
— *Fruttivendola*, 23.8  30.2 cm.
— *Calzolaio*, 23.8  30.2 cm.
— *Venditore di casalinghi*, 23.8  30.2 cm.
— *Vendita di uova*, 23.8  30.2 cm.
— *Traghetto per Ischia*, 24.2  29.9 cm.

— *Panni stesi, Napoli*, 23.9   30.4 cm.
— *Panni stesi*, 24.2   29.9 cm.
— *Reti di nave*, 23.8   30.3 cm.
— *Reti di barca*, 23.8   30.2 cm.
— *Carrucola di nave*, 23.8   30.3 cm.
— *Carrucola*, 23.9   30.3 cm.

— *Ombrelloni romani*, cm 24.1    29.9 cm.
— *Ombrelloni*, 24.2    29.9 cm.

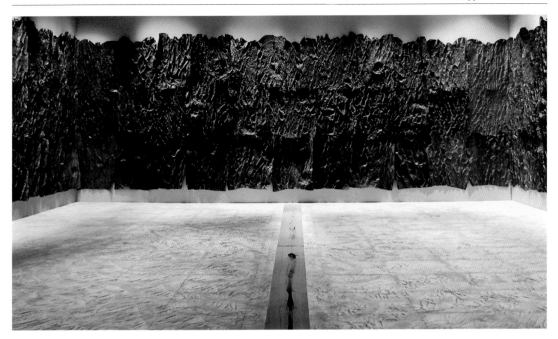

**Giuseppe Penone**
— *Sculture di linfa*, 2007, installation, Carrara marble, leather, wood, resin, room-size, MAXXI – Museo nazionale delle arti del XXI secolo.

*Sculture di linfa* was Giuseppe Penone's installation representing Italy at the Italian Pavilion at the 52nd Venice Biennale, in the Tese delle Vergini dell'Arsenale. The installation is a distillation of the themes and forms the artist has explored in recent years. Since the 1960s, Penone has used forms and materials from the landscape to create works with profound relationships to nature and its elements. His interests include organic processes of development and transformation, the hierarchical forces that connect man and nature, and the possibility of man's interaction with these phenomena. These themes are present in *Sculture di linfa*, a large environment that completely envelops the viewer. Penone sculpted the marble floor to resemble the rough, veined surface of tree bark. The walls are covered in rust-colored leather. In the center of the room, the artist created a totem-like structure in wood with a fissure running down its length containing resin/sap, the vital fluid. (g.s.)

Born in Garessio di Cuneo (Italy) in 1947, lives and works in Paris and Turin.

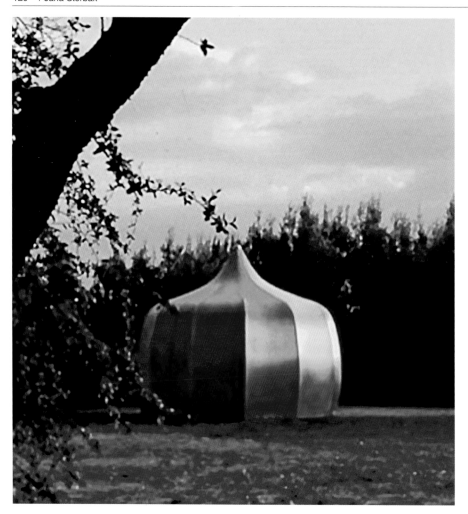

**Jana Sterbak**

— *Faradayurt*, 2001, stainless steel, flectron (polyester coated with copper), 290 × 350 cm, MAXXI – Museo nazionale delle arti del XXI secolo.

Jana Sterbak, a Canadian artist of Czech origins, examines the relationship between the body and space, understood as a physical and social environment. Having focused for years on constrictions related to anatomy, sexuality and feminine identity, Sterbak has more recently concentrated on the way in which the body can be controlled through technology. *Faradayurt* is a cylindrical tent with a cone-shaped ceiling. Its metal structure is covered with flectron, a high-tech material impermeable to electromagnetic waves. The tent marries the traditional and the contemporary.

It appropriates an archaic form that recalls the traditional dwelling of the nomadic populations of Central Asia, the *yurt*, but is constructed using a cutting-edge material. Rather than providing shelter from the physical external world, this refuge protects its inhabitants from a new type of invasive and pervasive pollution, electromagnetic waves. In doing so, it isolates us. The material allows light to penetrate but prevents direct contact with the outside world. *Faradayurt* expresses our era's growing ecological consciousness. It reveals the difficulty we face in defending our autonomy and our inability to control the context in which we live. (g.s.)

Born in Prague in 1955, lives and works in Montreal.

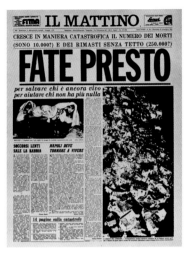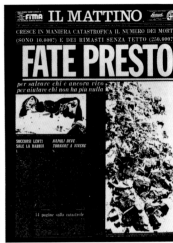

**Andy Warhol**
— *Fate presto*, 1981, acrylic and serigraph on three
canvases, 270 × 200 cm each, MAXXI – Museo nazionale
delle arti del XXI secolo.

The work reproduces the first page of the edition of the
daily paper *Il Mattino* that came out three days after the
Irpinia earthquake of November 23, 1980. The headline, in
very large print on the paper's front page, reads "Fate
presto" (Hurry), alongside images of earthquake damage.
As in earlier works, especially the early-1960s *Disasters*
series, Warhol reproduces a black and white image –
merely adjusting the degree of contrast – from a mass-
media source, using repetition to create a sense of distance
and coldness. The artist was expressly interested in the
idea of 'catastrophe' (collective or individual), in which death
– an element that constantly recurs in his work – is the
central theme. The idea of finite or limited time is reinforced
in this work by the contrast between the dramatic nature of
the appeal "fate presto" and the "too late" of the already-
occurred catastrophe, by a sense of death and tenuous
hope, a hanging in the balance between being and not
being. A "penultimate time" of an end that never stops
ending. (b.p.)

Born in Pittsburgh in 1928, died in New York in 1987.

### Gilberto Zorio

— *Untitled (Colonna)*, 1967, Eternit tube h 260 × 30 cm
diameter, inner tube approx. 80 × 60 cm, Galleria nazionale
d'arte moderna e contemporanea, Rome.

Transformation and recombination of elemental materials,
incessant circulation of energy and a contrast between
force and resistance are the dynamics that have always
defined Gilberto Zorio's work. In this piece, presented in
1967 at his first solo show, a vertically-positioned Eternit
tube rests on an inner tube like a column on its base,
generating a material and conceptual tension between pairs
of opposites: soft and hard, full and empty, heavy and light,
static and mobile. The artist thus juxtaposes the traditional
polarities of classical sculpture, removed from their
historical contexts and re-proposed in the form of a device
stripped of all symbolic or narrative purpose, and the result
is a configuration of great expressive impact. "Energy is the
possibility of rendering the conscious and unconscious
functions of language operational", Zorio wrote in a 1973
statement, and the naked juxtaposition between energy and
materials highlighted in this work can be read as a contrast
between antagonistic forces – historical ones, but also
psychological ones – as well as a visualization of the
generative grammar of the form itself. (s.c.)

Born in Andorno Micca (Biella, Italy) in 1944, lives and
works in Turin.

# Rintala Eggertsson Architects – Cabinet House

Cabinet House is an ecological prototype urban home.

It is based on a new division of space in keeping with the urban contemporary lifestyle; fewer square meters, mostly dedicated to social living space and incorporating a little piece of nature.

Firstly by using wood, secondly by minimizing space and thus amount of construction materials, and thirdly by facilitating the collection of rain water and sun energy, we want to offer a sustainable solution as an alternative to the short-sighted and monotonous production of the building market today. The project is placed in the public yard in front of the MAXXI where it can be viewed not only by Museum visitors but also by casual observers. Our hope is that the house becomes a mediator between this institutional building and the neighbourhood around it, offering visitors a peaceful place to stop in the middle of Rome.

*Sami Rintala and Dagur Eggertsson*

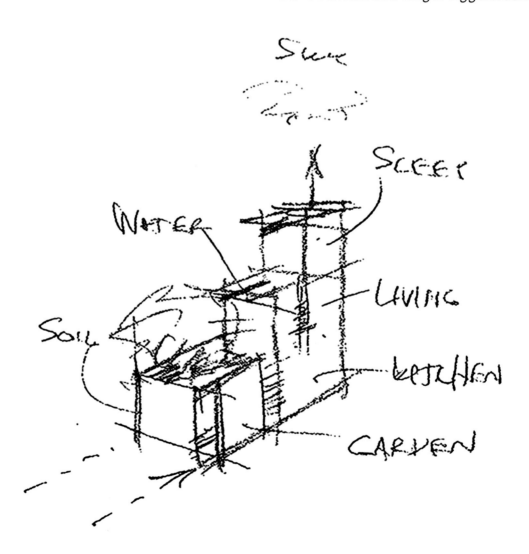

## Rintala Eggertsson Architects

— Sami Rintala defines himself as equal parts architect and artist, and over the years his work has often crossed the lines between the two disciplines. From installations to domestic architecture, from design to 'urban décor' projects, on every occasion his work has been unified not so much by the specific sector of action as by an intense and coherent exploration of the combination of space, light, materials and bodies. What is striking about his work is above all his capacity to grasp the characteristics of a site: the intervention, the work or the artifact produced is always able to serve as a reagent to unveil the physical, mental and conceptual characteristics that unequivocally identify it. To do this, Rintala, today joined by Eggertsson, has on several occasions utilized a language that owes a clear debt to Land Art, although a restriction to this definition would be too limiting.

His work gleans from 'nature' the principle of creating visible order from undifferentiated chaos, that order-giving element that we spontaneously attribute to man or to some unidentified entity. It recalls, for example, what Gombrich so accurately described in his study on the "sense of order": regularity as a mark of intentionality. Intentional regularity, which can at times pertain to natural structures, or to a personal sensibility that tips the scales towards a precise sequence or asymmetries, as in the oriental example which Rintala, through his work, often shows an affinity for.

One of the constants of his work is an uprooting from the ground, a suspended, floating condition, a liquid instability that manages to serve as a conceptual counterweight to a reading of the identity of the place. In his plans, there are huts on piles that seem to move, as well as suspended bridges and floating saunas and houses: the dimension of detachment from the ground manages better than any tectonic massiveness to give an indication of a slight shift in the natural order that creates a notable perceptive fracture. This caesura – almost a sort of arhythmia, at times barely perceptible and at others more substantial – triggers a mechanism of reflection on the state of things, on the order of nature and the order of man. Silence and penumbra are often active instruments of his architectural spaces, at least with regard to their materials and human-scale dimensions, because, as he has declared, "Sometimes a whisper is more powerful than a scream".

When Rintala works on a site, be it a swathe of countryside or an urban context, he truly seems to grasp its most intimate essence: first and foremost, the Scandinavian architect has the gift of being a great listener of the soul of a place, its *genius loci*. Even when it is absurdly identified with the concept of atopy and heterotopy, as in the globalized metropolitan dimension. Rintala's work arouses something absolutely primordial in us, something that seems to have been directly suggested to the architect by the place. Something that brings to mind Susanne Langer's notion of "ethnic dominion", the idea of man's conquest of nature and simultaneous submission to its laws.

It is no coincidence that Rintala uses the term "urban cavern" to define his *Boxhome*, his personal interpretation of the age-old theme of *existenz minimum*, motivated above all by social considerations – the need to reduce living space and its footprint on the ground – rather than by the mere architectural challenge of maximum concentration of functions. A snug space for reflection, in which the city dweller can retrieve a lost sense of intimacy and belonging to a place. Where he can regain a broader sense of the natural: that of a sheltering space and a livable refuge, built by man for man. In keeping with this line of research, Rintala presents *Cabinet House*, tangible proof of a revolution that leads from the theme of nature to that of sustainability, a theme to which no contemporary architecture – if it is truly designed for man and his environment – can be indifferent. (d.d.)

## Cabinet House

### Rintala Eggertsson Architects

Construction team: Richard Barriteau, Toni Karlsson, Jani Rintala, Sami Rintala
Description: 3-storey prototype of a wooden eco-cityhouse system
Materials: wood, stone, metal, glass
With the support of:
The Royal Norwegian Embassy, The Finnish Embassy, Acer – Associazione costruttori edili di Roma e Provincia
Sponsors: ONYX SOLAR ENERGY, S.L., Tuomalan Tekniikka Ltd., iGuzzini Illuminazione Norge A.S. (OSLO), Finnair Cargo Oy

Sami Rintala and Dagur Eggertsson founded the studio Rintala Eggertsson Architects in Oslo and Bodø Norway in 2007. Rintala – the creator of works like *Land(&)Scape* in Savonlinna, Finland (2000) and *Potemkin Park* in Nakasato Village, Japan (2003), combined his experience as an architect and an artist with that of the architect Eggertsson in projects like *Boxhome* in Oslo (2007) and *Ordos 100* in the Ordos desert in Mongolia (2008).

Following up on workshops at universities throughout the world, they have realized life-sized prototypes or installations, such as the Library in Ban Tha Song Yan, Thailand (2009) and the structure *Into the Landscape* (southern Norway). In 2009 they participated in the exhibition *Crossing: dialogues for emergency architecture* at the NAMOC-National Art Museum of China, with their work Graph.
www.rintalaeggertsson.com

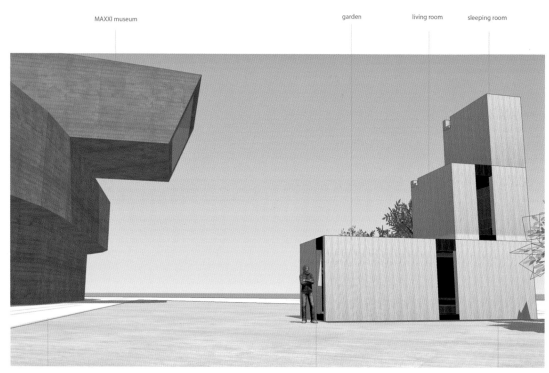

MAXXI museum    garden    living room    sleeping room

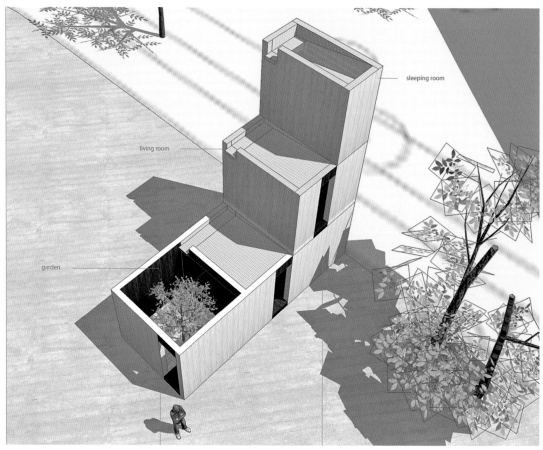

sleeping room

living room

garden

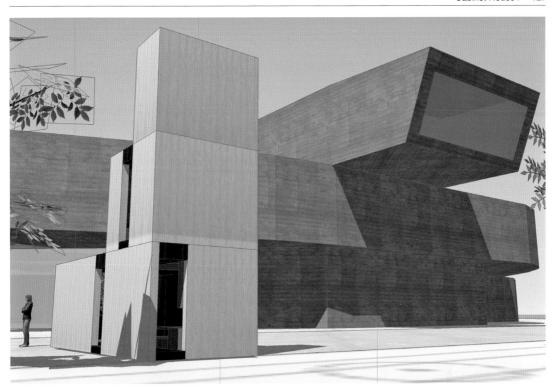

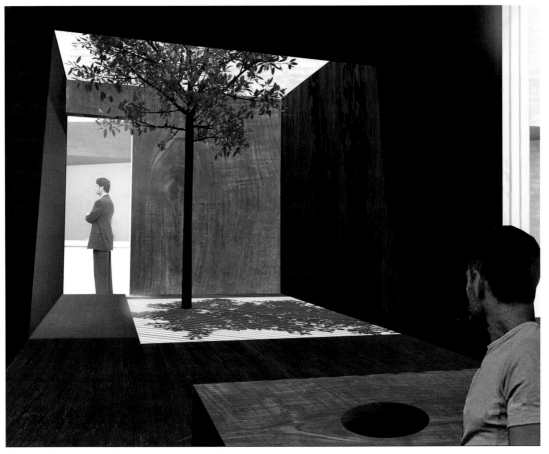

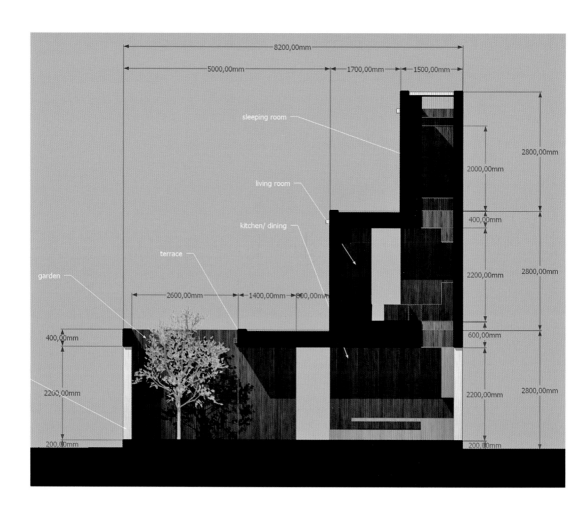

**SECOND FLOOR**

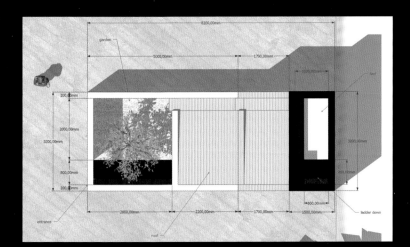

**FIRST FLOOR**

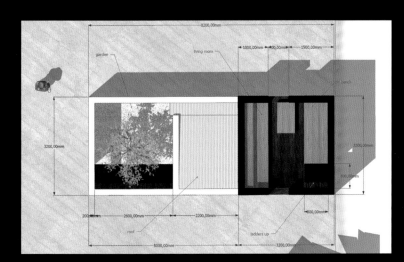

**GROUND FLOOR**

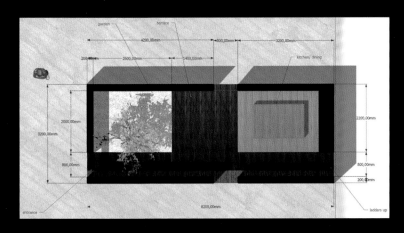

## West 8 – The stolen paradise

With this installation we have created a context for
contemporary art within an illusion of paradise.
This is an illusion built of textile, space, silhouette, texture,
light and shadow.

*West 8*

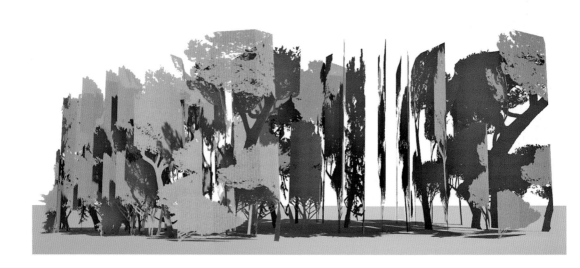

## West 8

— The group of architects, urban planners and landscape architects West 8 takes its name from the wind off the North Sea. Not a hurricane, but a strong wind in Rotterdam, where they have set up their main studio at the edge of the harbor – one of the most visceral characteristics of the environmental context. In fact, the streets of the city are aligned with this wind, and the wind sweeps them clean. A site may be read according to the interaction of natural and artificial factors; identifying these factors is one of the fundamental elements of their design process.

Usually it is architecture that marks a territory, producing landmarks that lend meaning to urban space. West 8 shows that this and other results can be achieved by acting on the landscape and environment. In their projects, the combined activity of different disciplines and of variations in spatial scale is clear, drawing on a wide range of creative experiences, from Environmental and Land Art to urban planning, from industrial design to architectural construction. What emerges is always guided by a fundamental awareness that assesses man's primordial need for contact with nature, but without capitulating to a perceived need to return to a sort of Arcadia where greenery is decoration, or compensation for a broken link with instinct.

The shared, cultural aspect of our conception of nature is equal to and perhaps even stronger than the individual one; a regionalism inherent in the discipline of environmental design and planning. Of Dutch origin – although the collective is now international – West 8 know that natural is not always better than artificial: in their tradition, the manipulation of tremendous natural forces has allowed for the settlement of regions that had once seemed inhospitable and treacherous.

Obviously, the goal of transforming a site, a general location, into a specific address, assumes a knowledge and research of the structure of society that will utilize said place.

West 8's projects always maintain a certain degree of unpredictability in terms of the influence of the context, determined by the active role played by the inhabitants who can colonize the space of the project, and 'must' live it, leaving impressions and interpreting it.

Some elements of their designs encourage an action, and it is left up to the user of the space to choose how to customize it – to live the habitat with awareness, a sense of presence and a feeling of 'being there'. Hence the architects' definition of "narrative spaces" – in the sense of spaces that trigger the narrative of human interaction with the environment, an activity they describe as "optimistic", but also capable of expressing the "vulnerability and euphoria of mass culture".

For the installation at MAXXI, West 8 found itself forced to deal with some key features of the museum space: first and foremost, a carefully planned designer space articulated in a complex arrangement of interiors and exteriors.

Specifically, it is the space of a museum that feeds on the cohabitation and mutual exchange between the arts, intended in terms of the widest possible diversity. On a larger scale, the connotation of the site coincides with the geography of the city of Rome, with its environmental and cultural implications.

The intervention develops the idea of a suspended, floating forest, recreating within the museum the illusion of a paradise, a place of bliss and peace in which to lose oneself (or perhaps to find oneself, in the 'uncorrupted' sense of the term?). Here, in this aerial dimension of heavenly light, this *Paradeisos* – a term used by Xenophon to describe the hanging gardens of Semiramis in Babylon – seems to rediscover its ancient origins.

The light, fluctuating weaves of the tree-shapes evoke a 'naturalness' that is not physical and vegetal, but rather intimate and conceptual, more literary than literal. Emerging from Eden, the illusion of artifice gives way to the concreteness of the emotional and sensory perception of the visitor, called upon to interpret new frontiers of space.

The abstract silhouettes of these trees, then, precisely identify the defining characteristic of the place: they evoke the umbrella pine, an element of the genetic code of Rome and coastal Italy, a tree that captures the essence of the link with the belonging and memory. It is almost a 'textbook' reference, this pine tree, so accurate an interpretation of local, regional references; but also so unexpected in terms of its magical effect of theatrical dematerialization.

The work also includes a turf carpet outside, studded with the remains of cut-off tree trunks from which the essence of the tree seems to have been removed, detached to be moved indoors. This is not a simple one-way migration from outside to inside, but an interplay of cross-references that forces the viewer to perceive the space in its most universal and complete sense. West 8 have always, in fact, dedicated the same attention to open, outdoors space as to closed, indoor space, and their action here seems to highlight the idea that the square outside the museum and the terraces are part of the museum itself.

Meanwhile, the cut trunk, as a strong symbol of the natural death of the plant, is reunited with its lighter part and alters the interior perceptual space.

It is an invitation to reflect on the visible and invisible parts of the things, both the evident, obvious ones and the obscure, mysterious ones, which are no less important just because they are hidden from our gaze. As if to remind us, with a breath of optimism and hope, that there is an inverted tree with underground roots behind what appears to be a sawed-off stump, an unimagined life that continues elsewhere. (d.d.)

## The stolen paradise

### West 8

Adriaan Geuze, Matthew Skjonsberg, Francesca Sartori
Material: fabric
With the support of: The Royal Netherlands Embassy

The West 8 studio was founded in Rotterdam in 1987, with the collaboration of Adrian Geuze with Edzo Bindels, Martin Biewenga, Jerry van Eyck and Theo Reesin, landscape and urban architects.
Their projects include: the *Borneo-Sporenburg Bridge* in

Amsterdam (1996), the *Sund Garden* in Malmö, Sweden
(1999), the *Simcoe Wavedeck* in Toronto (2008); the
Jenfen/Amburgo residential complex (Gold Award in the
International Urban Landscape Award competition, 2010).
Recently, West 8 has created a site-specific installation for
*Contemplating the Void: Interventions in the Guggenheim
Museum*, an exhibition at the Solomon Guggenheim
Museum in New York.
www.west8.nl

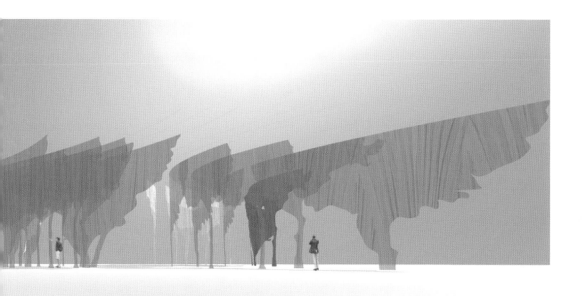

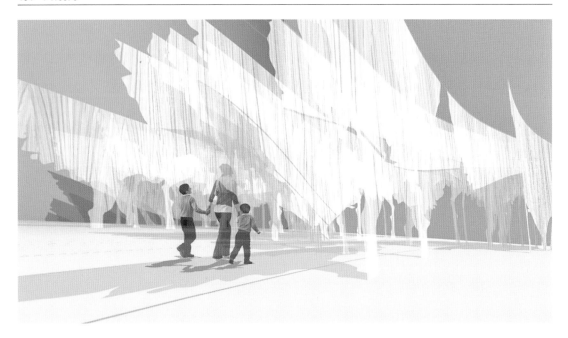

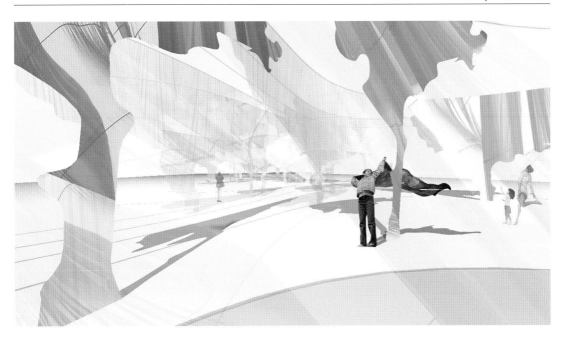

# From the Body to the City

# Spheres of Intimacy

Marco Belpoliti

The word 'intimacy' comes from Latin; it is the superlative of *interum*, interior. During the Middle Ages, the word was used to indicate what was "located inside the soul"; later, it came to mean that which is most secret or hidden. But eventually the term came to indicate the nature of a relationship between people: an extremely close friendship, always and in any case with a clear spatial significance. Indeed, the sense called upon to define intimacy, in terms of what one perceives or does not perceive, is sight. The sphere of intimacy is that which is not subject to the visual scrutiny of other people's gazes, and is inaccessible to others in general.

Sociologists have described two thresholds of sociability: the upper threshold, defined by the formality of social relations, and the lower one, constructed by intimacy, or by something personal and subjective. However, this intimacy, defended by modesty and even shame, is not a rigid structure, but rather something variable. Georg Simmel, one of the first analysts of intimacy, defined it an historical construction that varies according to social group.

In one of his essays dedicated to the description of the "circumstantial paradigm", Italo Calvino makes an interesting observation. For the Mehinacu indians, a Brazilian tribe of hunters accustomed to deciphering the slightest clues or tracks while hunting, the notion of privacy is almost non-existent, with evident disadvantages for the sphere of intimacy. These skillful hunters are capable of discerning the mark of a heel or a buttock in a spot where a couple stepped off the trail to have a sexual encounter, just as they can spot lost arrowheads that divulge a preferred hunting ground, and no one can enter or leave the village without being seen. To converse privately in this tribe – says Calvino, citing an anthropologist – one must speak in a whisper or murmur, but no straw hut wall can truly guarantee secrecy. Thus in the village there is a continuous buzz of malicious gossip about impotent men, or premature ejaculators, or the behavior of women during coitus.

This primitive tribe seems terribly similar to our contemporary societies, founded on the cult of intimacy but inimical to that same intimacy, and to the space necessary for creating good relationships with others. Video cameras, recorders, mobile phones, photo cameras and webcams scrutinize us without our permission every day, or, on the contrary, we expose ourselves willingly to that invisible and pervasive glass eye or electronic viewer. But let us take things in order.

Modernity

Let us return to Georg Simmel and his observations about intimacy. For the German philosopher and sociologist, modesty is the primary guardian of this space, a form of "opposition" to violation of the norms that protect the sphere of intimacy. In modern societies, discretion is the essential tool for maintaining a balance between exterior, social space and interior, personal space. Discretion is presented as a sort of one-way street, an opening granted by the Ego or Self to allow the possibility of an encounter without encroaching on those spheres in which "each person is truly with himself". When this innermost place is invaded, it is due to lack of sensibility regarding the differences that govern human relations.

In modern societies – Simmel asserted in 1908 – there are ambivalent processes in operation, which on the one hand protect individual intimacy, and on the other necessarily expose it to violation. Fashion is one of these two-faced processes: on the one hand, it encourages differentiation – however fleeting – through dress or clothing, but on the other, since items of clothing are not one-of-a-kind but are produced in (albeit limited) series, they define a style in which the individual identifies and thus loses him or herself. Identity and dis-identity are the two poles of this movement that celebrates the defense of the personal sphere, down to the level of intimacy *tout court*, but also calls on individuals to homologize themselves, to adopt a shared style or taste.

Simmel wrote these words at the beginning of the twentieth century. At that time, the fundamental institutions of Western society – family, church, school, professional associations etc. – constituted a solid base for distinguishing the sphere of intimacy from that of public relationships. The German sociologist also observed that for most people at that time, sexual love threw open the doors to the entire personality, allowing entry into individuals' spheres of intimacy; for a significant number of people, it even appeared to be the only form through which to express one's total Self.

However, Simmel also noted that there are reserves or caches of the personality, which he identified as the sphere of intimacy, that "lie beyond the erotic". Friendship is one example, due precisely to the lack of vehemence and uninhibited passion present in sexual love. "Friendship", he wrote, "can be seen as a way of overcoming the isolation of the soul to a greater degree and more lastingly than

erotic passion". Simmel also noted that modern man had too much to hide to maintain a friendship in the ancient sense of the term, and that except in youth, personalities seemed too highly individualized to allow for full and reciprocal understanding.

### Friendship as Intimacy

Siegfried Kracauer, who dedicated several essays – written in the early decades of the twentieth century but still relevant today – to the sentiment of friendship, differentiates friendship from comradeship and fellowship. The latter are sentiments that grow between men and women who do something together. They are not based on spiritual affinity, inner attraction or intimacy, but rather on something practical, a shared purpose, usually work, or a practical situation, or even an imminent danger that brings people together with a concrete bond. This does not mean that relationships between colleagues or comrades cannot develop into friendship, but in order for this to occur there must be a subjective, and no longer solely objective harmony.

"Friendship entails a spiritual act or emotion", Kracauer wrote in 1919. Today, we put the same idea in terms of psychic activity, as we – perhaps wrongly – find the word "spirit" outmoded, and we live under the dominion of "moods" or "states of mind". In 1985, a few years before his death, Andy Warhol, one of the major interpreters of contemporaneity, published a volume entitled *America*, in which he wrote: "In America, everything always starts with moods". Politics, art and all aesthetic behaviours were interpreted by the American artist on the basis of effects produced by changeable moods, induced by transitory states, but also the product of our own dramatizations of ourselves. "I've always thought politicians and actors really summed up the American way", Warhol wrote, noting their capacity to look at various pieces of themselves and choose the one best suited to show to others in a given situation. And that little piece of their personality "may be smaller and less interesting than the whole personality, but it's the piece everyone wants to see".

Does "mood" dominate in friendship as well? However all-encompassing and absolute it may be, particularly in adolescence, the sentiment of friendship nonetheless presupposes self-awareness and a capacity to withdraw into oneself – a form of

intimacy. Psychoanalysts maintain that "moods" often indicate a lack of interior stability; they are the effect of the absence of internal self-images, and thus expose individuals to infiltrations from the external world around them, which have an almost total influence over them. If true and lasting love is possible only for people with a strong awareness of their own personalities, friendship is a slightly different matter, given that it feeds on immediacy.

Without immediate, and at times even ephemeral, pleasure – and this is an important detail – friendship does not last long, especially between adolescents. It needs a spiritual connection – we are already friends, we do not become friends – and yet it feeds on a continuous passion: in true friendship, liking comes before intellectual compatibility. The case of adult friendship is different, as it is based on harmony as well as on the positive impulse evoked by liking, an inscrutable yet decisive feeling.

While friendship boosts the spirit, it nonetheless has two absolute enemies: jealousy and envy. Different but akin, these two emotions are real destroyers of the communion formed by friendship, unless envy changes into admiration and jealously gives way to a further form of love, in which passion evolves into a solid bond. Friendship often reaches a peak: two people are best friends, devoted to one another, and then suddenly the friendship fades. Tiredness, reciprocal irritation, depletion. Overexposure, or a sense of surfeit with no inner confirmation. At that point the friendship-passion ends, or falters, and it is best to suspend relations, to separate. Friendship is a form of symbiosis, and like love, can be snuffed out when one friend becomes too absorbed in the other, or on the contrary, when one excludes the other. One can even become sick over friendship, as over love. And depression is now one of the most common causes – and consequences – of the break-up of a romantic relationship.

Among the most widespread forms of friendship, Kracauer wrote, is one he defines as the "Sunday friendship": people who, due to life experiences (work, profession, various types of choices) have drifted away from one another, but later find one another and pick up their relationship again (think of how important Facebook has become in this regard). The reciprocal influence common in spiritual and erotic friendship is minimal in these cases. These friends seek comfort in one another, escape from routine, warmth denied them in everyday relations, even with family members. This type of friendship leaves

people unaltered, and does not change them through reciprocal sentiment. The bond is based not on a view towards the future, but on the past: a backwards-looking intimacy. This type of friendship seeks to temper the sense of uncertainty that tends to be predominant in our society, and fulfills the "needs of the heart", i.e., those needs that do not cut to the deepest aspects of the personality or bring them into question, but rather reassure them. This is probably another example of those "moods".

### Intimist Society

At the end of the 1970s, as Richard Sennett wrote, the public man was replaced by the private or intimate man. As Andy Warhol had foreseen, celebrities appeared on the scene who, in the eyes of the general public, were gifted with superior personalities because they were able to publicly reveal and show their emotions: a form of intimacy in public and with the public. This occurred at the moment in which television was becoming the main instrument of communication, and public dialogue was being supplanted by the function of the spectator: the capacity for judgment decreased as the passive force of the witness-spectator grew. What matters, Sennett wrote, is no longer what one does, but how one feels after having done it. Narcissism has become one of the dominant psychic experiences of the new era. This new type of intimist society makes individuals "artists without an art". The charismatic leaders who emerged in America and in Europe were those who were able to nullify any idea of distance between their own feelings and impulses and those of the audience that listened to and followed them. Attention shifted to "motivations", and this distracted followers from "evaluating actions". In this context, "the private sphere works to the detriment of the individual and society". "Charisma", Sennett wrote in a compelling turn of phrase, "is a psychic striptease". The public's attention is focused on the leader's tastes, his private or intimate sphere is revealed, his loves and passions discussed, and thus attention is diverted from the concrete problems of everyday life, abiding by a policy of image-making first introduced by the Hollywood star system.

A perfect example of this policy of intimacy is Richard Nixon's famous 1952 Checkers speech, soon thereafter imitated by all

politicians. To deflect public resentment over the news that businessmen had paid money to back his election, Nixon shed tears before millions of television viewers – not for long enough to give the impression of lacking self-control, but just enough to show he had a heart and was a trustworthy person. The exhibition of private, intimate emotions in the form of crying was the key to his success at that difficult moment. Nixon talked about his wife's dress and declared that he loved dogs, and that in fact he owned one, whose name – Checkers – he mentioned as if he were a member of the family.

Sennett maintains that from that era on, and culminating in the 1970s, the private sphere was transformed from a social resource into a form of tyranny, due also to the advent of the culture of narcissism. Now, individuals are led to consider control over one's self, one's own body and one's own mind to be more important than the control that might be exercised over the outside world, and over others. Others appear as mirrors of the Self, something Warhol would have understood perfectly: "I'll be your mirror". Moreover, sentimental tones have become of primary importance, and the first consequence of this is that the images of one's own and of the others' feelings counts more than acts that are effectively carried out. The Self now seems to be centered on "motivation", a Self completely commensurate to its own instinctual life. The very phenomenon of localism that spread at the end of the 1970s in the United States and then in Europe is, according to Sennett, a result of this tyranny of the private sphere: community against society. The American scholar asserts that idolatry of the private sphere keeps us from utilizing comprehension of the phenomena of power as a guide for political action. Thus resentment has become the feeling most fostered by the new policy of intimacy.

### Resentment

Resentment is the dominant mood of our era. More and more often, individuals feel a sort of animosity towards others, and towards the world in general – grudge, animosity, hostility, hatred, enmity, envy, maliciousness, acrimony, malevolence, bitterness, vendetta – in response to offenses, affronts or frustrations to which they believe they have been subjected.

Resentment and rancor are synonyms. Rancor comes from the Latin *rancor*, "lament, desire, request", and, as the Argentine psychoanalyst Luis Kancyper notes, has the same root as *rancidus*, "spiteful", but also "stale" and "lame". When we are wronged, what strikes us is the pain, the affliction it causes; the immediate reaction is fear, accompanied by anxiety, but often a state of depression as well. If the wrong has to do with the moral sphere and involves an outrage or an insolence, reactions such as rage or ire are aroused. In the ensuing process of rumination, of continually going over the incident in one's mind, these two emotions are transformed into rancor and resentment.

Rumination is the act of repetitive, compelling thinking through which people nurse their rancor; ruminate comes from the Latin *muginari*, to sway back and forth, a repetitive movement of thinking and rethinking about a single event. Resentment, on the other hand (in Italian *risentimento*) has the root *sentire*, meaning to feel, thus becomes "to continue to feel, to feel again"; that is, to incessantly go back to one's emotional state, with no possibility of definitively putting the offence or wrong behind one. Psychologists maintain that the deepest root of resentment lies in envy. Why him and not me? This is the main, and perhaps the only question that envious people ask themselves. According to the Slovenian philosopher Slavoj Žižek, envy is something more, or something less, than the desire to possess what someone else has, be it wealth, love or power: it is a "negative", a desire to keep the other person from possessing it. In one of his books, the philosopher recounts an emblematic little story. A witch says to a farmer: "I'll do to you whatever you want, but I warn you, I'll do the same thing twice to your neighbour!". And the farmer, with a sly smile, responds: "Take one of my eyes!". Žižek, after Jacques Lacan, asserts that the true opposite of egotistical self-love is not altruism, or concern for the common good, but rather envy. Or resentment, its twin brother, "which makes me act against my own interests".

In a famous passage from his *Confessions*, St. Augustine tells of a child envious of his baby brother nursing at their mother's breast: "It could not yet speak, but it turned pale and looked bitterly at the other baby sharing his milk". According to Lacan's theory, man is motivated by a desire for the Other: the child who envies his little brother does not envy the fact that the Other possesses the object of desire – the mother's breast – but rather the way in which the Other

is able to enjoy this object; thus it would not be enough for him merely to obtain possession of it, but he must also destroy his rival's capacity to enjoy it. This perverse sentiment, which poisons all forms of intimacy, is part of the triad of envy, avarice and melancholy, three forms of being incapable of enjoying an object, and at the same time vicariously enjoying this very same impossibility. Today, envy is considered a social sin, and hence worse than jealousy, which is considered a venial sin, a sort of unpleasant accessory to amorous passion. The psychoanalyst Leslie H. Faber maintains that while envy is a sentiment involving two actors, me and you, jealousy involves three: me, her and him. Faber considers jealousy to be more destructive to personal relationships because it obsessively brings together increasingly greater parts of reality, pushing the drama towards certain ruin, as innumerable novels and films narrate.

In reality, envy, from which resentment arises, is far worse than jealousy. In a passage from one of her essays from the 1960s, *Some Questions on Moral Philosophy*, Hannah Arendt speaks of human wickedness and writers who have given us portraits of great villains. These literary masters, like Shakespeare and Melville, tell us little about the nature of evil, and yet, Arendt underlines, they show us that deep down, in the most malevolent characters of their stories – Iago in *Othello* and Claggart in *Billy Budd* – "we always find desperation associated with its inseparable companion: envy". This connection between radical evil and desperation, the German philosopher continues, had already been made by Kierkegaard, but the reference to envy is particularly interesting. There is always an aura of nobility around a great malefactor, but Iago and Claggart commit evil out of envy for those who are their betters. The Fathers of the Catholic Church asserted that envy is linked to calumny and avidity, and evolves from pride, the first of the seven capital sins. Envy comes from *in-videre*, to glower at, with an evil eye: the envious person is one who does not see well.

In Christian doctrine, as two scholars of Medieval studies, Carla Casagrande and Silvia Vecchio, note in *I setti vizi capitali. Storia dei peccati nel Medioevo* (*The Seven Capital Sins: the History of Sins in the Middle Ages*), the envious person sins without pleasure: his sin is a woodworm that gnaws at his insides, an internal rust, a putrefaction of thought. Hence its close kinship with rancor, which recalls something that has gone bad, something rancid, an acrid and disgusting odor: a virulent emotion.

A psychologist hosting a radio show recounts that a listener calling from home once defined rancor and resentment in this way: "it's like taking poison and then waiting for the other person to die".

Hannah Arendt wrote of desperation that the sense of being lost pushes one towards wickedness, and envy is seen as a possible way out, a chance to aggressively re-establish one's diminished and offended Self. Thus, says the Germany philosopher, it is mediocrity that most readily produces wickedness, refuting the great moralists' Luciferine and seductive idea of Evil. For Arendt, Adolf Eichmann is an example of substantially mediocre evil. Psychoanalysts, like Melanine Klein in her *Envy and Gratitude*, have delineated a far more infernal scenario than that described by the Church Fathers. Klein links the emotion of envy to the death wish, an innate destructive force. In her view, envy begins with the relationship between a newborn and its mother, and contact with the mother's breast, the dispenser of nourishment and of pleasure; in this situation, the baby feels both gratification and envy.

John Berger writes that in the modern world, advertising – that great driver of consumerism and unequalled economic force – works through envy: the desire to be envied by others. And it goes even further: it makes people envious of themselves, of what they could be if they purchased that product, in a form of reification of the self. In fact, advertising does not talk about objects, but about social relations; what it offers is not pleasure, but happiness measured from the outside, against the yardstick of other people's judgment: "The happiness of being envied is *glamour*". No other word so perfectly renders the contemporary condition of active intimacy, a new concoction of envy and resentment, which fuel consumerism but also dispense bogus forms of shame.

The driving force behind advertising and fashion is the fascination generated by envy – a tenuous envy, certainly, but envy nonetheless. So has an unseemly emotion thus become one of the engines of social change? Are we being increasingly transformed into objects of ourselves thanks to envy? According to sociologists, consumerism, ostentation and the need to augment our buying power – merchandise and hyper-merchandise, as they are called – lead to dissatisfaction, obsessive forms of withdrawal into ourselves, which in turn produce the malady of resentment, the real infection of the contemporary private sphere. The shame of not achieving success, of not having attained the notoriety propagandized by our showbiz-

obsessed society – Andy Warhol's fifteen minutes of fame – leads to forms of rancor that pass through all levels of the social fabric and often find convenient scapegoats – foreigners, migrants, Rom, anyone different etc. – to vent on, thus feeding instincts that the process of civilization has so unstintingly sought to contain and direct through various social instruments.

Resentment thus appears to be the result of the continual struggle for self-affirmation, which is one of the most characteristic traits of contemporary society. Individuals today demonstrate an increasing incapacity to bear the massive doses of frustration necessary to the reproduction of the social system. In *On the Genealogy of Morality* Nietzsche wrote that resentment is the malady of emotions in modern societies, in particular democracies, which overturn the aristocratic and elitist morale of the pre-Christian era. Democracy and socialism – legitimate offspring of the "religion of slaves", Christianity – foster resentment and make rancor the very driving force of modernity.

Perhaps it is no coincidence that the very word – "resentment" – entered into the modern vocabulary through a sixteenth century legal brief entitled *Dialogue du Français et du Savoysien*, which spoke of the aristocracy's discontent over the access the middle classes and the nouveau riche had to noble titles. In the end, writes Stefano Tomellieri, resentment is the sentimental condition of those who have desired something at length but have failed to obtain what they aspired to, and now feel that what they had dreamed of will never come true. Resentment, for this reason, is truly a poisoning of the contemporary soul.

Rancor appears in the form of "a demonic prisoner" which carries on its eternal scheming, imprisoned within us, fueling inextinguishable angers, kept alive by our own desires. The demon ruminates, mulls, constantly chews over the same cud, as if the moment of definitive digestion will never come.

Kancyper asserts that this emotion is linked to the dimension of time, differentiating between two types of memories that impact the private sphere: the memory of pain, which persists over time through resignation, and the memory of resentment and rancor, which "becomes entrenched and feeds on the expectation of future revenge". For this reason the psychoanalyst sees a link between resentment and the death wish, "the repetitive and insatiable compulsion of vindicatory power". It is based on the principal of

Bibliography

For the etymology of 'intimacy' see the *Dizionario Etimologico della Lingua Italiana*, by M. Cortellazzo and P. Zolli, Zanichelli, Bologna 2008; the essay by I. Calvino, "L'orecchio, il cacciatore, il pettegolo", published in "La Repubblica", January 20-21 1980, can now be read in *Saggi*, vol. II, ed. M. Barenghi, Arnoldo Mondadori, Milan 1995; G. Simmel's writings on the theme of intimacy are collected in the volume: *Sull'intimità*, ed. Vittorio Cotesta, Armando Editore, Rome 1996. Essays on friendship by S. Kracauer can be read in the volume *Sull'amicizia*, Marietti, Genoa 1989; A. Warhol's *America* was translated into Italian with an introduction by A. Mecacci and published by Donzelli Editore, Rome 2009; R. Sennett wrote about intimist society in the final chapter of his *The fall of Public Man*, where he recounts Nixon's televised speech. *I'll be your mirror* is the title of a collection of interviews with A. Warhol published after his death, but the phrase is his. On resentment: the book by Argentine psychoanalyst L. Kancyper, *Il risentimento e il rimorso*, Franco Angeli, Milan 2003; see also S. Tomelleri's *Identità e gerarchia. Per una sociologia del risentimento*, Carocci, Rome 2009. S. Žižek has dealt with this subject in several books, in particular in *La violenza invisibile*, Rizzoli, Milan 2007. By H. Arendt see *Some Questions on Moral Philosophy*, which deals with the question of evil and desperation, with literary examples. Citation from C. Casagrande and S.Vecchio's *I sette vizi capitali. Storia dei peccati nel Medioevo*, Einaudi, Turin 2000, the definitive book on the subject. By M. Klein: *Envy and Gratitude*. For more on all of these themes, see my *Senza vergogna*, Guanda, Milan 2010; and on artistic themes see my volume *Crolli*, Einaudi, Turin 2004.

"torment", a calamitous thought, as one of the Argentine psychoanalyst's patients called it, in which cholera becomes the only outlet for inner torment. The rancorous person possesses an implacable memory, cannot forgive others or himself, and shares many traits with the person who suffers from a sense of shame: he is confounded by the memory of a past from which he is unable to distance himself. The person suffering from this sentiment lacks the capacity to relive, and thus make sense of, an offense to which he has been subjected, to filter it through his own experiences; he never lets go of the memory of frustration, but continues to feel the sting of the narcissistic, Oedipal or fraternal offenses he cannot or does not want to forget or forgive.

With resentment as with shame, the figure of "remorse" makes an appearance, the continual self-gnawing under pressure from a specific, repetitive emotion, fueling the desire for new vendettas aimed first and foremost against the resentful person himself.

Kancyper emphasizes that remorse is quite a different thing from hatred; while remorse promotes a regressive and sadistic cycle, hatred can induce a centrifugal motion of the libido. Making reference to the Freud of *Instincts and their Vicissitudes* (1915), he maintains that hatred is not the negative of love: hatred has its origins in self-preservation impulses, while love originates from sexual impulses. Hatred thus has nothing to do with sexuality, but can easily be transformed into resentment, thus taking on an erotic character in the perpetuation of this emotion's sado-masochistic aspect.

# Intimate, Profound Habitation

Maurizio Vitta

Until now, modern city planning culture has been dominated by the principle according to which habitation should be a problem of architecture. This principle should be reversed: in reality, it is architecture that sets itself up as a problem of habitation. This radical reversal hinges on the concept of "intimacy", which thrusts itself into the heart of the experience of habitation, identifying it from a more humanistic than technical viewpoint, made up of stories, cultures, sentiments, behaviors and aspirations that cannot be reduced to simple distributive or compositional criteria.

The twentieth century debate around the question of living structures translated the sociological and economic lexicon adopted from political analysis to unravel the collective knot of the "house" into architectural terms: it was mass society that imposed the problem, which architecture interpreted in the figure of the "habitation", organized according to the rules of scientific objectivity and embodied in typological diagrams, functional values, economic hierarchies and ergonomic schemas. What prevailed was the pure spatiality of living, expressed in a perspicacious syntax of functions and roles, and translated into 'forms' molded by a reasoning by which the occupant was nothing more than a variable of the planning theme, a social category or a 'type' of commissioner. Without a doubt, this was a utopian and generous impetus: the cultural matrix of nineteenth-twentieth centuries architectural thought is rooted in the fertile terrain of civil progress, collective redemption and economic development always anchored in individual dignity. This is quite evident in the theoretical elaborations that set the ethical statute of architecture and design between the nineteenth and twentieth centuries: the debate that arose over the new tasks of modern architecture highlighted the sincere desire to provide the democratic maturation of industrial and mass society with a residential planning capable of guaranteeing decorous living conditions for all. However, it is equally evident that the debate halted on the threshold of the problem. At the very moment when, in a society engaged in a laborious development, the experience of living assumed the awareness of a stable form of existence, a model of relations and a definite and inalienable identity, the culture of urban planning/design on the one hand allowed the problem of the "house" to remain framed within the juridical logic of the pure "right to habitation", which left it firmly in the administrative category of the construction industry, and on the other hand relaunched it in a strategy of formal

development that exalted its monumental, plastic presence in the territory with a marked insistence on style, image and language.

This led to a progressive separation between 'interior' and 'exterior' architecture. While the 'outside' of the building was vigorously inserted into history as a field of visual experience continually renewed and rich in meaning (affirmation of the architect/designer, declaration of aesthetic canons, uninterrupted experimentation), the 'inside' tended towards rigidity in a static functional diagram (traditional organization of spaces, regulation of kitchen and bath facilities, anonymity of roles) that repeats schemas widely accepted even in times of profound cultural and social change. If nothing else, this explains why attention to architectural interiors was progressively entrusted to other disciplines (interior architecture and design), which took it over not by delegation (as under the auspices of modern planning philosophy at the time of its birth), but according to completely independent criteria and modalities. And the split was even more radical than it seems: not only did it bring an end to the long-standing yen for organic qualities on the part of modern maestros, who would have liked to make the architectural artifact spring from its internal conformation (although they also expressed themselves mainly in purely spatial and functional terms), but it also nipped in the bud all the questions that the theme of the interior had begun to raise, beginning with the close relationship (barely hinted at in Wright) between architectural interior and living behavior. It is thus from this split that we must pick up the thread in order to individuate not only new planning protocols that are more attentive to the experience of living, but also a different cultural configuration within which to identify the correct relationships between architecture (and design along with it) and this experience.

The point of departure is again the concept of 'interior', the origin of the split. In strictly architectural terms, the interior is defined in its irreducible spatiality. It falls within the functional dialectic between 'inside' and 'outside', and is described using the oppositional rhythm of pairs: closed/open, opaque/transparent, entrance/exit, public/private. But this is only the literal translation of the behavioral options that lie at the basis of the simple concept of 'habitation': in its lexicon we find only models of usage destined to be repeated without variations. The 'experience of dwelling', on the other hand, is presented as an event in constant metamorphosis. It spreads out over time, develops in a continually renewing historical dimension,

and is consigned to changeable chronologies. The interior living space in which it takes place is not expressed in simple dimensions, proportions, juxtapositions or distances; it contains them, but transcends them; it appropriates them, but re-elaborates them incessantly according to individual strategies. In practice, it is an omnivorous and totalizing experience. It develops in space and time, but the space is that of sensation and emotion, and the time that of memory and projection into the future, all converging in a fluid present that flows continuously and imperceptibly. It is on the basis of this elementary consideration that the concept of 'intimacy' can be viewed as a boundary line between architectural space and living space. Certainly, these two families of spaces coexist, and in most cases overlap with one another to the point of coinciding. Nonetheless, distinct marks of a hierarchical relationship remain: the architectural space, once it is inhabited, must yield its primacy to that of the occupant, who not only alters it to meet his needs (distances, nearnesses, frequency of use, preferences, maintenance), but also molds it according to his own perceptions, inclinations and existential perspectives. It is here, within this re-elaboration of the domestic interior, that we find the figure of intimacy. It is worth nothing that the Latin *intimum* is the superlative of the comparative *interior*, and hearkens back to that which is most interior, hidden and secret, in both the spatial and psychological senses (if not even the ontological one, since for Thomas Aquinas, being *est magis intimum et profundum in re*). This lends the word an almost spiritual dimension, i.e. the dimension of 'profundity', which cannot be reduced to laws but is capable of being loaded with symbolic energy and feeding on memories, aspirations and reflections of the self. In the dizzying perspective of profundity, the habitation first and foremost sees its structural concreteness fragmented into an uninterrupted line of tiny events, the uniformity of which (habits, instincts, customary uses) does not exclude variability, but dissolves into a haze of situations, leaden or gilded, thrilling or stifling, from which the dwelling experience gathers its fundamental energy. But beyond this, when the dwelling event has insinuated itself into the most hidden folds of existence, the descent into profundity seems even more dense and definitive: it is the moment of the subject's total identification with his habitation, a moment that is not necessarily positive or exhilarating, and is in fact often negative and melancholic, but is always, in one way or another, vital, decisive and absolute.

The architectural sphere dealt with the question of the domestic interior at the start of the twentieth century, around the same time when developments in psychology and psychoanalysis delineated the concept of the 'unconscious'. But there was no connection between these two areas of research: the former, based on industrial and sociological motivations that made livability the primary objective, reduced the problem to the notion of a comfortable, salubrious and rational 'interior' under the juridical label of 'private'; while the latter put the domestic interior into the sphere of subjective psychic experience, working on its dream dimension and linguistic manifestations. The theme of our everyday relationship with spaces and objects, which, although apparently marginal, shapes the most complex and tortuous contours of our personalities and their presence in the world, has been neglected in both cases. Certainly, there are gaps in the idea of the unconscious even in psychoanalytical thought – it is, after all, an unknown that only as a hypothesis guarantees the theory's footing. "We approach the Id by comparisons", Freud noted; and Jung observed on this point that "we never got beyond a sort of 'as if'". But perhaps it is the very indeterminacy of the concept that makes it so useful in defining dwelling and its intimate profundity.

In this tangency between architectural outline and psychoanalytical outline, there is no hidden intention to develop a sort of psychoanalysis of dwelling. The attempt made by Gaston Bachelard in his day had the merit of bringing the problem to people's attention, but never went beyond the irksome illustration of a sociological 'type', i.e. the middle-class habitation far from the city center and pervaded by patriarchal tones. The concept of profundity that emerges from Bachelard does not go beyond purely spatial bounds; in practice, it is sought in antique wardrobes or in the bowels of basements. The intimacy of dwelling goes much further. It cannot be found in the occupant's simple gestures or sentiments, nor in the habitation's objects or spaces. Rather, it must be sought in the points of contact between the psychological universe and the object universe. It is in the direct exchange between these two worlds that the interior and exterior of dwelling confront one another, cancel one another out, meld or simply fit together, translating into a closed dialectic between interiority and exteriority, subjectivity and objectivity or, even more profoundly, into a 'hearing' that becomes 'feeling', a 'representing' 'to represent' itself.

First and foremost, naturally, is the occupant's body, the source of every living experience, invariant in all its variations, anthropological constant in which even the Cartesian *cogito* dissolves in the primeval union between history and nature. However, we must look for the deep meaning of this centrality not in the definitions of an already-structured theory, but in the ambiguities of mythographies. An anecdote from Aristotle recalled by Heidegger says that Heraclitus, surprised by some unexpected visitors who came to render him homage as he warmed himself by the fire wrapped in a shabby cloak, invited them in with no embarrassment, saying "The gods are here as well". In this episode, the experience of dwelling is embodied in the body of the occupant, who establishes it not in the living space or the iconography of its structures, but in the elemental reality of the subject's vital and irreducible presence in the world. It is this minute presence, the focus of an intensely-experienced 'milieu' on which the occupant bases all possibilities of identification, that makes dwelling into an event, a transcendent experience, an absolute truth.

This is where architecture comes to life, not as simple 'construction', but as a manifestation or epiphany of something that irradiates from the occupant's body into the space, but continually returns to – or must return to – that body to strengthen the original pact. It is telling that the figure to which the origins of architectural practice hearken back is Daedalus, who mythology notes was the inventor, among other things, of the plumb line and the compass; the former is an instrument of rootedness to the terrain, of structural equilibrium, of verticality as a living, recognizable presence, and the latter a device of progressive appropriation of space beginning from an indispensable center point to which we always return. These two figurations, which in the nebulosity of legend become eloquent symbols or poignant metaphors, show the truth of dwelling in its conceptual essentiality, as a pure graphic layout in which architecture finds its first, decisive point of contact with life.

From this perspective, there is no temptation of a mystical nature; the "gods" of which Heraclitus speaks are merely the expression of a radical humanity. Nor can we evoke the late-Romantic nostalgia that pervades Heidegger's notion of "Four-fold" between sky and earth, humans and divinities, in which the essence of dwelling should be defined through its connection to a "place". This vision is completely secular: it has to do with history and with the fragility of a human

being engaged in defining his position in the world through the space he occupies, which architecture is called upon to interpret and delimit in an emission of energies, instincts, desires and plans that focuses on the human subject and is distributed through the space.

Architecture's encounter with the intimacy – 'the profundity' – of dwelling is thus actuated in the bond between the architectural space and the subject, where the complex interweaving of relations between the occupant's experience (will, inclinations, models of use) and the objectivity of the structure is realized. The occupant holds the destiny of dwelling in his hands: he becomes its changeable, erratic center, insisting on every point of the living area and letting his own vital energy flow into it, so that the simple geometric outline of 'interiors' – edges, volume, dimensions – become individual figurations in what has been defined as the "space of life", animated by the deep current of empathy that connects it to the perceiving subject. But this space is not empty. Within the shell of the house, it is destined to be populated with objects, mute but expressive presences, which, in their simple collection, distribution and arrangement, impose themselves as attentive and watchful interlocutors of a dialogue that makes dwelling into an uninterrupted narration. In the end, the inhabited space is an Aristotelian space: it exists inasmuch as it is saturated with things that reveal it. Thus the shape of the things becomes the shape of the architectural space at the moment in which the occupant appropriates it and absorbs it into his intimate sphere.

From a purely technical perspective, this is the moment at which architecture gives way to design. But with a difference: while architecture entrusts its own space to the occupant, design accompanies him in dwelling and offers him a range of choices, as well as guidance and confirmation as he makes them. Gio Ponti interpreted this difference when, in his *Guida alla casa adatta*, he spoke directly to the occupant: "Say goodbye to the builders... At this point you will come in, with your furniture (but we'll talk about that again later), with your objects (but we'll talk about that again later), with your colors (but we'll talk about that again later), with your memories (but we'll talk about that again later), with your cultural interests... And with your dreams, whims and hopes...". His insistence on that "we'll talk about it again later" is an offer to open a dialogue: the furnishing of a house sanctions a certain measure of intimacy, and in this, design is proposed as an auxiliary, a

collaborator or a guide. Thus it is design which, in terms of the planning sphere, reaches the maximum limit of an intimacy that is entirely entrusted to the occupant from that moment on. In the universe of spaces and objects that constructs and completes the process of living, an empire of forms, images and representations is established, and there are subtle dialectic arguments between the self and others, between the individual and the group, between the Self and the World and even – or perhaps first and foremost – between the subject and the self reflected in that very universe, which constitutes the most intimate nucleus of everyday human experience. This is the truth of 'profound' dwelling: a dimension not hidden in secret recesses, but on the surface of everything, in the manifestation of every gesture, in the extension of every space.

It is here that, if we consider the psychological substance of the dwelling experience, the process of "individuation" described by Jung is prolonged and perhaps completed. For Jung, "individuation means becoming a single, homogeneous being, and, insofar as 'individuality' embraces our innermost, last, and incomparable uniqueness, it also implies becoming one's own *Selbst*", that is to say, "one's self", or, in a not fully comprehensive translation, one's "integral personality".

In short, the reality of habitation targeting is fully identified in the reality of the occupant; and in this coincidence, architecture and design play a complex role of mediation. In effect, in the occupant's absolute control over the living process, which consists of giving shape to the spaces and things as much as he gives shape to himself, the presence of those same spaces and things remains in any case exterior, objectified, immersed in a reality that is not the subject's. The everyday experience of living regularly reproduces the encounter between the Self and the world, between consciousness and phenomena, between the *res cogitans* and the *res extensa*: a fruitfully dialectical encounter, in which the otherness of the habitation takes on a value of reference with respect to the subjectivity of the occupant. From this point of view, the responsibility of architecture and design can be described not as the imposition of a self-sufficient and pre-constituted order resulting from a cultural hegemony, but as a spirited interlocution, a proposal, a sign, an orientation. At this level, dwelling becomes a sort of contract: a reciprocal collaboration pact is stipulated between architecture (the spaces), design (the things) and the occupant, which each party agreeing to develop dwelling practices for its own part, contributing to

a development – an evolution, an involution, it matters little – that coincides with the flow of existence and with the passing of history, in a continually constructed chain of memory and a continually expanding future, in the snarled skein of options offered up by life.

It is at this level that planning culture encounters the profound dimension of dwelling. Certainly, it is not a direct, calculable, measurable confrontation: profundity pertains more to feeling than to perceiving, more to intuition than to reason. It is always present in any habitation, but must be grasped, so to speak, with the corner of one's eye. No discourse, no language can contain it; no plan can configure or predict it. It can be found in the heart of experience as pure possibility, but is revealed as a burst of energy, as the triumph of a vitality capable of unhinging any form of logic, any system, any calculation. "No house is so small that a magnificent occupant cannot make it grand", reads a well-known maxim attributed to Leonardo: the geometric dimension, the exterior "form" of the habitation is destined to give way to the occupant's will to the same degree to which that will must adapt to the possibilities it is offered. The result of this uninterrupted dialectic, in which the roles of affirmation and negation continually alternate, is the complete experience of dwelling, in which the figure of the human subject finally emerges, reflected in the "house" whether he has knowingly molded it in his own image, or has submitted to the will of the "things" of which it is composed.

Against the background of this intense and complex exchange, the dwelling experience unfolds in all its highly developed manifestations. This is the true epiphany of profundity, the enveloping development of an intimacy that involves all its protagonists in a kaleidoscopic, unfathomable vortex. Here, history and nature coexist: the anthropological constants – wakefulness and rest, nutrition and hygiene, affection and passion, socialization and solitude – encounter social and cultural variables – the organization and functional hierarchy of spaces, the qualities of objects, instrumentation and technology – in an amalgamation developed along the axis of time – biological continuum or historical fragmentation. It is a form of consubstantiation without transcendence: existence becomes true in things, and in this becoming true, which no logic of planning will ever be able to touch, lies the ultimate meaning of dwelling – in a small space, in a room, in a house, in the city, in the world.

Bibliography

The citation from T. Aquinas is in *Summa Theologiae*, I, q.8, a.1. For the concept of the "unconscious" see S. Freud, *Introduzione alla psicanalisi* (1915-17), Bollati Boringhieri, Turin 1969, and G. Jung, *L'io e l'inconscio* (1928), Einaudi, Turin 1954.
For G. Bachelard's thoughts on the theme of dwelling, see *La poetica dello spazio* (1957), Dedalo, Bari 1975 and 2006.
The text by G. Ponti, *Guida alla casa adatta*, was published as a promotional material for "Ponti", Eurodomus 3, 1970.
The citation from E. Levinas is from *Totalità e infinito* (1971), Jaca Book, Milan 1980.

It is obvious that architecture and design must not – and how could they, after all? – pursue this irreducible and indescribable moment on which the very essence of dwelling is based. Their cultural statute keeps them contained in a universe of regulations, material equilibriums, functional technologies, in which the subjective option is favored only as a perception, a sensation, a predictable behaviour. But they can place this moment at the vanishing point of their project, pursue it along an asymptotic guideline that takes it to infinity without ever losing sight of it. They can look squarely at redundant elements of planning, not in order to eliminate them as superfluous, but to listen to and question them. The dwelling is one of the most complex manifestations of human nature, due precisely to its elementary truth, its origins at the very dawn of history and culture. As Emmanuel Levinas wrote, "the privileged role of the house is not based on its being the result of human activity, but being the condition for and, in that sense, the beginning of it". In fact, the human being "is not tossed brutally into the world and abandoned. Simultaneously inside and outside, he faces the external world setting forth from an intimacy…". These are the words of the philosopher, and this area of research should certainly include not only the disciplines of planning and design, but also the human sciences, and first and foremost – if, in order to fully understand the dwelling experience, we must grasp its most profound substance and its most exquisitely analogical, transversal, metaphorical aspect – what we call "aesthetics", the only field capable of momentarily capturing its most intimate and profound image, as shiny as a reflection in a mirror, and equally enigmatic.

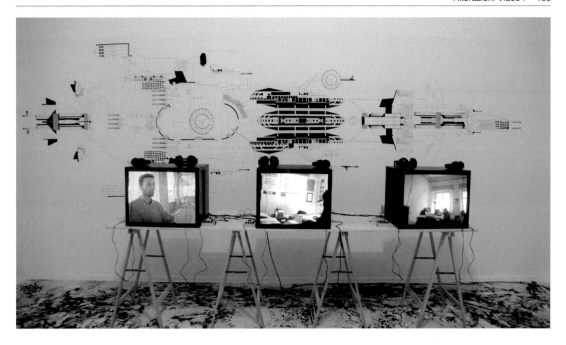

## Alterazioni Video

— *Incompiuto Siciliano*, 2007-2008, installation: three videos, *L'architetto* (43'49"), *Francesco* (19'15"), *Ufficio tecnico* (10'32"), 2008; *Astronave Madre*, digital print on adhesive paper, 2008; two videos, *Intervallo* (3'37"), 2009, *IN/OUT, IN* (7'34"), *OUT* (5'41"), 2007, MAXXI – Museo nazionale delle arti del XXI secolo.

Alterazioni Video is a partnership of artists who investigate the relationships between reality and representation, legality and illegality, freedom and censorship. *Incompiuto siciliano*, an installation made up of video interviews and a wall print, is the result of research on unfinished public building projects throughout Italy. In attempting to identify the common themes of these sites, Alterazioni Video mapped the territory and made an inventory of such buildings. Giarre, Catania, was found to be the area with the highest concentration of such phenomena and was identified as the capital of a true architectural style. At this point the partnership decided to make a paradoxical proposal to the local government: the establishment of a "Protected Archeological Area for Unfinished Buildings". The objective was to encourage a new perspective on these relics and foster new appreciation for an architectural style capable of representing Italy and the era in which the buildings were produced: the stereotype of the *Bel Paese* turned inside out. (g.s.)

The group was founded in Milan in 2004. Members include Paololuca Barbieri Marchi, Alberto Caffarelli, Matteo Erenbourg, Andrea Masu and Giacomo Porfiri.

**Francis Alÿs**
— *Sleepers II*, 2001, projection of 80 colour slides on
35 mm film, duration approx. 2'40", MAXXI – Museo
nazionale delle arti del XXI secolo.

Francis Alÿs becomes a sort of ethnographer in his work.
His projects are firmly rooted in specific contexts and
strongly influenced by urban experience. His work explores
the marginal aspects, contradictions, and isolation of
everyday life in the city. These discoveries give rise to new
sensual journeys, minimal yet emotionally rich stories.
*Sleepers* is a slideshow that alternates between images of
sleeping homeless individuals and dogs. Vulnerable,
excluded, dispossessed of their privacy, the subjects are at
the mercy of passersby. Alÿs photographed them in the
places where they live, in Mexico City, and from the vantage
point of the sidewalk. The result is a critical, but also
harrowing and intensely lyrical work. The presence of these
figures, who we know nothing about, evokes stories of life
and survival. They explore the differences between those
who have a home and those who do not, between those
who live in conventional yet comfortable situations and
those who must face life's challenges every day. (g.s.)

Born in Antwerp in 1959, lives and works in Mexico City.

**Charles Avery**
— *Mirror Piece*, 2005, mirror, frame, drawing pen, 76 cm diameter, MAXXI – Museo nazionale delle arti del XXI secolo.

Charles Avery's style is characterized by a dense series of literary and philosophical citations, and by fantastical improvisations that create paradoxical and surreal scenes and situations in his drawings (the artist's preferred technique). Packed with detail, his style, which recalls the caricatures of 1930s illustrated magazines in the 'unfinished' or sketch-like – albeit meticulous – appearance of the formal compositions, masks the artist's interest in an alchemical and 'pataphysical dimension of reality, which underlines their surreal nature. In the work *Mirror Piece*, the elements of the tarnished mirror – within which the black outline of a figure appears – and the authentically antique frame once again highlight the enigmatic and allusive dimension typical of Avery's work. (b.p.)

Born in Oban (Scotland, UK) in 1973, lives and works in London.

**Vanessa Beecroft**
— *Susanne,* 1996, photographic print, 100 × 100 cm.
— *Tine*, 1996, photographic print, 100 × 100 cm.
Galleria nazionale d'arte moderna e contemporanea, Rome.

Known mainly for art actions in which she utilizes models "choreographed" so as to create *tableaux vivant* in various places and situations, Vanessa Beecroft has always focused on the theme of the loss of identity and de-personalization. Her performances are never theatrical; the models are perceived neither as single individuals nor as actors or personifications, and establish no relationship whatsoever with the audience. They represent 'suspensions of identity' in which the individual becomes an object defined by means of an accessory, be it a wig, a shoe, a skin color or a covering over the face. Highly attentive to the formal compositions of her *tableaux*, the artist feeds off suggestions and references from the contexts in which her performances are realized, thus establishing a strong dialogue with the place. Consideration of the performances' internal structures also underlines the interaction between the models, who co-exist in contradiction with one another: "their beauty, their reference to the past, their immediate realness, their vulgarity, their purity, their compactness as a group, their isolation within the group". In the photos of *Susanne* and *Tine*, Beecroft makes her models wear blonde wigs; the portraits, which recall Andy Warhol's Polaroids, capture the inexpressive gazes of impersonal subjects, focusing attention on the attribute and the adjective while negating the subject. (b.p.)

Born in Genoa in 1969, lives and works in Los Angeles.

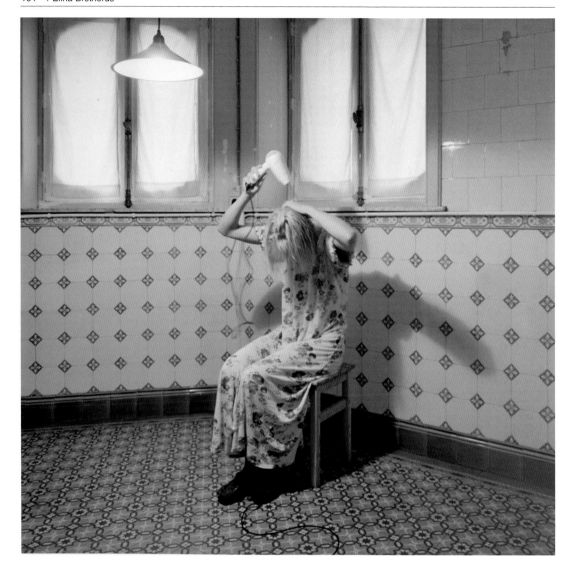

**Elina Brotherus**
— *Le Matin*, 2001, chromogenic color print on paper glued to aluminium,105 × 130 cm.
— *Femme à sa toilette*, 2001, chromogenic color print on paper glued to aluminium, 80 × 66 cm.
MAXXI – Museo nazionale delle arti del XXI secolo.

The relationship between man and his environment is the central theme of Elina Brotherus's work. Hers is a world that springs from a strongly psychological point of view in which rooms and landscapes are understood as references to individual identity. A sense of intimacy and an enigmatic impression of detachment are combined. In her photographs, the domestic landscape and the body seem to vibrate with identical sensations. The domestic space is the space of emotions, desire and the tension between the anxiety of renewal and resistance to change. The body is that of the artist, and her works take on an autobiographical aspect. However, there is no anecdotal element to suggest an exact interpretation of the delicate underlying balances. Although she uses photography, Brotherus's iconographic and stylistic references are rooted in art history. From Claude Lorrain's landscapes and Paul Cézanne's bathers to Pierre Bonnard's interiors, the artist openly states her indebtedness to her artistic forbears. Yet the key to interpreting her work always lies in the reverberations between the subject and the physical location, which is always a mental place as well. (g.s.)

Born in Helsinki in 1972, lives and works in France and Finland.

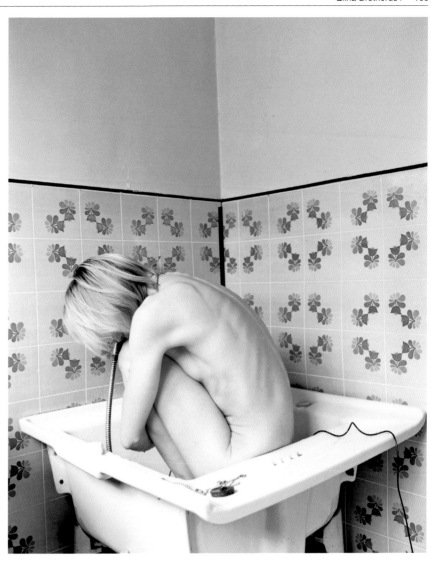

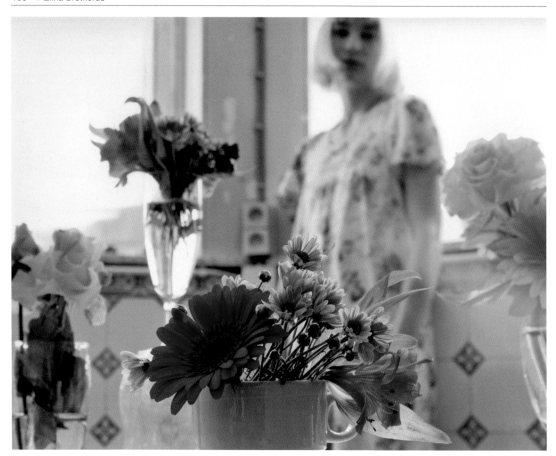

**Elina Brotherus**
— *Fille aux fleurs*, 2002, chromogenic color print on paper
glued to aluminium, 80 × 101 cm, MAXXI – Museo
nazionale delle arti del XXI secolo.

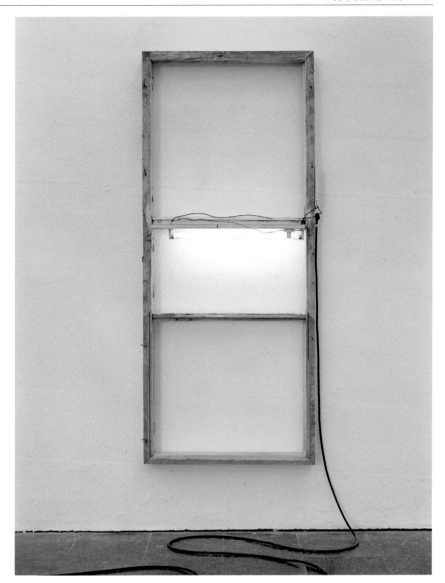

**Pedro Cabrita Reis**
— *Uma luz na janela (A light in the window)*, 2002, wood, enamels and fluorescent light, 186 × 81 × 20 cm, MAXXI – Museo nazionale delle arti del XXI secolo.

Pedro Cabrita Reis has been one of the leaders in the resurgence of sculpture over the last two decades. Although trained as a painter, since the end of the 1980s Cabrita Reis has been creating installations with simple, rough, or recycled materials such as chairs, tables and doors, as well as industrial materials like steel, glass, and neon. His constructive process consists of assembling various objects in combinations that create visual and metaphoric associations. Even when his works use doors or windows, the objects are covered, painted and obstructed in order to render them inaccessible. Although seemingly absent, man is continuously evoked in Cabrita Reis's work. The artist's work is therefore a way of designing space from a formal point of view, while its content is a metaphor more of an existential condition rather than a reference to the outside world. His *Uma luz na janela* is composed of an old window frame with a yellow neon light fixed in the center. The work is a "silent presence", concentrated and profoundly introspective. It implicitly raises questions regarding architecture, interior space, time and memory. (g.s.)

Born in 1956 in Lisbon, where he lives and works.

**Maurizio Cattelan**
— *Ninna Nanna*, 1994, rubble, wood, plastic, approx.
85 × 85 × 135 cm, Fondazione Sandretto Re Rebaudengo,
Turin.

During the night between July 27 and 28, 1993, a car bomb
exploded in Via Palestro in Milan, causing five deaths and
the destruction of the Pavilion of Contemporary Art (an
illustrious modernist building realized by Ignazio Gardella in
1949-1951). Utilizing rubble from the building in this work,
Cattelan has erected a singular memorial, which, without
proposing any analysis of the bombing, imposes its
cumbersome presence and refuses to let it go away. "I had
gotten ahold of some of the rubble and showed it in London

as a sort of postcard of Italy. It wasn't a political work, but a
way of reminding the world about what was going on", the
artist recalled ten years later. The title, *Ninna Nanna*, is a
sarcastic comment on the reaction of Italian society – which
was by no means 'woken up' by the terrorist attack – and
also alludes to the fate of one of the victims, Driss
Moussafir, killed by the explosion as he slept on a bench
near the PAC. Gathering up what the explosion had
dispersed, *Ninna Nanna* emulates the traumatic murkiness
of the incident and imposes it on the spectator in all its
unplaced brutality. (s.c.)

Born in Padua in 1960, lives and works in New York and
Milan.

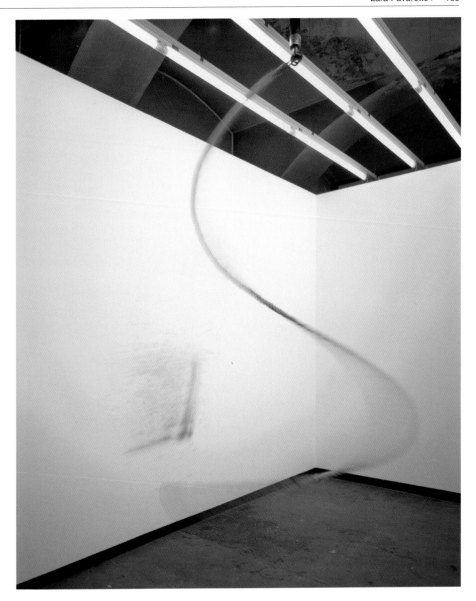

**Lara Favaretto**
— *È così se mi interessa*, 2006, installation: hemp rope, hair, driveshaft, black leather, rope 464 cm long, driveshaft 133 cm high, room-size, MAXXI – Museo nazionale delle arti del XXI secolo.

The rope that constitutes the work hides the artist's hair within it, and its length is determined by the sum total of the dreadlocks (typical Rastafarian braids) she grew and then cut off to create the installation. Attached to a motor hung from the ceiling, the rope moves in an irregular and intermittent circle; hitting one of the adjacent walls, it leaves a dark mark produced by the black leather end of the rope. As in a previous series of her works, the artist explores the space through the measure of her body, whether through the physicality of the weight of confetti blown about unceasingly, or the rollers of enormous colored brushes. Utilizing photography, video, installation or performance, Favaretto explores the personal and collective dimensions in a game of references and suggestions aimed at involving the spectator, in many cases physically as well as intellectually. (b.p.)

Born in Treviso in 1973, lives and works in Turin.

**Carlos Garaicoa**
— *Untitled*, 2004, color photographic print, pins, thread,
120 × 170 × 7 cm, SMS Contemporanea, Siena.

Cuban artist Carlos Garaicoa's work explores the area
between plan and result, reality and desire. In the city, the
artist sees organisms in constant transformation and the
continuous intersection of references, the plots of stories
and memories, the overlapping of individual and collective
sensibilities. The exhibited work is part of a large series in
which the artist photographically documents incomplete
buildings in his native Havana and other cities. He then
completes or reworks the shapes of the buildings by
drawing or using colored thread pinned to the photographs.
The photographs represent concrete reality, while the
thread represents mental design and the projection of
desire. He creates an alternative structure, drawn from the
past or from an imagined future, which is possible or only
dreamed. Garaicoa tells stories of loss or unfulfilled
expectations, but he also explores how the imagination can
intervene when reality is unsatisfactory. (g.s.)

Born in Havana in 1967, lives and works in Havana and
Madrid.

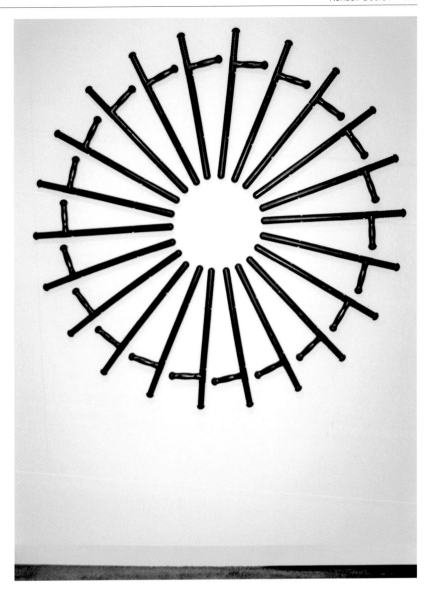

## Kendell Geers
— *T. W. Batons (Circle)*, 1994, 22 batons, edition of 3 exemplars, 150 cm diameter, MAXXI – Museo nazionale delle arti del XXI secolo.

A South African artist raised in Johannesburg under apartheid, Kendell Geers has since the beginning of his career created works with a strong political content, using the instruments of provocation and shock to comment on themes of political violence, racism, abuse of power and gratuitous violence, sex and religion. With a sampling of elements that make direct reference to the situation in question – police batons, barbed wire, broken bottles, police sirens, megaphones – the artist creates installations which, with their apparent formal strictness, surprise the viewer who notes the elements of which they are composed. This is the case of *T.W. Batons (Circle)*, in which anti-riot police batons make up a circular form hung on the wall as a sort of decoration that evokes the tranquility of Zen, but in reality represents the brutality of the violence in power. (b.p.)

Born in Johannesburg, the artist changed his birth date to May, 1968.

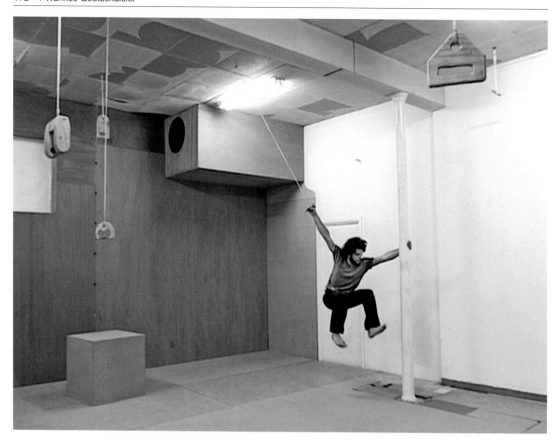

**Wannes Goetschalckx**
— *1 Story*, 2005, DVD, video, 19'08", MAXXI – Museo nazionale delle arti del XXI secolo.

Flemish performer Wannes Goetschalckx's work unites performance and theatre, dance and video art. He creates the environments for his performances, and each object is thought out in relationship to its interaction with his body. Frequently, his work has a playful or 'athletic' quality and reflects on the physical, psychological, and conceptual relationships between the body and space. In *1 Story*, he has designed an entire room filled with various objects constructed from simple materials: ropes hanging from the ceiling, boxes attached to walls, handles and climbing poles. In one continuous action, shot in a slow sequence over about twenty minutes, Goetschalckx climbs on and interacts with the objects, acrobatically moving from one element to the next. In a balancing act which tests the limits of physical possibility, the artist ironically plays with the history of performance and body art. At the same time, his artistic reinterpretation explores the specificity of the space of art. (b.p.)

Born in 1978 in Antwerp, where he continues to live and work.

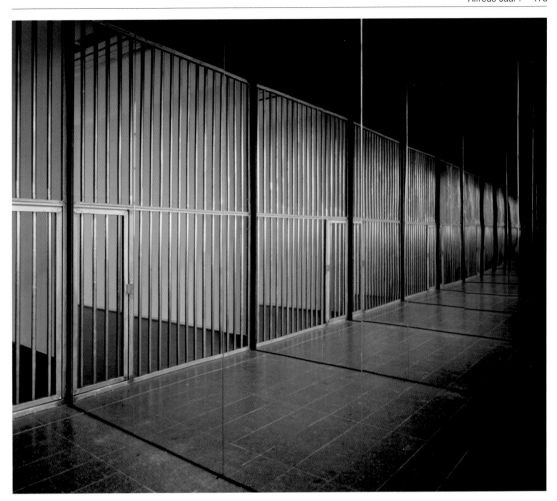

## Alfredo Jaar

— *Infinite Cell*, 2004, steel, painted wood, mirrors, room-size, 525 × 550 × 570 cm; *Twenty years*, 2004, serigraph; *Gramsci (m-n-o-p-q)*, 2009, 5 drawings in India ink on parchment.
MAXXI – Museo nazionale delle arti del XXI secolo.

Alfredo Jaar developed as an architect and filmmaker in Santiago during Pinochet's military dictatorship. He produced works that were explicitly critical of the regime and then moved to New York in 1982. A believer in the correlation between ethics and aesthetics and the possibility of a social and political role for art, he deals with themes linked to humanitarian emergencies, political oppression, and social marginalization, and denounces the media's use of rhetoric to manipulate and transmit information. Jaar appropriates Antonio Gramsci, one of the most influential intellectuals and political thinkers of the twentieth century as a symbol of this effort. *Infinite Cell* is a replica of the tiny cell in which Gramsci was confined between 1929 and 1935, during which time he wrote his *Prison Notebooks*. The cell

is accessed from the front wall. Inside, the two mirrored lateral walls reflect the cell bars infinitely, in an almost baroque fashion. The condition of constriction extends infinitely in space and metaphorically in time.
The installation includes some portraits of Gramsci done in India ink on parchment paper and the serigraph *Twenty years*, in which the length of Gramsci's imprisonment is indicated on a red background. The work is a metaphor for the cage of conventionality that restricts us all. It also explores the separation between culture and society and the dramatic isolation experienced by the contemporary intellectual. On the other hand, the expansion of the space through the use of mirrors alludes to the way in which freedom of thought and intellectual passion can overcome any barrier and survive in even the harshest conditions. In his reference to Gramsci's struggle, Jaar reclaims an active and socially responsible role for thought, art and culture in his attempt to concretely transform the world. (g.s.)

Born in Santiago (Chile) in 1956, lives and works in New York.

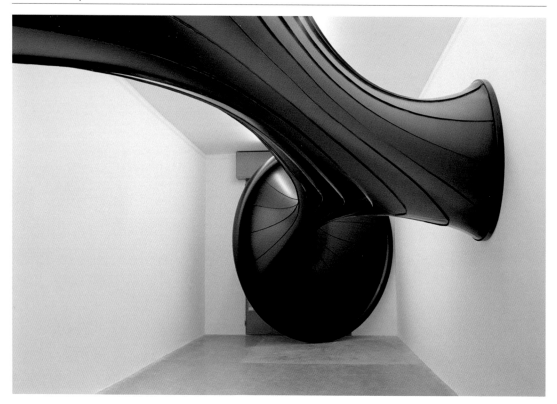

**Anish Kapoor**
— *Widow*, 2004, installation: PVC, steel,
4610 × 14,630 × 4610 cm, MAXXI – Museo nazionale delle
arti del XXI secolo.

With a modeled and visual impact that has made him an
unmistakable presence on the contemporary art scene,
Anish Kapoor's work deals with a nucleus of themes that
have been fundamental for sculpture from minimalism on,
such as the relationship between work and environment,
between visual unpredictability and formal rationality,
between sensation and materiality. His installations are
always conceived in relation to a specific architectural
space or urban scenario, in which they stand as enigmatic
and imposing signs that act at the same time as generators
of forces and 'configurers' of space. In a 2007 conversation,
the artist stated, "I'm interested in a sculpture that places
the spectator in a specific relationship with space and time":
form and colour thus become means for widening and
deepening perception, but also for disorienting it, for
bringing out what does not appear at first glance, the
obscure recesses, the disturbing element, the hidden origin.
Kapoor conceives his works as dynamic devices that reveal
the latent characteristics and tensions of a space, volumes
endowed with their own disconcerting vitality, often alluding
to organic, biomorphic, sexual shapes. The work designed
for the MAXXI in fact resembles a giant 'organ' that has
grown within and on the building, an impenetrable, black,
alien form that moves through the space like a presence
that is both archaic and futuristic. (s.c.)

Born in Mumbai in 1954, lives and works in London.

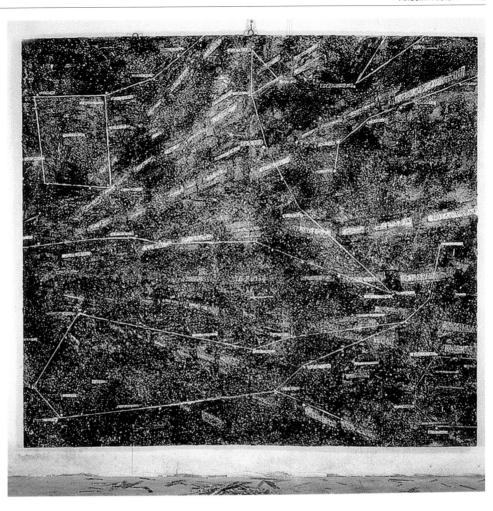

**Anselm Kiefer**
— *Sternenfall*, 1998, canvas, acrylic emulsion, shellac, gesso and painted glass, 456 × 530 cm, MAXXI – Museo nazionale delle arti del XXI secolo.

Fascinated by the expressive power of materials, Anselm Kiefer creates monumental works in which diverse techniques and materials create a powerful emotional impact. Kiefer pursues a personal exploration of history and collective memory in his work. His large canvases, like his sculptures and books, present history as a succession of catastrophes. Man's confrontation with these events constitutes his only chance at cathartic redemption. The

artist has also dealt with thorny issues such as German national identity and history in his work. After moving to Provence, Kiefer began to take on more existential themes like the exploration of the cosmos. *Sternenfall* – the work exhibited here – is a dark sky dense with white falling stars and alphanumeric symbols; at the foot of the canvas are what appear to be lead cartridges. Kiefer depicts the painful stratification of memory in the accumulation of material and junk. The work creates a kind of visionary and hallucinatory tension, a dramatic quality that reveals Kiefer's expressionistic roots. (g.s.)

Born in Donaueschingen in 1945, lives and works in Paris.

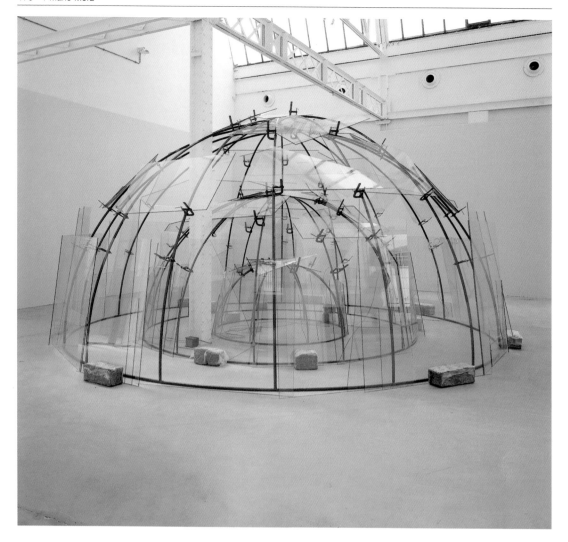

**Mario Merz**

— *Untitled (triplo igloo)*, 1984-2002, glass, clamps, iron, unfired clay blocks, series of blue neon Fibonacci numbers from 1 to 8, individual igloos:  300 × 600, 400 × 200, 200 × 100 cm, MAXXI – Museo nazionale delle arti del XXI secolo.

Mario Merz is one of the most emblematic figures of the *Arte Povera* movement. The series of igloos – one of the most characteristic elements of his work – was developed, beginning in 1968, in very different forms, materials and typologies, intersecting the languages of painting, sculpture, architecture and installation. For Merz, the igloo is both a "world and little house", personal and cosmological, physical and mental space. The hemispherical form is protection, "the right shape to withstand the force of reality itself", a

circular thought in which space and energy are inversely proportionate and in perfect equilibrium (the two halves of the sphere – the visible one and the invisible one). In the dynamic between interior and exterior, permeability and impermeability, an interplay of references is created that underlines its composition between contrasting forces held in place by the tension between opposites.

In this work, three igloos are superimposed on one another, in an interpenetration of spatial planes that dialogue with elements of the surrounding architectural context. Around the iron-and-glass structure, neon Fibonacci sequence numbers run, underlining the energetic and temporal element, while on the ground, blocks of unfired clay mark their circumferences. (b.p.)

Born in Milan in 1925, died in Turin in 2003.

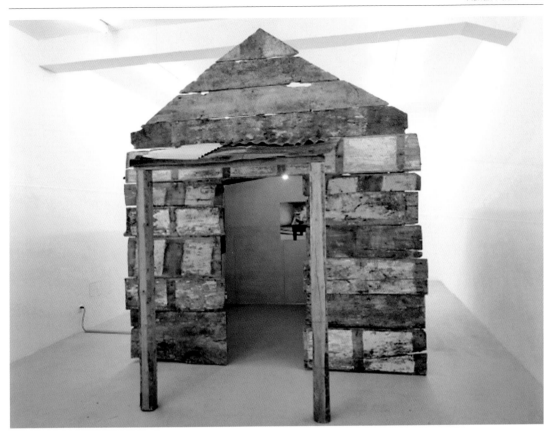

**Adrian Paci**
— *Cappella Pasolini*, 2005, installation: wood, metal, light bulb, acrylic on wood, 390 × 300 × 320 cm, MAXXI – Museo nazionale delle arti del XXI secolo.

After moving to Italy from Albania at the end of the 1990s, Adrian Paci focused his work on his experience of Italian culture in possible synthesis with his own cultural roots, with a reflection on the migrant condition of contemporary man seeking to maintain a delicate balance between different cultural and identity references. *Cappella Pasolini* is an installation made up of a wooden shack that contains a series of paintings of frames and scenes from Pier Paolo Pasolini's 1964 film *Il Vangelo secondo Matteo*. The artist has created a series of works that, through painting, establish an intense dialogue with the director's visual imagery. As he himself declared, "by subjecting frames from his films to my language of painting, I construct pictorial narrations, reversing a process that, in Pasolini's original approach, had begun with painting". In the faces and gazes of the film's characters, Paci finds an ancient but dynamic humanity, simultaneously sacred and profane, playful and tragic, that reconnects him to the culture and life of his homeland. (b.p.)

Born in Shkodër (Albania) in 1969, lives and works in Milan.

**Cesare Pietroiusti**
— *Quello che trovo, quello che penso*, 2010, performance.

Concept and action, subjectivity and association,
conceptual rigor and analytical clarity form the basis of
Pietroiusti's artistic exploration. While his performances
resist becoming spectacle, risk, physical endurance and
emotional strength are fundamental to his work. Cesare
Pietroiusti has created a performance for the inauguration
of *Space* that examines the physical, mental, spatial, and
temporal aspects of isolation. The artist locks himself inside
one of museum's emergency stairwells. During his

confinement, he verbally describes all of the objects he
encounters, including those seen with the aid of
magnification tools. He also reports what mental
associations the objects create in relation to the temporary
condition of isolation and marginality he experiences.
Because it has been conceived for the opening of the
exhibition, Pietroiusti's performance becomes a reflection on
the role of the artist in relation to the institution of the
museum. (g.s.)

Born in 1955 in Rome, where he lives and works.

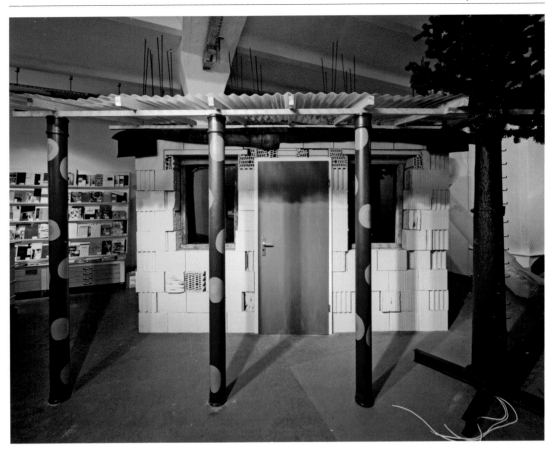

## Marjetica Potrč
— *Permanently unfinished house with cell phone tree,*
2003-2006, installation, clay bricks, steel, PVC, plexiglas,
plastic, wood, MAXXI – Museo nazionale delle arti del XXI
secolo.

Marjetica Potrč is attracted by the haphazard nature of
structures built during periods of emergency and social
crisis. In peripheral urban zones like favelas and shanty
towns, Potrč sees experimentation with alternative housing
models. In these areas housing is built rapidly, cheaply, and
using locally found or recycled materials. The floor plans of
such structures are flexible, easily enlarged and adaptable
to the terrain and to changing needs. In many cases,
homes originally built as temporary shelter in times of
emergency become permanent. The houses Potrč
constructs inside exhibition spaces make direct reference to
structures the artist has encountered during lengthy stays in
areas characterized by this form of architecture. The work
exhibited here is part of a series entitled *Contemporary
Building Strategies*, focusing on the search for solutions to
infrastructural problems. The house is made with recycled
materials and is placed next to a synthetic tree that hides a
mobile phone antenna. There are three columns at the
entrance painted to resemble tree trunks. The trunks allude
to the eighteenth century theories of Marc-Antoine Laugier
who saw the "primitive hut" as the emblem of man's
passage from a natural state to an artificial one. Iron rods
protruding from the top of the house suggest the organic
nature of a structure destined to grow. The fake tree
suggests the pervasive presence of communications
technology and infrastructure even in areas which lack
every other comfort. The painted columns communicate the
tendency to give classical visual forms to contemporary
structures and the way in which nature is represented in
urban culture. (g.s.)

Born in 1953 in Ljubljana, where she lives and works.

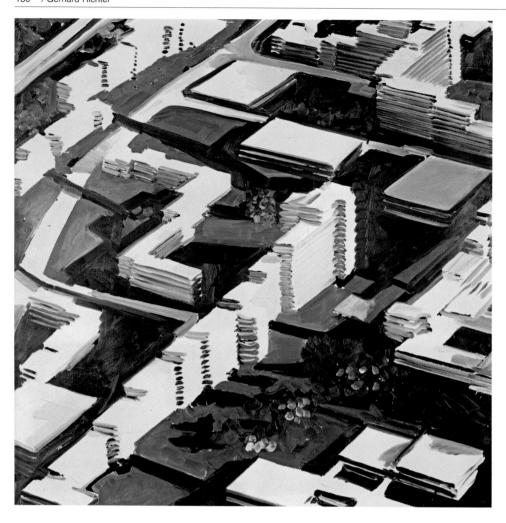

**Gerhard Richter**
— *Stadtbild SA (219-1)*, 1969, oil on canvas, 124 × 124 cm, MAXXI – Museo nazionale delle arti del XXI secolo.

Among the various components of the pictorial language of Gerhard Richter – one of the protagonists of the revival of painting in Europe beginning in the 1960s – photography has played the major role, as exemplified by the monumental work *Atlas*, the vast archive of newspaper clippings and all sorts of images from which the artist has incessantly drawn motifs and inspiration. "Photography", Richter declares, "had no style, no composition, no judgment. For the first time, there was nothing but the pure image. This is why I wanted not to use photography as a pictorial vehicle, but on the contrary, to use painting as a photographic vehicle". In this painting from the series *Stadtbild* (1968-1970), the artist – who as a child had witnessed the destruction of Dresden – was inspired by aerial photographs that ominously recall "the point of view" of Second World War bombardiers. Done with thick strokes in a few tones of gray, the painting depicts an urban zone dominated by squarish, modernist-style buildings and the voids of areas not yet rebuilt, an eloquent summary of the panorama of German cities in the post-war reconstruction period. As Benjamin Buchloh wrote, Richter's work is a reaction to the "crisis of memory" linked both to the specific condition of post-war Germany and to the artist's personal story (he escaped from East Germany in 1961), in which collective denial of history, the repression of the recent past and the irresistible diffusion of photographic imagery in mass society are all factors. (s.c.)

Born in Dresden in 1932, lives and works in Cologne.

**Kiki Smith**
— *Large dessert*, 2004-2005, wood, porcelain, fresh flowers, 850 × 231 × 110 cm, MAXXI – Museo nazionale delle arti del XXI secolo.

A table holds and supports twenty-odd miniature white porcelain sculptures, a group of figurines depicting elegant ladies from a bygone era. They sit or stand, some resting their heads in their hands, and are engaged in various activities. They wear long dresses and have braided hair. Some have dogs sitting on their laps or wear masks. The figures are rooted in the eighteenth century European portraiture of Pietro Longhi and the Sèvres *biscuit* porcelain figurines which once adorned dining room tables. Yet, they also evoke colonial America and the United States at the beginning of the twentieth century. They create an inexpressible sense of nostalgia. In observing them, one has the sense of entering into a rich world that reverberates with a chorus of stories and voices. Since the 1980s, Kiki Smith has explored female identity in a world which is codified and regulated by gender separation. She focuses first on an organic and intimate female identity, and then on the female figure in cultural history, myth and religion. This work examines the historical relationship between women and 'their' environment, the cloistered domestic sphere. (g.s.)

Born in Nuremberg in 1954, lives and works in New York.

**Haim Steinbach**
— *Black and Grey: Pitcher Series*, 1988, ceramic and
Formica, 52 × 61 × 28 cm, MAXXI – Museo nazionale delle
arti del XXI secolo.

One of the protagonists of object experimentation in the US
in the 1980s and of that 'return to the real' that
characterized artistic experimentation throughout that
decade, Haim Steinbach uses his work to reflect on the
nature of objects and their 'display'. Using the 'shelf' as a
linguistic element, he explores the semantic, iconic,
psychological, aesthetic, social and cultural meanings of
everyday objects, which he presents in a cold, antiseptic
manner on colored shelves. In his arrangements, often
realized with the specific display context in mind, the artist
aims to produce in the spectator what he defines as a "state
of psychological anxiety". In *Black and Grey: Pitcher Series*,
two differently-coloured but otherwise identical pitchers are
placed on a shelf which repeats the black and gray colors of
the pitchers themselves, inverting them. In this game of
allusions and inversions in which color and composition
sublimate the object, abstracting it from its functionality, the
artist leads us to reflect on the contemporary meaning of
fetish. (b.p.)

Born in Rehovot (Israel) in 1944, lives and works in New
York.

Marco Tirelli / 183

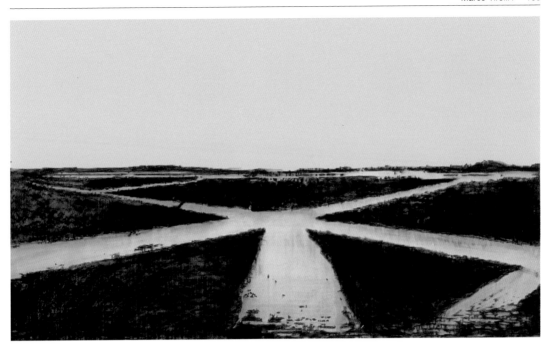

**Marco Tirelli**
— *Untitled*, 2009, charcoal and tempera on paper,
127 × 213.5 cm, loaned by the artist.

Marco Tirelli began his career in Rome at the end of the
1970s in an artistic environment which rotated around the
ex-Pastificio Cerere studios in the San Lorenzo
neighbourhood. The period saw a rediscovered sensuality
in painting and was marked by an affinity for large images
with immediate visual impact and symbolic associations.
After an early phase in which a kind of rhythmic
accumulation of architectural fragments and geometric
forms prevailed, Tirelli moved towards more simplified and
monumental forms. He creates basic volumes which are
isolated and depicted frontally achieving a kind of atemporal
immobilization which combines European geometric
abstraction and De Chiricean metaphysical influences.
His painting is austere and uses just a few fundamental
tonalities (dark reds, black, white and few other colors).
He often creates series of similar works, and he also
crosses the line into figurative work, although as in this
'landscape', he presents an enigmatic skeleton in which the
illusion of depth recalls both photography and abstract
composition. (s.c.)

Born in 1956 in Rome, where he lives and works.

**Rosemarie Trockel**
— *Untitled*, 2000, powdered varnishes on aluminium, 20
electric stove-burners, 172 × 260 × 11.3 cm, MAXXI –
Museo nazionale delle arti del XXI secolo.

It is difficult to classify Rosemarie Trockel as an artist
because she has so many influences and works in various
disciplines. Her work, generally based on appropriation and
physical and semantic shifts, uses diverse expressive
means and can be read on multiple levels. She has
produced a series in which stove-burners are hung on the
wall like paintings. This inversion of use creates a geometric
and abstract effect which ironically echoes trends in
minimalist and conceptual art, leaving intact her reference
to the traditionally feminine sphere – the kitchen – and
gender roles in which women were responsible for nurturing
men at home while men went out into the world to do and
create. Until a few decades ago, the art world was also an
exclusively male domain. Trockel reclaims an essential role
for women in her critique of society, yet does so with humor
and levity. (g.s.)

Born in Schwerte (Germany) in 1952, lives and works in
New York.

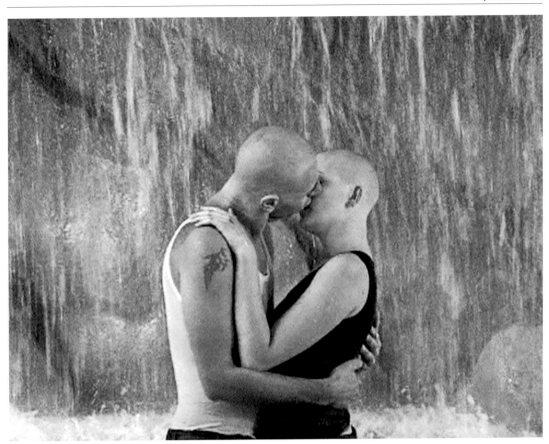

**Sislej Xhafa**
— *Skinheads swimming*, video, 3'40", Accademia Carrara, Galleria d'Arte Moderna e Contemporanea, Bergamo.

In the first light of dawn, in the silence of a sleeping city, two young skinheads immerge themselves in the waters of the Trevi fountain, symbol of the splendor of Baroque Rome and the Dolce Vita. They dance joyously and play with abandon. Conventionally considered to be individuals in conflict with society and their surroundings, here the skinheads represent an innocent and exuberant appropriation of the city and its history. The video is an invitation to alter our perspective and avoid being conditioned by ideological conformism. The work of Sislej Xhafa, who is Albanian and moved to New York after a period in Italy, is based on analysis of cultural and intercultural dynamics. He reveals stereotypes, gullibility and the contradictions of coexistence in contemporary society. The literal and allegorical themes of living underground, of belonging and not belonging, run through his work. His work is often ironic and always critical, yet empathetic. It is based on the mechanisms of dislocation and uncertainty, the friction between languages, and the mixture of 'high' and 'low' culture. (g.s.)

Born in Peć (Kosovo) in 1970, lives and works in New York.

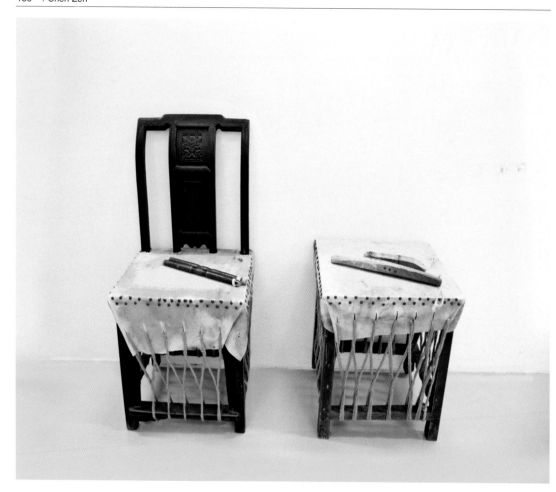

**Chen Zen**

— *Un-interrupted voice*, 1998, chairs, ropes, wood, 95 × 100 × 40 cm, MAXXI – Museo nazionale delle arti del XXI secolo.

Chen Zen lived in China until the mid-1980s, when he moved to Paris. His work is the result of a synthesis of different cultural influences of Chinese spiritual and philosophical tradition with a Western aesthetic, in an artistic vocabulary that presaged the phenomenon of multiculturalism and globalization. Trained with a specific focus on traditional Oriental medical practices – an interest he developed as a result of an illness he endured until his untimely death – the artist incorporated its theoretical premises and physical practices into an aesthetically highly

evocative artistic discourse. *Un-interrupted voice* is indicative of the artist's characteristic line of research that calls for spectator interaction and participation in the work, as in the famous installation *Jue Chang (Fifty Strokes to Each)*, presented at the 1999 Venice Biennale, in which a series of tables and beds hung on an enormous wooden structure were covered with skins that made them into drums visitors could play. Art becomes the instrument through which the artist creates what he defines a "trans-experience": a ritual or therapy which, through interaction with the artwork, allows the user to discover new pathways of awareness and of the spirit, individual and collective. (b.p.)

Born in Shanghai in 1955, died in Paris in 2000.

# Estudio Teddy Cruz – Cultural Traffic: from the Global Border to the Border Neighbourhood

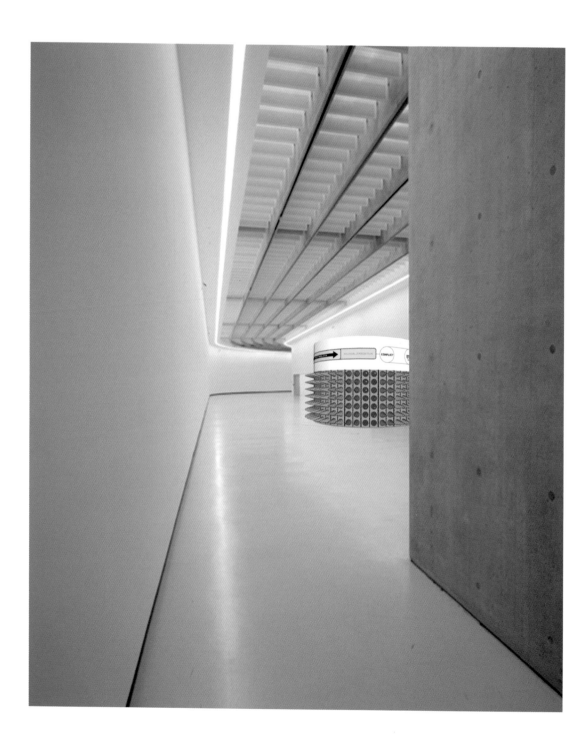

## Estudio Teddy Cruz

— Estudio Teddy Cruz is one of the most important urban planning experimentation and research groups working in the United States today. Founded in 2000 in San Diego, the studio is engaged in a constant exploration of the dynamics of urban conflict generated by living conditions on both sides of the US-Mexico border, from the wealth of the zone north of San Diego to the homelessness and dilapidation of Tijuana. The San Diego-Tijuana border checkpoint is one of the most heavily trafficked in the world, with around sixty million people passing through it every year.

The studio is committed above all to developing new forms of living spaces, including shared housing, in contexts where globalization manifests its most extreme phenomena. All of the studio's most important projects, including *Manufactured Sites, Casa Familiar* and many others, hinge on the question of habitation – marginal, collective/shared, self-buildable – and on the socio-geographic conditions of the California/Mexico border. (p.c.)

## Cultural Traffic:
## from the Global Border to the Border Neighbourhood

We see the possibility of being part of the group of architects featured in this exhibition primarily as an opportunity to participate in a conversation with the other architects/studios and the public at large about the conditions that are transforming our ways of operating as architects, our thinking and practice in the context of pressing sociopolitical and economic realities worldwide. For this reason, we are proposing to contribute to this conversation with a small pavilion of stories, a series of visual narratives (animations), translating the works and processes that have emerged from our research on Tijuana-San Diego urban dynamics. Critical observation has transformed this border region into a laboratory for our practice, from which to reflect the current politics of migration, labor and surveillance, the tensions between sprawl and density, formal and informal urbanisms, wealth and poverty, all of which incrementally characterize contemporary cities everywhere.

The small pavilion containing these stories is a circular room made of recycled traffic cones and covered with a scrim. The entrance to the pavilion's interior will be located against the wall of a gallery, allowing the majority of the traffic cones to be displayed against the space. As seen from the outside, the upper scrim above the traffic cones will contain a "practice Diagram" that circles around the exterior of the pavilion, allowing a viewer to understand the issues that construct the modes of operation behind our practice: 'what' the issues and resources we are engaging are, 'who' our audience and the institutions we engage and negotiate with are, 'where' the sites of intervention are and 'how' we construct the particular procedures to engage conflict, transforming it into our operational tool. The inside of the pavilion contains seven flat-screen monitors. Three are dedicated to brief, three-minute animations, each conveying three aspects of our process. The remaining four

tell the stories of four selected projects located on both sides of the border and in Latin America. In front of each of these four project-narrative monitors are green plates extending out from the wall, with four small models of four different "devices", artifacts that are the main, small infrastructures behind the development of the projects in question and serve as the main characters that introduce each story. In the center of the pavilion's interior is an installation called *McMansion retrofitted*, which tells the story of a generic Southern California retrofitted by immigrants, 'pixilated' with different conditions of ownership and use across time. This central piece is the conceptual hinge pin connecting all the stories inside the pavilion. The audience can engage this pavilion with different speeds and modes of attention. On one hand, a visitor can view the pavilion from the outside and never enter, simply reading our practice diagram in the context of the traffic cones. Or, one can enter the pavilion but engage only the *McMansion* piece, which in itself is very telling of the fundamental question of altering the selfish urbanization and sprawl of Southern California. Or, a visitor might see only one of the three-minute loops in one of the monitors, or see all of them, one after the other etc. The idea is that each piece on its own is 'complete' enough to suggest the need for experimental practices of intervention in the collective territory and the territory of collaboration. They suggest that in our time, new models of possibility will emerge not in sites of abundance but in sites of scarcity, zones of conflict. It is in such edge-zones that conditions of social emergency are transforming our ways of thinking about urban matters, and matters of concern about the city. The radicalization of the local in order to generate new readings of the global will transform the neighbourhood – not the city – into the urban laboratory of our time. In this context, the task of architectural practice should not only be to reveal ignored sociopolitical and economic territorial histories and injustice within our currently ideologically polarized world, but also to generate new forms of sociability and activism.

Teddy Cruz

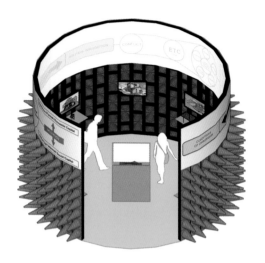

**Plan of Proposed Cone Room**
Not to Scale

**Plan of  Proposed Cone Room with Models and Monitors**
Not to Scale

Project Narratives

Process Stories

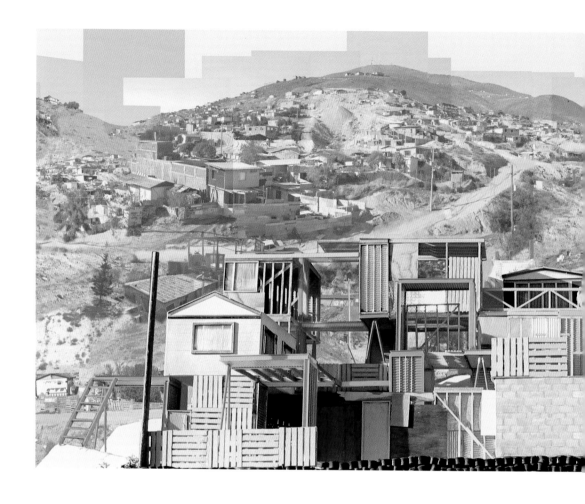

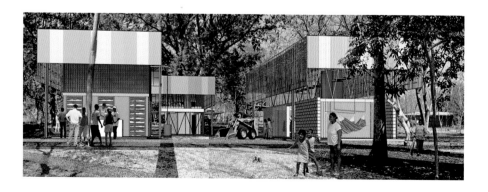

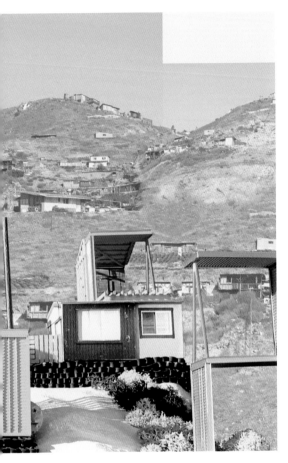

## Cultural Traffic: from the Global Border to the Border Neighbourhood

**Estudio Teddy Cruz**
Teddy Cruz with
Mark Clowdus, Cesar Fabela, Mark Gusman,
Brian Jaramillo, Stella Robitaille, Megan Willis
Past Collaborators: Giacomo Castagnola, Adriana Cuellar,
Andrea Dietz, Jesus Fernando Limon, Mariana Leguia,
Gregorio Ortiz, Alan Rosenblum, Jota Camper,
Nikhil Shah, Rastko Tomasevic
Materials: traffic cones, room with video animation loops
and plastic models

Teddy Cruz was born in Guatemala City in 1962 and
founded Estudio Teddy Cruz in San Diego, California in
2000.
He is currently an associate professor of Public Culture and
Urban Planning in the Visual Arts Department at UCSD,
having earned a Master in Design Studies from Harvard
University and the Rome Prize in Architecture from the
American Academy in Rome. He received the James
Stirling Lecture on the City Prize from the CCA – Canadian
Centre of Architecture and the London School of
Economics. In 2008, he participated in the Venice Biennale
of Architecture.
www.politicalequator.org

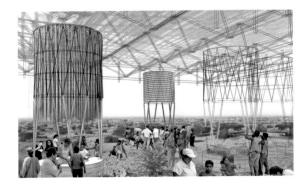

## Lacaton & Vassal – Space of Art

Attempting to represent space in an exhibition always raises complex questions regarding its meaning. We believe that space cannot be expressed through an installation, a form, or a conceptual space. Therefore we do not feel comfortable with this kind of representation. Space is created and determined in relation to the particular constraints and problems of a situation in addition to the concepts of pleasure, sensation, the body and movement.

How can we express such complexity?

We prefer to represent our position by analyzing the conceptual process of a space, a particular project, in relation to our architectural methods and understanding of space.

*Anne Lacaton and Jean Philippe Vassal*

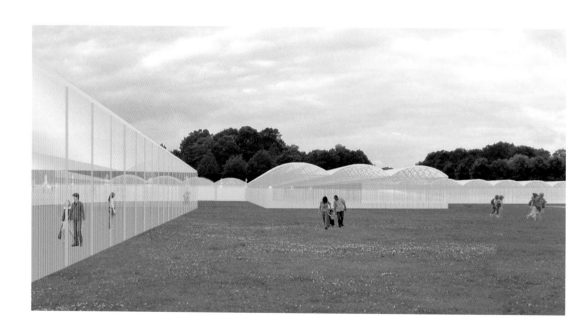

## Lacaton & Vassal

— Lacaton & Vassal transfer into contemporaneity the great tradition of French functionality, which has always been linked to the industrialization of constructive elements. Their work aims to express the essence of both the commissioned project and the constraints that govern it. They manage to obtain maximum results with minimal intervention, containing costs and enhancing the space through reinterpretation and use of what is already available including mass-produced prefabricated materials.

Lacaton & Vassal's presentation at the MAXXI explores their project for a contemporary art pavilion at the Documenta 12 art exhibition in Kassel, Germany. It is a project that exemplifies their understanding of space. The French studio has decided not to present an installation, which would have required the interpretation of symbolic and aesthetic elements in order to accurately represent their research. Instead, Lacaton & Vassal have chosen a specific architectural project and have presented it exactly as an architect would: through the use of drawings, plates and models. They believe that this is the most effective and practical means to tell the story of a specific and extraordinary case. They hope to illustrate their interpretation of artistic space, 'their' concept of a museum. The German pavilion at Kassel involved the creation of a vast temporary exhibition space composed of structures derived from agricultural greenhouses. The project's limited cost and low impact – the greenhouses were completely recyclable – corresponded to the informal utilization of the exhibited works. According to the stated aims of the project, this would have a stimulating effect and break apart the traditional concept of an exhibition space.

The architects are clear and resolute in their position. They favour light, temporary architecture, which lends itself to a variety of uses, over 'heavy' permanent architecture with limited functions. However, the proposal developed for Documenta 12 was so heavily modified during its realization that the essence of the project was distorted. Thus, the presentation of the original project at the MAXXI serves as a living and valid testimony to an entirely new way of conceiving artistic space. (a.do.)

## Space of Art

We propose breaking down and revealing the design process for one of our projects, an exhibition space for contemporary art.

The objective is to understand the spatial and atmospheric complexities that exist between art, the artist and the visitor.

The process will be fully illustrated using a variety of means, including documents. In general, we will employ the normal methods used by architects to explain projects, so as to avoid any ambiguity or contradiction with regards to the museum space in which the project will be presented. In addition to an exploration of the specific project for Documenta 12 in Kassel, we hope to reflect more broadly on the concepts of 'inhabiting' and 'inhabited spaces'.

### Documenta 12, Kassel, 2007

Documenta, which takes place in Kassel, is one of the world's most important exhibitions of contemporary art. It takes place every five years and lasts one hundred days. For the twelfth edition, in response to the curator's desire to have more space for the public's observation and contemplation of the artwork, we proposed installing a temporary exhibition pavilion in the orangery area of Karlsaue Park below the city center.

The temporary pavilion was a 12,000 square meter structure made from prefabricated greenhouses covered in a transparent plastic material. The construction was simple, light, reliable, economical and created a limited building envelope.

This new space doubled the available surface area in order to reduce the concentration of works in existing buildings. It also lengthened the route between exhibition spaces and was an addition to the buildings normally used by Documenta: the Fridericianum, the Documenta Halle and the Neue Galerie.

The greenhouse modules, $20 \times 9.6$ m, were not installed as a block, but in a more fragmented layout, which created spatial intervals. Their transparency allowed them to relate to the city and the beautiful surrounding landscape. Thus, the exhibition became more accessible and less isolated from the outside world. The artwork was protected but desacralized and removed from its sanctuary.

The greenhouse is neither a simple formal object nor a systematic element of our architecture. It is an elegant and minimalist structure capable of transforming the external climate and making it inhabitable for visitors and works of art. It is an open system whose signature element is lightness.

The space is transparent and filled with light, but also adaptable. Light and air are natural, filtered just enough to soften them. The walls can be hidden thanks to horizontal and vertical curtains placed internally and externally according to the levels of brightness and the quantity of lighting desired for each work of art. It is a flexible and precise space which allows for all the necessary conditions for the presentation of works of art.

The abundance of space made the distribution of the works of art less difficult. This increased flexibility also allowed for more space to be given to larger works in order to encourage reflection, discussion and criticism. The objective was to permit a dialogue between the artwork and the visitors as well as a dialogue between the viewers about the artwork.

In conclusion, while Documenta carried out the project, drastic and expensive modifications were made (air conditioning, concealment, locks) which modified the very sense of our project. These changes were in total contradiction to the intentions expressed by the curator during the initial discussions of the project regarding the necessity of lightness and the desire to exhibit works of art in a new fashion.

This was the result of conventional pressures regarding the presentation of the works and knee-jerk reactions to exaggerated fears of very improbable climactic

catastrophes, such as extreme heat or cold, flooding etc.
No installation, no matter how durable, could have resisted
such conditions. Nevertheless, the installation highlighted
the greenhouses' suitability for the creation of ample and
pleasing exhibition spaces for contemporary art.
In keeping with the ecological principle of the project, the
greenhouses should have been reused after the Documenta
exhibition to create housing.

<div style="text-align: right">Lacaton & Vassal</div>

### Space of Art

**Lacaton & Vassal**
Anne Lacaton and Jean Philippe Vassal with
Julien Sage-Thomas
Materials: project for Documenta 12, paper documents and
video

Anne Lacaton (Saint-Pardoux La Rivière, France, 1955) and
Jean Philippe Vassal (Casablanca, 1954) founded the
Lacaton & Vassal Studio in 1987. Their architectural
research has earned them many prizes including the Grand
Prix National de l'Architecture Jeune Talent and the Mies
van der Rohe Prize. They won the prestigious Grand Prix
National d'Architecture in 2008.
The attracted the attention of international critics with their
project for the *University of Grenoble Department of Art*
(1995) and the conversion of the *Palais de Tokyo* in Paris
into a center for contemporary creation (2001).
Recent projects include: the *Sciences de Gestion University
Campus in Bordeaux*; a *building complex in Mulhouse*
(France, 2005) and the *School of Architecture of Nantes*
(2009).
www.lacatonvassal.com

performance : 80
personnes dans 37 m2

conférence : 40 auditeurs
dans 35 m2

conférence : 105
auditeurs dans 72 m2

concert : 150 spectateurs
dans 70 m2

Andreas Siekman
1 hudge painting, 1 record
player placed on a table.
16 m2

Café : 36 places
dans 42 m2

projection : 24 places
dans 18 m2

Olivier Zabat
a film on monitor, duration : 45
min, sound, comfortable situation
for watching. 20 m2

Table ronde : 12 personnes
dans 12 m2

discussion : 15 personnes
dans 12 m2

Walid Raad
framed pictures behind glass
space : 10x3 m

Vestiaire, dans 49 m2

WC : 6 wc femmes,
6 wc hommes, dont 2 wc
handicapé, dans 70 m2

Espace d'activité enfants :
24 places dans 22,5 m2

Véronèse
Les noces de Cana (990x665 cm)

Saadane Afif
Power chords (170 m2?)

Dan Flavin
Untitled (in honor of Harald Joachim)
3, 1977

# Cino Zucchi Architetti – In the Body of the City

## Cino Zucchi Architetti

— In describing Cino Zucchi's planning career, we can trace a line of theoretical research developed through suggestions and metaphors drawing expressions and languages from the most varied disciplines into the architectural discourse. Each of these aspects contributes to create an architecture which, on the small scale as on the urban scale, is attentive to details and use of materials, as well as to a spatial configuration that manages to relate with the context. The quality of his buildings and complexes realized in Italy and Europe lies in the idea of space constructed as an integral part of the landscape and of the city as a living element. Thus the construction of new urban centers becomes an added value for the environment we live in rather than a painful laceration.

"Every project is grafted onto a place", the architect writes, "and a graft entails a wound in the host organism, but also a deep understanding of its physiology".

Reviewing some of his best-known projects, like the Nuovo Portello residential buildings in Milan (2002) or the ex-Junghans area in Venice (1998-2002), we note the extraordinary capacity to piece together a narration that links the individual parts involved, stimulating a dialogue among architecture, context and inhabitants. A dialectic that unfolds in assonances and references, with the declared intention of using an architectural gesture to make up for the lack of quality that characterizes so many contemporary public spaces.

The conception that sees the city transformed into a pulsating organism finds its exegesis in a few installations, like *The Boho Light Trap*, a temporary pavilion designed for the 2002 Venice Biennale of Architecture. The structure, conceived as a nomadic domestic space for an ethologist involved in battles for the environment, seems to recall body cavities and vibrating tissues.

In Cino Zucchi's project for the MAXXI the human body is the main reference: a sculptural object visitors can pass through recalls the heart, and the projection of Giovan Battista Nolli's eighteenth century map of Rome represents the blood circulation system. The use of this first important cartographic operation on the Eternal City – taken as a reference point and symbol by generations of intellectuals, artists and architects – is hardly a coincidence. It is considered an ideal map of relations between natural and artificial landscapes, in which the urban fabric had not yet been fragmented by the infamous devastation wrought by two decades of fascism and by the real-estate speculation of later years. (e.g.)

## In the Body of the City

The analogy between urban conglomerates and biological organisms has a long history passing through centuries of urban culture in unexpected ways. It speaks of "urban fabric", of "green lungs", of "traffic arteries" and "construction cells", and the medical metaphors of "healing" and "disembowelment" attest to the violence modern urban planning has wrought on ancient cities.

From nursery rhymes to sixteenth century architecture treatises, the analogy between the building and the human body pops up in a series of not particularly imaginative analogies. Andrea Palladio makes a curious comparison between the body's entrails and the storage spaces of buildings, which, with their hidden functions, support the 'noble' parts such as atriums and staircases. While the paradigm of the human body is continuously evoked in architectural theory as the source of all coherence and beauty, structures built by man have also often been taken as models to explain our physiology. An eloquent figure from Tobias Cohn's 1707 anatomy treatise *Ma'aseh Tobiyyah* compares the human body to a four-story building, and Fritz Kahn's famous 1926 drawing *Der Mensch als Industriepalast* inaugurated the modern series of diagrams that represent man as an edifice or a machine. The anti-naturalism of the early modern period denied the existence of any animistic aspect in architecture, which thus became a transparent object, a simple climate-controlled container from which to enjoy a panoptic view of the landscape. The optical transitivity of the *pan de verre* comes up against the classical theory of mimesis and incorporates it; 'visible' nature need no longer be 'represented'.

But contemporary architectural experimentation breaks down the boundaries between simulation and reality, and the "sex appeal of the inorganic" of which Walter Benjamin spoke continually blurs the lines between the body and its casing, as if all of the former's movements could design the

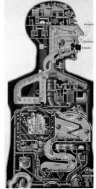

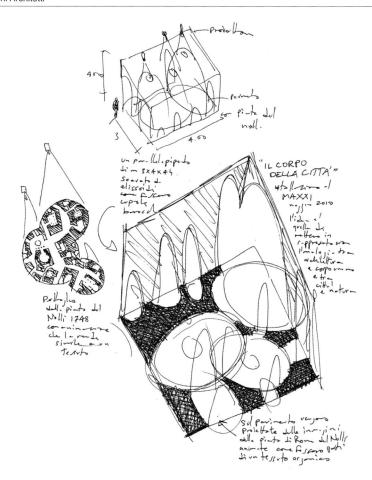

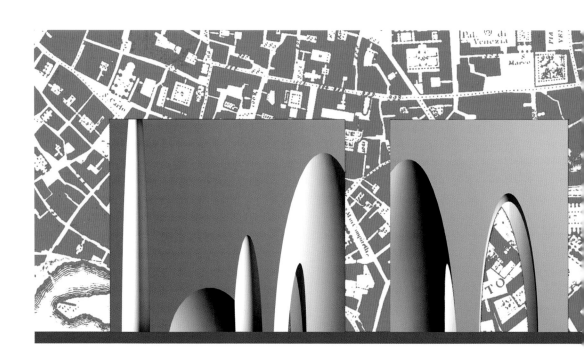

hollow space of a primary interior, or reduce it to the amniotic sac of Reyner Banham and François Dallegret's environment bubble.

Our installation at the MAXXI seeks to represent the analogy between the human body and the city taken to its most extreme consequences: a series of elliptical cavities create a compact, dark-red block, like Baroque Roman cupolas transformed into the ventricles of a giant "stone heart". A famous map of Rome engraved by Giovan Battista Nolli in 1748 – which depicts the city as a solid body in which streets, courtyards and public interior spaces are dug out – is projected onto the floor, computer animated so that it almost appears to be a microscope view of human tissue cultivated *in vitro*. Streets as veins, columns as red corpuscles, Piazza Santa Maria della Pace as a stomach, the Pantheon an eye opened towards the sky: the city brings every aspect of our lives into its dilated time, into its solid body, which lasts through the generations.

The installation makes an animate object of the ideal of an "organic" architecture, as well as the idea of the urban planner as the city's "barefoot physician", capable of recognizing its irreducible uniqueness and the need to find new non-invasive therapies to govern its growth and life.

Cino Zucchi

**In the Body of the City**

**Cino Zucchi Architetti**
Cino Zucchi, Marco Campolongo, Stefano Goffi, Leonardo Zuccaro Marchi with
Armine Arustamyan, Zhanna Hovhannisyan, Finola Doyle (coordinator), Kalimera (video installation), Alkimia (model), Eurostands S.p.A. (realization)
Sponsor: Auredia S.r.l., Sto Italia S.r.l.

Cino Zucchi (Milan, 1955) graduated with a degree in architecture from the Milan Polytechnic, where he has taught and done research since 1980. He has participated in several editions of the Milan Triennale and the Venice Biennale. With the studio Cino Zucchi Architects, he has realized urban-scale projects, including: the redevelopment of the Fiera neighbourhood in Abbiategrasso, the redesign of the ex-Junghans Area in Venice (mentioned in numerous international prizes), the project for sector 2b-2c of the ex-Alfa Romeo Portello area in Milan, the Epano Skala port in Mytilene-Lesbo, the redevelopment of the Keski Pasila area in Helsinki, and the redesign of the new Cornaredo neighbourhood in Lugano.
www.zucchiarchitetti.com

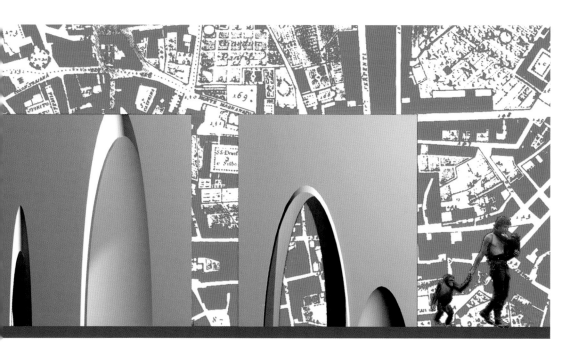

0.00      + 1.75      + 3.5

AA'      BB'      CC'      DD'

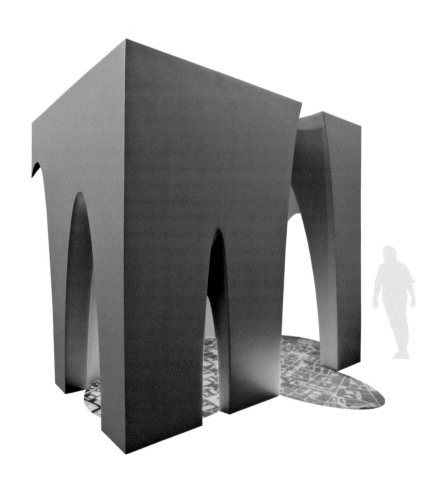

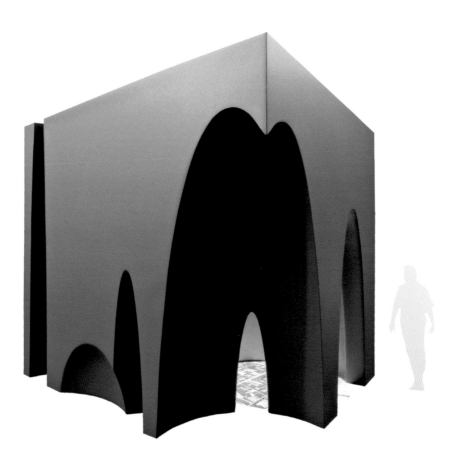

# Maps of Reality

# Space and Three Models of Language

Franco Purini

To live together in the world means
essentially that a world of things lies
between those who have it in
common, as a table stands between
those who sit around it; the world,
like every in-between, relates and
separates men at the same time.
*Hannah Arendt*

If we consider the idea of space from the geopolitical point of view,
we can assert that, today, it is characterized by a series of complex
and contradictory aspects. In fact, considered in the broadest terms,
space is configured as a single and total entity directly identified with
geographical space, thus coinciding with the entire planet. This is the
physical space of globalization, a continual and potentially isotropic
vastness, interconnected in its various parts, which consequently
depend on one another in their evolution, all in a simultaneousness
that nullifies all distances and all borders. A few years ago, Achille
Bonito Oliva summed up this situation in a highly insightful aphorism,
which Alighiero Boetti had similarly represented with his "flag
mosaics", compositions that depicted continents and countries using
colored tiles which, placed alongside one another, created the effect
of an unknown form of writing. "While in the past artists wanted to
become a part of history, today they want to become a part of
geography", the inventor of the *Transavanguardia* asserted,
individuating a conceptual and operational shift that delineated a
strategic plan regarding the presence of art and artists in the world.
Faced with this globalization of space, which somehow annuls the
duration of time and thus history, projecting itself into that
immanence of the present that dominates much of the planet's social
and cultural life today, space itself has become both increasingly
abstract and virtual. In today's metropolises, where it was once
present mainly in the form of public space as a powerful civic bond, it
is now completely extinct, becoming, in what Massimo Ilardi has
called the "city without places", a "space of consumption". Places –
originally proposed as recognizable and positive spaces, territories
for social encounter and exchange – were first stripped of all
authority and then destroyed by Marc Augé's "non-places", "urban
viruses" which, already in the early 1990s, robbed the components of
cities of their identities, replacing them with an operational presence-

absence. All of these reasons have led to the definitive disappearance of Hannah Arendt's "infraspace", that 'in-between' that made the inhabitants of cities into authentic and enduring communities within which one could still carve out pockets of separation or active isolation.

Space today is thus twofold and adversarial. In fact, there is a geographical space that covers the entire Earth, an apparent continuity that transcends all local differences, proposing itself as homogeneous or utterly lacking in inflections and elements of differentiation. A finite space that stands in contrast to the endlessness of cosmic space, the latter being a black infinity against which the now-legendary photographs of the "Blue Marble" first offered a glimpse from the outside, evoking an intrinsic 'antipolarity' of the world with respect to itself, as if the Moon had become its dislocated eye. In the face of this geographic space, which is at the same time an 'economic' space, the 'de-realized' space of the contemporary metropolis unfolds, very similar to the virtual space of the Internet in its abstraction. Actually, the virtual abstractness of the immaterial is not completely true. In fact, a new concreteness has arisen within the net itself, shaped by the free association of people who use the Internet to form sometimes powerful opinion groups, which enter into dialectic of power, modifying its logic and its equilibriums. In this sense, the geopolitical scenario seems to merge physicality and immateriality, heralding new forms of political and social action.

The characterization of the global condition is generally 'negative'. Aside from its explicit opponents like Naomi Klein and Saskia Sassen, or those like Michael Hardt and Antonio Negri who criticize it while at the same time exploiting the spaces of subversion it leaves open to political and social action, there is no doubt that this new worldwide era – which is certainly not an absolute novelty, but which nonetheless seems like one due to the range and reach of phenomena it is spawning – is shrouded in an atmosphere of prevailing diffidence, widespread misunderstanding and pervasive fear. This atmosphere, while dominated by a strong sense of urgency, is above all marked by an intractable 'indecipherability'. Global warming, with the consequent climatic changes and the inevitable exhaustion of fossil fuel sources, have become the main cause of growing alarm, and concern has also grown regarding the

equitable distribution of renewable resources, from which less-favored territorial contexts seem to be excluded for the moment. Nation-states are losing a large part of their roles, and this produces anxiety and a sense of indeterminacy. In contrast, the economy, which has become the dominant category, is becoming ever-less comprehensible in its pervasive phenomenology, appearing as an 'invisible entity' that looms over everything, relegating every choice and every intervention to its own purposes. In the meantime, migrations on a Biblical scale are profoundly changing the world order, shifting multitudes of people from zones of the planet beleaguered by war or plagued by hunger for various reasons towards countries that may offer better life opportunities. In these countries, the arrival of hundreds of thousands of migrants produces a series of consequences too complex to discuss here, which have profound and long-lasting effects on the underlying structures of society and the values they foster. Hence, obstacles and conflicts are created which require complex and, above all, prolonged mediation to overcome. Alain Touraine's attentive analyses on the "end of community"; Thomas Lauren Friedman's reflections on the impact of digital technologies on interpretive models of the world in the book *The World Is Flat*, and the hypotheses on the "creative class" proposed by Richard Florida have painted theoretical landscapes in which pessimism is transcended in more positive visions, but without completely eradicating a sense of impending catastrophe. One of the most effective paradigms for elucidating the current world situation is that of the multitude, a concept formulated by Michael Hardt and Antonio Negri. The inhabitants of contemporary metropolises are a multitude, not only because they are an extremely varied and complex component of the social organization, but above all because they possess a mutable, multi-faceted identity that allows them to orient themselves in the convoluted labyrinth of global society with a certain possibility of self-determination. Multitude also indicates a plural space that can only be workable if it is not reduced to a limited number of dimensions, a space that must be accepted in all its metamorphic potential, in its simultaneity, in the combinations of concreteness and abstraction mentioned above. 'Crossing', 'nomadism', 'contamination', 'drift', 'fluidity', 'interference' and 'fragment' are some key words that allude with a certain precision to the modes of awareness and modification of reality that this space – divided between a growing loss of meaning and the birth of

peripheral articulations and increasingly pronounced desires for identity – is capable of suggesting.

The birth of a unique space which, although it traverses specific ambits, does not deter individuals from inserting particular themes and motifs into it, is the source of new problems regarding the conception and practice of artistic languages. These problems arise from the need to conciliate the permanence of the unique and original character of the artistic experience with the exigency that said expression reach the largest and widest-ranging audience possible. In short, artists (including architects), having taken up Achille Bonito Oliva's paradigm, have for some years been wondering how to "concretely become a part of geography". Towards this end, we will try in the next few paragraphs to formulate some hypotheses regarding these aspects. To better place such strategies within the problematic context in which they are to be individuated and carried out, it may be useful to note a few general conditions in which artistic experimentation takes place today, conditions engendered by the dual essence of contemporary space. The suspension of the metropolis between being a physical reality and a virtual flow of information; the primacy of communications; the rediscovery of the body as an irreducible antipole to the vastness of the metropolis and as an irreducible emblem of the materiality of experiencing the world; and the ambiguous but fecund equivalence between reality and simulacrum are a few of these conditions. They apply to a context in which the innovative presence of the digital integrates with both a growing identification of architecture with art and the theoretical horizons of ideas of complexity, while the dimension of the landscape seeks to gradually replace that of architecture. The intertwining of these components has generated a series of experiments in which the disassociation between the structure and the casing of buildings is joined by the fact that they are transformed into installations, i.e., interventions intended to offset the urban atopia with their expressive energy, inserting a network of highly recognizable forms into the city. Slotting into a line of thought that includes Kurt Schwitters' *merzbau*, the "manifesto architecture" of experimental neighbourhood like the Weissenhof in Stuttgart, the *Via Novissima* conceived by Paolo Portoghesi for the 1980 Venice Biennial, and increasingly numerous site-specific interventions, the installation is viewed as an interpretation of a given context by

means of a plastic-spatial action aimed at lending an unexpected and innovative formal structural presence to said context.

If we look at the phenomenon of globalization from the point of view of architectural language, considering how it constructs itself as a system of signs oriented, finalized and 'planned' in its grammatical and syntactic reality and in its own contents, we can note three distinct modalities by which it defines its constitutive coordinates and then creates the landscape, the city and the building. Thrust into the new logics of an increasingly intense and accelerated planetary discourse, architectural language today is articulated in themes and structural expressions that are very dissimilar, yet which often crossbreed through more or less convincing and efficacious syncretisms. Before outlining these three modalities, we should very briefly ascertain whether there is any difference between the internationalism of the past – which had such an impact on twentieth century architecture, as in the International Style theorized, or rather 'invented' in 1932 by Henry Russell Hitchcock and Philip Johnson – and the current globalization. In effect, there is no real overlapping between the two notions. Internationalism entailed the diffusion of certain trends, as well as a few thematic focuses, in various contexts, while, however, maintaining boundaries between states, perceptible 'barriers' that functioned as discriminating devices. Cultures acted as filters, allowing some linguistic forms to penetrate – sometimes with opportune adaptations – while blocking others. Let us take France, for example, a country that has always been very vigilant in distinguishing between what can be organically assimilated into its own system of identity and what must be excluded. In contrast to this critical underpinning principal internationalism, globalization brings an idea of singleness – i.e., that which is global is no longer subject to modifications linked to the individualities of states, but rather seeks to transcend them. Furthermore, states are progressively relinquishing their own fundamental traits to the process of homologation, concentrating those that remain in their most important cities. In a certain way, the globalized world is no longer a world of nation-states, but of cities in competition with one another. To summarize, we can assert that, while internationalism was not initially 'atopical', but dialectically suspended between localization and limited phenomena of de-localization, globalization almost completely lacks ties with individual contexts, at least apparently. Additionally,

internationalism was not 'simultaneous', while globalization is. The final element, which we have already mentioned, is 'interconnection', or the strong dependency of one situation on another.
Atopia, simultaneity and interconnection – to which we must add the now-all-encompassing dimension of communications – are thus the elements that marked the transition from the internationalism of the 1950s and 1960s to the globalization of today. We should also note that globalization is not a natural development or a mechanical extension of internationalism, but a phenomenon with many autonomous and original aspects.

With regard to atopia, we have just spoken of 'de-localization', a phenomenon that crops up today in various theoretical and operational formulations of the city and of architecture, but it would be more accurate to speak of what has been called "de-territorialization", the definitive cutting of all ties between an architectural intervention and its site: it is to places (now replaced by "non places") what the old social classes identified by Marxism are to the multitude. Eliminating any sort of need-based relationship with its site, the building somehow goes beyond itself, proposing itself as a hyper-abstract, completely rootless entity, immersed in the destabilizing liquidity that has for some time been Zygmunt Bauman's main object of contemplation. The very difficulty of describing the multitude in all its manifestations shows us how current architecture, destined for the multitude itself, is inserted into a domain as problematic as it is intricate and metamorphic.

After this brief digression, we can now get back to the three linguistic models relating to architectural globalism, noting that what we have said above renders the rest of this discussion quite limited, if not merely indicative of a situation far too broad to be exhaustively examined here. The first model might be called 'neo-imperialist', and consists of the worldwide imposition of products from the most powerful countries. The United States in particular, but also the UK, France, the Netherlands and Japan have in recent decades managed to impose their architecture and urban design throughout the world. This has taken place within a pure market logic which, while not in contradiction with the intrinsic value of the works and architects involved in this colonization – works and architects that are often of indisputable importance – certainly does not base its

phenomenology (which, we should note, is still rather obscure) primarily on qualitative elements. Architects and their buildings are exported like any other merchandise, with the support of adequate informational strategies, including the creation of narrative constructions that mythicize movements and personalities. The very notion of the 'starchitect',
so widespread today, is a 'mass-media multiplier' that feeds on itself, drawing propaganda tools from the show-business world, such as the celebration of the diva, performatory provocation and the hyper-estimation of the quantities brought into play. Frank O. Gehry, and especially Rem Koolhaas, are the major representatives of this first model of architectural globalization.
The Canadian-Californian Gehry has managed to produce works of remarkable renown throughout the world, above all because they look nothing like buildings but are rather presented as surprising 'inhabited plastic performances', or "archisculptures", to use Germano Celant's term. Even more incisively than Gehry's work, Rem Koolhaas' theory and buildings, from *Bigness* as materialization of space on a geographic scale to the *Generic City* as an impassive and interchangeable, contextual and repetitive urban environment, perfectly represent the resources and limitations of a geopolitical view of architecture.

The second model might be called "neo-esperantist". In this case, there is an attempt to bring together multiple architectural writings from different linguistic contexts in often highly complex compositions. In other words, the endeavor is to construct an alchemical combination of fragments of writing in order to create a sort of 'common language'. Like so many collages, works like Cesar Pelli's *Petronas Towers* in Kuala Lumpur are an excellent example of this line of experimentation, in which elements drawn from Malaysian architecture mingle with typically North American stylistic features, with the addition of European accents especially in the interiors. The hundreds of skyscrapers that stud the Pudong area of Shanghai are also part of this new genre of architecture, a sort of 'statistical average' of a plurality of linguistic expressions. The effect produced by this line of constructions is that of a mosaic of partial architectural writings which, albeit evocative, emits contrasting and sometimes contradictory signals. In these buildings, the method of sampling takes the place of the real work of composition, and as a

consequence, the end product is almost inevitably unfocused and discontinuous.

The third model, which is a radical reversal of the first, is the "local". As has happened with the work of Alvaro Siza, a building capable of interpreting the most profound characteristics of a specific context can achieve a level of notoriety comparable to that of the works of the architects comprised in the first and second models. But this category differs from the other two due to the presence of an oppositional attitude to the current conditions of architecture and, more accurately, of the situation, while the first and second groups simply represent the existing situation, sometimes very well. Within this third group we may also place those architects who, although pertaining to internationally pervasive movements – think, for example, of the latest products of "critical rationalism" – have, like Oswald Mathias Ungers, Aldo Rossi, Vittorio Gregotti, Max Dudler, Antonio Monestiroli, Giorgio Grassi, Rafael Moneo and others, managed to give their contributions to a common situation completely new and highly personal connotations, shaped by their references to cultural themes and motifs drawn from their native contexts. These local themes and motifs are brought into interaction with more general elements, often giving rise to poetically intense writings in which the singularity of a landscape or urban location is released into a higher dimension, without losing or weakening its legibility.

This writer maintains that of the three models, the third has the greatest capacity to involve the largest and widest-ranging audiences, to guarantee a high quality of writing and, above all, to reestablish a meaningful relationship between an architecture and the spot of land on which it stands. Nevertheless, aside from the author's declared preference, it seems reasonable to think that in the next few years, the three models will intersect with ever-greater intensity, moving towards an integration. This will be facilitated by the predominance of the image, which today impacts the architecture of all three of the models described above, as well as that of the digital, which in some way homologizes – or at least so it seems – the works of contemporary architects, and, finally, that of the inexorable tendency to insert architecture into the ephemeral and multi-faceted spheres of art, fashion and custom, with no mediation. Having become one of the many manifestations of the communicative fluidity

which in this global age seems to have replaced things that have been supplanted by their own simulacra, architecture has been transformed into an absolute linguistic virtuality, a lexicon restlessly searching for its words and its rules. And all within a substantial loss of density of the idea of space, which has itself become random, haphazard and intransitive, as asserted at the beginning of this essay. Only a new alliance between the body as the sole antipole to the immaterial dissolution of the metropolis and space as the result of a re-designation of human habitation (which must also be completely reinvented) might perhaps restore to the architect's work that quality of necessity and truth that is capable of expressing.

# Political Plastic

Eyal Weizman

### Assassination in Junkspace

A few weeks after the January 19th 2010 assassination in Dubai of Hamas official Mahmoud al-Mabhouh, (most likely) by Israeli Mossad agents, the emirate's internal security department released a video composed of dozens of CCTV fragments. The video, thirty minutes long, inter-titled like a silent movie and edited like a murder mystery, takes the viewer through a series of non-spaces, generic interiors of flow and transit. The members of the assassination team are seen arriving separately at the Dubai Airport, casually going through passport control and baggage security, checking into different luxury hotels, gathering in a shopping mall, moving into another hotel, tracking and following the victim through the lobby, reception, elevators and corridors, some of them changing costumes and wigs, entering into the hotel room where the dead body of al-Mabhouh was later found, leaving this room, checking out and flying off to different places worldwide. Mabhouh himself, also traveling on a false identity, was seen at his entry into the hotel.

The entire drama occurs in a kind of spatial continuum, an interconnected network of air-conditioned interior spaces, somewhat familiar from recent architectural studies of the Gulf, that Rem Koolhaas has elsewhere referred to as "Junkspace" – a constantly mutating generic space that seems to have no outside.

"The escalator [...] and the air conditioning have launched the endless building [...] interior, so extensive that you rarely perceive limits; it promotes disorientation by any means (mirror, polish, echo) [...] Junkspace is sealed, held together not by structure, but by skin, like a bubble".

It is perhaps because architects are still presumed innocent, that Koolhaas's account misses out on the new type of policing that grows within the veins of this endless and globally interconnected junkspace. The movements of the assassination squad through this spatial continuum was recorded every time they entered and exited a fold within this space – the cameras being located at the transition areas of this incessantly elastic and ever-transforming space. It has so happened that the movements of the team across thresholds is what has scripted the video, later edited by the government's media department, an agency better known for highlighting the spectacles of Dubai's new built economy – exterior shots of islands, shopping malls and high-rises – than an international murder taking place

within the systems of flow that curl through its guts. But surely this video (and the story that unfolds within it) is the best manifestation of the policing of the architectural continuum that no map or drawing could capture. The innocent architecture of Dubai, whose archipelago of the world, so Shumon Basar tells us, does not contain Israel and Palestine, lest they bring in "politics" into the neutral, good for business, emirate, seems to have been now irrevocably contaminated with this very war, a fast forward cold war that flows across the globe, following each party's supply networks, in an attempt to enhance or disturb them. Mabhouh's task in Dubai, it was reported, was to reactivate and accelerate the network of arm delivery to the Gaza Strip, the territorial enclave most isolated under blockage.

### Forensic Videography

The video, and the method of its distribution, manifested the consequences of a certain radicalization of the contemporary techniques of state security, one based on the "thanato-politics" of state assassination, but also on this new, and intricately related policing work. Filmed police might indeed be the only kind of policing possible in this kind of automatic spatial continuum.

If the archiving of police files and evidence suited the logic of cities of discrete buildings (in discrete quarters or neighborhoods), the video-sequence is the emblem of the policing logic of the interconnected interiors that span from Tel Aviv to Dubai. Office buildings (Mossad headquarters) – airport – airplane – airport – hotel – shopping – mall – hotel – airport… dead body. There is little sense in talking about "the city" as a discrete object of research, as if one city could be held distinct from another. It makes also little sense to talk about distinct buildings, as this narrative flows through this endless, smooth continuity.

Rather than keep the evidence secretly filed in an archive until the conclusion of the investigation, or until legal charges are brought, or indefinitely as in all other cases, the Dubai police chief – probably the best contemporary candidate for the role of the new global police chief – has spectacularized and then widely disseminated his evidence, making it some of the most fascinating, photogenic and compelling evidence sequences ever seen. Evidence has inevitably

turned into the only thing it could turn to, infotainment, released in mid policing process into the public domain. The mesmerizing character of the video is what has made it so effective. Moreover, it is this very engagement with these images that has unwillingly turned global society into an extension of Dubai's internal security department. Every person that has seen this video becomes an unwitting policeperson. Many journalists, bloggers and other citizens of the contemporary junkspace-continuum, quickly filled the gaps in the investigation, extending the reach of Dubai's police. Secondary evidence kept on piling up, as in a global quiz show. It was a demonstration, if one was still needed, that the principle of diffusion, that Michel Foucault identified as one of the central ones in the working of the (neo) liberal security, is exponentially more effective than the intimidating policing and brutal investigative techniques of past and past-present modern dictatorships. Indeed, Foucault's concept of "security" referred of course to threats coming no longer from the outside (is there still anything "out there"?), but from within, virus-like, shifting within the networks of circulation, from the living mass, the population itself and its inherent tendency to create deviations, random events, and unpredictable crises. It is thus the circulation networks themselves that are in need of incessant monitoring and analysis. Counter intuitively perhaps, it was not the differences but rather the radical similarity of Dubai and Tel Aviv that lead to the exposure of Mossad's assassination techniques. Both Israel and Dubai are examples of Middle Eastern laboratories of extreme development sustained by imported and highly segregated labor.

State borders (at the airport), much like boundaries of buildings and doors of hotel-rooms, are thresholds that function both as filters of movement but also as media spheres – a combination of sensors and archives that register and store information about every-body and every-thing that passes through them. Acts of crossing are also acts of registration. Every act of registration is an act of archiving. It is the crossing of thresholds that we see in this video, the moving of bodies across borders and boundaries.

This is possible because of the duality of contemporary space: space is now both increasingly sequenced by border devices and woven together by highly policed and intensely filtered networks of transport and communication. Checkpoints and registration points mean that sovereignty (of a state, an institution, a corporation) is

exercised in its ability to block, filter and regulate movement across its boundaries. The global politics of flow is embodied in the way in which 'internationals' – people with business or security clearance (be their moustache fake as it may) – move swiftly across most borders/filters, but 'foreigners' – undesirables without appropriate papers – are stopped, delayed and often detained at most thresholds, architectural or national. Within this larger system, architecture operates as a valve regulating the flow of passengers under the global volatile regime of security. The regulation of flow equally affects money, labour, goods, energy, sewage, water and diseases. The location of government has thus shifted to transport nodes and networks. To a large extent the function of government is that of valves modulating the "mobility regime". Indeed, the contemporary conception of security includes a complex territorial, institutional and architectural apparatus conceived in order to manage and record the circulation of people through global space. It is an extension and acceleration of what Gilles Deleuze called the "societies of control", where "enclosures are modulation (in movement), like a self-deforming cast that will continuously change from one moment to the other, or like a sieve whose mesh will transmute from point to point [...] in continuous variation". "The coils of a serpent are even more complex that the burrows of a molehill", Deleuze concluded.

## Walling and Unwalling

But there is another type of space. Political space is also highly fragmented. Figures of extraterritoriality returned to haunt current political order. After we assumed that borders were replaced with bureaucracies, issues and concepts, regulation with boundless flow, new fault lines started to reappear and steer this order apart. Just as along Norwegian coasts – where fjords, Islands and lakes break the coherent continuity of both water and land – political surface has now splintered into discontinuous territorial fragments set-apart and fortified by makeshift barriers, temporary boundaries, or invisible security apparatuses. Instead of its edges clearly demarcated by continuous lines, political space has now grown to resemble a territorial patchwork. These shards are islands, externally alienated and internally homogenized extraterritorial enclaves – spaces of

refuge and violence, political void or strategic implants – lying outside the jurisdiction that physically surrounds them. The more it fragments, the more the selective networks that bind its bits together thicken. These islands thus become territorialized nodes of a deterritorialized power – one distributed through military, political or financial networks. Although, and perhaps because, the new world order, governed by super-national and non-localized institutions, is non-territorial, that it increasingly relies on the physical infrastructure that physical space provides.

Depending on one's passwords or papers, the space of action may resemble either a great mutating continuum of flow or an increasingly fragmented series of discrete enclaves, adding up to a proliferating archipelago of extraterritoriality, hollow at its core. For most writers there seems to be either no outside or no inside. The great *Gestalt* of contemporary space depends of course on who does the moving, the seeing, and the talking. It demonstrates that both intertwined aspects of the same structural logic cannot be experienced simultaneously. This is the reason why some writers about space discern its networked connectivity while the others discern its fragmentation – both are right, both see only a single aspect of a complex system.

Within each of the distinct spatial perception zones and between them, there is a constant war being waged. It is the same conflict, appearing differently from each distinct perspective. In these intertwined aspects of the same space, war and politics are no longer separated by the time/space designation of exception. War is endemic to the network of circulation and to the fragmented archipelagos. One contemporary military analyst described the built environment as "the postmodern equivalent of jungles and mountains – citadels of the dispossessed and irreconcilable". This perception of perpetual war does not tolerate distinction between the laws of peace and acts of war, between outside and inside, between foreign conflicts and homeland security.

Within this spatial conflict there are also important complementary techniques of spatial intervention, namely "walling" and "unwalling". Both types of action must be understood as intervention in the logic of flow within and between the complementary aspects of the spatial system. Walling and unwalling are more similar than different. Both walling and unwalling are active concepts of security. Regimes and corporations that build walls often

also engage with unwalling the barriers of others. Spatial practices of security across Israel's frontiers of occupation are exemplified by the erection of walls, such as, but not exclusively, the West Bank Wall, and also by unwalling the walls erected by Palestinians, be them the walls of their homes, or the notional boundaries of their cities. Un/walling is thus not only an act of resistance to the system of hardening enclaves, but also its necessary and complementary practice. This doing and undoing blurs what remains of both the public and the private domain. Private space (like the home) is being increasingly invaded by public agencies, just as what is left of public space is being increasingly invaded by private corporations.

Contemporary urban warfare is increasingly focused on methods of transgressing the limitations embodied by the domestic wall. American, British and Israeli soldiers have recently learned to move across the city through domestic walls. Thousand of soldiers and hundreds of guerrilla fighters manoeuvre through the thick of cities, saturated within their fabric to a degree that they would have been largely invisible from an aerial perspective at any given moment. This form of movement is part of a tactic that the military refers to, in metaphors it borrows from the world of aggregate animal formation, as "swarming" and "infestation". Moving through domestic interiors, they thus turn inside and outside private domains and thoroughfares. Fighting now takes place within half-demolished living rooms, bedrooms and corridors. It was not the given order of space that governed patterns of movement, but movement itself that produced space in its path. Trajectories of movement become material interventions, temporary corridors in space. This three-dimensional movement through walls, ceilings and floors, through the bulk of the city reinterpreted, short-circuited and recomposed both architectural and urban syntax. The tactics of "walking through walls" involves a conception of the city not just as the site, but as the very medium of warfare – a flexible, almost liquid matter that is forever contingent and in flux.

Complementing military tactics that involve physically breaking and "walking" through walls, are new technologies that allow soldiers not only to see, but also to shoot through solid walls. New types of hand-held imaging devices combine thermal images with an ultra-wideband radar that, much like a contemporary maternity ward ultrasound system, has the ability to produce three-dimensional renderings of biological life concealed behind

barriers. Human bodies appear as fuzzy heat marks, floating like foetuses within an abstract, blurred medium wherein everything solid – walls, furniture, objects – has melted into the digital screen. "All that is solid (but life itself) melts into air". These practices and technologies will have a radical effect on the relation of security practices to architecture and the built environment at large. Architecture seems stripped of its materiality. The opacity and the protection of the solid wall have also evaporated together with its dematerialization. Buildings become not much more than an organization that locates bodies in space. Instruments that render walls transparent and permeable are the main components in the search to produce a military fantasy world of boundless fluidity in which the city's space becomes as navigable as an ocean. By striving to see what is hidden behind walls, and to fire ammunition through them, the security agencies of contemporary space seem to have sought to elevate contemporary technologies to the level of metaphysics, seeking to move beyond the here and now of physical reality, collapsing time and space.

## Elastic Walls

We have seen walls that evaporate, opaque walls becoming transparent. Let us now examine the elastic character of contemporary walls.

Contemporary space can no longer be understood as fixed; rather, it is elastic, almost liquid. How so? The linear border, a cartographic imaginary inherited from the military and political spatiality of the nation state has splintered into a multitude of temporary, transportable, deployable and removable border-synonyms – separation walls, barriers, blockades, closures, road blocks, check points, sterile areas, special security zones, closed military areas and killing zones – that shrink and expand the territory at will. These borders are not only fragments of a larger static system of separation, but also dynamic, ever mutating. They are constantly shifting, ebbing and flowing; they creep along, stealthily surrounding buildings, infrastructures, villages and roads. They may even irrupt into one's living rooms, bursting in through the house walls. At one day during 2002 all Palestine shrank to the size of a room, the only space in Arafat's headquarters that was not

occupied, held back by American decree while bulldozers destroyed the buildings around and supporting it. The dynamic morphology of contemporary political space resembles an incessant sea dotted with multiplying archipelagos constantly shifting and rearranging. In this unique territorial ecosystem, various types of zones – those of political piracy, of 'humanitarian' crisis, of barbaric violence, of full citizenship, "weak citizenship", or no citizenship at all – exist adjacent to, within or over each other, intertwined in unprecedented proximities.

The anarchic geography of the contemporary space is an evolving image of transformation, which is remade and rearranged with every political development or decision. Some structures of security might be evacuated and removed, yet new ones are founded and expand. The location of security apparatuses is constantly changing, blocking and modulating traffic in ever-differing ways. Mobile policing stations create the bridgeheads that maintain the logistics of ever-changing operations. The military makes incursions into towns and refugee camps, occupies them and then withdraws. Separation walls are constantly rerouted, their path like a seismograph registers the political and legal battles concerning them. Adi Ophir and Ariela Azoulay called the path of such border devices, and mainly the West Bank Wall, "the monster's tail": to arrive at the multi headed hydra of political power you must follow its violently shifting path, but then again, you wouldn't be able to eliminate it all with a single cut of a sword. Where territories appear to be hermetically sealed, static, by 'fixed' borders, tunnels are dug underneath them and projectiles fly overhead. Elastic territories could thus not be understood as benign environments: highly elastic political space is often more dangerous and deadly than a static, rigid one. The elastic nature of this incessant frontier, now encapsulating the whole, does not imply that built structures are compliant, soft or yielding to touch, but that the continuous spatial reorganization of the political borders they mark-out respond to and reflect political and military conflicts.

This material and spatial characteristic should be referred to as a "political plastic", the map of the relation between all the forces that shaped it. Forms and spatial organizations – rather than the result of a top down system – could be unpacked as the embodiment of multivalent forces within an extended political field.

Architecture becomes implicated in politics through the elasticity

of its structures. Spatial deformations occur in response to economic, aesthetic, cultural and political influences. Elasticity is the condition by which form adapts to a changing environmental force field. Borders are formed by micro and macro conflicts about their path. The route of the West Bank Wall is not a result of top down planning but the diagram of force relation between its sides. Form, according to D'Arcy Thompson is "a diagram of forces", and to Nietzsche "a substratum of force". It is through elasticity that form, the path of barriers and borders, incorporates forces into its own organizational structure. Architecture, that is the formal characteristics of the elastic medium in which we flow, can thus no longer be said to be simply "political" (or "not political") but rather "politics in matter".

Material agency within the political plastic cannot simply be understood as the preserve of government executive power alone, but rather one diffused among a multiplicity of often non-state actors. Because elastic geographies respond to a multiple and diffused rather than to a single source of power, their architecture cannot be understood as the material embodiment of a unified political will or as the product of a single ideology. The spatial organization is not only a reflection of an ordered process of planning and implementation, but, and increasingly so, of "structured chaos", in which the often deliberate, selective absence of government intervention promotes an unregulated process of spatial transformations and dispossession. The actors operating within these contemporary security spaces with the differences and contradictions of their aims all play their part in the diffused and anarchic, albeit collective authorship of its spaces.

Conflict is an acceleration and an accelerator of spatial transformation. Space is not simply the backdrop of this conflict, neither is it its consequences, space is never simply 'political' (in as much as there can't be an architecture that is political and another which is not political), but it is the very medium within which conflicts are conducted. Contemporary politics operates *through* space, and *in* spatial practice. Every political struggle is as well an urban struggle, a conflict not about – but by – space. The inhabitants of the *political plastic* do not operate within the fixed envelopes of space – space is not the background for their actions, an abstract grid on which events take place – but rather the medium that each of their actions seeks to challenge, transform or

appropriate. The relation of space to action could not be understood as that of a rigid container to soft performance. Political action is fully absorbed in the organization, transformation, erasure and subversion of space. Individual actions, geared by the effect of the media, can sometimes be more effective than government action. In the meantime the erratic and unpredictable nature of the political plastic is exploited by governing powers, those modulating the flows. Chaos has its structural advantages. The chaos of circulation is no exception. It supports one of the foremost strategies of obfuscation: the promotion of complexity – geographical, legal or linguistic. Sometimes, following a terminology pioneered by Henry Kissinger, this strategy is openly referred to as "constructive blurring". This strategy seeks to simultaneously obfuscate and naturalize the facts of domination, when chaos naturalizes.

Without sufficiently accounting for elasticity, we'll fall trap to the conceptual impasse in which space is simultaneously mistakenly understood to be too hard and resistance too soft. Too hard in the sense that built realities – the work of planners and architects – appear as solid, fixed and unchangeable, a material given. Too soft because the possibility of political action is resigned to "subversion lite" – to re-imagine, to playfully misuse, to walk different paths. Must De Certeau be still relevant to contemporary spatial production within the *political plastic*? For many of the writers of space, on space, Paris has been the name of this conceptual trap. Paris like the camp. A hard and bounded reality, ruled and designed top-down, whose planners seem to be fond of straight lines and surveillance geometries. This idea of Paris as a material/political reality has dominated spatial discourse. In applying the spatial theory of Paris to a dynamic, and gelatin-like space of the *political plastic*, we miss elasticity and the leveling of agency that goes within it. You cannot solve the problems of Paris in the elastic frontier of contemporary conflicts.

Bibliography

— G. Deleuze, *Postscript on the Societies of Control, October* 59, The MIT Press, Cambridge-London, Winter 1992, pp. 3-7.
— M. Foucault, *Security, Territory, Population. Lectures at the College De France 1977-1978*, Picador, London 2009.
— M. Foucault, *Society Must Be Defended. Lectures at the College de France, 1975-1976*, Picador, London 2003.
— D'Arcy Thompson, *On Growth and Form*, Cambridge University Press, Cambridge 1961.
— R. Koolhaas, *Junkspace, October 100*, The MIT Press, Cambridge-London, Spring 2002, pp. 175-190.
— G. Lynn, *Folds, Bodies & Blobs*, La Lettre Volée, Brussels 1998.
— F. Nietzsche, *The Will to Power*, Vintage Books, New York 1968.

## Forensics of Political Plasticity

The political plastic requires its own forensic practices. Border and thresholds, as we have seen through the lenses and on the screens of Dubai's CCTVs, are cluttered with sensors that register and archive movement and flow, but, given the pliability and elasticity of space itself, could we read space itself, its contours and material organization, as a sensor? If 'historical' (in the sense of belonging to human time) events are registered in material organization, the forensic investigation of the political plastic might potentially trace the processes that produced them, the force fields now folded within them. If histories are inscribed in spatial products through acts of force it must be possible to help them 'speak' under different inductive circumstances.

## Giovanni Anselmo

— *Verso oltremare in basso a Sud e a Ovest Nord Ovest, in alto a Nord Ovest*, 1984-1990, granite, compass, acrylics, granite: 87 × 65 × 15.5 cm, 3 paintings: 65 × 15.5 cm each, MAXXI – Museo nazionale delle arti del XXI secolo.

The contrast and interpenetration between forces, materials and spaces has always been one of the guiding motifs of Giovanni Anselmo's work. His pieces are often constructed around a process, a change of state, a tension between physical and/or conceptual attributes (from *Scultura che mangia* to *Torsioni*, to slide projections with the words *Particolare* or *Visibile*, for example), through which he gives perceptible forms to phenomena that are by definition 'invisible' (the force of gravity, the opposition between finite and infinite, between historical time and universal physical laws, between 'real' and 'rational') and to the immanent structures of knowledge and of representation. In this installation, three small ultramarine-blue rectangles are painted on the walls in cardinal points indicated by a compass set in a block of granite (granite being a recurrent element in Anselmo's work since 1967). Here we find some themes characteristic of the most recent phase of the artist's career: an analytical interest in space, in terms of its geometric coordinates (the geographically-oriented triple 'projection') and attention to the metaphorical values of materials, with square, heavy terricolous stones contrasting at a distance with the airy transparency of the ultramarine blue, symbol of an 'elsewhere' that is by definition unreachable but which directs creative forces and imagination like a magnetic pole of attraction. (s.c.)

Born in Borgofranco d'Ivrea (Turin, Italy) in 1934, lives and works in Turin and Stromboli.

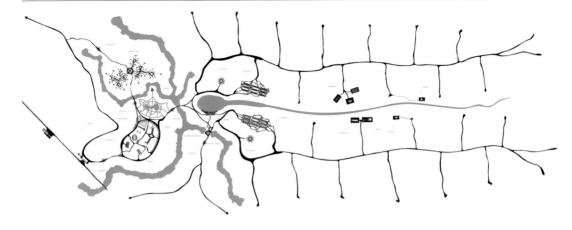

**Atelier Van Lieshout**
— *Urban Plan of Slave City*, 2008, ink and acrylic on canvas, 232 × 560 × 7 cm.
— *The Globe*, 2007, electric motor, fiberglass, varnish, 140 cm diameter.
MAXXI – Museo nazionale delle arti del XXI secolo.

The Atelier Van Lieshout group's work develops in a borderline territory between art, architecture and design. Their projects, from furniture to homes, technological systems and buildings, are characterized by a utopian, visionary energy as well as a radically critical attitude towards conventional forms of social existence. *Slave City* is a comprehensive plan for a utopian city, from the urban layout to the architectural details of the buildings to the social and administrative structures. The city, intended for two hundred thousand inhabitants, is designed to be completely self-sufficient and eco-sustainable, capable of producing everything it needs within its boundaries, including energy from renewable sources and food from eco-sustainable cultivation. The rhythms and life cycles of its inhabitants are perfectly regulated according to set schedules. No waste is permitted; everything is recycled in a system that even includes recycling of the bodies of the dead – or of non-productive individuals – to generate energy. To achieve this goal, *Slave City*, as the name itself indicates, nonetheless deprives inhabitants of personal liberties. The work, consisting of dozens of mock-ups, drawings, functional diagrams and scenes of everyday life, is a critical reflection on the risks latent in any ideological construction, even an apparently 'positive' ecological one. (b.p.)

Atelier Van Lieshout was founded in Rotterdam in 1995.

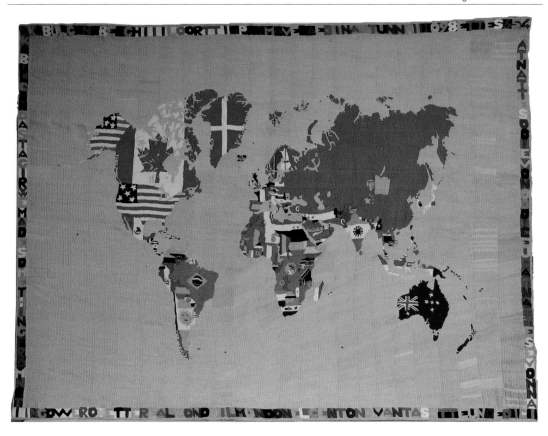

**Alighiero Boetti**
— *Mappa*, 1972-1973, hand-embroidery on linen,
163 × 217 cm, MAXXI – Museo nazionale delle arti del XXI secolo.

"I haven't done anything, I've never chosen anything, in the sense that the world is the way it is and I didn't design it; flags are what they are and I didn't invent them; in short, I've done absolutely nothing: when the underlying idea – the concept – springs up, the rest is not a matter of choice". So said Alighiero Boetti in a 1973 interview in reference to his *Mappe*, large planispheres embroidered in Afghanistan according to local craft traditions, which quickly became his best-known and most emblematic works. Each map blends order and disorder, chance and necessity: geography and geology, the immutable shapes of continents and oceans and the eternal order of Nature and cosmic and geological time are mixed with the muddle of history and the unpredictable upheavals of politics, represented by flags that mark the perimeters of nations and their inexorable shifts. Thus each map clearly shows how Boetti's approach is based on a structural conception, a serial process that actively regulates itself, welcoming the inevitable effects of time as well as the accidental marks and errors of slow handcrafted production. A familiar image – like the geo-political maps we can find hanging in the classrooms of innumerable schools – thus becomes a precious tapestry in which a reflection on the long duration of the Earth and the brief interlude of human existence, the enigmatic relationship between the material dimension of life and its symbolic imprint, is woven in filigree. (s.c.)

Born in Turin in 1940, died in Rome in 1994.

**Flavio Favelli**
— *Carta d'Italia Unita*, 2010, 59 sheets of Touring Club Italiano maps of Italy, 1:250,000 scale, wood, map mounted on 16 wood panels 138 × 120 × 3 cm, loaned by the artist.

In his works, Flavio Favelli re-composes fragmented individual and collective memories, using the process of collage and composition to find new and updated meanings in images and symbols, which he re-contextualizes in a contemporary perspective. Objects, furnishings and architectural fragments make up installations and spaces in which the visitor perceives a sense of something familiar, of recognition, but one that goes beyond captions or descriptions, opening up a further, evocative mental dimension. *Carta d'Italia Unita* is made up of an early-twentieth-century road atlas of Italy that has been taken apart and put back together in the shape of the outline of the Italian peninsula, in 1:250,000 scale. The result is a gigantic map that fits together like a puzzle; an attempt to put back together what remains of our sense of national unity, with a conceptual and political value. As often occurs in the artist's work, memory takes on an existential dimension – as well as a political one, in this case – defining an identity by dredging up and utilizing ordinary elements.  (b.p.)

Born in Florence in 1967, lives and works in Savigno (Bologna, Italy).

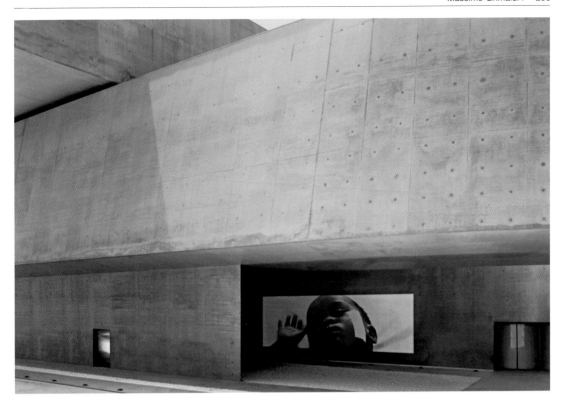

**Massimo Grimaldi**
— *Emergency's Paediatric Centre in Port Sudan Supported by MAXXI*, 2010, video projection, DVD, DVD player, projector, room-size, MAXXI – Museo nazionale delle arti del XXI secolo.

*Emergency's Paediatric Centre in Port Sudan Supported by MAXXI*, a project by Massimo Grimaldi, won the public competition which the MAXXI organized based on Legal Regulation 717/49. Also known as the "2 percent law", the regulation sets aside two percent of the cost of new public buildings for works of art. Grimaldi's project utilizes the competition's funding to construct a paediatric hospital managed by the association Emergency in Juba, Sudan. The artist will photograph or commission photography of the hospital's construction as well as its daily activities upon completion. The images will be projected on one of the external walls of the museum in a continuous cycle. As in his other projects, which have raised large amounts of money for Emergency's humanitarian efforts, Grimaldi poses questions which move from an institutional critique of the system of art to a deeper reflection on the principles of reality and function. In a process of subtraction, function becomes a concrete gesture with conceptual and ethical implications. In his project for the MAXXI, a new architectural entity (the museum) generates another (the hospital) through an artistic process which calls into question the functions and values on which the institution is based. In the words of the artist, "the success of a work becomes the historic failure of what it believed itself to be".
(b.p.)

Born in Taranto in 1974, lives and works in Milan.

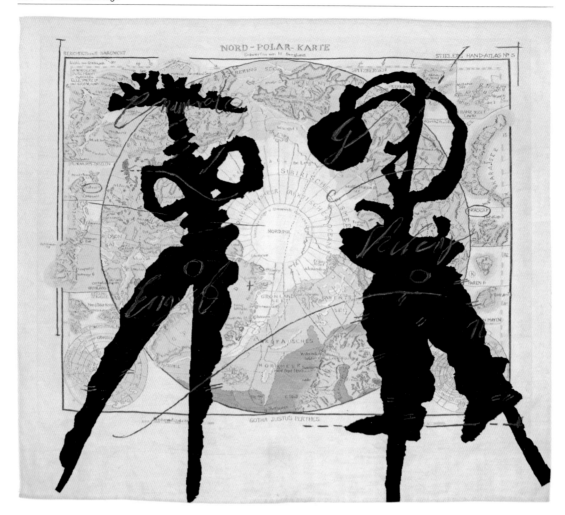

**William Kentridge**

— *North Pole Map*, 2003, embroidered silk tapestry, 340 × 390 cm, MAXXI – Museo nazionale delle arti del XXI secolo.

An artist, filmmaker and theater director, William Kentridge is a modern-day storyteller. Using traditional expressive means like charcoal, pastels, gouache, engravings, shadow theatre and anamorphosis, the artist explores current events, especially in his native South Africa; yet his sensitive and visionary use of imagery gives his work universal meaning. The artist often creates sketches that become the basis for animated short films and video installations, evoking the magic lantern shows of the past rather than relying on modern special effects. *North Pole Map*, however, is a tapestry made in a South African workshop from the artist's design. The silhouettes of two large dark shapes stand out against the background of an antique map, facing each other in elegant movement. They are phantasmagoric, metaphoric, dream-like figures whose journey or exodus has the rhythm of a dance. Shadow theatre is one of the recurring elements in Kentridge's work. It is as if shadows, so mobile and ephemeral, have the power to reveal the profound and authentic nature of reality. Another recurring technique is that of drawing on pages from old books. The graphic symbols therein become part of his work. The sensations of images and thoughts that emerge from a specific background become tangible. Expressive energy and poetic and symbolic power emanate from this artist's work. (g.s.)

Born in 1955 in Johannesburg, where he lives and works.

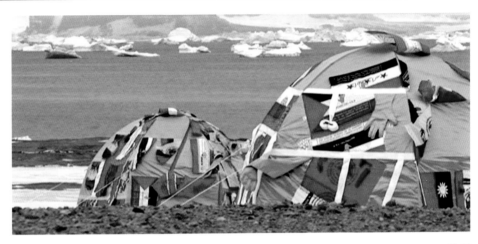

**Lucy + Jorge Orta**
— *Antarctic Village – No Borders. Dome Dwelling*, 2007,
installation: various fabrics, serigraph print, secondhand
clothing, aluminium frame, 2 elements, 180 × 180 × 150 cm.
— *Antarctic (Antarctica Diptych)*, 2007-2008.
MAXXI – Museo nazionale delle arti del XXI secolo.

For over fifteen years, Lucy + Jorge Orta's work has dealt
with the theme of global emergencies: humanitarian and
environmental crises, the deterioration of cities and of social
cohesion, nomadism and mobility, sustainable development
and ecology, intercultural dialogue. Through performances,
group actions, planning and production of apparently
functional objects, laboratories and prototypes and
publications, the Ortas fit into the category of the sort of
"political aesthetic" that deals directly with social and
humanitarian themes; their strategy has them working
simultaneously on a symbolic level as well as a more
concrete one of denunciation, sensitization and intervention.
The *Antarctic Village – No Borders* project is part of the
broader *Antarctica* project, divided into a series of actions,
installations and objects on themes characteristic of these
artists, including diaspora and free circulation of peoples,
climatic/environmental threats and lack of resources. In April
of 2007, the artists made an actual expedition in the
Antarctic, where they created a temporary village of about
50 tents they had designed. Here, the Antarctic is intended
as a non-territorial place that allows for free circulation of
peoples and, at the same time, as a symbol of the global
environmental threat. (b.p.)

Lucy Orta was born in Sutton Coldfield (England, UK) in
1966; Jorge Orta was born in Rosario (Argentina) in 1953.
They live and work in Paris.

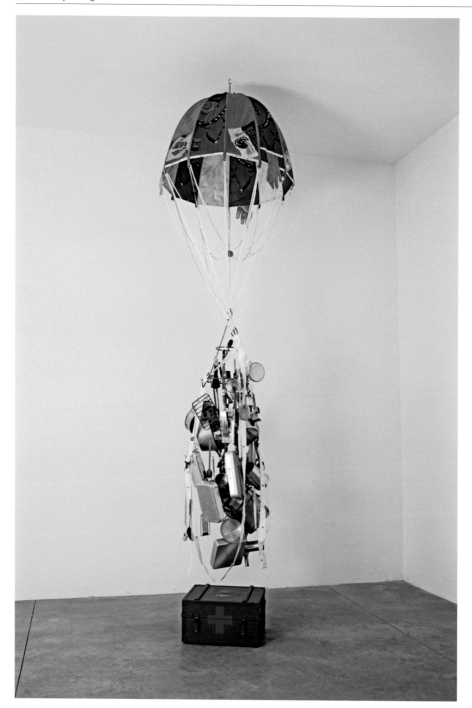

**Lucy + Jorge Orta**
— *Antarctic Drop Parachute*, 2007.
MAXXI – Museo nazionale delle arti del XXI secolo.

**Thomas Ruff**
— *M.D.P.N. 02*, 2002, c-print on paper mounted on aluminium, 186 × 297 cm, MAXXI – Museo nazionale delle arti del XXI secolo.

One of the foremost exponents of Düsseldorf's 'objective' school of photography, Thomas Ruff develops a systematic, both visual and conceptual exploration of the contemporary visual landscape in his series, captured in its often radically heterogeneous aspects (architectural photography, portraiture, pornography, televised images, scientific illustrations). These two photographs are part of a 2002 series dedicated to an interesting example of Italian rationalist architecture, the Fish Market in Naples, built between 1929 and 1934 on a design by Luigi Cosenza. Here the artist works in two different and complementary ways: in the first image, a documentary, frontal and impersonal view of the building prevails, in keeping with the lessons Ruff learned from his maestros Bernd and Hilla Becher, highlighting both the formal qualities of the building and the impact of time, usage and the surrounding urban environment on its abstract geometries. In the second photo, obtained through superimposition and digital elaboration of two different shots, the interior space is recreated in such a way as to accentuate its evocative characteristics, bringing to light the traces of an architectural memory that reaches back from modernism to the monumental fantasies of Étienne-Louis Boullée, such as the famous plan for the Bibliothèque du Roi (1785). (s.c.)

Born in Zell am Harmersbach (Germany) in 1958, lives and works in Düsseldorf.

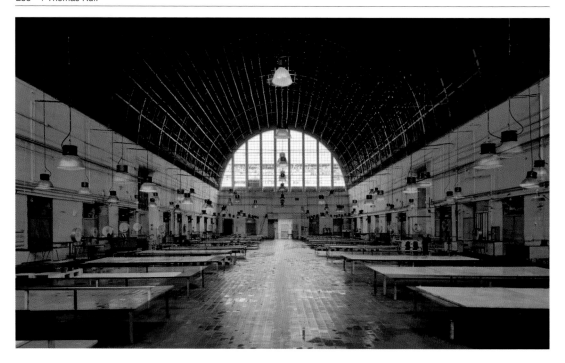

**Thomas Ruff**
— *M.D.P.N. 32*, 2003, c-print on paper mounted on
aluminium, 186 × 297 cm.
MAXXI – Museo nazionale delle arti del XXI secolo.

**Luca Vitone**
— *Sonorizzare il luogo (Grand tour)*, 1989-2001,
iinstallation: 20 laser-engraved birch wood bases,
79 × 37 × 37 cm, 20 loudspeakers with power units, digital
recorder, room-size, MAXXI – Museo nazionale delle arti
del XXI secolo.

Since the end of the 1980s, Luca Vitone has replaced the
parameters and instruments of traditional cartography with
other elements dictated by a physical and cultural
experience cf places that allows him to represent them in
alternative ways. For the artist, attention to the place and
the context defines individual and collective identity,
establishing an orientation to being in the world. It is a map
of experience that takes its cues from a topological loss, a
sense of existential disorientation linked to the
transformation of the notion of place in our contemporary
age. *Sonorizzare il luogo* is an installation in which different
Italian regional musical traditions are utilized to reconstruct
a sort of sound map of folk cultures which, while slowly
dying out, still coexist in our country. Along the perimeter of
the room, wooden silhouettes are arranged, each carved
with the outline of a region and emanating recorded songs
or musical pieces. As often happens in Vitone's work,
minority cultures or groups or subordinate social strata –
those who are in some way 'subjugated' – become the
protagonists of an archeological operation that aims to bring
traditions and differences back to light, redrawing a map of
memory. (b.p.)

Born in Genoa in 1964, lives and works in Milan.

**Lawrence Weiner**
— Catalogue 936, Nestled within Some Stones Covered with Whatever is at Hand; Used for & Used In a Manner Not Quid Pro Quo... , 2008, PVC, wall installation, room-size, MAXXI – Museo nazionale delle arti del XXI secolo.

From the end of the 1960s on, Lawrence Weiner has been one of the most coherent and radical proponents of the dematerialization of the work of art and its metamorphosis into a process of a purely mental nature. His entire career has been based on the idea that verbal language can be used as an actual sculptural material, to be employed in different formats and contexts, from architecture to books, from films to songs. His most characteristic works are presented as statements, phrases of various lengths 'printed' in large dimensions on walls, suggesting ideas, events and actions that the spectator is called upon to re-compose and complete on the basis of imaginary narrations or landscapes. In this installation the artist takes his cues from the ancient and Renaissance history of Rome, re-evoking a culture and an urban context through free association of English and Latin phrases printed inside rectangles linked by a curlicue, all with a subtly ironic tone, as in the case of quid pro quo (that is, a more or less equitable exchange of favors) or the proverbial Virgilian verse si parva licet componere magnis repeated like a refrain or a bass line around the perimeter of the room. (s.c.)

Born in New York in 1942, where he lives and works.

## Bernard Khoury – Untitled

As an ultimate act of resistance to a falsified history in which we have become passive actors, we are capable of inventing the tools that can derail Beirut as an object of innumerable fantasies, overturning sensational stereotypes and denouncing the ruse of exoticism.

We propose to draw an infernal circuit in which the sensation-driven tourists seeking instant gratification are propelled in a predetermined course. Like passive projectiles, the tourists are placed in a hermetically lethargic situation and are inscribed in the neocolonialist clichés, the fetishized scars of our interminable conflicts, the sublime sonic and visual cacophony of the city as well as in the flagrant contrast of a supposed modernity in a stagnant Eastern society. All are objects of our history's representations that escape us. Beirut becomes an exotic amusement park, destined to be consumed and immortalized through postcards that will hopefully be deemed historical waste.

*Bernard Khoury*

## Bernard Khoury

— Bernard Khoury's work takes shape and inspiration from the city of Beirut, where the architect was born and lived until 1986, when he moved to the United States to study. He returned to Lebanon in 1993, shortly after the end of the conflict that had monopolized media attention for 15 years, feeding the world a superficial and sensationalist view of the city.

The Lebanese conflict involved about thirty nationalities in various ways, primarily the ethnic groups that have always lived there, from Druze to Maronite Christians, from Shiite Muslims to Palestinians – a multi-ethnic mosaic that falls together to create the current face of Beirut, a city of paradoxes, where post-war reconstruction has all too often focused on grand, speculative projects intended above all to erase, in one fell swoop, the painful traces of the past. Khoury has been radically opposed to this dynamic since his first project, *Evolving Scars* (1991), an experimental, never-realized proposal for a 'conscious' recuperation of buildings damaged during the war. Two vitreous layers wrap around a ruin as a mechanism gradually demolishes it, transferring a selection of findings into the space isolated by the glass. A provocative idea intended to use an architectural 'performance' to reiterate the need to preserve historical memory, in spite of the prevailing denial of it. On the other hand, as stated by the voice narrating Chris Marker's 1962 film *La Jetée*, set in post-WWII Paris: "Nothing distinguishes memories from other moments; only later will they allow themselves to be recognized by their scars".

Despite the continuous destructions and reconstructions it has had to undergo over the years, Beirut is still an absolutely dynamic city 'fighting' to restore a long-lasting normalcy. As Samir Kassir writes: "Is the war forgotten? Every day, but also at no time. You may face a lone sniper's bullets passing through an unsecured street to get to a concert on time. Or see a car bomb explode on your way to the supermarket. Be exposed to howitzer fire going to the beach. Above all, you might never come back from where you're going, but you go there anyway [...] Perhaps this is what is so enthralling about Beirut, because life grits its teeth in the face of all the scars, and because the city, even in ruins, is still a city..." (Samir Kassir, *Histoire de Beyrouth*, Fayard, Paris 2003).

Here, leisure-oriented architecture (discos, restaurants and shopping centers) takes on a particular symbolic and civic importance, capable as it is of highlighting shared aspirations rather than differences, regardless of religious creed or ethnic group.

Khoury's subsequent projects, however, exalt contradictions rather than veiling them. Irony and disenchantment are his design materials, his stylistic mark. Hence, private commissions, free from the limitations imposed by institutional – and thus abstractly political – requirements, become one of the best instruments for transforming architecture into an act of general critique. The buildings that gave Khoury international recognition, both built in Beirut, fall into this category: the *B018* disco and *The Central* restaurant. *B018* was realized in 1998 and is located near Beirut's port in an area that was completely destroyed during the civil war, and in an earlier era, under the French protectorate, had been designated to host quarantine ships' crews. It is a hypogeum construction that communicates with the exterior world only through its roof of heavy iron slabs, which can be opened or closed by hydraulic mechanisms as needed. It is a monument to the place, and at the same time a reassuring treasure chest intended to preserve the essence of the city's nightlife.

*The Central*, realized in 2001, is in the middle of the historic city center, right next to the green line, the no-man's-land that divided Beirut into sectors controlled by various militias. Here, in the city's most history-laden zone, extremely violent clashes took place. Khoury recuperated a 1920s building, deeply scarred by the conflict, literally imprisoning it in a cage of reinforcement beams surmounted by a glass surface. In this way, a simple fragment of history is highlighted, and also brought back to collective community life.

The Lebanese architect's installation for MAXXI is a bomb-shaped capsule large enough to hold a man. It is a prototype, in which a hypothetical tourist would ideally be hurled in a loop-the-loop over the amusement park of the ruined city. With this action, Khoury reiterates his rejection of the idea of war-centered exoticism that the West continues to embrace with regard to Lebanon and the Middle East in general. The association between the bomb and the Western thrill-seeker critically underlines the idea that both categories pertain to an extrinsic system of abuse of power that favours maintaining the status quo; in fact, the two are equivalent in terms of their dangerousness and their capacity to damage the city in all its forms and aspirations. (a.do.) (e.g.)

## Untitled

### Bernard Khoury

Concept: Bernard Khoury in collaboration with Yasmine Almachnouk
Production: DW5 / George Daou, Ryan Mhanna

Bernard Khoury (Beirut, 1968), after graduating with a degree in Architecture from the Rhode Island School of Design, earned a Master of Architectural Studies at Harvard University in 1993.
Co-founder of the studio Beirut Flight Architects, he has realized projects for Beirut, Dubai, Kuwait, Berlin and the U.S.
In 2001, he earned a special mention in the young architects' section of the Borromini Prize in Rome for his plans for the *B018* disco in Beirut (1998). He received the Architecture + Cityscape Award in 2003. That same year, the International Forum for Contemporary Architecture organized a solo exhibition for him at the Aedes Gallery in Berlin (2003).
www.bernardkhoury.com

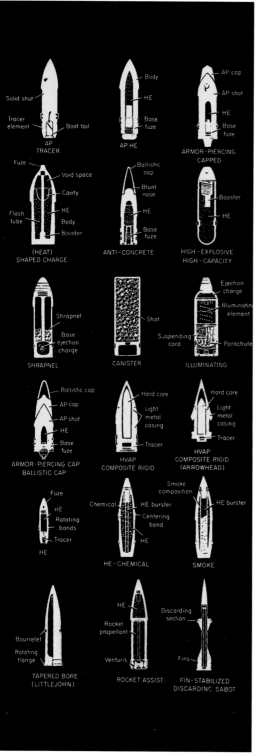

# Recetas Urbanas – Camiones, Contenedores, Colectivos

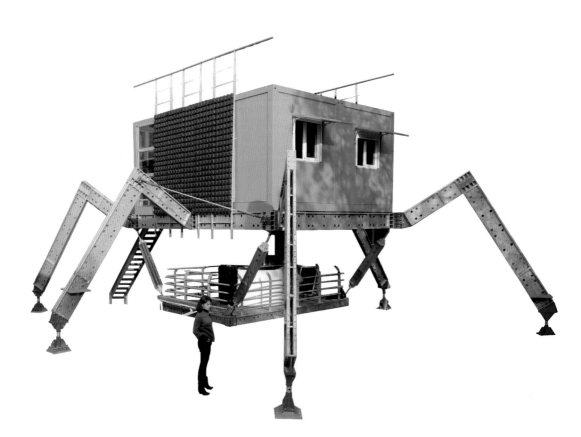

## Camiones, Contenedores, Colectivos

— *Camiones, Contenedores, Colectivos* (Trucks, Containers, Collectives) stems from an exceptional opportunity in the heritage of street furniture recovery: a series of housing-containers handed over by the Municipal Society for Urban Rehabilitation of the City Hall of Saragossa, for different collectives, associations and citizen groups to use.

Although around thirteen activist collectives have been involved in re-using containers up until now, using self-construction as one of their weapons of participation, polls and contacts made over the past two and a half years of intense work have not been limited to just these collectives. The initiative's success and viral expansion show the importance of self-management processes as supplements or proposals for social and political work different from that of the Establishment, which attempts strictly to control and capitalize on any citizen activity.

The range of situations experienced so far is wide and heterogeneous. First and foremost, the groups involved in the experiment stem from very diverse fields. Some of them are linked to alternative education, such as the cooperative La Fundició and the youth collective SpaiDer3*, while others are creative networks such as Alg-a or cultural associations such as Caldodecultivo. There are activist groups, such as the collective Todo por la Praxis or Alien Nación, and unconventional architectural studies such as Straddle3 or ourselves. In addition to these and other collectives, there are people from institutions who have supported the creation of spaces granted to residents, with a greater or lesser degree of autonomy.

The wide range of case studies for projects carried out goes beyond the diversity of promoters in order to show different ways of operating, constructing and managing spaces in very diverse situations, thus involving different types of occupation and agreements, funding and management and relationships with surroundings and the context.

### Re-use

Coincidentally, after a lecture I gave at the Official College of Architects in Saragossa on February 15, 2007, Juan Rubio del Val, from the Municipal Society, told me that a village was being dismantled and that fourteen 42-square-meter residences would be vacated, and whose fate would most likely find them in the scrap yard. These residences, each built with three prefabricated modules, had been temporary shelters for a Gypsy population that was eventually re-lodged in government-subsidized housing.

On March 1, 2007, Urban Prescriptions started taking the necessary steps towards offering different assemblies, cooperatives, collectives and associations the possibility of obtaining containers, free of charge, so that they could build their own residences and/or work areas. The groups who would use these modules would have to be in charge of transporting and installing modules as well as the

paperwork involved in obtaining licenses and permits. Urban Prescriptions would collaborate in fitting them out, and we would offer the possibility of including technical justifications for their legalization, installation projects and the civil liability insurance policy of the author who is currently writing.

On March 12th, only two weeks later, the first trucks were on their way to Vigo with six containers, and another six were on their way to Castellon. The following week, new trucks set off for Valencia with six containers and another eight for Barcelona. On May 3rd, twelve containers left for Seville, and the following day we picked up the last module, bound for the same city.

Within only two months, the majority of housing-containers had left Saragossa; some were to be temporarily stored while others were to be installed at once, however indefinitely, in often risky and at times uncertain situations.

### Occupation

In reality, none of the *Camiones, Contenedores, Colectivos* projects were easy to get off the ground, and we have all learned a lot from it. In most cases, collectives, like Alg-a, joined the initiative with enthusiastic alacrity and picked up the containers without even knowing where they were supposed to go. Once the modules had been received, there remained a greater challenge: to obtain a plot of land and negotiate temporary or peremptory occupation so that each of the spaces could germinate and grow.

The occupations have been an arduous and controversial task where opportunity has played a fundamental role. At one end of the scale, we have experienced cases such as that of Alg-a, which involved occupying private parcels in scenic, rural areas by means of verbal agreement with their owners (Park-a-part, Nautarquia, AlgaLab). At the other end, we have occupations of public plots of land or buildings (Künstainer, el Niu, Socio-cultural Centre in Castuera, Estudio las Arañas) in urban settings by means of agreements with the public administration, which lie between "a-legality" and what we call "induced legality". At times both situations have overlapped, as in the case of Park-a-part from Straddle3. Before being able to transport and establish the modules in Arbucies, an area in which a verbal agreement was being negotiated for the occupation of part of a private plot, we had to resort to our emergency measures and use the containers for an urban art festival in order to gain time.

In addition to these occupations, whether legal, a-legal or awaiting legality, we have had highly urgent cases in which we have been obliged to fall into illegality. This occurred with the occupation carried out for the Education Centre in La Cañada Real with the collective Todo por la Praxis and the Church of Santo Domingo de la Calzada. Similar was the case of the successive unlawful occupations which saw containers being moved and transported various times for the self-run educational space SpaiDer3*. Their promoters, La Fundició Co-operative, took the risk of acting in this way with the hopes and the will of legalising the space in the

future. Unfortunately, efforts to achieve legal occupation and negotiations with institutions culminated in the local police removing the containers the day before the municipal elections – just when they were about ready to be lived in.

<div align="right">Santiago Cirugeda Parejo</div>

---

**Camiones, Contenedores, Colectivos**

**Recetas Urbanas**
Materials: recycled containers, metal structure and other building materials
Sponsor: Rehasa

---

The leader of Recetas Urbanas, Santiago Cirugeda Parejo (Seville, 1971), studied architecture in Barcelona and in Seville, where he lives and works.

Since 1996, when he began working, he has realized numerous projects shown in international group exhibitions, including: *Research Room*, Manifesta 4, Frankfurt (2002); *Crossroads of n° 11 creation, Design and habitats*, Centre George Pompidou, Paris (2003); *Utopia Station*, 50th Venice Biennale of Architecture, Venice (2003); Biennial of Architecture, Rotterdam (2003 and 2007); Moscow Biennial (2005).

He had two solo exhibitions in 2007: *Quiero una casa*, Borgovico 33, Como and *Urban Disobedience: The Work of Santiago Cirugeda*, New York Institute of Technology.

Also in 2007 he published the book *Situaciones urbanas*, Tenov Editorial.
www.recetasurbanas.net

**3**

Zaragoza
02 - 2007
**42** contenedores

**4**

MARTORELL
Ayuntamiento
Martorell
04 - 2007
**6** contenedores

**5**

INTERFERENCIAS
Barcelona
07 - 2007
**6** contenedores

**6**

EUTOPIA '07 - Córdoba - 09-2007

**7**

SPAIDER
LaFundició
Esplugues
01 - 2008
**3** contenedores

ALG-A LAB
Alg-a
Vigo
04 - 2008
**6** contenedores

PARK-A-PART
Straddle3
Arbucies
06 - 2008
**3** contenedores

SOLAR C/ OLIVAR - Madrid 06-2008

KÜNSTAINER
Caldodecultivo
Tarragona
06 - 2008
**3** contenedores

GRADA Cañada Real Madrid 06-2008

FANC '08 - Arbucies - 08-2008

EL NIÚ
El Bólit + RU
Girona
09 - 2008
**4** contenedores

NAUTARQUÍA
P.E.L.I
Sant Pere de Torelló
09 - 2008
**3+2** contenedores

CASA SALU
Salu Lopez
Sevilla
10 - 2008
**5** contenedores

ARAÑA
Recetas Urbanas
Sevilla
05 - 2009
**2** contenedores

La socialización del arte
Expo Iniciarte
09-2009

ARAÑITA
Straddle3 + RU
Sant Pere de Torelló
09 - 2009
**1** contenedor

Paraderos y Parasectores - Sant Pere de Torelló - 09-2009

TALLER
Todo x Praxis + RU
Cañada Real
11 - 2009
**2** contenedores

CACHARRO 2.0.
Straddle3 + RU
Cáceres
11 - 2009
**2** contenedores

PRÓTESIS
Proyecta + RU
Benicasim
04 - 2010
**6** contenedores

Arquitecturas Colectivas - San Sebastián - 07-2010

Recetas Urbanas
Gandía
09 - 2010
**4** contenedores

Proyecto con Contenedor

Otro Proyecto

Producción de Materiales

Encuentro de Colectivos

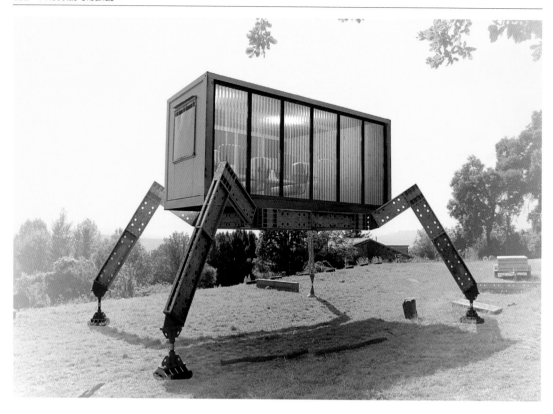

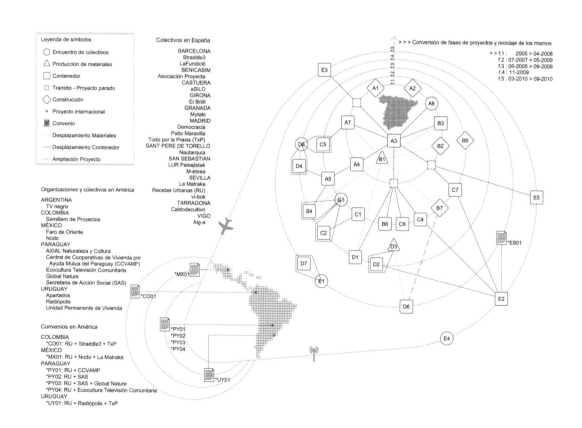

Leyenda de símbolos

○ Encuentro de colectivos

△ Producción de materiales

☐ Contenedor

☐ Transito - Proyecto parado

◇ Construcción

• Proyecto internacional

▧ Convenio

—— Desplazamiento Materiales

----- Desplazamiento Contenedor

-·-·- Ampliación Proyecto

Organizaciones y colectivos en América

ARGENTINA
    TV negra
COLOMBIA
    Semillero de Proyectos
MÉXICO
    Faro de Oriente
    Nodo
PARAGUAY
    AXIAL Naturaleza y Cultura
    Central de Cooperativas de Vivienda por
        Ayuda Mutua del Paraguay (CCVAMP)
    Ecocultura Televisión Comunitaria
    Global Nature
    Secretaria de Acción Social (SAS)
URUGUAY
    Apartados
    Radiópolis
    Unidad Permanente de Vivienda

Convenios en América

COLOMBIA
    *CO01: RU + Straddle3 + TxP
MÉXICO
    *MX01: RU + Nodo + La Matraka
PARAGUAY
    *PY01: RU + CCVAMP
    *PY02: RU + SAS
    *PY03: RU + SAS + Global Nature
    *PY04: RU + Ecocultura Televisión Comunitaria
URUGUAY
    *UY01: RU + Radiópolis + TxP

Colectivos en España

BARCELONA
    Straddle3
    LaFundició
BENICASIM
    Asociación Proyecta
CASTUERA
    aSILO
GIRONA
    El Bólit
GRANADA
    Mytaki
MADRID
    Democracia
    Patio Maravilla
    Todo por la Praxis (TxP)
SANT PERE DE TORELLÓ
    Nautarquía
SAN SEBASTIÁN
    LUR Paisajistak
    M-etxea
SEVILLA
    La Matraka
    Recetas Urbanas (RU)
    vi-bok
TARRAGONA
    Caldodecultivo
VIGO
    Alg-a

> > > Conversión de fases de proyectos y reciclaje de los mismos

> > f.1 :    2005 > 04-2008
     f.2 : 07-2007 > 05-2009
     f.3 : 06-2005 > 09-2009
     f.4 : 11-2009
     f.5 : 03-2010 > 09-2010

# CONTENEDORES & COLECTIVOS
[PROYECTOS EJECUTADOS o EN PROCESO]

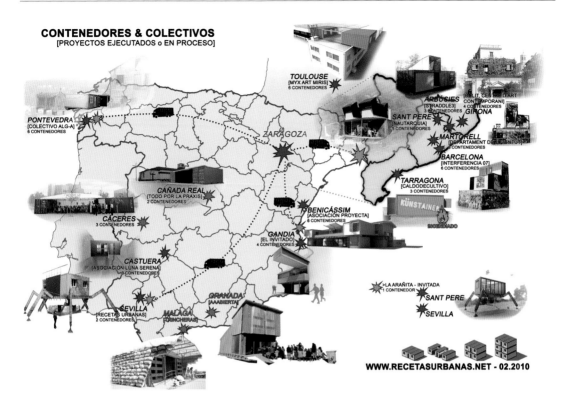

TOULOUSE
[MYX ART MIRIS]
6 CONTENEDORES

ARBÚCIES
[S'RADDLE3]
3 CONTENEDORES

[BÓLIT, CENTRE D'ART CONTEMPORANI]
4 CONTENEDORES
GIRONA

SANT PERE
[NAUTARQUIA]
5 CONTENEDORES

PONTEVEDRA
[COLECTIVO ALG-A]
6 CONTENEDORES

ZARAGOZA

MARTORELL
[DEPARTAMENT DE JOVENTUT]
5 CONTENEDORES

BARCELONA
[INTERFERENCIA 07]
6 CONTENEDORES

CAÑADA REAL
[TODO POR LA PRAXIS]
2 CONTENEDORES

TARRAGONA
[CALDODECULTIVO]
3 CONTENEDORES

CÁCERES
3 CONTENEDORES

KÜNSTAINER

INCENDIADO

BENICÀSSIM
[ASOCIACIÓN PROYECTA]
6 CONTENEDORES

GANDIA
[EL INVITADO]
4 CONTENEDORES

CASTUERA
[ASOCIACIÓN LUNA SERENA]
3 CONTENEDORES

>LA ARAÑITA - INVITADA
1 CONTENEDOR
SANT PERE

GRANADA
[AAABIERTA]

SEVILLA
[RECETAS URBANAS]
2 CONTENEDORES

MÁLAGA
[TRINCHERAS]

SEVILLA

WWW.RECETASURBANAS.NET - 02.2010

# CASETAS PREFABRICADAS

Superficie util :       41,42 m2
Superficie construida :   43,59 m2
Peso aproximado : 4500 kg  ( 3 x 1500 kg )

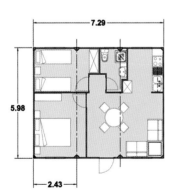

7.29

5.98

2.43

2.30

2.70

# The Scene
# and the Imaginary

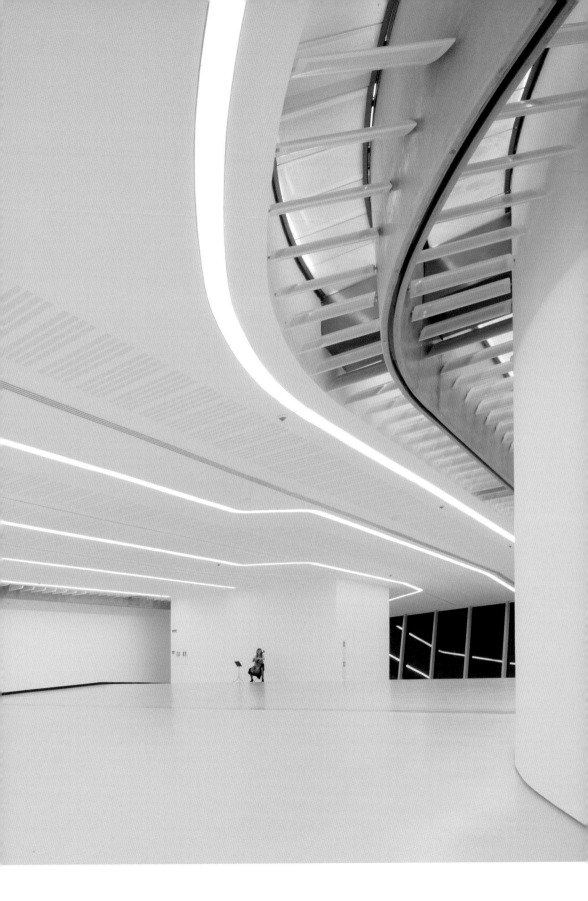

# Fabricated Worlds:
## The Architecture of Imaginary Space

Giuliana Bruno

The history of architecture is a history of spatial feelings.
*August Schmarsow*

The door... transcends the separation between the inner and the outer...
*Georg Simmel*

A window cuts out a new frame for looking. Walls put up barriers, but their borders easily crack. The perimeters of the room change into boundaries to be crossed. Doors open up new access, morphing into portals. Entrance way becomes gateway to an inner world. A mirror shows specular prospects for speculation and reflection. Objects of furniture turn into lively objects of an interior design. A bed tells sweaty stories of love, lust, and dreams. The couch can couch new forms of dialogue and exchange. A staircase takes us up to a whole new level of intimate encounter, and we rise and fall along with it. Well, to tell the truth, we mostly fall. But then a washing machine washes away the stain of pain. And, finally, the stovetop cooks up some great new life recipes. How can you resist? The offerings of this imaginary kitchen are deliciously hot. For here, in architectural space, you can taste morsels of the imagination.

In the galleries of the museum we can encounter imaginative forms of building, taste the imagistic power of architecture, and be seduced by imaginary space. A widespread phenomenon is taking place in contemporary art: it is melting into spatial construction, and, as a consequence, architecture has become one of the most influential forms of imaging. A virtual version of architecture is increasingly produced in visual representation, and we can witness creative architectural constructs and inventive ways of spatial thinking take shape on gallery walls, floors and screens. The visual arts are intertwined with a particular 'architecture': with our sense of space, urban identity and experience. They have become sites for the building of our subjectivity and the dwelling of our imagination. We may call this phenomenon a display of the "architectural imaginary". It is an alluring concept, yet one whose definition is not at all obvious or easy to pin down. I will reflect upon this notion and offer a conceptual navigational map of this particular space: along the way, we will encounter a vast cultural

'construction' that encompasses many realms of fabrication and layers of representation as it traverses the visual arts.

## Image and Imaging

What is an architectural imaginary? In unpacking its layers of meaning it is useful to begin by noting that image is inscribed in a spatial imaginary. Think of the city, whose existence is inseparable from its own image, for cities practically live in images. A city can be a canvas to be imaged and imagined, which is the result of a composite generative process that supersedes architecture per se and even actual building to comprise the way the place is viewed from a variety of perspectives. This includes the ways the city is rendered in different media: how it is photographed in still frames, narrated in literature as poem or tale, portrayed in paintings or drawings, or filmed and circulated in different forms of moving images. An image of the city emerges from this complex scenario: a process that makes urban space visible and perceivable. The city's image is thus creatively generated in the arts, and the city itself cannot but end up closely interacting with these visual representations, becoming to some extent the product of an artistic panorama.

If we consider the history of urban space, we can see that it is inextricably connected to artistic forms of viewing. The city became historically imaged in the visual arts when paintings of city views were effectively recognized as an autonomous aesthetic category. In the late seventeenth century, following a growing interest in architectural forms, a flurry of urban images emerged in art, making the city a central protagonist. *Vedutismo* was an actual "art" of viewing. View painting did not simply portray the city; it essentially created a new aesthetics and mode for seeing. The genre, as practiced by Dutch artists, gave rise to the "art of describing"[1]. This descriptive architectural gaze was intensely observational, and it developed further in later forms of urban observation. In the nineteenth century, the city re-entered the frame of art and enlarged its perimeter with panorama paintings. Perspectival frames exploded and expanded as the city filled the space of painting, extending it horizontally. Representing the life of the site in wide format, the urban panorama captured its motion in

1. See S. Alpers, *The Art of Describing: Dutch Art in the Seventeenth Century*, University of Chicago Press, Chicago 1983.

sequential vistas, narrative views, and more fluid time. In portraying the city as a panoramic subject of observation, these views contributed to establishing modernity's particular "way of seeing"[2]. Panorama paintings created "panoramic vision" and anticipated the work of pictures that would be brought about by the age of mechanical reproduction. With photography, it became possible to observe space at the actual moment it was captured. Later, with motion pictures, it became possible to map a spatiotemporal flow and fully experience a sense of space in visual art.

### The Architectural Imaginary: Collective and Collecting Images

The image of the city is as much a visual, perceptual construction as it is an architectural one. This is because in one sense a place can only be understood in its "imageability" – the quality of physical space that evokes an image in the eye of the observer[3]. Although it is important to acknowledge this visibility, the image of the city nevertheless should not be seen as singularly optical or construed as a unifying vision. An architectural image is not a unique view, a still frame or a static construct, for it endlessly changes, shifts, and evolves in representation[4]. Pictures and visions are constantly generated, and they, in turn, change the very image of the city. Art plays a crucial role in this process of constructing a mobile architectonics of space. Places are activated and constantly reinvented in art, which can give shape to a fictional universe of morphing fields and energetic alchemy. The fiction of a city develops along the artistic trajectory of its image-movement as cities become artistic afterimages on our own spatial unconscious.

This spatio-visual imaginary can only come into being across the course of time. An urban image is created by the work of history and the flow of memory. This is because the city of images comprises in its space all of its past histories, with their intricate layers of stories. The urban imaginary is a palimpsest of mutable fictions floating in space and residing in time. Mnemonic narratives condense in space, and their material residue seeps into the imaginative construction of a place. The density of historical and mnemonic interactions builds up the architectural

**2.** See S. Oettermann, *The Panorama: History of a Mass Medium*, trans. D. Lucas Schneider, Zone Books, New York 1997.

**3.** K. Lynch, *The Image of the City*, The MIT Press, Cambridge-London 1960.

**4.** Although Lynch pioneered a form of experiential understanding of the city, his view of the image of the city resulted in the unifying vision of "cognitive mapping". I argued for a different, fluid notion of the urban imaginary, more open to different forms of imagination, in my books *Atlas of Emotion: Journeys in Art, Architecture and Film*, Verso, London and New York 2002), and *Public Intimacy: Architecture and the Visual Arts*, The MIT Press, Cambridge-London 2007. On the architectural imaginary see also A. Huyssen, ed., *Other Cities, Other Worlds: Urban Imaginaries in a Globalized Age*, Duke University Press, Durham (NC) 2009; and J. Donald, *Imagining the Modern City*, University of Minnesota Press, Minneapolis 1999.

imaginary of a city. The process becomes visible in the visual arts, which are capable of capturing temporality and memory. Artworks can fabricate traces of existence and exhibit the sedimentation of time. In art, we can feel the texture of an image and the substance of place when layered forms come to be visible on the surface and mnemonic coatings become palpable to our sensing. The actual folds of history and the fabric of memory can thus be 'architected' in art, which can expose the density of time that becomes space.

In this sense, an architectural imaginary is a visual depository that is active: it is an archive open to the activities of digging, reviewing and revisioning in art. In this urban archive, doors are always unlocked to the possibility of reimagining spaces, and archaeology here is not simply about going back into the past; rather it enables us to look in other directions, and especially forward into the future, in active retrospective motion. This is because the urban archive contains more than what has actually occurred or already happened. It is made up of trajectories of image-making that are varied, some not yet existing or materialized, others not even achievable. This construct contains even the unbuilt or the unrealized. In other words, the urban imaginary contains all kinds of potentialities and projections, which are creative forms of imagination. It is this potentially projective form of imaging that creates new urban archaeologies in art and makes the visual matrix that is the city a moving one.

The image of a city is a moving one because it is also formed collectively as a product of cultural experience. It does not emerge or evolve as an individual act but rather depends on how the site is imagined and experienced by a collectivity, which is made of real and virtual inhabitants. As Walter Benjamin said, "streets are the dwelling place of the collective. The collective is an eternally unquiet, eternally agitated being that – in the space between the building fronts – experiences, learns, understands and invents"[5]. In this sense, architectural space is not only the product of its makers but also of its users, the consumers of space. And it is these users who have the power to activate it. Architecture per se does not move, but those who make use of it can set buildings, roads and sidewalks in motion. The street, in particular, can become such a moving structure. Siegfried Kracauer declared that "the street in the extended sense of the word is not only the arena

5. W. Benjamin, *The Arcades Project*, trans. H. Eiland and K. McLaughlin, Harvard University Press, Cambridge (MA) 1999, p. 423.
6. S. Kracauer, *Once Again the Street*, in Kracauer, *Theory of Film: The Redemption of Physical Reality*, Oxford University Press, New York 1960, p. 72.

of fleeting impressions and chance encounters but a place where the flow of life is bound to assert itself"[6]. A special traversal occurs on the urban pavement, and this is not simply a physical act but an imaginary activity. Structures themselves become perceptually mobilized as people traverse them, changing into transitory forms of imaging and fleeting places of encounter where the flow of life itself becomes architected.

As a form of collective image-making, the architectural imaginary is actually a product of social space. An outcome of experience and the forces of public agency, space is always the expression of social conditions, which can be externalized or transmitted, and subject to change in architecture. In this sense, an imaginary is a very real and material concept, which emerges out of substantial negotiations with the environment and built space. The abstract, imaginary power of architecture is an everyday reality, for architecture functions daily as the place where social relations and perspectives are modeled. Space provides a material kind of "modeling": it fashions our social existence. Our mode of social interaction and our position as subjects are affected by where we live. Architecture houses the multiple shapes of our diverse, quotidian, collective experience and figures their styles. It plays a crucial part in the fashioning of social forms of connectivity and in the actual modeling of intersubjectivity.

## The Urban Imaginary as Mental Image

If an imaginary is a collective image that is formed and transformed in the flow of social space, this process involves not only subjects but also subjectivities. In a seminal essay from 1903, *The Metropolis and Mental Life*, the German sociologist Georg Simmel gave a pioneering introduction to this essential component of the architectural imaginary when he saw the urban dweller as a subject partaking in a novel, destabilized form of subjectivity that proliferates on the urban terrain. Simmel conceived the city as an experiential site of interaction and a stirring place of intersection that produces intense sensory and cognitive stimulation. His city is a real experience; he pictures it as a subjective space of sensations and impressions, a place inundated by shifting representations:

"The psychological foundation, upon which the metropolitan individuality is erected, is the intensification of emotional life due to the swift and continuous shift of external and internal stimuli... the difference between present impressions and those which have preceded... the rapid telescoping of changing images, pronounced differences within what is grasped at a single glance, and the unexpectedness of violent stimuli... The metropolis creates these psychological conditions – with every crossing of the street, with the tempo and multiplicity of economic, occupational and social life – it creates... the sensory foundations of mental life"[7].

If we follow this view, architecture becomes experienced not only as exterior world. The city becomes a collectively lived experience that is internal as well as external – an affair of the mind. As the metropolis shapes the self and the dynamics of intersubjectivity, it creates "the sensory foundations of mental life". In the city we feel the rhythm of perceptual and mental processes and are immersed in the sensory ambience of representational flow with its "rapid telescoping of changing images". Our being in social space is dependent on our ability to sense and activate this mental space. Ultimately, the dynamics of the city evoke an inner force – the movement of mental energy.

## Conceptual Foundations

The "psychological foundation" upon which Simmel erected his argument permits us to dig the foundation for the conceptual construction of spatial imagination. The architectural imaginary, as it emerges in art, shows clear signs of psychic formation. This visualized city exists in physical space as a creative, mental figuration: it is a projection of the mind, an external trace of mental life. In other words, what we experience in art is architecture as a particular mental condition – a state of mind. In this sense, an architectural imaginary is much more than a cognitive space. A state of mind is, after all, an emotional place as well as a mental one. This aesthetic metropolis is an internal state of feeling. It rests on delicate psychic foundations in that it is built on that restless ground that is "the intensification of emotional life". Its

7. G. Simmel, The Metropolis and Mental Life, in G. Simmel, On Individuality and Social Forms: Selected Writings, ed. D.N. Levine, University of Chicago Press, Chicago 1971, p. 325.

effects are affects; its motion is an emotion.

In this imaginary site, "foundation" does not refer to a concrete pillar but rather stands for a mobilized psychosocial underpinning. To speak of an architectural imaginary, then, means to understand architecture in the broadest sense: as space, comprising images of built or unbuilt places that are part of a diverse collective practice marked by multiple histories, social perspectives and intersubjective imagination. Ultimately, an urban imaginary is this mental image: a form of representation of the way we imagine our lived space. This is an image of place that we carry deep within ourselves. It is a material mental map, redolent of mnemonic traces and energized by subjective experiences. In this sense, an architectural imaginary is a real inner projection. It is an interior landscape – a psychic map that is as moving as it is affecting.

## Aesthetic Connections and Relational Imaginaries

In the historical sense, the notion of an architectural imaginary is fundamentally a twentieth century concept that emerged with the theorization of modernity, to which Simmel, Kracauer and Benjamin all contributed. Architecture came to be conceived and understood as space only with the entrance of the modern era. Our modern concern with the inner projections of space, in particular, has a specific origin in German aesthetics, which produced psychological theories of *Raum* as space and place[8]. This discourse emerged in the late-nineteenth century as the findings of philosophical aesthetics, psychology and perceptual research were combined with art and architectural history to provide a theoretical framework to explain the human response to objects, images, or environments. One thinks in particular of the work of philosophers Theodor Lipps and Robert Vischer, and of the art historians August Schmarsow, Heinrich Wölfflin and Alois Riegl, among others[9].

These theories can help us dig further into the conceptual foundations of modern space, for they changed the aesthetic viewpoint on architecture in palpable ways. For example, from Schmarsow's theory of spatial creation, we have come to accept that the perception of space is not the product of the eye and of distance from a stationary building-form but a more kinetic affair

**8.** See H.F. Mallgrave and E. Ikonomou, eds., *Empathy, Form and Space: Problems in German Aesthetics*, 1873-1893, Getty Center for the History of Art and the Humanities, Santa Monica 1994.
**9.** On the emergence of space as a modern concept, see A. Widler, *Warped Space: Art, Architecture, and Anxiety in Modern Culture*, The MIT Press, Cambridge-London 2000.
**10.** For a useful summary, see M.W. Schwarzer, *The Emergence of Architectural Space: August Schmarsow's Theory of Raumgestaltung*, in "Assemblage" 15, The MIT Press, Cambridge-London August 1991, pp. 50-61.

produced in engagement with the built environment[10]. Architecture is a place activated by bodily movement and mobilized by concrete perceptual dynamics. It is particularly dependent on the sense of touch, which offers us the possibility of sensing our existence in space.

These properties of touch can also shape our relation to the art space. When tactility is culturally emphasized, a more spatial understanding of art can be achieved. Alois Riegl showed that art can extend beyond the optic into the haptic, a mode of perception based on the sense of touch[11]. Schmarsow, who expanded on Riegl's ideas of tactile art and the haptic perception while incorporating tactile sensations in space, arrived at a form of spatial thinking that engaged what he called "art architecture". A spatial imaginary – comprising a kinesthetic sensation of motion and sensory interaction – is the foundation of modern "art architecture".

The modern aesthetic rested on the understanding that a place, like an art object, cannot be separated from the viewer: the aesthetic experience is haptic when it tangibly establishes a close, transient relationship between the work of art and its beholder. After all, the term *haptic*, as Greek etymology tells us, refers to more than just touch, for it means "able to come into contact with". As a surface extension of the skin, then, the 'haptic' is that reciprocal con*tact* between the world and us that "art architecture" embodies.

Theodor Lipps also embraced the diminishing sense of aesthetic distance and added psychic closeness and exchange as further components of proximity to aesthetics. In his 1905 essay, *Empathy and Aesthetic Pleasure*, Lipps claimed that the reception of art is a process of encounter: it depends on the ability to sense an inner movement that takes place between the object and the subject[12]. Such movement is the basis of *Einfühlung*, or empathy, which is not only a psychic state of closeness and interaction but also a condition of pleasure. Ultimately, he conceived of empathy as a series of projections inward and outward, between that which moves in an art object and that which moves (in) the beholder.

What is particularly interesting about Lipps is that he joined art and architecture in significant psychic motion, thus providing a key to approach this confluence in contemporary art. If empathy is activated as a mimicry or transfer between the subject and his

11. For a discussion of Riegl's notion of the haptic in ancient art and of the different uses of haptic in theories of modernity, see M. Iversen, *Alois Riegl: Art History and Theory*, The MIT Press, Cambridge-London 1993.
12. T. Lipps, *Empathy and Aesthetic Pleasure*, in Aesthetic Theories: Studies in the Philosophy of Art, ed. K. Aschenbrenner and A. Isenberg, Prentice Hall, Englewood Cliffs, NJ 1965. See also "Aesthetische Einfülung", in *Zeitschrift für Psychologie und Physiologie der Sineesorgane 22*, J.A. Barth, Leipzig 1900.

surroundings, the boundaries between the two can blur in close aesthetic encounter with the art space. In this view, one can empathize with the expressive, dynamic forms of art and architecture – even with colours and sounds, scenery and situations – and these 'projections' include atmospheres and moods. In the end, aesthetics and empathy could then be joined in the very fabrication of architectural expression.

Following this theme, the art historian Wilhelm Worringer wrote of empathy as the enjoyment of self that is projected in an object or a form. In his book *Abstraction and Empathy*, he described this projective moving space:

> "In the forms of the work of art we enjoy ourselves. Aesthetic enjoyment is objectified self-enjoyment. The value of a line, of a form consists for us in the value of the life that it holds for us. It holds its beauty only through our own vital feeling, which, in some mysterious manner, we project into it".[13]

*Einfühlung* is, literally, a "feeling into" that can migrate. So empathy can be understood as a spatial transmission of affects – that transfer that we have identified as foundational for the architectural imaginary, and that informs a contemporary form of "art architecture".

### Contemporary Models of Art Architecture

Haptic space, kinesthetic motion, memories of touch, the inner movement of mental life and the psychic transfer of empathy have become key concepts for understanding our material world and building our modern sense of aesthetic space. Today we can experience this relational movement in the mobilization of space – both geographic and architectural – that takes place in the articulation of spatial art. When art joins architecture in this tangibly moving way, turning contact into communicative interface, it can construct real architectural imaginaries, for these are, indeed, about the movement of habitable sites and how, in turn, these movements shape our inner selves.

In contemporary art, architecture has become a definitive screen on which we sense the relational motion that places

13. W. Worringer, *Abstraction and Empathy: A Contribution to the Psychology of Style*, trans. M. Bullock, Elephant Paperbacks, Chicago 1997, p. 14.

inspire in us. Art shows ever more clearly that architecture is a generative matrix, visualizing its tactile construction as the collective product of a perceptual, mental, affective imaginary. Contemporary artists make particularly inventive use of architecture in this sense: for them, architecture is a fabricated construct, a tangibly constructed affair of the mind, whose task is to convey haptic, dynamic, imaginative space. Many artworks are now haptically conceived or drawn as maps of memory, fragments of lived space, states of mind, fluid inner and outer constructions. They require relational engagement from mobile viewers and empathy with spatial forms. In the visual arts, architecture is far from being abstracted space; rather it becomes the envelope, the skin of our inhabitation.

Here, the architectural imaginary shows itself as a fully habitable concept: a visual space of intimate fabrication, the very delicate fabric we live in.

# Platforms

David Joselit

## Conceptual Art 2.0

During the late 1960s art underwent a 'conceptual turn' as marked by watershed exhibitions in Europe and the United States such as *Live In Your Head: When Attitudes Become Form* (1969) at the Kunsthalle Bern, and *Information* (1970) at the Museum of Modern Art in New York. This first era of conceptual art was marked by a tendency to establish direct analogies between art and information. Dan Graham's work, *Figurative* (1965), consisting of a found cash register receipt with its total cropped out, is exemplary. *Figurative's* play on the double meaning of *figure* – as both a 'numeral' and a 'body' – emerged wittily when it was published between ads for women's hygiene products and underwear respectively in *Harper's Bazaar* in March 1968. In this context, the numerical figure was juxtaposed, and therefore implicitly associated with, commodities dedicated to the care and discipline of femininity as represented by tampons and brassieres. As in so many works of conceptual art made during the late 1960s and 1970s, information, in the form of numbers, language, or photomechanical reproduction, was found to be fungible, subject to easy translation (or liquidity) between two distinct states.

We are now in a second era of conceptual art, which might, in a nod to the parlance of software, be called *Conceptual Art 2.0*. Here the translation of information from one form to another (which during the 1960s corresponded to the rise of computers and the great postwar cybernetic age) has branched and multiplied into the distributed network of the Internet. Instead of a bilateral translation from one form into another (i.e., from the *figure* of a woman, to the *figure* of a cash receipt) the possibility for multilateral and simultaneous translations and remediations[1] are now legion. In his important book *The Culture of the New Capitalism* sociologist Richard Sennett demonstrates how this shift has affected business enterprises under global capitalism. He compares these structures to an electronic device – the MP3 player:

"This new [business structure] performs like an MP3 player. The MP3 machine can be programmed to play only a few bands from its repertoire; similarly, the flexible organization

**1.** See J. D. Bolter and R. Grusin, *Remediation: Understanding New Media*, The MIT Press, Cambridge-London 2000.

can select and perform only a few of its many possible functions at any given time. In the old-style corporation, by contrast, production occurs via a fixed set of acts; the links in the chain are set. Again, in an MP3 player, what you hear can be programmed in any sequence. In a flexible organization, the sequence of production can also be varied at will... Linear development is replaced by a mind-set willing to jump around"[2].

Sennett identifies an informational logic characteristic of the age of search engines like Google or Yahoo. The MP3 player is an effective metaphor for corporations because it exhibits two important qualities: first, an over-capacity for information storage, and second, the potential to access infinitely flexible configurations of information (in the shape of songs or video in the case of the MP3 player). Electronic tools such as this one, as well as large networks like the Internet, consequently enable dizzying jumps from one thing, or fact, to another. Think of typing any word into a search engine like Google – the results will inevitably be diverse and disconnected, making the kind of 'poetic' association that existed between Graham's *Figurative* and the ads that framed it in *Harper's Bazaar*, but to the nth degree.

The MP3 player of Sennett's analogy is a certain kind of digital *platform* which, for the purposes of this essay, I will define as an apparatus dedicated to converting raw information or data into a particular meaningful message or informational 'object'. Google is a platform in the sense that its algorithms organize data in numerically precise ways, but not all platforms are digital. Indeed, platforms not only serve as models for contemporary business enterprise, *pace* Sennett, but they also offer models for contemporary art under the conditions of *Conceptual Art 2.0*.

Platforms

As curator of Documenta 11 (2002), one of the world's most prestigious international art exhibitions, Okwui Enwezor traveled the world organizing five *platforms*[3]. Taken together, these symposia in five world cities expanded art's public, and

2. R. Sennett, *The Culture of the New Capitalism*, Yale University Press, New Haven 2006, pp. 47-48.
3. Documenta is held every 5 years.

Documenta's reach, beyond the confines of Kassel, its mid-size German host city. Each platform included the primary constituencies of contemporary art – artists, scholars and community representatives: "In proposing the five platforms that make up our common public spheres we have above all else been attentive to how contemporary artists and intellectuals begin from the location and situation of their practice"[4]. A platform, in Enwezor's terms, unlike totalizing models of power such as 'capitalism' or 'democracy' is a public space which is finite, local and site-specific. But like computer terminals that function as discrete portals onto open networks, Documenta's platforms were oriented toward a wider world. In other words, a platform is a conjunction between a local discussion and a global network of interlocutors. In this sense, Enwezor's discursive platforms fulfill my general definition of platforms as apparatuses that convert raw data into informational objects.

It is no coincidence that Enwezor used the term *platform* commonly associated with digital architectures like Google, Twitter, or YouTube, to describe his symposia – as I have suggested, alongside new *virtual* spaces produced by digital platforms, objects of art and architecture, as well as the spaces for discussing and evaluating them, have undergone a significant transformation of their own. What matters now is how artworks collect and configure an array of activities – how they produce various informational objects often changing from one state to another in the course of an exhibition or action. In behaving like search engines in real space, works of art exhibit capacities like those of the MP3 player for translating, reformatting and transporting images electronically[5]. This mutability in form corresponds to related changes in political agency, where traditional political *states* have been challenged, undermined or remade by vast migrations of people across borders, whose forms of collectivity have been theorized in terms of the multitude[6].

The best effort to come to terms with this new model of objectivity is still Nicolas Bourriaud's concept of "Relational Aesthetics"[7], which describes the artwork as a kind of physical platform for social interaction. But I wish to move beyond Relational Aesthetics in two important ways: first, I will define platforms as active

**4.** O. Enwezor, *Democracy Unrealized: Documenta 11_Platform 1*, Hatje Cantz, Ostfildern-Ruit, Germany 2002, p. 1.
**5.** J. Beuys captured such transformations for art long ago in his preoccupation with warming, and his work with materials like fat that can exist in either liquid or solid states. In our digital era where the capacities for production, dissemination of images have vastly expanded, the meaning of all kinds of images is also tied to changes in state or status.
**6.** The concept of the multitude is closely aligned to the work of M. Hardt and A. Negri. See for instance, Hardt and Negri, *Empire*, Harvard University Press, Cambridge (MA) 2000; Hardt and Negri, *Multitude: War and Democracy in the Age of Empire*, The Penguin Press, New York 2004; and P. Virno, *Multitude: Between Innovation and Negation*, trans by I. Bertoletti, J. Cascaito and A. Casson, Semiotext(e), Los Angeles 2008.
**7.** See N. Bourriaud, *Relational Aesthetics*, trans by S. Pleasance and F. Woods with the participation of M. Copeland, Les Presses du réel, Dijon 2002 and C. Bishop, ed., Participation, The MIT Press, Cambridge-London 2006 & Whitechapel Art Gallery, London 2006.

producers of images which format, translate and generate images and events with or without the literal participation of museum visitors. Second, I wish to posit a deep structural relationship between digital platforms and new kinds of physical spaces and objects. I want to describe what it looks like to operate as a search engine in *literal* versus virtual space.

Enwezor's theory of the platform as a space of debate or discursive interchange emerged alongside a contemporaneous *aesthetics* of the platform that spans the unapologetically commercial and the assertively egalitarian. These poles are exemplified by architect Rem Koolhaas's designs for the Soho Prada store in New York (2001) on the one hand and artist Rirkrit Tiravanija's *Secession*, a 2002 exhibition for the Vienna Succession on the other. Both Koolhaas and Tiravanija produce forms that physically function as platforms, but these platforms, like digital architecture, also produce informational objects. Koolhaas is one of the most visible pioneers of architecture's widespread migration to infrastructural concerns, both at the scale of the city and that of the single building. Faced with the challenge of distinguishing Prada's so-called 'Epicenter' stores from its smaller and more homogeneous outposts around the world, he concluded that instead of merely increasing the size of a flagship store, he could diversify its *program*, allowing it to generate activities not only associated with a commercial establishment, but also a theater, a street, a prototype gallery, a trading floor and so on[8]. Formally, this proliferation of activities was accomplished by organizing the main floor plane of the loft building housing the Soho store as a platform – a broad, continuous ribbon-like surface that dips from street level at the Broadway entrance, to basement level in a graceful curve in the middle of the space to accommodate amphitheater seating on one side (which doubles as shoe display) and a retractable stage on the other, as the platform rises again to street level on Mercer St. Although, to my knowledge, Prada did not extensively program the retractable stage Koolhaas provided for them, the potential was there for the store to erupt into a theater. And indeed, it was not uncommon for shoppers (or *browsers*) to spend time seated in the stepped 'amphitheater' opposite the stage gazing at displays or other shoppers, while others used the store as a pass-through when

**8.** Koolhaas publishes a wonderful bar chart that visualizes these changes in programming in OMA/AMO, R. Koolhaas et al, eds, *Projects for Prada Part 1*, Fondazione Prada Edizioni, Milano 2001, unpaginated.

walking from Broadway to Mercer St or Mercer T to Broadway. The physical ground of the undulating platform was therefore capable of hosting a range of activities corresponding to different modes of urban spectatorship: shopping, strolling, theatergoing.

If Koolhaas's platform for Prada is a "convertible surface" where a variety of activities can be accommodated, in Tiravanija's *Secession* piece the platform functioned as a time machine. The exhibition, at the Secession in Vienna, was focused on a different kind of platform: a pavilion in the form of a section of Viennese architect Rudolf Schindler's 1922 home in Los Angeles that was entirely faced in reflective chrome. Like the undulating floor of the Prada store, this pavilion-platform, which was constructed in the gallery during the span of the exhibition, hosted a number of activities including Thai Massage, a summer party, a weekly DJ session and film screenings. On Thursdays the exhibition was open 24 hours, in theory making it available as an overnight hostel for drop in visitors. Tiravanija has described his mirrored platform as a time game: "What we'll remember from this exhibition is the construction of a space in chrome, a space which reflects everything that happens inside. It's temporal camouflage. It's an exhibition that's comprised of a series of games… Time games. Chrome is a great agent of time"[9]. The irony here is that while all the activities hosted by the platform were indeed reflected in it, these reflections could never be fixed in the mirrored surface as photographs can be (and as documentation of works of *Conceptual Art 1.0* would be). Tiravanija's platform is a container for activities that will disappear in time. This emphasis on fugitive temporalities is enhanced by the physical platform itself – the "return" or transit of Rudolf Schindler's house to Vienna, where he began[10]. For indeed, this platform is itself a kind of physical or objectified memory.

The three types of platforms I have described thus far – the discursive, the programmatic and the temporal – can only be fully understood in association with *digital* platforms. To be more precise, the constellation of public spheres situated locally but integrated internationally that Enwezor organized, the convertible mixed-use infrastructure corresponding to Koolhaas's undulating floor for Prada and the time machine hosting a variety of activities

**9.** R. Tiravanija: *Secession*, D.A.P., New York: distribution outside Europe, Köln: König 2003, p. 14.
**10.** Indeed, his house in LA currently functions as an Austrian cultural center, and it was already something of a de facto cultural center during Schindler's lifetime.

in Tiravanija's Vienna exhibition respectively share a deep
structure with digital operating systems like those of Microsoft or
Apple, search engines like Google or Yahoo and social networks
like Facebook or Twitter. To take a simple example, Microsoft
Word *formats* documents, *translates* keystroke commands into
text and *generates* new documents, which it can *store*. Similarly,
both Koolhaas's Prada store and Tiravanija's *Secession* project
format activities (i.e., Koolhaas's amphitheater, or Tiravanija's DJ
nights etc.); translate information (Koolhaas's "direct" translation
of market research, and for Tiravanija, the translation of the
Schindler House into a hall of mirrors); and generate new
activities (shopping, theatergoing and discussion for Koolhaas;
partying, sleeping, chatting, movie watching etc. for Tiravanija).
What is present in both digital and physical platforms and what is
demonstrated through their three fundamental procedures –
formatting, translating and generating – are the conditions of what
I've been calling *Conceptual Art 2.0*: a sometimes wild
multiplication of meanings, images and actions emanating from
the artwork. In a networked era, artworks function as apparatuses
– platforms – for generating (or searching) content.

### Transitive Objects

If the platform formats, translates and generates other images,
then how can we describe the kind of object that results? Is this
thing a "network-object"? Before attempting an answer, it's worth
pausing to consider how difficult it is to visualize networks, which,
in their incomprehensible jumps in scale, ranging from the
impossibly small microchip to the impossibly vast global Internet,
truly embody the contemporary sublime. One need only Google
"Internet maps" to turn up *Star Trek*-inspired images of
interconnected solar systems that do little to enhance one's
understanding of the traffic in information but do much to tie digital
worlds to ancient traditions of stargazing. Artists have recently
approached the problem in a different way. Rather than picturing
networks per se, they trace the behavior of *objects within
networks*. The result is a kind of oxymoron: the dynamic, or
transitive object – precisely the kind of thing produced by
platforms, as I have described them. Understanding "transitive" as

"expressing an action which passes over to an object" perfectly captures the status of objects within networks[11] – they are defined by their *passage* or circulation from place to place and their subsequent translation into new contexts. Tiravanija's platform in Vienna, for instance underscores this state of perpetual passage in three ways: it translates and transports an architectural monument from half a world away; its construction was accomplished live during the exhibition (it was only completed two days before the show closed) and hence its parts were literally in transit; and its complex mirrored surface, which reflects without being able to fix everything that goes on around it, constitutes a third form of transitivity.

What I'm calling the "transitive object" corresponds to a widespread shift in how artists work. No longer is their primary emphasis on the *invention* of form, but rather in its *reconfiguration* (which is precisely the work accomplished by platforms). Since around 1980, but greatly accelerating in the 1990s, there have emerged at least three strategies among artists for marginalizing content per se, and emphasizing questions of movement – in the sense of both physical or conceptual relocations[12]. First, there is the strategy of appropriation – the re-production and re-situation of existing images making few if any changes in their form, but significant changes in their context. Sherrie Levine, for instance might rephotograph an iconic image by photographer Walker Evans, but in her hands (the hands of a woman of a different generation, redeploying the works decades after their original exposure) the meaning of *the very same image* is completely different. What this suggests is that the value and significance of works of art inheres not in what they show, but in the specific characteristics of their position in time and space. In other words, what appropriation takes as its medium is not visual representation, but the transitive adventures of the image.

**11.** *Oxford English Dictionary* on line.
**12.** I am grateful to F. Casetti for many interesting discussions on relocation. See for instance his, *Elsewhere. The Relocation of Art,* in *Valencia 09/Confines*, Institut Valencià d'Art Modern, Valencia 2009, pp. 348-51 [English translation].

In a related strategy a number of artists involved in performance have become interested in the reenactment of earlier images or actions. Mike Kelley's *Day Is Done* (2005), for instance, is a 'spatialized' video opera of reenactments of high school theatricals derived from the artist's collection of high school yearbook photographs. In the same year Marina Abramović restaged six

canonical performances of the 1960s in the atrium of the Guggenheim Museum in New York plus one new action of her own. For Abramović the only way to *reproduce* an action is to literally *reenact* it and this form of reenactment is both a tribute to a former piece and an entirely new work. Taking up John Cage's notion of the *scored* action that has been highly influential in the history of performance art since the 1950s, Abramović has stated, "In *Seven Easy Pieces*, I reenacted seminal works that had been performed by my contemporaries in a prior time and space... I interpreted them as one would a musical score"[13]. But her use of the score is very different from that of Cage or Fluxus performance, for instance, because she is literally inhabiting or embodying the earlier performances. Her work is transitive in terms of time – she expands and standardizes the duration of each performance to 7 hours, explicitly marking a difference in time and space from the 'original'.

Finally, artists have begun to use avatars as surrogate figures that they may control remotely. In 1999, for instance, Pierre Huyghe and Philippe Parreno bought the rights to a Japanese manga character, named Annlee, which they used to make various video works and then lent out to other artists for their own projects. In Huyghe's video *Two Minutes out of Time* (2000), Annlee narrates 'her' own story: "An image, a product tells its story – the story of a sign emancipated from the fiction market to become a character that lends its voice to other authors"[14]. Artists as different as Matthew Barney, in his elaborate mythological pageants, or Andrea Fraser, in her ironic recitations of texts that mimic and remix stereotypical art world voices (the dealer, the museum director, the artist), create fictionalized characters – avatars, that may circulate in ways that distort or amplify the individual artist. The avatar is able to inhabit a multiplicity of virtual spaces and fictional identities that no individual human could navigate.

13. M. Abramović, *Reenactment*, in Abramović, *Seven Easy Pieces*, Charta, Milan 2007, p. 11.
14. C. Christov-Bakargiev, ed., *Pierre Huyghe*, exhibition catalogue (Castello di Rivoli Museo d'Arte Contemporanea, April 20-July 18, 2004) Rivoli-Turin 2004, p. 348.

The three strategies I have pointed to – appropriation, reenactment and the avatar – all take content for granted and gesture toward a kind of form that unfolds across time and in space – a transitive form. Here, what matters are changes in location, in duration, or frequency of reproduction or scale. In this regard, Koolhaas, who already in 1997 had published his firm's

projects in a massive, 1376-page compendium entitled *S,M,L,XL*, indicates a framework of evaluation rooted in transformation between scales – small, medium, large, extra large – as opposed to fixed meanings inherent in a particular place or building. Most analysis of art and architecture isolates individual objects in order to interpret their 'content'. But as Koolhaas's method implies, questions of scale like other quantitative factors such as the speed of dissemination of an image or the sheer quantity of its reproductions can be more critical in a global world where things are perpetually changing state, where even a building shifts from a flow chart to a floor plan to a structure, or, in Tiravanija's case is transported halfway around the world and rendered in chrome. Such dislocations demonstrate how, on the level of culture, the *transitive object* is an index of globalization. The dislocation of things is experienced not as a neutral movement, but as *transformation* in the literal sense of *formation* that occurs in and through *transit*. The content of an artwork is less important than how and where it *translates* information even if it remains in its 'own' culture.

This essay represents one step toward a methodology for assessing the significance of such acts of transformation, in terms of their effect both on individual judgment and on the formation of a public audience. Since the Enlightenment, works of art have assisted in reconciling private persons to public values. Modern museums and academies arose to consolidate national identities and tabulate stable cultural differences in space and time. Transitive works, in marking transit in the ways I have suggested, develop a mode of objectivity that encompasses multiple locations and states of being simultaneously. A digital platform like Twitter can become a tool in organizing Iranian resistance or an idle pastime for American teens: it is a *global* form because it produces local effects – even local identities – anywhere in the world, anywhere the technology is available. In their own ways, art and architecture have developed an analogous structure: they are apparatuses with standardized international styles but highly specific local effects. Producing and translating these local effects for the world beyond, as in Enwezor's platforms, is how art and architecture now create value – by helping to build a global civil society founded in a thousand platforms[15].

**15.** I am of course alluding here to G. Deleuze and F. Guattari's, *A Thousand Plateaus: Capitalism and Schizophrenia*, trans by B. Massumi, University of Minnesota Press, Minneapolis 1987.

**Mario Airò**
— *Aurora*, 2003, neon, wood, electric transformer,
20 × 263 × 13 cm, MAXXI – Museo nazionale delle arti del
XXI secolo.

From his 1989 debut at the artist-run exposition space in
Via Lazzaro Palazzi in Milan up to the present day, Mario
Airò's work has functioned on two levels simultaneously: on
the one hand, the involvement of the perceptive sphere and
of the real space in which the spectator moves, and on the
other the stimulation of cultural memory, of the allegorical
and historical profundity concentrated in everyday life. The
static or moving sound installations, colored projections,
objects and three-dimensional elements (often evocative of
far-off, cosmic or 'magical' dimensions) Airò utilizes are
interwoven with poetic, philosophical and cinematographic
references and citations within spaces of contemplative
suspension, in which visitors can have – and ponder on –
an intensified emotional experience, temporarily removed
from the 'background noise' of contemporary society. Some
of his works are real artificial landscapes, as is the case of
this electric *Aurora*, which artificially recreates the eternal
theme of the dawn, stripped of the usual rhetoric and
brought back to an intimate, almost domestic dimension,
veined with melancholy. "In my works", the artist says,
"a silence is created, a general softening of tones and
volumes, a reflective, enduring dimension [...] To me it
seems the ideal context, because that's what interests me,
making things speak, making them resonate with one
another". (s.c.)

Born in Pavia in 1961, lives and works in Milan and Radda
in Chianti (Siena, Italy).

**Francis Alÿs**
— *Study for Untitled (Redemption)*, 2000, oil and pencil on transparent paper, 12 × 13 cm, MAXXI – Museo nazionale delle arti del XXI secolo.

Francis Alÿs has created a diverse body of work from a linguistic point of view. Whether working on an urban scale or producing small drawings, the artist creates works characterized by a refusal to use any special effect, by an atmosphere of enigmatic suspension, and by his ability to unite lyricism and attention to social milieus. Alÿs's metaphors are the fruit of his imagination. He directs his gaze beyond the normal or everyday in order to find greater meaning. His subjects are strange short stories and objects whose functions are inverted in such a way that they seem to take on a life of their own. The drawings in this exhibition are formally light and spare like little storyboards, yet they conceal multiple meanings. Created on fragments of transparent paper, they serve as preparatory drawings for other works with the same subject, two youths in waist-high water attempting to write on each other's backs. For Alÿs, writing becomes an act of redemption, and the submersion in water might be read as a reference to baptism. This interpretation is supported by the fact that some of the works have been subtitled *Redemption*. (g.s.)

Born in Antwerp in 1959, lives and works in Mexico City.

**Francis Alÿs**
— *Study for Untitled (Redemption)*, 2000, oil and pencil on
transparent paper, 21.08 × 16.3 cm, MAXXI – Museo
nazionale delle arti del XXI secolo.

**Francis Alÿs**
— *Study for Untitled (Redemption)*, 2000, oil and pencil on
transparent paper, 28 × 21.5 cm, MAXXI – Museo nazionale
delle arti del XXI secolo.

**Francis Alÿs**
— *Study for Untitled (Redemption)*, 2000, oil and pencil on transparent paper, 20 × 29.5 cm.
— *Study for Untitled (Redemption)*, 2000, oil and pencil on transparent paper, 28.4 × 20.6 cm.
MAXXI – Museo nazionale delle arti del XXI secolo.

**Francis Alÿs**
— *Study*, 2000, oil and pencil on transparent paper,
29 × 20 cm.
— *Study*, 2000, oil and pencil on transparent paper,
30.5 × 23 cm.
MAXXI – Museo nazionale delle arti del XXI secolo.

## Domenico Gnoli
— *White bed*, 1968, acrylic and sand on canvas,
140 × 200.7 cm, MAXXI – Museo nazionale delle arti del
XXI secolo.

A large bed viewed from its foot, covered in white *gaufrée*
cloth with little rhomboid designs, occupies the entire
surface of the painting and even goes beyond its frame and
out of sight. But although observed from close-up, the bed
in this painting by Domenico Gnoli has undergone a
process of distancing, and has become an anonymous icon,
timeless and 'without qualities', lacking a context and a
specific social framework. It has achieved a degree of
objective fixedness, of outdatedness without nostalgia and
without theatricality which, as Daniel Soutif noted, recalls
the sense of endurance of things that emanates from
Giorgio Morandi's still lifes. Comprised within the brief

passing of a decade, Gnoli's best-known paintings focused
on a few categories of 'objects': clothing and accessories,
furniture and hats, a meager inventory far removed from
that of pop art, as well as from that of the metaphorical and
disturbing surrealist one. Gnoli's universe is a secluded
world, rendered in a perspective that accentuates planes
rather than suggesting volume, in which the close-up
framing and enlargement of detail produces an instant
disorientation: "I am metaphysical", the artist said in 1965,
"in that I am trying for an eloquent, immobile and
atmospheric sort of painting that feeds on static situations.
[...] I always use simple elements as they are, I don't want
to add or take away anything. I have never had the desire
to distort either: I just isolate and depict". (s.c.)

Born in Rome in 1933, died in New York in 1970.

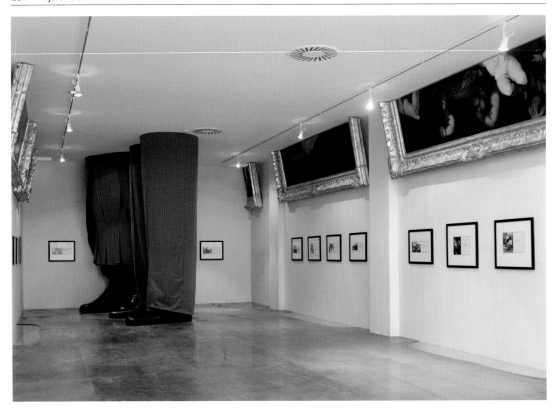

### Ilya and Emilia Kabakov

— *Where is our place?*, 2003, installation, oil on canvas, wood, black and white photographic prints on paper, fabric, leather, glass, acrylic on styrofoam, room-size, MAXXI – Museo nazionale delle arti del XXI secolo, Rome.

At the end of one of the routes through the museum, the visitor encounters the theatrical environment created by Ilya and Emilia Kabakov's installation. The work divides the space into three parts and presents radical shifts in scale. There are a series of works of art hung on the wall at eye level. Above these works, two 'old' paintings in antique frames have been enlarged, to such a degree that they are cut off by the ceiling. Additionally, the viewer sees two human figures whose bodies are also cut off, leaving only the legs visible. The third section of the work is made up of trap doors in the floor that offer glimpses of a world smaller than our own. The installation, which forces the viewer to confront oversized or miniaturized worlds, explores the relativity of progress and the attribution of value. Our enlarged egos cause us to establish divisions between before and after and to see ourselves and our time as having greater importance. In reality, we are just another link in a chain. This understanding also impacts the way we evaluate art. We cannot respond to the challenges of the present; only the filter of time will determine who is saved and who is not. (g.s.)

Both artists were born in Dnipropetrovsk (Ukraine), Ilya in 1933 and Emilia in 1945. They live and work in New York.

**Avish Khebrehzadeh**
— *Untitled (Triptych I)*, 2006-2007, oil on gesso and wood,
127 × 101 cm, 127 × 165 cm, 127 × 101 cm,
MAXXI – Museo nazionale delle arti del XXI secolo.

Khebrehzadeh creates drawings and animated videos with
a fairytale-like quality. Her worlds are populated by women,
men, children and animals whose shapes, drawn with
delicate and minimal lines, emerge from dark backgrounds
or move softly through indistinct landscapes. Figures,
architectural elements and landscapes are reduced to the
bare minimum. She often draws using olive oil brushed on
simple paper. Poetic and sensitive, these works create a
world of nostalgia and melancholy. In this dream-like vision,
everything exists in a state of suspension. Khebrehzadeh
does not want us to dwell on details. Her work, like all
beautiful fairytales, tries to transport us to faraway places.
Yet, it is not mere escapism; the artist's use of basic
materials permits her to create an essential world void of
any superfluous elements. The mind is permitted to wander
without being stopped by anything in particular. The artist
invites us to embark on new paths and accept whatever
diversity we encounter along the way. (g.s.)

Born in Teheran in 1969, lives and works in Washington.

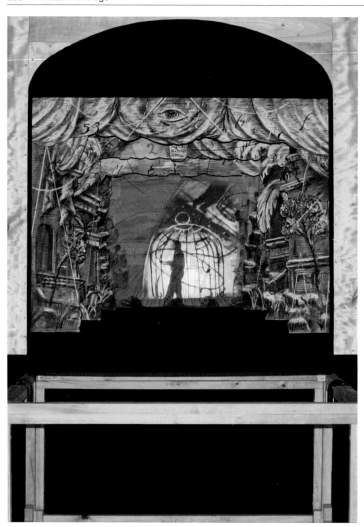

**William Kentridge**
— *Preparing the Flute*, 2004-2005, video projection on a wooden structure, pastels, pencil, charcoal on foam core, PVC, diffusion gauze, 2 DVDs, 2 projectors, 2 DVD players, 166 × 70 × 177 cm, MAXXI – Museo nazionale delle arti del XXI secolo.

Artist and filmmaker, Kentridge sometimes returns to his first passion, theatre, as he does in *Preparing the Flute*. The work uses a model of an Italian-style theatre with wings made of panels which frame a video projection of black-and-white animations inspired by Mozart's *The Magic Flute*. The light, produced by the captivating images of the Milky

Way and the fireworks that accompany the Queen of the Night, moves across and invades the entire space of the hall. The miniature theatre becomes a large *camera obscura*. In Kentridge's words, "this work represents, through the protagonists' process of initiation, a larger metaphor for transformation in the passage from dark to light. This theme is the basis of photography and video, which essentially consist in capturing light to create real or imaginary scenes". Thus, the mystery of creation is condensed into the theatrical space Kentridge creates. (g.s.)

Born in 1955 in Johannesburg, where he lives and work.

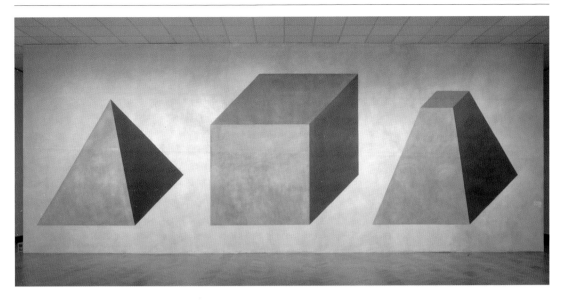

**Sol LeWitt**
— *Wall Drawing #375*, 1982, India ink on wall, various
dimensions, MAXXI – Museo nazionale delle arti del XXI
secolo.

"In conceptual art the idea or concept is the most important
aspect of the work. When an artist uses a conceptual form
of art, it means that all of the planning and decisions are
made beforehand and the execution is a perfunctory affair.
The idea becomes a machine that makes the art". Thus, in
his *Paragraphs on Conceptual Art* (1967), Sol LeWitt
rethought the limitations and possibilities of artistic work,
shifting the center of gravity from material realization to the
mental dimension. His *Wall Drawings* are among his most
efficacious illustrations of this radical theoretical shift. They
are large compositions – in this case, three solids in
isometric projection – based on written instructions, a 'plan'
that identifies the elements of the image, temporary
creations (destroyed at the exhibitions' conclusions) that
rendered traditional attributes of artwork, like uniqueness or
the artist's signature, irrelevant. But for LeWitt, the 'ideas'
are something vastly different from deductive reasoning.
As Rosalind Krauss noted, his ideas remain unexplained,
unjustifiable: they pertain more to the dimension of time,
chance and the infinite than to that of reason, precisely
because according to LeWitt, as we can read in *Sentences
on Conceptual Art* (1969), "Conceptual Artists are mystics
rather than rationalists. They leap to conclusions that logic
cannot reach".  (s.c.)

Born in Hartford in 1928, died in New York in 2007.

**Fabio Mauri**
— *Manipolazione di cultura / Manipolation der Kultur*, 1976,
11 photographic prints transferred to canvas, acrylic,
45 × 72 cm each, Associazione per l'Arte Fabio Mauri,
Rome.

One of Fabio Mauri's most significant works on the theme of
the ideological instrumentalization of language,
*Manipolazione di cultura* originated as an artist's book,
published in 1976 by the publisher La Nuova Foglio. Mauri
drew on the original lithographs to create a series of plates,
which he utilized for exhibitions in the years thereafter. The
results are large canvas-backed photographs with a
tripartite structure: in the upper part is a documentary
photograph of Nazi and fascist iconography, in the central
zone a monochromatic black-painted band, and in the lower
part a phrase (in Italian on the left and in German on the
right) describing the action depicted in the impersonal,
alluding to the subject. The actions refer to the power of
cultural "manipulation" that totalitarianism utilized as an
instrument of conquest and to maintain power. The size of
the black band depends on the proportions of the image
and varies in each piece, with the different levels of black in
the sequence of images lending rhythm to the series. With
this and other works, Mauri exposes the "root of evil" hidden
within the ideology and language that sustain it. (b.p.)

Born in 1926 in Rome, where he died in 2009.

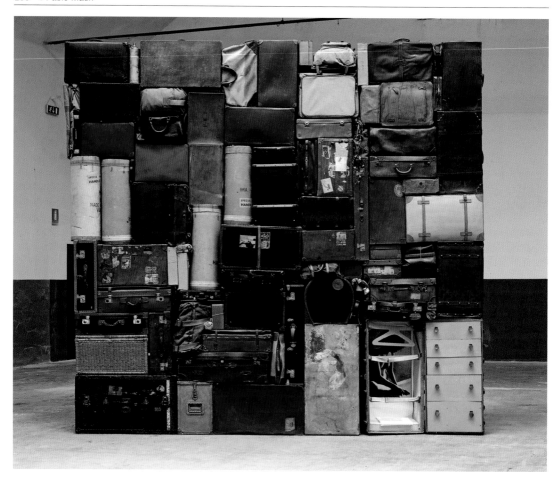

**Fabio Mauri**
— *Il muro occidentale o del pianto*, 1993, suitcases, bags,
chests, leather, canvas and wood wrappings, ivy plant,
canvas-backed photograph, 400 × 400 × 60 cm,
Associazione per l'Arte Fabio Mauri, Rome.

This work – one of Fabio Mauri's most representative
pieces – is made up of a series of old leather suitcases
piled up and arranged so as to create a four-meter wall with
a regular front surface and an irregular back one, adorned
only with a small ivy plant and a 1970s photograph of his
first performance (*Ebrea*). The wall, an explicit reference to
the Wailing Wall in Jerusalem, becomes the symbol of all
exiles, all diasporas in which "a sense of transmigration, an
infinitely initiating story of the sorrow of the world, is
evident", as the artist himself indicated. In a maniacal
attempt to create a regular surface by composing a diverse
collection of individual elements, the artist sees the
possibility of brining any and all types of diversity into
balanced coexistence. (b.p.)

Born in 1926 in Rome, where he died in 2009.

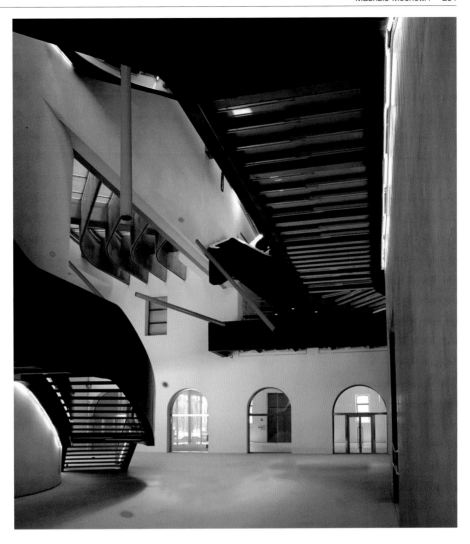

## Maurizio Mochetti

— *Linee rette di luce nell'iperspazio curvilineo*, 2010, aluminium, steel, projectors, electrical cords, tubes 22 cm diameter, room-size, MAXXI – Museo nazionale delle arti del XXI secolo.

The project Maurizio Mochetti conceived for the MAXXI (2009 winner of the international competition launched in compliance with law 717 of 1949, better known as the "2 percent law") reiterates a few constants that have been present in the artist's work since his debut in the mid-1960s: the use of light, conceived as a physical constant and a manipulatable plastic element; the utilization of sophisticated technologies; the pursuit of an unconventional relationships with architectural space. For Mochetti, technical devices, whether intended to spectacularize or to camouflage, are essentially the tools that highlight currents or points of maximum concentration of energy, or the melding of material and space as part of a poetics that echoes elements of futurist theory and Lucio Fontana's creative practices. Speed, force, tension, resistance, reflex, weight, elasticity and power are the terms Mochetti has used in his career to describe his idea of art as a physical and mental experience intended to change our perceptive profile and thus our comprehension of the world. His work for the museum calls for the permanent installation of four long red-painted 'tubes' hung with steel tie bars and containing within them a complex light-projection device that throws a band of red light onto the architecture, designing profiles that change depending on the light's angle of incidence. (s.c.)

Born in Rome in 1940, where he lives and works.

 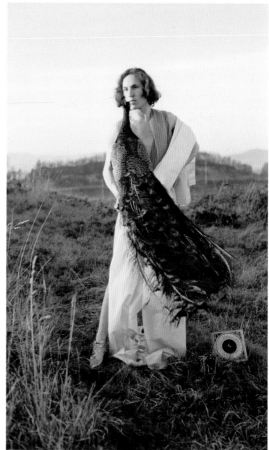

**Luigi Ontani**
— *Le ore*, 1975, 24 photographic prints in paper on aluminium, solid gold frame, 216 × 136 cm each, MAXXI – Museo nazionale delle arti del XXI secolo.

This work represents the 24 hours of the day, personified by the artist in poses that recall figures from the most varied of cultural references, from the Greek world to religious iconography, from the Orient to the Renaissance. Recurrent elements in the cycle include the astrological clock that marks the hours, the silk drapery in three colours symbolizing the male, the female and the union between the two opposites (the androgynous). Since his debut in the late 1960s, Ontani has been using his body as a work of art to deal with themes of identity (gender and cultural) and the elements that characterize it through the skillful and sophisticated use of multiple cultural references. In his works, these elements blend together, merge and pursue one another in a sort of game in which boundaries are widened and overlaid, giving rise to new and suggestive visions; as the artist asserts, "Through the mask, I look for the ideal heirs of a rituality that is omnipresent in the world, independent of the current conditions". Space and time become a grand reservoir from which he instinctively draws to attempt to rethink an identity in constant mutation and redefinition. (b.p.)

Born in Montolvolo di Grizzana (Bologna, Italy) in 1943, lives and works in Rome.

**Tony Oursler**

— *Gargoyle*, 1990, magnetic tape, VHS player, video projector, iron structure, shattered mirror and plastic, 265 × 18 × 77 cm, MAXXI – Museo nazionale delle arti del XXI secolo.

The mannequins, cloth puppets or small objects that populate Tony Oursler's video installations are 'screens' on which he projects talking bodies and faces, fragments of a humanity used to stage personal dramas, psychotic episodes, unsettling or grotesque narrations. As in Samuel Beckett, everyday life becomes a disturbing landscape and all discourse is reduced to pointless chatter, revealing the disassociation that afflicts the characters (*effigies*, the artist calls them), often reduced to ventriloquists' mouths or eyes, engrossed in angry, embarrassing or inane ruminations, empty speeches full of anxiety and frustration. *Gargoyle* (a

contemporary version of a Medieval dragon-head-shaped gutter spout) seems to force its way out of the wall, straining in an effort to disrupt the video contained within its maw, two 'talking heads' recounting their reclusive lives from two contrasting points of view, one emotional and engaged, the other objective and apparently detached. The world Oursler evokes is pervaded by a sense of irreversible conflict between body and mind, between time and space: the reproduction and transmission from a distance of sounds and images and the wonder said transmission arouses thus become instruments for destabilizing perception and creating disorientation, as in *Carousel*, a revisiting of an amusement park ride projected onto a 'drum' that recalls the nineteenth century forerunners of the motion picture. (s.c.)

Born in New York in 1957, where he lives and works.

**Tony Oursler**
— *Carousel*, 2000, magnetic tape, VHS player, 1 video
projector, wood, 36 × diameter 55 cm,
MAXXI – Museo nazionale delle arti del XXI secolo.

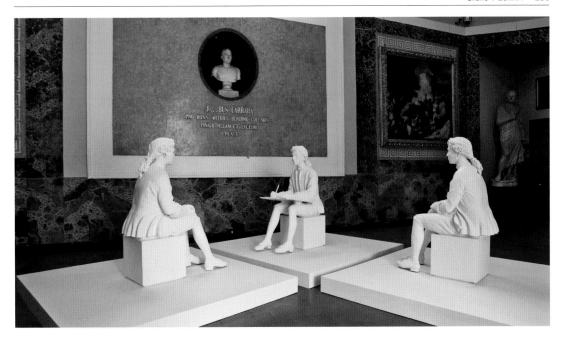

**Giulio Paolini**

— *Tre per tre (ognuno è l'altro o nessuno)*, 1998-1999, plaster, 3 elements 130 cm h, 3 platforms 15 cm h, MAXXI – Museo nazionale delle arti del XXI secolo.

The enigma of figuration and the ruses of resemblance, the volatile relationship between observer and observed, analytical logic and *mimesis*, the artist's freedom of invention and the rules of his trade. Around these pairs of opposites, Giulio Paolini has for the past half-century been weaving a body of work dense with internal references, from his first, seminal *Disegno geometrico* (1960) – which shows the geometric squaring-off of the surface, the preliminary and conclusive act of every representation – to this complex installation in which the same character (a life-sized plaster figure inspired by an eighteenth century etching by Chardin) appears in the three different and complementary roles of a model, the artist doing his portrait and the spectator observing the scene. "The first step is the one that counts", the artist wrote in 2003, "it is the decision to look at the world, but a world 'framed' by a surface (the picture) which instantly (in an instant disguised as eternity) becomes the representation of one's self in the world". For Paolini, the sense of art – present, past and future – is summed up in this perceptive and philosophical triangulation, in which "*how* one looks" counts much more than *what* one looks at. (s.c.)

Born in Genoa in 1940, lives and work in Turin.

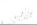

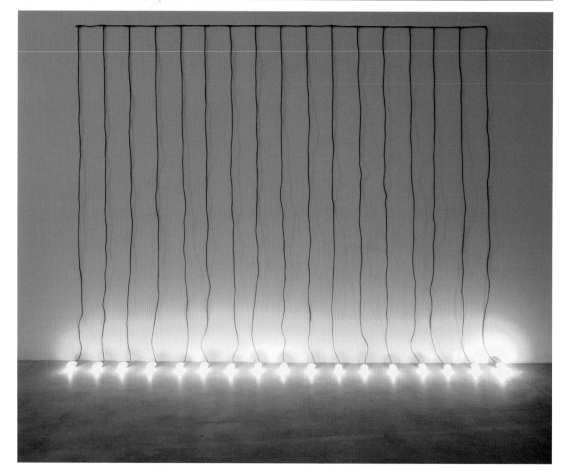

**Michelangelo Pistoletto**
— *Quadro di fili elettrici – tenda di lampadine*, 1967,
electrical cords, light bulbs, 268 × 440 cm, MAXXI – Museo
nazionale delle arti del XXI secolo.

Michelangelo Pistoletto is one of the central figures of the
*Arte Povera* movement as its inspirer and catalyzing force.
*Quadro di fili elettrici – tenda di lampadine* (Electrical cord
painting – light bulb curtain) is the result of experimentation
that took its cues from *Oggetti in meno*, a series the artist
began in 1965 focusing on the "non-repeatability of the
creative moment", which he represented through the
complete stylistic disunity of individual elements. In this
perspective, the artistic object is hardly differentiated from the
ordinary, everyday household object. For Pistoletto, the
deliberate use of 'poor' materials – utterly lacking in aesthetic
qualities – in such works represents the very nature of artistic
action, the "freedom from a necessity". Thus his *Oggetti in
meno* were from their very first appearance on the scene a
concrete manifesto of the reasoning behind an art that
attempts to reassert the artist's autonomy of action, an
expressive freedom detached from the limitations of style, and
from the production and merchandising of the artwork. (b.p.)

Born in Biella in 1933, lives and works in Turin and Biella.

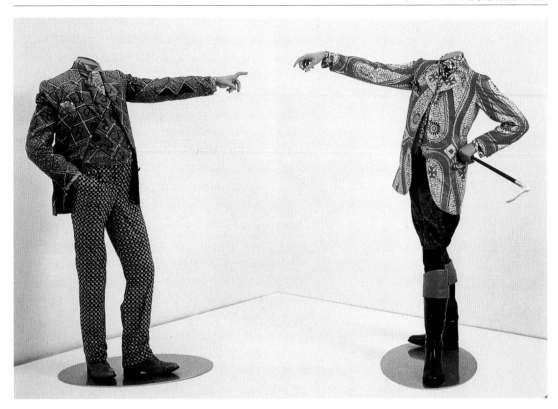

**Yinka Shonibare**
— *Henry James and H. C. Andersen*, 2001, 2 life-sized mannequins, cotton clothing, room-size, Galleria nazionale d'arte moderna e contemporanea, Rome.

The Anglo-Nigerian artist Yinka Shonibare critically confronts and debunks ideas linked to cultural identity and stereotypes hidden in the concept of ethnicity.
His installation presents two life-sized figures wearing Western-style clothing made with batik fabric, which is considered typically African. In reality, batik was originally made in the Netherlands using an Indonesian technique, and subsequently exported to Africa. It is therefore emblematic of the dynamics of the colonial era and is an example of how Western perceptions of Africa are rooted in a post-colonial perspective. Shonibare sees fashion as an indicator of status and power. He makes reference to eighteenth century Anglo-Saxon fashion, considered one of the apexes of style, but also explores the reality of a colonial system based on slavery. The figures are headless, alluding to the fact that the colonial ruling class has been literally and metaphorically decapitated by democratic revolution. (g.s.)

Born in 1962 in London, where he lives and works.

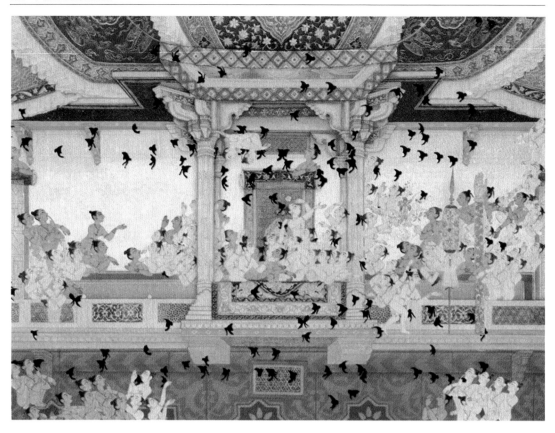

**Shahzia Sikander**
— *Spinn V*, 2003, Video animation, 6'30",
MAXXI – Museo nazionale delle arti del XXI secolo.

In her works, Shahzia Sikander uses the traditional oriental, Persian and Indian technique of miniature painting, reinterpreted in a contemporary key. Her work is the result of a skillful fusion of the methodical precision typical of the oriental method and the more creative, subjective approach of Western culture. The subjects of her work include iconographic elements from Hindu and Muslim culture, in an attempt to make the different and often conflicting visions of the two traditions coexist harmoniously. For the artist, this process corresponds to the parallel and intertwined question of India and Pakistan and the conflict/comparison between the two cultures. The video *Spinn V* is constructed around a juxtaposition of the female and male figures; the former is represented by a compact group of Gopi, female divinities from Hindu tradition, gathered around a throne, which symbolizes the male element. But little by little, we see the Gopi transformed, through the element of their hair, into a flock of birds. Here too, the illustrative tradition of miniature painting is liberally reinterpreted using digital techniques, going beyond the preestablished rigidity of religious tradition to move towards individual self-determination. (b.p.)

Born in Lahore (Pakistan) in 1969, lives and works in New York.

**Grazia Toderi**
— *Rosso*, 2007, continuous colour video loop projection with sound, Digital Beta tape transferred to DVD, variable dimensions, MAXXI – Museo nazionale delle arti del XXI secolo.

The visionary exploration of the urban landscape, always observed from above, is a recurring theme in Grazia Toderi's recent work. The images, fruit of complex digital manipulations, are presented in large-scale video projections with high visual impact. The bird's eye perspective in *Rosso* creates a double effect of alienation: the original context (in this case the city of Rome) becomes unrecognizable and is transformed into a kind of phantasmagoric apparition. Lights blink and streak across the surface, accompanied by a particularly evocative soundtrack of layered urban noise. The majority of the screen is taken up by an elliptical 'window' which splits the image into two distinct spatial and perceptual fields, combining a typically baroque form (Borromini's oculi come to mind) with a more contemporary allusion to the imagery of science fiction. The viewer, captivated by this spectacle of technological wonder, imagines himself aboard a spaceship slowly soaring above a massive metropolis, a futuristic city, or the capital of an alien civilization. (s.c.)

Born in Padua in 1963, lives and works in Turin and Milan.

**Vedovamazzei**
— *Climbing*, 2000, iron, light bulbs, rock-climbing ladder,
electric chandelier, silver-fox sleeping bag, approx. 300 cm
diameter, MAXXI – Museo nazionale delle arti del XXI
secolo.

Hung from the ceiling above with thick chains swings an
enormous gilded chandelier. In the middle of the space,
amid vaguely Baroque-style volutes, arranged on a metal
platform accessed by a narrow rock-climbing ladder, are a
luxurious fox-fur-lined sleeping bag and a lamp. It is as if
the duo Vedovamazzei had transformed a typical homeless
person's pallet – the grid heated by the humid exhalations
of an underground metro – into a dazzling, oversized
theater set, intentionally designed to elicit surprise and
disorientation in the white spaces of the museum.

Combining with their typical irony a socially-conscious
anecdote (a sort of cynical re-visitation of the story of
*Miracolo a Milano*) and a moral apology (the illusory ascent
under the false light of worldly success: social "climbing"),
Stella Scala and Simeone Crispino also play with the
contrasting mythologies of artistic life: *bohème* and success,
obscurity and fame. With its artificial splendour, the
chandelier thus becomes both the enchanted refuge of a
childhood summoned up at will, a Montalian "honeycomb
cell" from which a mysterious energy emanates, and an
illusory prison with gilded bars. (s.c.)

Simeone Crispino was born in Frattaminore (Naples, Italy)
in 1962; Stella Scala was born in Naples in 1964. They live
and work in Milan.

**Francesco Vezzoli**
— *Democrazy*, 2007, 2-channel video installation; *Untitled (Embroidering 50 Stars)*, 2007, inkjet print on Ida canvas with metallic thread embroidery, MAXXI – Museo nazionale delle arti del XXI secolo.

Francesco Vezzoli's work has always intersected with television genres and formats – video clips, advertisements, soap operas, reality shows – and explored the functioning of the mass-media image, its incessant production of mythologies and instant 'celebrities', the rites of appearing and the narcissistic voyeurism that has spread into all areas of contemporary social life. In this video installation, the artist deals directly with the political use of television (the "factory of consensus" as Noam Chomsky calls it),

envisaging the clash between two imaginary candidates in the 2008 American presidential elections, Patrick Hill (played by the French philosopher Bernard-Henri Lévy) and Patricia Hill (the actress Sharon Stone). The ads were produced in collaboration with two different media advisors, those public image consultants today so indispensable in political contests to effectively individuate and propagandize the candidates' different 'visions'. Thus, as Vezzoli explains, this work highlights "the inescapable strategies of electoral communications, raising questions about how fame, mass-media power and the manipulation of truth can distort the meaning of 'democrazy'". (s.c.)

Born in Brescia in 1971, lives and works in Milan.

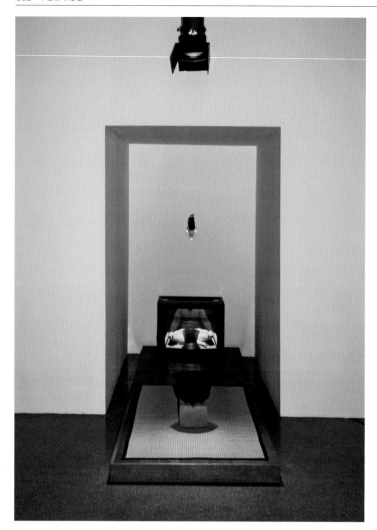

**Bill Viola**
— *Il vapore*, 1975, video and audio installation, duration 60',
MAXXI – Museo nazionale delle arti del XXI secolo.

The undisputed international protagonist of video art in the
last thirty years, Bill Viola has consistently explored the
border zones in which the synthetic image meets reality,
entering into relation with it or even seeking to replace it.
In early works like *Il vapore*, the artist created the
installation by bringing together the three elements of video,
performance and audience interaction: in a small room on a
tatami mat sits a pot, which the artist used in a performance
recorded and shown in the video. The scent of mint rises

intermittently from the pot, while images of the spectator
looking at the work fade in and out of the recorded images
of the performance thanks to a closed-circuit camera. In
recent years, the artist has explored all of the possibilities
offered by state-of-the-art technology to create installations
in which the perfection of the image tends to elude the
spectator and blur spatial parameters; this line of
experimentation, explicitly inspired by the great classics of
Renaissance painting, focuses on themes of life and death
in particular. (b.p.)

Born in New York in 1951, where he lives and works.

## Diller Scofidio + Renfro – Mural

Guided by an intelligent navigator, the robot selects a point along a 25-meter wall and directs the drill to that location, piercing the surface of the wall and moving on to its next position. The holes, which initially begin as lone and random blemishes on the pristine wall, accumulate with variable depth and size to produce the equivalent of a monochromatic dot screen photographic image. Rather than putting art on the museum wall, this contemporary engraving destroys the wall as it generates art within its thickness. The robot is a continuous nuisance, contaminating the galleries with a constant background drone.

Decommissioned after the DS+R retrospective at the Whitney Museum of American Art in 2003 where it made the gallery walls increasingly unstable, the robot is revived and now touring museums, each time re-scripted to produce a new reflection on the fate of the museum wall.

*Diller Scofidio + Renfro*

## Diller Scofidio + Renfro

— DS+R, founded by Elizabeth Diller and Ricardo Scofidio with Charles Renfro joining in 2004, is perhaps the studio that most closely approaches the ideal of the twenty-first century "architect". The New York-based firm has worked in a variety of disciplines including architecture, urban and landscape design, product design and media-oriented performance installations. They never back away from the challenges or research opportunities presented by such a wide variety of projects.

At the same time, they maintain their primary role as architects of buildings, cultural infrastructure and public spaces.

From their *Bad Press: Dissident Ironing* project created in 1993 and the (real) cloud which they produced for the 2002 Swiss Expo, to the Institute of Contemporary Art in Boston (2006), the High Line in New York (with James Corner) and the still-in-progress redesign of the Lincoln Center, the studio has embarked upon an arduous and exemplary journey. Their work emphasizes the necessity of continuously focusing on 'projects'' effects on people. Indeed, for these architects, the simple act of "folding" shirts differently was enough to suggest innovations and new potential with regard to the way we move in and use our homes, and in the forms and dimensions of furniture and domestic spaces. Nearly twenty years later, the studio's transformation of New York's High Line from an infrastructural relic to a "perfect public space" reminds us of the fundamentally public nature of the city. The 'relevancy' of DS+R's method lies in two areas. On the one hand, it can be seen, as we mentioned previously, in their ability to work in different disciplines, an ability rooted in absolute conceptual rigor and an almost didactic rational clarity. On the other hand, it lies in their expressive freedom, asserted with insistence and precision in every project. Their intellectual individuality prevents their work and methods, spectacular as they are, from being likened to the work of their 'starchitect' contemporaries.

The installation *Mural*, shown for the first time at the Whitney Museum in New York in an exhibition dedicated to DS+R, represents the more conceptual side of their work. It emphasizes the 'accidental' nature of the

micro-transformations which every building experiences in its continuous interaction with a myriad of automatic and computerized factors. It represents the continuous sabotage of perfection and architectural design and the way in which the museum risks damaging and distorting works of art when it brings them together in an exhibition. *Mural* creates a seemingly random and chaotic design, the completion of which will coincide with the conclusion of the exhibition. (p.c.)

## Mural

### Diller Scofidio + Renfro

Project Team: Mark Wasiuta, Donald Shillingburg, David Allin
Honeybee robotics: Paul Bartlett, James Powderly, Chris Santoro, Sase Singh
Materials: Mixed media with Drywall, Steel track and Robotic-Drill
Originally exhibited, Whitney Museum of American Art, New York, NY, 2003

The Diller Scofidio + Renfro studio specializes in an interdisciplinary approach to architecture. Currently, DS+R is completing a redesign of the Lincoln Center for the Performing Arts and the High Line Public Park in New York. Other projects include: *Brasserie*, a restaurant in the Seagram Building in New York (2000); *Blur Building* for the Swiss Expo.02; *Slither*, a 105-unit apartment building in Gifu, Japan (2003); the new home of the Institute of Contemporary Art in Boston (2006) and the expansion of the School of American Ballet in New York (2007).

In 2003, the Whitney Museum of American Art in New York dedicated an important retrospective to the studio's work. In 2009 Elizabeth Diller and Ricardo Scofidio were named among Time Magazine's one hundred most influential people for their contributions to the world of art and architecture.

www.dillerscofidio.com

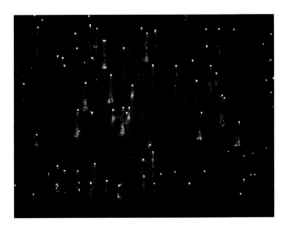

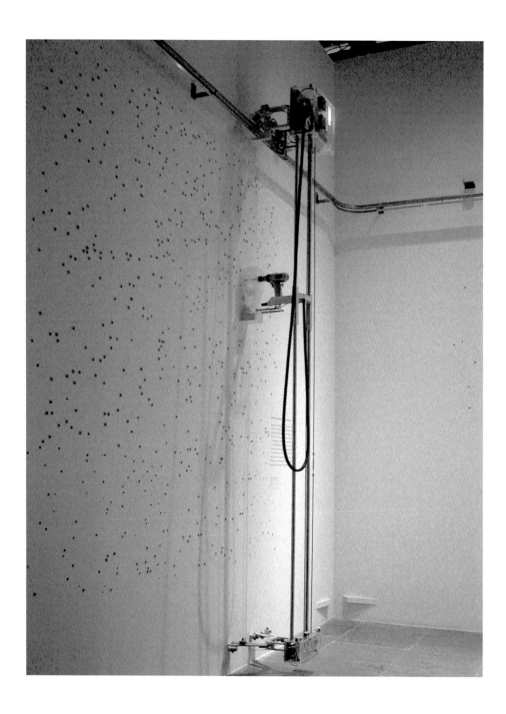

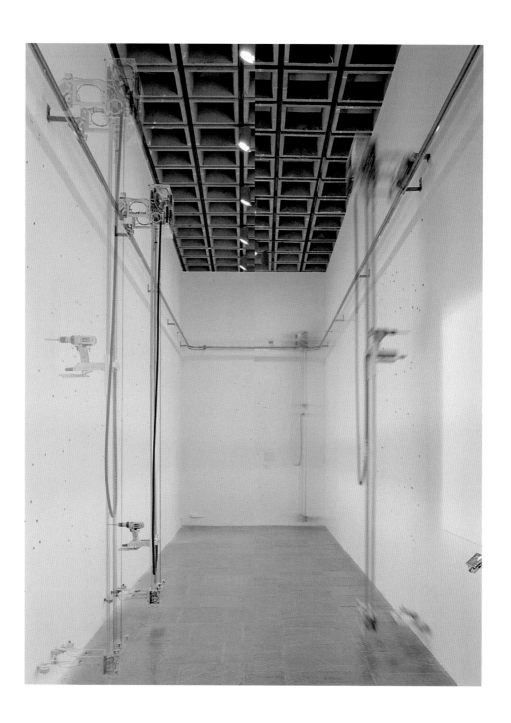

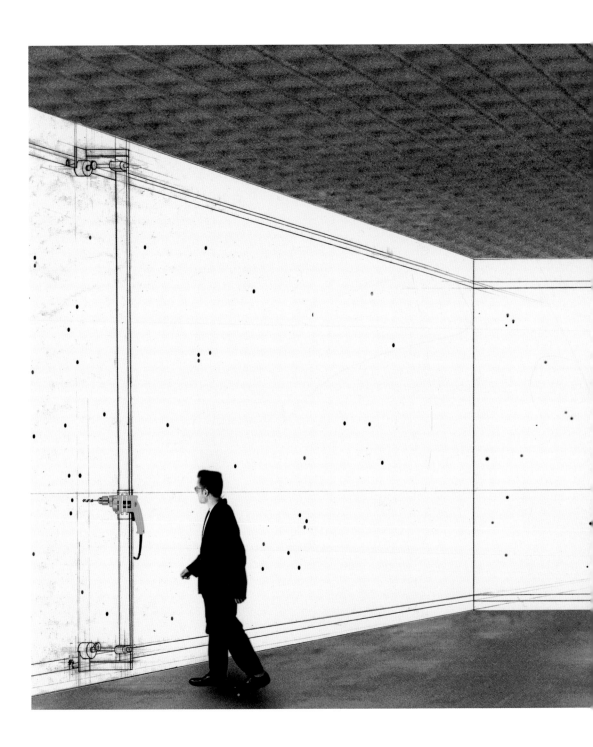

SPADE ½"

PLUG CUTTER ½"

HOLE SAW ⅝"
[NO PILOT]

FORSTNER ½"

HANSEN ½"

AUGER ½"

HOLE SAW 3/4"
[W/ PILOT]

5/8"

## HPNJ+ – Moare

In the museum premises, at the crossroads of paths, there is an invisible object of forty cubic feet of volume, and its absence is present only through reflection.

A medium which shines, 'behaves' and 'breathes' in the rhythm of light and communicates with visitors by oscillation.

The presence of the floor plan of irregular perimeters supports the geometry of an 'exhibition palace', while the site-specific interaction with the object brings about spontaneity and unpredictability by turning the museum space into a space of the random meeting with a barely visibly medium.

The threads of a very thin wire set in a grid, which allow the visitors to pass through, are of various voltages thus suggesting the oscillation of the body, and individually communicate through electrostatic charge.

*Helena Paver Njirić*

## Helena Paver Njirić

— For nearly a decade Helena Paver Njirić has been recognized as one of the most interesting and consistent figures in the Balkan and continental architectural scene. She studied in Zagreb, at the Berlage Institute in the Netherlands, and other highly-regarded European architectural institutes. In 1996 she founded the Njirić+Njirić Studio with Hrvoje Njirić. Their work immediately attracted the attention of critics and specialized media. The most convincing aspect of their work was their ability to translate the freedom and unlimited energy of figurative research of that era. Their work was accessible, concrete and perfectly matched the needs of the newly founded Croatian democracy which yearned to grow. The two architects created a series of projects and buildings marked by surprising clarity: the *bauMax Shopping Mall* in Maribor, a McDonald's restaurant with a roof playground, also in Maribor, and a series of residential projects in Croatia which were innovative yet respected the needs of the local community. In 1997, the magazine *El Croquis* dedicated a monographic issue to the studio which was followed by their participation in important exhibitions and appointment to important positions in Croatian academic and professional structures. In 2001 Helena Njirić separated from her partner and opened her own studio in Zagreb with a group of young local architects. Apart from her continued commitment to research on residential buildings, art spaces and public spaces, Njirić has focused on themes and issues closer to the art world in this second phase of her career. At the 2004 Venice Biennale of Architecture, she was curator of the Croatian Pavilion and produced a complex installation in collaboration with a group of young architects based on the idea of movement, the architectural use of glass and the impossible stability of space. In 2006, in close collaboration with a team of curators and historians, she created an exhibition space for the Jasenovac Memorial, her most incisive and dramatic work to date. The most memorable and penetrating feature of the project is a long and dark space, broken by large plates of glass engraved with the names of many of the victims of the concentration camp: Jews, Rom, Bosnians, communists and Tito's partisan fighters massacred by the Ustaše. These projects, which straddle the boundaries between territory and art, are representative of recurring themes in Njirić's work but also provide a precedent necessary to understand the objectives of this exhibition. *Space* is also based on the uncertainty between transparency and opaqueness, on the idea of an architecture which is suspended and modified by the passage of individuals, on an instability exalted by light and changing relationships with the context, on a choice of form which is simple but made complex by movements which cross through it. Apart from their insistence on a relationship between art and memory, Njirić's other recent projects again confirm the fundamental themes of her work: domestic space precisely conceived in order to unite simplicity, modernist rigor and vernacular melancholy; the relationship between the ever-present Balkan landscape, understood both as a real presence in the context of public action and as an imitation and summary in the form of architectural elements; and, finally, the constant tension between the space of art and the space of memory, creators of sense and identity. (p.c.)

---

## Moare

### HPNJ+

Helena Paver Njirić
Associates: Miro Roman, Jelena Botteri
Art technology: Dubravko Kuhta – Tesla
Light design: Ninoslav Kušter – Ortoforma
Photography: Marko Ercegović
Structure: Andrej Marković
Materials: plexiglas board / hanging flax wires, plexiglas board / on floor
Dimensions: area 14 m², hight 2.60 m

---

Helena Paver Njirić studied and graduated in Zagreb, where she founded Njirić+Njirić Arhitekti with Hrvoje Njirić in 1996. The studio received attention and acclaim from international critics.

In 2002, she opened the HPNJ+ Studio and created important buildings in Croatia: the Štanga residential complex in Rovinj (2004) and the Jasenovac Memorial Museum, which in 2007 won the Fondazione Benetton's International "Carlo Scarpa" Prize for best memorial project in Europe and the "Bernardo Bernardi" Prize for design. She was curator of the Croatian Pavilion at the Venice Biennale of Architecture (2004). Since 2003, she has held the position of vice president and head of publications at the Croatian Association of Architects (UHA).

constructive
inox wires
+
electricity

+ 600.00

+ 246.8    plexy  0.6 cm
+ 241.2    plexy  2 X 0.6 cm
+ 240.00

flax wires
235.4 cm height

+ 0.60
± 0.00     plexy board
           0.6 cm height

2A

2B                                        2B

## R&Sie(n) – Weeping prototype

The melancholy of a fragment weeping its own substances.

As a protocol of life span he will slowly shrink on itself to become a flake, a 'souvenir' of what he pretended to be.

Without *raison d'être*, its nonexistence affected his physicality, reduced to tears dirtying the floor.

*R&Sie(n)*

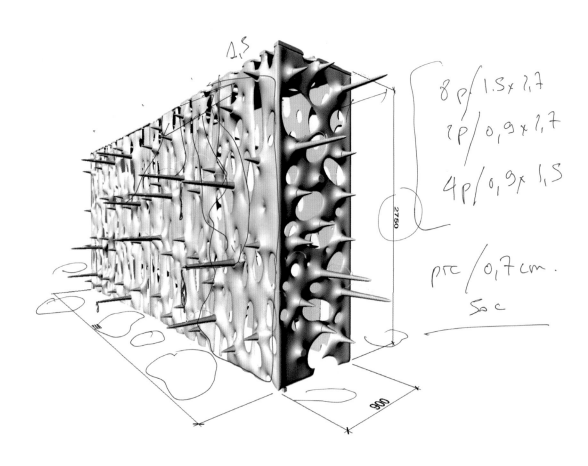

## R&Sie(n)

— Over the years, the R&Sie(n) studio has demonstrated a varied and complex character, mirroring the course of its architectural research. Case in point, the studio has long chosen not to divulge photos of its members and to modify the acronym of its name with every personnel change, contravening the most common publicity and media-visibility strategies. The architects' image is replaced by an avatar, a sort of digital hermaphrodite with a schizophrenic nature who constantly changes personality with an eye towards depersonalization. And in place of a single brand or consistent logo, the designers have preferred to emphasize the coherence of their research, which has long revolved around a few focal themes: the concept of the dynamic system, investigation of the paradigm of complexity, analysis of repetitive or iterative process, the ideal of hybridization and transformation, and the chemical rereading of moods. Or, more generally, the study of natural structures and their processes of organization, development and growth. In their efforts, the French architects have often made recourse to abstract models, undoubtedly aided by the fact that François Roche, one of the studio's founders, is a former mathematician. Initially, their hypotheses seemed to be based on the integration of nature as the internal substance of architecture. Today, their assumption of nature as a protocol or an algorithm is more evident, with clear reference to irregular or more properly "fractal geometry", a term coined by its discoverer Benoît Mandelbrot in the early 1970s. This geometry comprises shapes existing in nature, such as ramifications, irregularities, jaggedness and repetition of the same shape on different scales according to the so-called property of self-resemblance. The presence of such shapes in nature has been amply demonstrated, as has their presence in examples of architecture, including ancient ones, worldwide. The architectural works conceived within this line of research seem to be made of the "material of uncertainty" of which Paul Valéry wrote in his celebrated *Eupalinos*, a material that seems shapeless, but in reality is endowed with internal laws of admirable logic, such that it has catalyzed an investigation that spills over from science into philosophy.

The French group has also often developed machines in the Duchampian sense – that is, ones that are not emblematic for their efficiency, but rather intended as elements that trigger creative processes. These processes often lead to the development of "concept buildings" – hypotheses of future buildability rather than proposals intended for immediate construction – that push the boundaries of architectural experimentation towards, for example, systems integrated with renewable energy. Rather than façades, such buildings have sun-sensitive 'skins' with photovoltaic cells that deform their exterior membrane, making the concept of perspective and the dividing lines between interior and exterior flexible. Thus they are not just organisms that utilize energy, but are capable of producing it themselves and returning it to the city, increasingly conceived as a living, pulsating organism.

Another of the studio's fields of interest has to do with the distribution systems of natural habitats. In this regard, they analyzed a 1920s study of termites conducted by Maurice Maeterlinck, which describes the constant alteration of the insects' habitat and way of life, as well as their use of trajectories for movement across spaces based on odors and perceptions of body and atmospheric temperatures. The idea they drew from the study was that of a constant work in progress, a continual rearrangement with nothing finalized or pre-set, as a hypothesis to be tested in human living systems. In fact, R&Sie(n) has recently extended the idea of an organic, irregular and continually changing system to city planning. The French collective's city-utopia would be built by a VIAB (a term suggested by Bruce Sterling, combining Viability and Variability), a machine that expels cement, autonomously weaving the urban fabric. For the MAXXI installation, R&Sie(n) has proposed a prototype that raises a series of questions on the consistency and material nature of space. (d.d.)

## Weeping prototype

### R&Sie(n)
Prototype Company: CHD
Material unknown
Dimensions: $6 \times 1 \times 3$ m

R&Sie(n) was founded in Paris in 1989, by François Roche (Paris, 1961) and Stéphanie Lavaux (Saint-Denis, France, 1966). Notable projects include: the office building *(Un)Plug Building in Paris* (2001) and a museum of contemporary art in Bangkok, currently under construction. Their work has been shown in international museums like the Tate Modern in London, the Centre Georges Pompidou in Paris and MIT in Boston. They have participated in four editions of the Venice Biennale of Architecture (1990, 1996, 2000, 2004). In 2009, their installation *Hybrid Muscle*, realized in collaboration with Philippe Parreno in Sanpatong, Thailand (2003), won the PAALMA – Artista + Architetto Prize in Montemarcello (SP).
www.new-territories.com

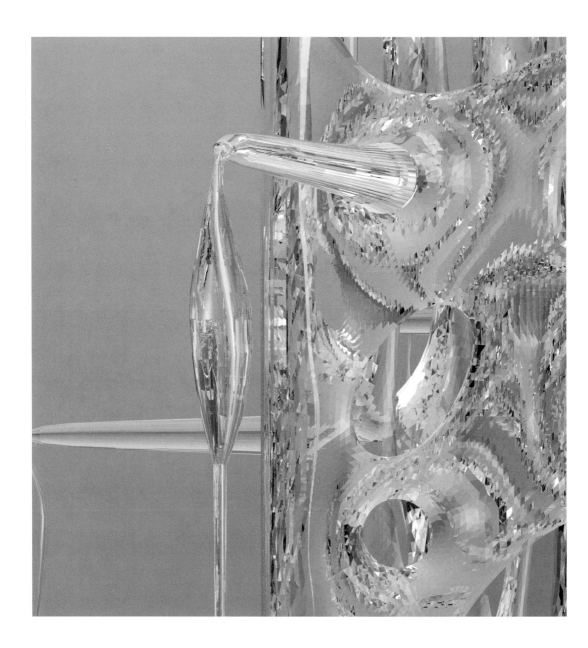

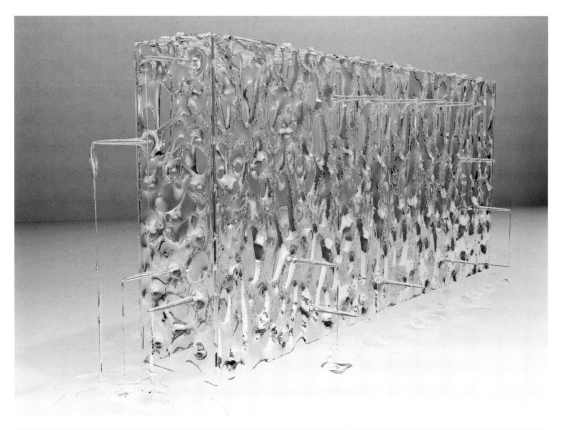

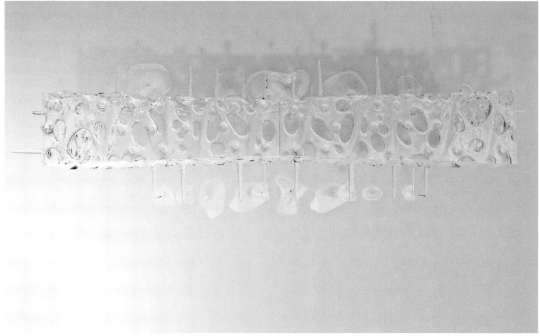

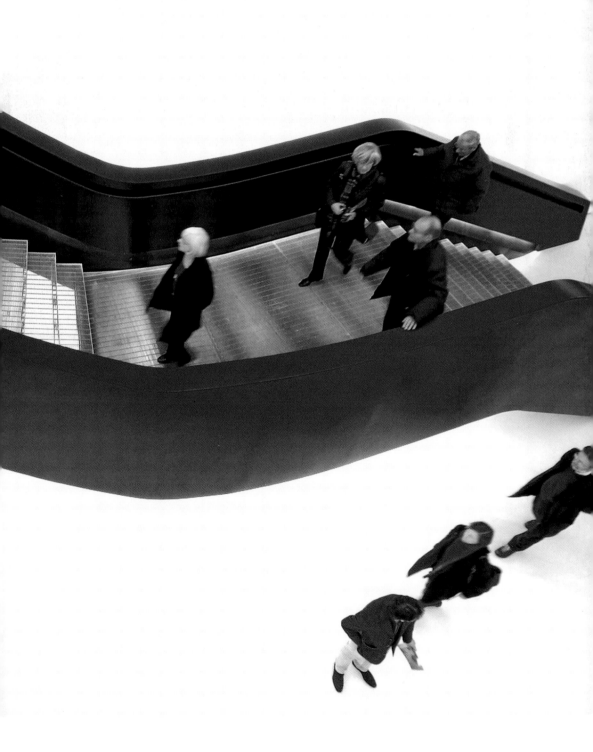

# Studio Azzurro – Geografie italiane

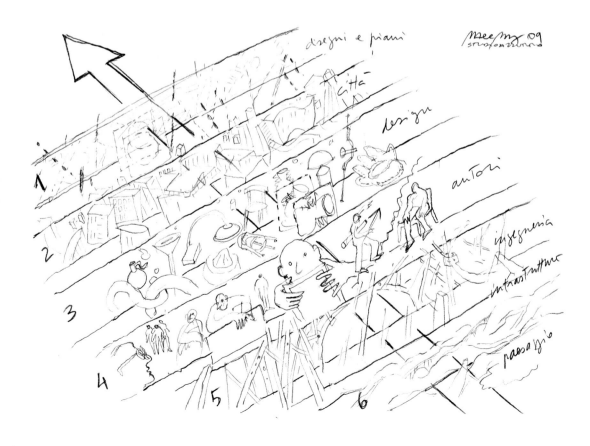

— Geografie italiane. Viaggio nell'architettura contemporanea (Italian Geographies. A Journey through Contemporary Architecture) is a video installation which functions simultaneously as a kind of history and laboratory of contemporary architecture. The various developments in Italian architecture during the second half of the twentieth century are interpreted through the introduction of guiding themes which form a narrative backbone for the visual presentation.

The installation Geografie italiane is made up of a sequence of "worlds", which come together to form a kaleidoscopic image of architectural landscapes.

A term with multiple meanings, the plural noun "geographies" is used to refocus attention on the variety of forms architecture has produced over the last fifty years. This array of forms demonstrates that Italian architecture is not univocal, but in fact represents a system of interrelations at both the micro and macro levels. "Geographies" is marked by a chronologically disjointed narrative sequence. The objective of the installation is to read the recent past as a fragment of the present, interpreting different "worlds" as a sort of musical score with a steady but upbeat rhythm.

Each "world" is created using a variety of iconographic and visual materials including drawings, photographs, film clips and interviews in order to create a specific narrative script. The selection of the components for each world is diverse. Buildings, authors, concepts and places have been freely reworked and assembled by Studio Azzurro to allow for a myriad of possible pathways and interpretations within the general narrative framework of the installation.

As indicated on the wall, the sequence of "worlds" explores the following themes in this order: cities I engineering I landscape I competitions I heritage I design I landmark I museum I protagonists I media and next.

The visitor can experience the various "geographies" using monitors which list the names of leading figures, keywords, aphorisms, and places. Selecting one of these opens an informational box. In this way, the visitor is given the opportunity to create a personal interpretation of Geografie italiane.

## Geografie italiane.
## Viaggio nell'architettura contemporanea

### Studio Azzurro
Production: Studio Azzurro and Fondazione MAXXI
Curators: Maristella Casciato, Pippo Ciorra, Margherita Guccione/MAXXI
Conception and direction: Paolo Rosa, Stefano Roveda/Studio Azzurro
Development and realization:
for Studio Azzurro, Marco Barsottini, Matteo Cellini, Monica De Benedictis, Daniele De Palma, Chiara Ligi, Silvia Pellizzari, Lorenzo Sarti, Giulio Pernice
for MAXXI Architecture, M. Elena Motisi with Sara Marini, Giulia Menzietti
Technique: Interactive video installation with 9 synchronized screens and 4 touch-sensitive lecterns

Studio Azzurro is an environment of artistic research which uses new technology as its expressive tool. Founded in 1982 by Fabio Cirifino, Paolo Rosa and Leonardo Sangiorgi, with Stefano Roveda joining in 1995, it has explored the poetic and expressive power of these means for over twenty years. Its innovative use and creation of video environments, interactive environments, film and theatre performances, and exhibitions has given it international recognition.
www.studioazzurro.com

# NETinSPACE

curated by Elena Giulia Rossi

— NETinSPACE is a voyage along the boundary between two worlds, the virtual and the physical, exploring their reciprocal contaminations. Hacker Art, performances, net art, already-realized works as well as site-specific ones will infiltrate spaces adjacent to the designated exhibition venues.

NETinSPACE, thus, carries on the program of NetSpace which, over a three-year period (2005-2008), invited MAXXI visitors to interact with works created exclusively for the web – known as "net.art", "web art" or " Internet art" – and to explore its historical-artistic roots.

In a dialogue with the first exhibition of the MAXXI's collection Spazio, of which this edition of NETinSPACE is a part, this project hovers in the space between two dimensions, the virtual and the real. Internet materializes in a net that traverses the two dimensions to create a new territory in which different languages intertwine with and contaminate one another in an osmotic process.

Miltos Manetas (whose work is included in the MAXXI's collection), the duo Bianco-Valente and Katia Loher are the three artists intervening in the space as well as on the web. Manetas, the initiator of artistic movements like Neen – the name commissioned by Lexicon, the company that coined the terms "Pentium" and "Powerbook" – continues his exploration of virtual territory, the nationality of which materialized in the Internet Pavilion presented at the 53rd Venice Bienniale (2009). In the work realized for the MAXXI, some of the contents of the Internet Pavilion come back into play, as well as a 2001 work, IamGonnaCopy, and together they encapsulate his work and his vision of a new territory in which the body and information converge into one single thing. The Italian duo Bianco-Valente, who have always been interested in the boundaries between the material (body) and the ephemeral (mind), have now extended their work to include comparison between real and virtual space, the structures of which can be recognized in the functioning of universal natural laws. A site-specific intervention and a software work investigate the theme, with particular attention to "analogies" between the branching processes of natural ecosystems – such as those that structure neurons for the functioning of mnemonic processes – and the structure of the network. Macrocosm and microcosm meet in a single dimension in the universes conceived by Katia Loher in her series of Video-planets, which, in this latest version, extend to include a web component. Performers shot from above in specific choreographic movements are projected in tiny scale dimensions onto a large ball and, through a post-production process, become letters (video-alphabets), and the letters form phrases in which the language of the real world dialogues with that of the computer world.

The six on-line works outline an anthropological analysis of the new territory.

In Mitozoos (2007) by the group Bestiario, synthetic organisms are born by means of a mathematical calculation and by the interaction of visitors. Organizing themselves into ecosystems, they grow and die according to laws very similar to those of nature. Fuzzy Dreamz (1996) by the Belgian pioneer Dr Hugo Heyrman is a voyage in temporal space, passing through dream sequences that lead us from the personal sphere to collective memory. Stop Motion Studies (2003) by David Crawford uses film collage elements composed online to investigate the impact of technology on social dynamics, in particular those produced between individual and society in the urban sphere. Google is not the Map (2008), a recent work by the "imaginary" group Les Liens Invisibles (Clemente Pestelli and Gionatan Quintini), is a playful and provocative exploration of the conventional systems that determine our perception of space. Cartographic maps, stripped of their original function, become the site of linguistic and visual games.

The stylized forest in Forest of Imagined Beginnings (2007) by the English duo Boredomresearch, is the visualization of a forum in which visitors can actively participate, permitted to navigate in a place constructed by data in which the parameters of orientation are the latitude and longitude of the mouse on the screen. Icons of the four elements – earth, fire, air and wind – are the doors through which visitors gain access to the sound-landscapes of Tetrasomia (2000), a pioneering work by the well-known American sound artist Stephen Vitiello. Sounds recorded in nature are translated on a web site into an interactive composition that also leaves traces of the presence of another element: ether.

1. Dr Hugo Heyrman, Fuzzy Dreamz, 1996 – ongoing
Screen-shot: www.doctorhugo.org/dreamz/index.html
2. Les Liens Invisibles (Clemente Pestelli e Gionatan Quintini), Google is not the Map, 2008
Screen-shot: www.lesliensinvisibles.org/2008/11/14/google-is-not-the-map/
commissioned by LX2.0 Lisboa 20 Arte Contemporanea
3. Bestiario, Mitozoos, 2006
Screen-shot:
www.bestiario.org/mitozoos/english/mitozoos.html
commissioned by Fundación Telefónica, Madrid
4. Stephen Vitiello, Tetrasomia, 2000
Screen-shot: www.awp.diaart.org/vitiello/
commissioned by Dia Art Foundation for its series of web projects, New York
5. Boredomresearch (Vichey Isley e Paul Smith), Forest of Imagined Beginnings, 2007
Screen-shot: www.boredomresearch.net/forest/index.html
co-commissioned by Folly, Digital Arts Organisation, Lancaster UK & Enter_Unknown Territories, International Festival & Conference for New Technology Art, Cambridge UK
6. David Crawford, Stop Motion Studies. Series 7, 2003
Screen-shot:
www.artport.whitney.org/gatepages/artists/crawford/index_01.html
Commissioned by Whitney Artport for its series of Gate pages, Whitney Museum of American Art, New York
7. Katia Loher, Sculpting in Air /Video Planets, 2010
8. Bianco-Valente, The effort to recompose my complexity, 2008
9. Miltos Manetas, IamGonnaCopy, 2010
Sticker, design: Experimental Jetset

# Credits

**Images courtesy of**
Accademia Carrara, Galleria d'Arte
Moderna e Contemporanea, Bergamo
Alterazioni Video
Archivio Giulio Paolini
Stefano Arienti
Associazione per l'Arte Fabio Mauri –
L'Esperimento del mondo
Atelier Van Lieshout B. V.
Marina Ballo Charmet
Bernier / Eliades Gallery, Athens
Castello di Rivoli Museo d'Arte
Contemporanea, Rivoli-Turin
Diller Scofidio + Renfro
James Cohan Gallery
Flavio Favelli
francesca kaufmann, Milan
Fondazione Querini Stampalia, Venice
Fondazione Sandretto Re Rebaudengo,
Turin
Amish Fulton
Gagosian Gallery
Galerie Nordenhake, Berlin
Galerie West, The Hague,
The Netherlands
Galleria Continua, San Gimignano /
Beijing / Le Moulin
Galleria dell'Oca, Rome
Galleria Emi Fontana
Galleria Franco Noero, Turin
Galleria Lia Rumma
Galleria Massimo Minnini, Brescia
Galleria Monica De Cardenas, Milan
Galleria nazionale d'arte moderna e
contemporanea, Rome – with
permission from the
Ministero per i Beni e le Attività Culturali
Galleria Raffaella Cortese, Milan
Galleria S.A.L.E.S., Rome
Galleria Sonath, Paris
Galleria Zero, Milan
Carlos Garaicoa
Massimo Grimaldi
Luhring Augustine, New York
Magazzino d'Arte Moderna, Rome
MAMbo, Museo d'Arte Moderna
di Bologna
Maurizio Mochetti
Museo civico di Palazzo della Penna,
Perugia
Palazzo Reale Caserta – Collezione

Terrae Motus
Cesare Pietroiusti
Marjetica Potrč
Recetas Urbanas
R&Sie(n)
Rintala Eggertsson Architects
Sikkema Jenkins & Co., New York
SMS Contemporanea, Siena
Sprüth Magers
Studio Cabrita Reis
Marco Tirelli
Francesco Vezzoli
Luca Vitone

**Photographic credits**
© Claudio Abate, Rome
© Iwan Baan
© Hélène Binet
© Richard Bryant/Arcaid
© Roland Halbe
© G. Schiavinotto
Alterazioni Video
Marina Ballo Charmet
Ela Bialkowska
Matteo Bonaldi
A. Burger, Zürich
Simone Cecchetti
Luca Fabiani
Roberto Galasso
Wannes Goetschalckx and
Kurt Augustyns
Gerhard Kassner
Avish Khebrehzadeh
Boris Kirpotin
Dario Lasagni
Barbara Ledda
Fabio Lensini
Claudia Losi
Antonio Maniscalco, Milan
Attilio Maranzano
Roberto Marossi
Kieron McCarron
Paolo Pellion
Matteo Piazza
Luciano Romano
Silvio Scafoletti (GNAM)
Seton Smith
Studio Bernhard Schaub, Cologne
Dimitris Tamviskos
Patrizia Tocci
Matthias Vriens